A
SPIRITUAL
APPROACH TO
ASTROLOGY

A SPIRITUAL APPROACH TO ASTROLOGY

Myrna Lofthus

CRCS PUBLICATIONS
Post Office Box 1460
Sebastopol, California 95472
U.S.A.

Library of Congress Cataloging in Publication Data

Lofthus, Myrna, 1935–
 A spiritual approach to astrology.

 Includes index.
 1. Astrology. 2. Reincarnation. 3. Karma.
I. Title.
BF1711.L58 1983 133.5 78–62936
ISBN 0–916360–10–5 (pbk.)

FIRST PAPERBACK EDITION
INTERNATIONAL STANDARD BOOK NUMBER: 0-916360-10-5
LIBRARY OF CONGRESS CATALOG CARD NUMBER: 78-62936
Published simultaneously in the United States and Canada by:
CRCS Publications
Distributed in the United States and internationally by
CRCS Publications
(Write for current list of worldwide distributors.)
Cover Design: Image & lettering both by Rebecca Wilson.

Contents

Preface

*This chart is an illustration from *The Digested Astrologer*, Volume I, by Virginia Ewbank and Joanne Wickenburg.
†These illustrations were prepared by Ragnar de Sharengrad.

**This chart was designed by Joanne Wickenburg
†This illustration was prepared by Ragnar de Sharengrad.

†These illustrations were prepared by Ragnar de Sharengrad.

Dedicated to
My Parents, My Husband, My Son
and
Seekers of Knowledge

Preface

Fifteen years ago, I read my first book about Edgar Cayce, the sleeping prophet. It was entitled *There Is a River* by Thomas Sugrue. As I read that book, a feeling of inner peace filled me, for I had at last found the "loving" God the Bible spoke about. It seemed to me that God played favorites because of the inequities in the world. What had these souls done to merit their punishment?

I was reborn after reading Sugrue's book, as it gave me the key to unlock some of the mysteries surrounding human incarnations. Edgar Cayce discovered, quite by accident, that souls reincarnated over and over again in order to earn their way back to God. Here at last was proof that God is a kind, loving, and compassionate Creator, willing to give us many, many opportunities to become at one with Him again.

My study of astrology evolved out of my reading many books on Edgar Cayce in which he consistently emphasized that souls select the time to reincarnate in order to obtain planetary vibrations that would help them complete karmic debts and promote soul growth. By now you are saying to yourself that you *can't* remember any of *your* past lives. The reason we temporarily forget our past lives is God's protection from the remembrance of negative lives which would only cause deep distress. However, your subconscious remembers them, and they surface in dreams, through fears, and personality difficulties. When you are ready to face yourself, the veil lifts and allows you to remember. Hypnosis, of course, has the ability to lift this veil, but should only be attempted by hypnotists who have an understanding of reincarnation and can be of assistance to the client if any difficult lifetimes are relived. Too many times, the client becomes the personality he once was rather than being the observer. Thus, great distress can ensue.

In our spiritual form, we remember all of our physical lifetimes and recognize the areas of life that still need work. Preparation is, then, started to seek the best time, parents, and country which would be most suited to meet the specific karmic atonements and would, also, allow spiritual growth.

A natal astrology chart indicates what you have programmed to repay karmically, your problem areas, and your blessings which are a reflection of the good you have accomplished in other lives. For this reason, I have written and rewritten for three years in order to present astrology in a different way. Of course, it is, also, possible to use astrology to help you in your daily living, and there are many reasons for doing so. *But,* for me, the main purpose in studying a natal chart is to see the areas of life that need to be worked on in order to accomplish soul growth. I believe that this was the original purpose of astrology eons ago.

In discussing each planet, I correlated its color, terrain, interior, atmosphere, and satellites to human characteristics and global concerns. Because of the spiritual assistance we are receiving, new discoveries concerning the planets in our solar system will go on forever. So, I ask your pardon for any planetary descriptions that are inaccurate.

I want to thank Ragnar de Sharengrad and Roger Sweum for their probing questions which helped stimulate the growth of this book. And, my especial thanks to Jorun Armour and Nikki Jensen for their hours of work helping me index it. Then, too, many thanks to my students for being a constant source of stimulation in our mutual quest for truth, wisdom, and understanding.

A SPIRITUAL APPROACH TO ASTROLOGY

CHAPTER 1

Introduction

IN THE BEGINNING . . .

What is man's relationship to the universe? Or, for that matter, to earth? These and many similar questions have forced many of us to search for the truth. But how blind we humans are, for the truth we seek is located within our unconscious mind. To unlock the door to our unconscious mind, we need to have a key.

There are many different keys, but strangely enough, they all seem to fit the door of the unconscious. These keys have many different names, such as tarot, palmistry, numerology, Rosicrucian, Zen, and, of course, astrology. These keys merely unlock the door so that you can get a glimpse as to who you are, where you have been, and where you hope to go. The key, or keys, you use is unimportant. What is important is for you to unlock the door. Once this door is unlocked, there is more work to do, but at least you will have seen a glimmer of light.

Astrology, as a key, can help you understand yourself and others better. All of us are involved in the same struggle for soul development and growth. The planets in our solar system have certain vibrations which we react to unconsciously. We call these vibrations urges or inclinations. But, because they are urges only, we can bring them under control by the use of our free will.

Free will means the ability to make your own personal choice. Free will can change the direction of our life at any time we decide to use it. We used free will when we entered our present bodies. It was our own decision as to who are parents should be, and what vibrational influences we wanted from the planets in order to help resolve some of the karma from previous lifetimes. Planets have a set vibrational influence, but they operate differently in each of the zodiac signs. For instance, Mercury in Aries gives a different thinking pattern than Mercury in Taurus. In

1

Aries, the mind is alert, and quick to react, whereas in Taurus, the mind is methodical and moves at a slower rate in order to absorb all the material before decisions are reached.

We have no one to blame for the life pattern of this particular incarnation but ourselves. In the astral world, we are not weighted down by our emotions so that we can make an accurate appraisal of our record of deeds and misdeeds. A decision is then made as to what area we need further improvement on and in what area we wish to make atonement. After our decision has been reached, a suitable vehicle (body) and parents must be found that will best suit the selected program.

Our entanglement into physical bodies began eons ago because of our curiosity about emotions. Were we wrong to allow our natural curiosity to involve us with physical matter? No, I don't think so. All experiences are important to the formation of a complete, perfected soul.

We learned, much to our sorrow, that the price we had to pay for feeling emotions was to experience ALL emotions. In the beginning, we so cleverly chose which emotion we wanted to experience. Then, when we saw an animal experiencing that emotion, we flitted into their body. Thus, we were able to enjoy the emotion briefly. Naturally, we were intelligent enough to choose only the pleasant emotions. No one was foolish enough to want to enter an animal's body if the animal was experiencing pain. Our lives were exciting and pleasant. We were like children playing games, as we watched earth's slow evolution process.

So, what happened? Why aren't we still resting on a cloud watching the animals' adapting to the ever-changing environmental conditions? Alas, the audience became the actors instead. The answer as to why this happened can be simply stated by saying that we interfered in the natural evolution laws. No one has the right to interfere in anyone's life. We can guide them, love them, encourage them, but not interfere. Our interference earned us our "reward." Since we wanted to experience emotions, we found that we could no longer remove ourselves from the animal's body when we flitted in for an "emotional experience." Thus, the fall of the angels was complete.

This fall of the angels meant that we had to live out that animal's life until it either died or was killed. Before the animal's death, however, the soul had to experience many emotions. In a three-dimensional world, emotions have two sides. All the pleasant emotions had been experienced, but imagine the torment when the emotions of hunger, thirst, cold, and fear invaded the soul. How could one eat unless one killed? Our first kill placed us under the "law of cause and effect." The Bible refers to this as "an eye for an eye, and a tooth for a tooth." Thus, we were totally entrapped to incarnate over and over again until we had perfected emotions to their highest possible state.

Other souls who were not entrapped watched the anguish of the entrapped ones and decided to help them work through their karma (the consequences of one's behavior). This was attempted in many ways. To simplify things, we will say that volunteers in perfect human bodies came attempting to help. They used their psychic creative ability to perfect the animal bodies and to advise on how to resolve their karma. But what started out as an errand of mercy turned out to be an entrapment for the volunteers, also. Emotions got in the way of their clear, analytical thinking. Some of them began to treat the entrapped souls as inferior creatures who were only fit to serve them. Thus, they too, fell under the law of "cause and effect."

Though the earliest knowledge of astrology dates back to the mists of antiquity, it lives and grows and needs re-presentation based on current research. Its development is similar to that of medical knowledge. From time to time, certain medical treatments have been dropped when other methods have proved to be more effective. Today, most astrologers have dropped the "fated" or "doomsday" interpretations of natal charts. This has been the direct result of the discovery of Pluto in 1930. Pluto caused an upheaval in the thinking of astrologers. This does not mean that it was not affecting us before that year, but means that its visibility forced astrologers to study again. The results of their studies have gradually updated astrology. As more and more souls reach a higher level of soul evolution, we will discover another planet. It is commonly referred to as Vulcan and will probably rule Virgo. Thus, the rate of soul evolution will be accelerated even more on the long journey back to our original home.

Astrology is both a science and an art. It is a science, because the setting up of a chart is an exacting process for each factor has to be calculated. As an art, it depends on the astrologer's skill in interpreting the chart. Like all skills, it improves with practice, but the genius astrologer is just as rare as a genius in any other field of endeavor.

Astrology can't solve your problems for you, but it can go a long way toward giving you a greater understanding of both your problems and yourself. It can, also, tell you when to proceed with your plans so that you obtain the best possible results.

Personally, I think astrology's greatest value lies in its method of self-analysis. No man sees himself as others see him, and he is tempted to discount other people's unfavorable opinions of himself as being founded on prejudice. Each sign and each planet have positive and negative traits. Are you willing to admit to yourself your negative traits and begin developing the positive traits?

Too many people think that astrology is based on the star constellations. This confusion of thought exists because the constellations have the same names as the signs of the zodiac. However, it is possible to set

up a natal chart based on sidereal astrology (or star constellation astrology), but this is entirely different from traditional astrology. India uses sidereal astrology and a few astrologers in the West, also.

Zodiac astrology begins with 0° Aries when the sun crosses the equator heading north. (It is actually the earth doing the moving, but it clarifies things to say the sun.) Thus, when the sun crosses the equator heading north, this is called vernal or spring equinox (*equi* = equal and *nox* = night). It is autumnal equinox or 0° Libra when the sun crosses the equator heading south.

Seasonal changes are seen in the house cusps of a natal chart. In the Northern Hemisphere, Aries on a house cusp indicates "spring," Cancer indicates "summer," Libra indicates "fall," and Capricorn indicates "winter." In order to adjust to the seasonal differences between the Northern and Southern Hemispheres, a six-month adjustment is made for births in the Southern Hemisphere so that the correct natal house cusps can be determined. This adjustment places the Southern latitudes in the identical position relative to the sun as the Northern latitudes were six months before. Seasonal differences are only important to the house cusps and not to the twelve sun signs. The sun signs are determined by where the sun is reflected on the zodiac belt. For example, the sun is reflected on the zodiac belt in Aries from March twenty-first to approximately April twenty-first each year. No matter where you were born on our globe, you would be an Aries if you were born during that time. This is because the sun would be directly between the earth and the Aries section of the zodiac belt. To visualize this better, see *Chart No. 2.*

It is because of the four zodiac names which are used to herald spring, summer, fall, and winter in the Northern Hemisphere that the controversy concerning the unsuitability of using "Northern Hemisphere Astrology" for the Southern Hemisphere began. Some astrologers feel that if a person is born in the Southern Hemisphere, their natal sun sign should be the polar opposite of the Northern Hemisphere in order to correspond to the seasonal differences. Thus, they feel that someone born in the time period for Aries should be considered a Libran. However, most astrologers, myself included, disagree with this theory. The other eight zodiac signs are not in the least seasonal, except for Sagittarius, the hunter, but he could refer to hunting in the fall in the Northern Hemisphere or hunting in the spring in the Southern Hemisphere. So, each of the characteristics assigned to Aries marks the beginning of spring in the Northern Hemisphere, or the beginning of fall in the Southern Hemisphere, when day and night are equal. The symbol for Aries is the ram. In the spring and the fall, the ram will use his head to dig around on the ground for food to feed his family. Arians, too, are thinkers, leaders, and

4

"seekers" of new ideas. And, like spring, fall, and the ram, they can, also, be stormy.

Chart No. 1 illustrates our small solar system drawn in, with the zodiac belt drawn around it. The oval is the pathway of our solar system through the galaxy and can, also, represent the star constellations' movement, since they are not fixed in the sky either. The star constellations are light-years away from us so this oval is an exaggerated pathway, but is only meant to give you an idea of the precession of ages which is based on the star constellations. It takes over 2,000 years for each age, and, approximately, 25,800 years to go through all twelve star constellations and to begin again. Ages are determined by the poles of the earth. Whatever constellation the North Pole points to determines the age. At this time, it is still pointing to the stars forming the Pisces fish constellation. By the year 2064, we will be in the Age of Aquarius. This, of course, is an approximate date.

It is interesting to note that each age has a sub-age which is the polar opposite sign of the age. This is determined by what star constellation the South Pole is pointing to. Polar opposite signs are linked magnetically and bring their influence in the later half of the age. The breakdown of the ages and sub-ages are listed on separate pages, but the following is a brief summary.

In the Piscean age, Rome wanted world peace and total acceptance of their *Pax Romana*. But, the Roman Empire fell into decadence and decay which is a manifestation of a negative Piscean. Jesus, the spiritual leader of that age, was called the Prince of Peace, but, also, the Man of Sorrows, again, both Piscean phrases. He was referred to by many as Ichthus, meaning the fish. The sign of the fish was used by the early Christians as their symbol.

In the age of Aries, people desperately needed leaders to guide them. Exploration and conquest was at a peak. Empires rose and fell. The ram, the symbol of Aries, was carved on the end of wooden battering rams and used to break down gates of cities. Roman soldiers wore emblems of ram's horns on their uniforms. The Jews used the lamb as a burnt offering. During that age, Moses became a great leader and was chosen by God to give the people his new commandments. These commandments are still relevant today.

In the Taurean age, there was great cultivation of the land, especially in Egypt. The worship of the bull was common. The tombs of the sacred bulls can still be seen today. Taurus is associated with solid construction, and many of the buildings built during this age will stand as witness to this. Similar structures were built in Mexico and Central America, which are, also, still standing today.

5

ILLUSTRATION OF GALAXY

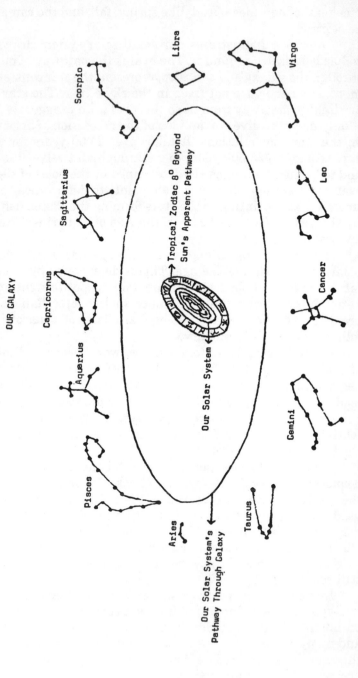

CHART NO. 1
OUR GALAXY

Libra

Virgo

Scorpio

Leo

Sagittarius

Tropical Zodiac 8° Beyond
Sun's Apparent Pathway

Cancer

Capricornus

Aquarius

Our Solar System

Gemini

Pisces

Taurus

Aries

Our Solar System's
Pathway Through Galaxy

ILLUSTRATION OF ZODIAC BELT

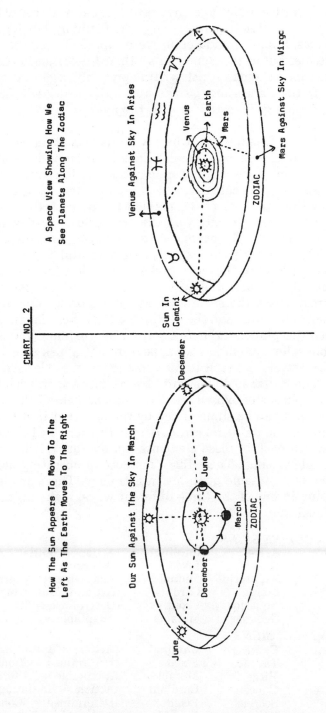

A Space View Showing How We
See Planets Along The Zodiac

Venus Against Sky In Aries

Mars Against Sky In Virgo

Venus

Earth

Mars

ZODIAC

Sun In
Gemini

CHART NO. 2

How The Sun Appears To Move To The
Left As The Earth Moves To The Right

Our Sun Against The Sky In March

June

June

December

March

December

ZODIAC

7

In the Geminian age, the prevailing cult was that of the twins. Sacred pillars dedicated to pairs of gods were found in Babylonian and Assyrian temples. Romulus and Remus were supposed to be the original founders of Rome. Later, the Romans had their Castor and Pollux, sons of Zeus. This was the age in which writing probably began in some form.

In the Cancerian age, the world was struck with floods. Moon cults and female goddesses of the "fertile mother" were prevalent during this time.

In the Leonian age, when Atlantis was at its peak, the use of solar energy was common. Temples have been found in South America with carved lion's faces which were dedicated to the sun.

Astrology is calculated from a geocentric view, because we want to know the influence of the planets to us on earth. "Geocentric" means "from the earth." *Chart No. 2* illustrates how our view from earth makes the sun and the planets appear to be moving to the left in the sky.

Chart No. 3 portrays the planets' orbital pathway around the sun. Once every year, the earth makes a complete journey around the sun in a roughly circular orbit. The other planets all revolve around the sun at approximately the same level as earth's orbit. Mercury and Venus are closer to the sun than the earth, and the other planets are farther away. Since the planets orbit the sun on approximately the same level, the whole solar system has an appearance of a disk or saucer. For convenience, astrologers refer to the sun and moon as planets.

The zodiac is divided into twelve signs with each representing different phases of experience. The reasons behind this are quite complicated, but can be summarized by the fact that in nature there are four main "elements" (fire, air, earth, and water), and there are three ways in which each of these elements can operate (initiating, consolidating, and alternating). These three methods of operating are called cardinal, fixed, and mutable qualities in astrology. The four elements, each operating in one of the three different ways, make up the twelve signs of the zodiac.

MASCULINE SIGNS

Fire:	Aries	Cardinal	(Action = "Initiating")
	Leo	Fixed	(Determined = "Consolidating")
	Sagittarius	Mutable	(Adaptable = "Alternating")
Air:	Libra	Cardinal	(Action = "Initiating")
	Aquarius	Fixed	(Determined = "Consolidating")
	Gemini	Mutable	(Adaptable = "Alternating")

FEMININE SIGNS

Earth:	Capricorn	Cardinal	(Action = "Initiating")
	Taurus	Fixed	(Determined = "Consolidating")
	Virgo	Mutable	(Adaptable = "Alternating")
Water:	Cancer	Cardinal	(Action = "Initiating")
	Scorpio	Fixed	(Determined = "Consolidating")
	Pisces	Mutable	(Adaptable = "Alternating")

ILLUSTRATION OF PLANETS

CHART NO. 3

THE PLANETS

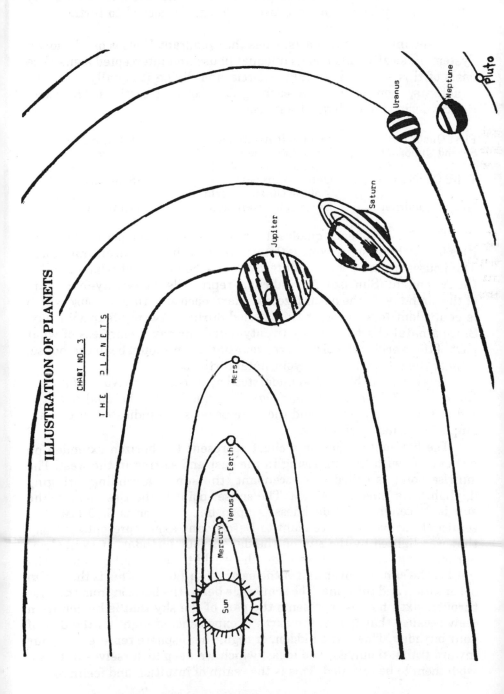

Sun
Mercury
Venus
Earth
Mars
Jupiter
Saturn
Uranus
Neptune
Pluto

9

The cycle of the zodiac is a cycle of experience. We have seen many different zodiac sun signs, because each sign is needed to further soul growth.

In setting up natal charts, I use the Quadrant Houses or Placidean System. Basically, this means unequal house and intercepted signs. The basis of this system is to take a circle and divide it equally into four quadrants, then to subdivide each again into three sections. The experiences derived in each quadrant are:

First Quadrant:	Inner Self-Awareness	(Intuition)
Second Quadrant:	Inner Awareness of the Outside World	(Emotion, Feelings)
Third Quadrant:	Outer Awareness of the Outside World	(Sensation)
Fourth Quadrant:	Outer Self-Awareness	(Thinking)

The division of each quadrant into three sectors comprises the qualities in which the signs express themselves (cardinal, fixed, and mutable). The houses are numbered counterclockwise beginning at what is called the Ascendant (Sunrise). A natal chart represents the twenty-four hours of the birthday. In the natural zodiac chart, each sign rules a house which is equivalent to a two-hour time period during a twenty-four-hour day. Since a natal chart is for any twenty-four-hour day, regardless of what part of the world is the birthplace, your natal sun should be in the house, or near the house that rules your natal birth time.

This can probably be best understood by illustrating a *Natural Zodiac Chart for a Twenty-Four-Hour Day*. The quadrants, the qualities, the zodiac signs, the planets, and the time periods are indicated in this example for visual clarification.

The horizontal lines on a chart represent the horizon extended on either side, with the sun rising in the east and setting in the west. The sunrise point is called the Ascendant (the sun is ascending, bringing daylight). Its time is 6:00 A.M. The sunset point is the Descendant (the sun is descending and darkness is upon us). Its time is 6:00 P.M. The semicircle above the Ascendant-to-Descendant axis represents the sky that was lighted by the sun on the day of your birthday. It symbolizes our outgoing traits, what we allow the world to see. In other words, the light of the sun cast over half of the earth for all to see. This is the realm of sensation and thinking. The semicircle below the horizon from the first through sixth houses represents the part of the sky that is hidden from view because that half of the earth is experiencing night on the day of your birthday. This is the hidden, or night, hemisphere representing our inward traits, thoughts, and ideas, which we keep to ourselves until we wish them to be revealed. This is the realm of intuition and feelings.

NATURAL ZODIAC CHART FOR A 24-HOUR DAY

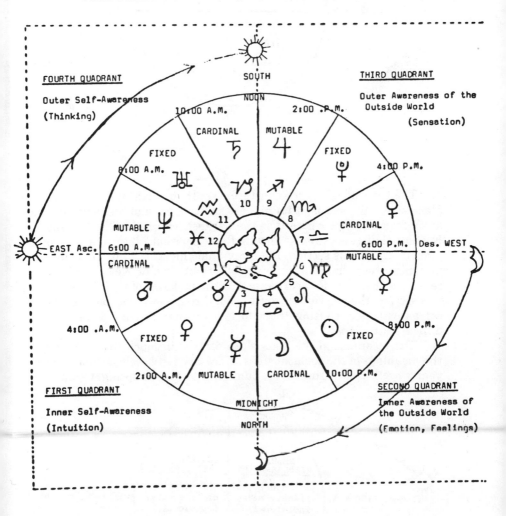

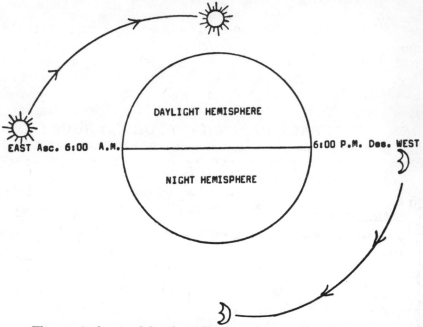

The vertical axis of the chart from south to north cuts the sky at the place where the sun is at its highest point, *noon*, and the farthest place away from the sun where it is the darkest, *midnight*. The left side, or Eastern Half, represents a "Sowing Reincarnation." If the majority of the planets are in this section, the individuals must learn by their own experience, study, and self-analysis. The right side, or Western Half, represents a "Reaping Reincarnation." If the majority of the planets are in this section, the individuals must learn through other people. People will act as catalysts, causing them to learn either through instruction or difficult situations.

The meanings of the houses are derived in much the same way as the meanings of the zodiacal signs, since the daily cycle is similar to the yearly cycle in its significance. Sunrise is similar to spring, because this

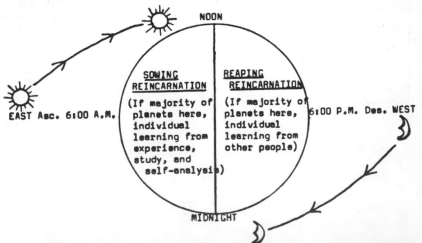

is the time when the entire world of nature and humanity begins to stir once more and to become aware of itself. For example, if the sun were in the first house, indicating you had been born somewhere between 4:00 A.M. to 6:00 A.M., this house would be telling you to awaken to a new awareness of yourself and to begin new growth and development. This is even more meaningful when you realize that the first house rules self-awareness, our personality, and our approach to life.

The noonday sun is the same as high summer and represents the peak of achievement. That is why the tenth house refers to personal achievements in the community and in a career.

The sunset position represents autumn when the leaves blend into orange, yellow, and brown. The sunset position rules the seventh house of cooperative relationships and indicates the need to blend and harmonize our personalities with others.

The midnight position of the sun represents the heart of winter when all the vitality of nature is dormant, awaiting the opportunity to grow again in the spring. This is why the fourth house refers to our personal foundations, such as our inner security and our home.

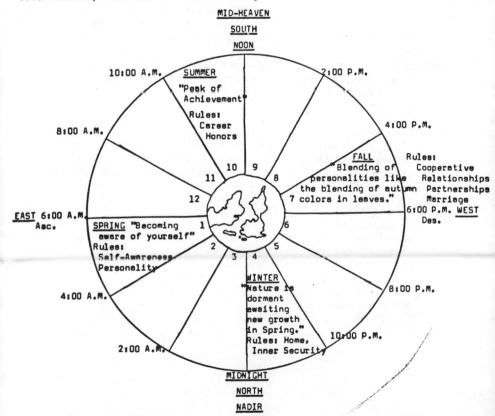

Since the earth, during its journey around the sun, rotates on its axis every twenty-four hours, each zodiac sign will pass successively over the various house cusps every two hours. However, it sometimes happens in the quadrant system of house division that there are more than 30 degrees between one house cusp and the next.

There is no question that astrology can be of considerable benefit to everyone, but always remember, "The wise man rules his stars, the fool obeys them."

PRECESSION OF AGES

4220 A.D. to 6380 A.D.

Age of Baha-Ulla (Bahi) *Capricorn*
Sub-Age Cancer
(Idea of brotherhood structured into state, the law, and social form of man itself.)

2060 A.D. to 4220 A.D.

Age of Aquarius
Sub-Age Leo
(Carrying ideal of brotherhood of man to group intelligence and then acting upon this principle through self-expression in Leo.)

980 A.D. to 2060 A.D.
(Forming ideas and principles around brotherhood of man.)

Sub-Age Virgo
(Crusades to present period.)

100 B.C. to 980 A.D.
(Compassion for others—brotherhood of man principle.)

Age of Pisces
(Dawn of New Man—Christ the prophet. "Have *faith* in what you see in me and that it can come to life in you also.")

1190 B.C. to 100 B.C.
(Appreciation of world's beauties created by others.)

Sub-Age Libra
(Athens, Rome in its move around the world, India in its dying classical days.)

2260 B.C. to 1180 B.C.
(Proclamation of laws for the sake of self-preservation of the tribe.)

Age of Aries
(Moses and the sacrificial lamb.)

14

3340 B.C. to 2260 B.C.
(Underground gods,
sacrificial rites.)

Sub-Age Scorpio
(Sphinx, Egypt, Babylon—life
surrounds the temples which are the
schools.)

4420 B.C. to 3340 B.C.
(Back to land to
make it productive.
Use of oxen.
Practical sacrifices.
Long, slow lives.)

Age of Taurus
(Egyptian, Oriental, Near Eastern,
Babylonian, Central and South
American. Worship of the bull.)

5500 B.C. to 4420 B.C.
(Looking for ideal
place and
adventures.)

Sub-Age Sagittarius
(Wanderers—traveling in tribes
because of a disaster.)

6580 B.C. to 5500 B.C.
(Twin
concepts—philoso-
phy of Ying and
Yang—the twin life
forces of opposite
polarity.)

Age of Gemini
(Mediterranean-like world—lots of
travel, talk, socializing.)

7660 B.C. to 6580 B.C.
(Stoicism, but
uncaring of what
happens—bodies
without spirit.)

Sub-Age Capricorn
(Aftermath of Atlantis
sinking—powerful men, but they were
not pertinent to what was needed.)

8740 B.C. to 7660 B.C.
(Turmoil and
trouble—water
everywhere where
not expected.)

Age of Cancer
(Final days of Atlantis. Experimenting
on others—physically, mentally, and
emotionally.)

9820 B.C. to 8740 B.C.
(Spreading
knowledge—confer-
ences. Travel by
air, undersea
laboratories.)

Sub-Age Aquarius
(Science is a religion. Mental, diffusive
ideas applied to electronics,
magnetism, and wave theory)

10900 B.C. to 9820 B.C.
(Pinnacle of Self-
expression.)

Age of Leo
(Golden Age of triumph. Living in
grandeur but frustrated. Magnificent
cities. Felt power was in them rather
than coming to them and then out
through them to others.)

Orbital Time Period of Planets Around Zodiac

	Approximate Time Around Zodiac Chart	Approximate Time in Each Zodiac Sign
Moon	1 Month	2½ Days
Sun	1 Year	1 Month
Mercury	88 Days	7½ Days
Venus	225 Days	19 Days
Mars	2 Years	2 Months
Jupiter	12 Years	1 Year
Saturn	29 Years	2½ Years
Uranus	84 Years	7 Years
Neptune	165 Years	14½ Years
Pluto	248 Years	20 Years

The Elements and Qualities*

	MASCULINE SIGNS		FEMININE SIGNS	
	Leaders (Inspirational)	Communicators (Mental)	Builders (Practical)	Nurturers (Emotional)
	Fire—Polar Opposites—Air		Earth—Polar Opposites—Water	
Cardinal (Initiates Action)	Aries (Starts a fire but may burn out fast)	Libra (Thinks and plans ideas)	Capricorn (Plows the soil for planting)	Cancer (Becomes emotionally involved with a variety of people)
Fixed (Determined, Persistent)	Leo (Keeps the fire going)	Aquarius (Carries an idea through to completion)	Taurus (Sows the seed until field has been completed)	Scorpio (Develops intense emotional involvement with select group of people)
Mutable (Flexible, Adaptable)	Sagittarius (Jumps from one fire to another)	Gemini (Jumps from one idea to another)	Virgo (Jumps from one field to another, sowing a few seeds in each field)	Pisces (Jumps from one emotional involvement to another)

*The manner in which the elements can operate or express themselves.

The Twelve Houses of the Zodiac

FIRST HOUSE:
Angular House—Activity
House of Life—Enthusiasm and Energy toward personal views on life
(Natural Zodiac House of Aries—*Fire*)

FIRST QUADRANT

INNER SELF-AWARENESS

SECOND HOUSE:
Succedent House—Stability
House of Substance—Material and Objective Goals toward the accumulation of money and possessions
(Natural Zodiac House of Taurus—*Earth*)

THIRD HOUSE:
Cadent House—Adaptability
House of Relationships—Intellectual and Social Relationships with relatives and neighbors
(Natural Zodiac House of Gemini—*Air*)

FOURTH HOUSE:
Angular House—Activity
House of Endings—Inner Emotional Levels pertaining to personal foundations
(Natural Zodiac House of Cancer—*Water*)

SECOND QUADRANT

INNER AWARENESS OF THE OUTSIDE WORLD

FIFTH HOUSE:
Succedent House—Stability
House of Life—Enthusiasm and Energy toward personal interests
(Natural Zodiac House of Leo—*Fire*)

SIXTH HOUSE:
Cadent House—Adaptability
House of Substance—Material and Objective Goals dependent upon your physical ability to work
(Natural Zodiac House of Virgo—*Earth*)

THIRD QUADRANT

OUTER AWARENESS OF THE OUTSIDE WORLD

SEVENTH HOUSE:
Angular House—Activity
House of Relationships—Intellectual and Social Rela-tionships with partners
(Natural Zodiac House of Libra—*Air*)

EIGHTH HOUSE:
Succedent House—Stability
House of Endings—Inner Emotional Levels pertaining to the death of the selfish ego and spiritual rebirth
(Natural Zodiac House of Scorpio—*Water*)

NINTH HOUSE:
Cadent House—Adaptability
House of Life—Enthusiasm and Energy toward spirit-ual urges
(Natural Zodiac House of Sagittarius—*Fire*)

FOURTH QUADRANT

OUTER SELF-AWARENESS

TENTH HOUSE:
Angular House—Activity
House of Substance—Material and Objective Goals ob-tained through profession, reputation, and honors
(Natural Zodiac House of Capricorn—*Earth*)

ELEVENTH HOUSE:
Succedent House—Stability
House of Relationships—Intellectual and Social Rela-tionships with friends and organizations
(Natural Zodiac House of Aquarius—*Air*)

TWELFTH HOUSE:
Cadent House—Adaptability
House of Endings—Inner Emotional Levels pertaining to the subconscious and the completion of karmic re-lationships
(Natural Zodiac House of Pisces—*Water*)

TYPES OF HOUSES AND THEIR FUNCTIONS

The Angular Houses (1.4.7.10) correspond to the cardinal signs, representing activity in physical matters. The planets in these houses have a greater scope of action than planets in other houses in a material sense, at least.

The Houses of Life (1.5.9) correspond to the fire signs. These are houses of dynamic energy, enthusiasms, and motivations of power as well as conviction. Here are the (1) personal views, (5) personal interests, and (9) spiritual urges.

The Houses of Substance (2.6.10) correspond to the earth signs. These are houses of material or objective activity. Here is the (2) accumulation of money and possessions, (6) the facility to work, or occupation, and (10) profession, reputation, and honors.

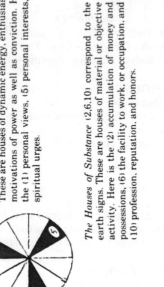

The Succulent Houses (2.5.8.11) correspond to the fixed signs, representing stable qualities, and matters to do with inner emotions. Planets in these houses tend to give willpower and fixity of purpose.

The Houses of Relationships (3.7.11) correspond to the air signs. These are houses of intellectual and social inclinations and describe relationships in the community: (3) relatives and neighbors, (7) partners, and (11) friends and organizations.

The Cadent Houses (3.6.9.12) correspond to the mutable signs, representing mental expression, variable conditions, communication of ideas, and the ability to get along with others. (Cadent means rhythmic vibration, swinging of the pendulum, motion to and fro.)

The Houses of Endings (4.8.12) correspond to the water signs. These houses are related to the psychic or subjective phase of human nature: (4) personal foundations and end of matters, (8) death and rebirth, union and (12) subconscious and completion of relationships.

ILLUSTRATION OF LATITUDES

CHART NO. 4

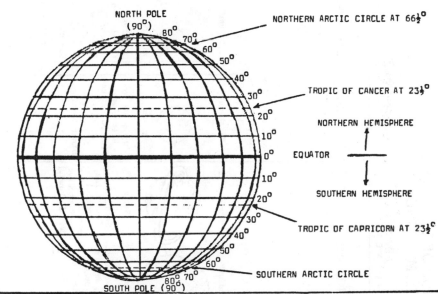

NORTH POLE (90°)
80° 70° 60° 50° 40° 30° 20° 10°

NORTHERN ARCTIC CIRCLE AT $66\frac{1}{2}°$

TROPIC OF CANCER AT $23\frac{1}{2}°$

NORTHERN HEMISPHERE

0° EQUATOR

SOUTHERN HEMISPHERE

TROPIC OF CAPRICORN AT $23\frac{1}{2}°$

SOUTHERN ARCTIC CIRCLE

SOUTH POLE (90°)

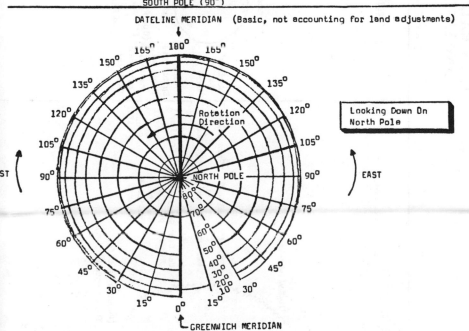

DATELINE MERIDIAN (Basic, not accounting for land adjustments)

Rotation Direction

Looking Down On North Pole

NORTH POLE

EAST

GREENWICH MERIDIAN

ILLUSTRATION OF PLANETS AND THEIR MEANINGS

THE PLANETS

UNDER FREE WILL				SOCIETY RULED		COLLECTIVE UNCONSCIOUS		
"Mind"	"Values"	"Personality"	"Desires"	"Expansion"	"Structures"	"Awakener"	"Disolver"	"Rebirth"
Mercury	Venus	Earth Moon	Mars	Jupiter	Saturn	Uranus	Neptune	Pluto
(How We Use Our Minds)	(Our Spiritual, Physical, Mental, Emotional Values)	(Our Emotional And Habitual Reactions To People And Life)	(Our Spiritual, Physical, Mental, Emotional Desires)	(Our Principles, Ethics, Morals, The Urge To Expand)	(Sets Limits, Boundaries, Social Responsibilities. We Must Live Within Laws.)	(Prods Us To Break Away From Societies' Structures To Look For Other Meanings To Life)	(Dissolves Life Patterns In Order To Teach New Meanings In The Search For Universal Truths)	(Shows Us We Have A Larger Role To Play In Life Involving, Our Fellowman)

Sun

"Individuality"

(Purpose In Life, The Essence Of You)

Door Between Conscious And Unconscious

22

ILLUSTRATION OF RETROGRADING PLANETS

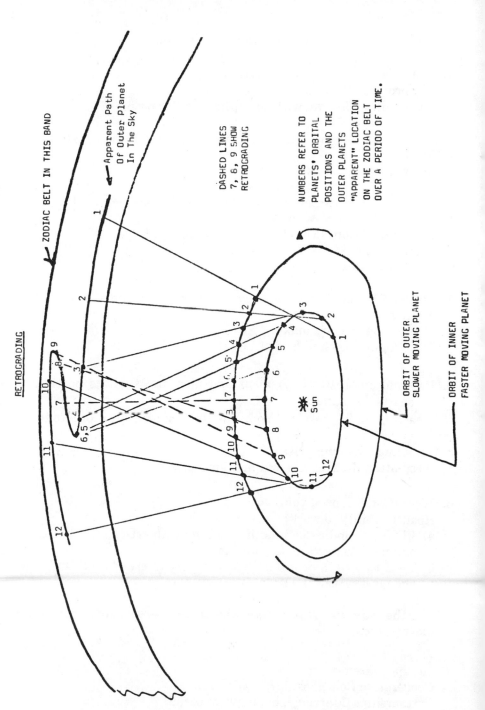

RETROGRADING

ZODIAC BELT IN THIS BAND

Apparent Path
Of Outer Planet
In The Sky

DASHED LINES
7, 8, 9 SHOW
RETROGRADING

NUMBERS REFER TO
PLANETS' ORBITAL
POSITIONS AND THE
OUTER PLANETS
"APPARENT" LOCATION
ON THE ZODIAC BELT
OVER A PERIOD OF TIME.

Sun

ORBIT OF OUTER
SLOWER MOVING PLANET

ORBIT OF INNER
FASTER MOVING PLANET

23

House Rulership Outline

1. Self-awareness (Approach to life)
 Physical Body
 Personality (How we wish to appear to other people)

2. Personal Resources (Hidden talents, sense of self-worth, self-esteem)
 Money
 Movable Possessions

3. Environment (Community, neighbors, and relatives)
 Knowledge (Concrete evidence)
 Early Education (Pre-school, grade school, high school)
 Short Journeys
 Communications

4. Personal Foundations (Inner emotional security and self-image)
 Mother
 Home (The one you make)
 New Beginnings and End of Life

5. Personal Interests (Enjoyment and pleasure, such as parties, sports, love affairs)
 Creative Self-Expression (Your talents brought out for others to see and enjoy)
 Gambling (Involving risk)
 Speculation (Real estate and new enterprises)

6. Work (Conditions of your work)
 Health (Ability to work)
 a) Ill Health indicates inability to cope with crises and challenges, or a need to reevaluate your life.
 b) Good Health indicates ability to cope with crises and challenges, and good care of the body.
 Service (Giving of yourself because it is needed and not for reward, and the way we treat others who serve us—servants, clerks, employees, etc.)

7. Group-awareness
 Cooperative Relationships
 Partnerships (Marriage, business, or social)

8. Joint Resources (Yours and others)
 Death and Regeneration (Physical or symbolic)
 Personal Sacrifices (Your own and others for you—taxes, inheritances, legacies)

9. Higher Education (College, graduate school, experiences)
 Understanding and Wisdom (Abstract thoughts)
 Law (Society's laws, legal affairs, in-laws)
 Long Journeys (Physical or mental)

10. Social Foundations (Recognition and respect)
 Professional Career and Personal Achievements (Social standing and power)
 Father (Representing authority figures—teachers, employer, police, etc.)

11. Friends
 Social Groups (Non-ritual relationships)
 Goals and ambitions (What are you seeking?)

12. Self-Undoing, Frustration, and Limitations
 Karma
 Service (For atonement or out of love)
 Confinement (Institutions, hospitals, monasteries, etc.)
 Ultimate Understanding (Oneness with humanity and God)

Psychological Urges, or Personality Functions of the Planets

Sun: "Individuality." Our ego, the inner you, your essence. It is the unchanging part of you—the calm, steady, deep, and lasting force felt within a person. It enables you to exert willpower, make decisions, and direct all the other parts (planets) of your life.

Mercury: "Mind." Mercury is our capacity to collect, sort, classify, and communicate the knowledge you gain through your experiences. It, also, analyzes and discards what is unnecessary.

Venus: "Values." Venus is our capacity to attract and appreciate the things of the physical world, whether they are emotional, physical, mental, or spiritual things. It, also, defines the type of people you draw to yourself, based on your social values.

25

Moon: "Personality." The moon is our emotional responses based on past experiences. It comprises all the little surface peculiarities, moods, and changes which have to do with physical life which are disturbing and fleeting.

Mars: "Desires." Mars represents your desires and aspirations for emotional, physical, mental, and spiritual things which stimulate activity. You have to want something before you reach out and take it.

Saturn: "Structures." Saturn represents your ability to find your place in society and function there at a practical level (referred to as your society ego). It is the laws, boundaries, and limits set by society or Karma.

Jupiter: "Expansion." Jupiter represents the urge for self-improvement through participation in the larger whole. It urges us to go forth exploring life.

Uranus: "Awakener." Uranus represents the unconscious urge to become aware of your true inner individuality (the sun). It is your intuition awakening you to a world beyond our social structure.

Neptune: "Dissolver." Neptune is the unconscious urge to dissolve the boundaries of your ego-centeredness in order to "lose yourself" in the "Kingdom of God" within . . . our Superconscious. It dissolves life's patterns in order to teach new meanings in the quest for universal wisdom.

Pluto: "Regeneration." Pluto represents an unconscious urge to transform repressed ego-desire energies into group-desire energies in order to live out your role in society's evolution.

Keywords for Zodiac Signs

Aries (New Growth): "Independent." In the house where Aries rules the cusp is where you need to grow and develop. There is a need to learn and discover for yourself. New things will be started all the time.

Taurus: "Productivity." In the house where Taurus rules the cusp is where you need to be productive and to see the actual results of your productivity.

Gemini: "Curiosity." In the house where Gemini rules the cusp is

where you need to be curious, or inquisitive. Your curiosity will help you grow through experience.

Cancer (Peak of Achievement): "Nurture." In the house where Cancer rules the cusp is where you need growth through instruction and training. The instruction may prove painful, but is necessary in order for you to be able to express the positive qualities of your sun sign. This house tells you where you need to use the positive qualities of your sun sign.

Leo: "Self-Expression." In the house where Leo rules the cusp is where you feel a need for "personal development." If you are using the positive qualities of your sun sign in the affairs of this house, you will feel a deep sense of inner peace and contentment.

Virgo: "Analyze." In the house where Virgo rules the cusp is where you need to "discard the chaff from the wheat." There is a need to analyze your feelings with regard to the affairs of the house in a practical, unemotional manner.

Libra (Harvest Time): "Balance." In the house where Libra rules the cusp is where you have been "out of balance" in previous lifetimes. You need to be adaptable with regard to the affairs of this house, with a strong need to see both sides before any decision is made.

Scorpio: "Deep Involvement." In the house where Scorpio rules the cusp is where there is an emotional need for intense involvement and secrecy in order to fulfill subconscious needs and those of others. You will have an intense approach to the affairs of this house.

Sagittarius: "Expansion." In the house where Sagittarius rules the cusp is where you need to expand your experiences. You have felt limited in the affairs of this house in previous lifetimes, so need to explore all the areas in the house. Don't overexpand.

Capricorn (Restoration): "Social Foundations." In the house where Capricorn rules the cusp is where we need respect and recognition from others, but do not actively pursue this recognition for it can only be earned through merit. There is always a feeling of frustration with regard to the affairs of the house ruled by Capricorn.

Aquarius: "Reforming." In the house where Aquarius rules the cusp

27

is where you need to obtain new knowledge in order to break down old ideas from past lifetimes.

Pisces: "Faith." In the house where Pisces rules the cusp is where you need to allow your intuition to guide you for you will feel as if you are acting blindly. No one can give you proof for these affairs so allow yourself to be guided by your intuition.

Traits of the Zodiac Signs

	POSITIVE	NEGATIVE	NEED TO LEARN
ARIES (Actively Inspired)	1. Inspirational 2. Courageous	1. Impulsive 2. Rebellious	1. Patience
TAURUS (Determined Practicality)	1. Perseverance 2. Reliability	1. Possessive 2. Stubborn	1. Detachment
GEMINI (Adaptable Intellect)	1. Inquisitive 2. Versatile	1. Impatient 2. Inconsistent	1. Channel (control) his mind and energy.
CANCER (Active Feelings)	1. Conscientious 2. Sympathetic	1. Possessive 2. Overly Sensitive	1. Discernment
LEO (Persistent Enthusiasm)	1. Ambitious 2. Optimistic	1. Intolerant 2. Inflexible	1. Humility
VIRGO (Adaptable Practicality)	1. Analytical 2. Thorough	1. Critical 2. Intolerant	1. Tolerance
LIBRA (Active Intellect)	1. Diplomatic 2. Charming	1. Indecisive 2. Dependent	1. Decisiveness
SCORPIO (Determined Feelings or Emotions)	1. Efficient 2. Ambitious	1. Possessive 2. Resentful	1. Forgiveness
SAGITTARIUS (Adaptable Enthusiasm or Inspiration)	1. Friendly 2. Versatile	1. Tactless 2. Changeable	1. Restraint
CAPRICORN (Active Practicality)	1. Responsible 2. Efficient	1. Self-absorbed 2. Pessimistic	1. Sociability
AQUARIUS (Determined Intellect)	1. Original 2. Intuitive	1. Rebellious 2. Detached	1. Warmth
PISCES (Adaptable Feelings)	1. Compassionate 2. Industrious	1. Indecisive 2. Overly Sensitive	1. Perseverance

CHAPTER 2

Quadrant I

Aries, Mars, First House, or Ascendant
Taurus, Venus, Second House
Gemini, Mercury, Third House

ARIES

Aries is the first sign of the zodiac.

Its glyph looks like this ♈ .

Its glyph symbolizes ram's horns. Sometimes it is known as the Fountain of Life

The picture used to describe the sign is a ram. Why? The ram ploughs stubble with its horns in order to expose new budding greens which can feed its family. Thus, the ram represents a leader, one who blazes new trails.

Aries begins the spring equinox on March 21 and leaves the sign on approximately April 21.

The planetary ruler is Mars.

In the natural zodiac, it rules the First House.

It is masculine, positive, and a fire sign. The element fire can be described as enthusiastic and inspirational. Its quality is cardinal, meaning action-initiating and ambitious. This can be combined to describe Aries as "actively inspired."

The parts of the body that are ruled by this sign are: head, face (except nose), and brains.

Some of the things that Aries rules are: adrenalin, hats, fire, sharp instruments, and surgical operations.

Five positive key words are: (1) inspirational, (2) courageous, (3) enthusiastic, (4) original, and (5) independent.

Five negative key words are: (1) impatient, (2) aggressive, (3) headstrong, (4) selfish, and (5) impulsive.

Aries people enjoy any work requiring enterprise and initiative, such as: medicine, surgeons, dentists, athletes, steel workers, military, politics, salesmen, TV.

The key phrase is "I am."

The key word is "action."

Their basic nature is "the pioneer or warrior."

The opposite sign of the zodiac is: Libra.

Aries is the point of all beginning. The person with his sun in Aries is in the process of building a new personality. All the energies are self-centered and self-directed. Before one can give oneself away, there must be something to give.

The Arian assumes authority quickly, but must resist the impulse to "ram" ahead, pushing whoever is there out of the way. It is natural for the Arians to assume authority and responsibility. They can be inspired forces within a group. There is a joyousness and enthusiasm about the Arians. Thus, they are an inspiration to others. Ideas and creative projects seem to flow from them in a never-ending stream. They are full of energy and never lack courage.

However, they can, also, project the negative traits of their sun sign. Negative traits come into being when the person misuses his positive traits. Because of this, you will find Arians who are self-centered. They are apt to forget that other people may have good ideas and can assume responsibility, too. This makes it difficult to form a partnership with an Arian. It is, also, difficult for an Arian to be an employee. Their natural instinct is to be the employer. They have a tendency to start a project, then to suddenly lose interest in it if the progress is too slow or things have become too complicated.

These people have a gift for waking up an environment they find themselves in. They do not sit quietly in a corner waiting for someone to speak to them.

They are not subtle or devious. If they want something, they go after it.

Both sexes enjoy having a career as well as being attracted to community or political activities where they can use their talent for leadership.

They like people, but they may drop out of orbit while pursuing new interests. In six months, they may be back again as if no time had elapsed.

In love, they are passionate, with strong sexual feelings.

They are usually healthy, because they move around enough to ex-

ercise their bodies. This produces good circulation. They rarely overeat. Their head is the most vulnerable spot. They are prone to headaches due to tension. They almost always end up with some type of injury to their head. You will find a number of small scars on their head from running into things or from accidents.

Aries is a positive, masculine sign. Women who are Aries have some difficulties in relationships, because they are likely to be far too positive, opinionated, and masculine. They have to learn to build in their feminine side and be willing to be quiet and receptive.

Fire, the element of Aries, is symbolic of Aries' burning desire to keep pushing onward against all obstacles. They react similar to a horse with blinders on, looking neither to the right nor the left, but straight ahead to their destination.

As Parents:

Arian parents tend to push their children too hard in school. Their lack of patience doesn't help, either. Even so, they make good parents.

Children:

As children, Arians are noisy and full of energy. They must be doing something every minute. Firm discipline is needed, but it shouldn't be too strict, either. They like games and sports, for they have a large amount of energy. There is a tendency to run high fevers.

The three things an Arian should learn are: (1) patience, (2) conservation of energy, and (3) completion.

Wherever you find the sign Aries in your natal chart indicates where you as an individual need to be independent. That's the house where you will have to be "The Little Red Hen" because only then will you feel a sense of completion within yourself.

The gem for Aries is the diamond, which the ancients called the gem of light. It was believed to be an eternal flame. The name diamond means "invincible." In A.D. 100, it was called the most valuable stone known and was only permitted to be owned by kings.

The flowers for Aries are the daisies and anemones. Their metal is iron, and their colors are bright red, gold, and deep blue.

MARS

This planet rules the sign Aries.

Its natural house is the First House.

Its orbit takes two years.

One complete revolution on its axis takes 24½ hours.

It is masculine and positive.

Its glyph looks like this ♂

This glyph symbolizes spirit held down by matter.

Five positive key words describing this planet are: (1) courage, (2) energy, (3) activity, (4) initiative, (5) originality.

Five basic key words describing this planet are: (1) desires, (2) energy, (3) originality, (4) courage, (5) endurance.

Five negative key words describing this planet are: (1) arrogant, (2) aggressive, (3) headstrong, (4) selfish, (5) impulsive.

The basic personality function of this planet is to prod man to action.

The parts of the body it rules are: red blood cells, iron in blood, muscular energy, and adrenalin glands.

Some of the things ruled by this planet are: weapons, sharp instruments, the color red, Tuesday, heat, wounds, and iron.

The people represented by this planet are men.

Some of the similarities between this planet and the sign it rules are that both show activity and energy.

They differ because Mars is the "desire" to reach *outwardly* for experiences and things, while Aries is the soul's *internal* "desire" for the development of a new personality.

Mars retrograde indicates that the energy is directed within with the reliving of experiences inwardly and the rethinking of motivations.

Mars, the red planet, whose color suggests blood, is the planet of war. Some say the symbol used for Mars represents a shield and a spear and that the two tiny satellites, Phobos (fear) and Deimos (terror), were named for the war god's attendants.

The diameter of Mars is 4,200 miles, half that of earth. It experiences four seasons in its orbit around the sun. This orbit takes approximately two earth years. A complete revolution on its axis takes 24½ hours.

Craters dominate the landscape. These craters appear as though their rims have been sandpapered off. The bottoms are very flat. Swirling dust storms come and go. The winds occasionally reach 100 miles an hour and can quickly fill in a crater. We can see the correlation of an Aries temper in the coming and going of the dust storms. Then, too, many an Aries has been known to talk their way out of a difficult spot, or "hole."

Thus, a crater has been filled. Sometimes the winds blow hot air and sometimes cold air. This illustrates the Aries approach to projects. He can blow hot and then blow cold. This is, also, representative of their energy level—up and down.

Surface temperatures at noon on the equator are comparable to earth on a spring day. At midday, the temperature reaches around 80° Fahrenheit, but at night it drops to 150° below zero.

There are polar ice caps which are made up of frozen carbon dioxide, or what we know of as "dry ice." As the ice caps warm up in the spring, they do not melt but evaporate. When an Aries gets bored with a project, he puts it in cold storage where it eventually evaporates as if it never existed.

The Martian atmosphere reaches a height of only sixty miles above the surface and is composed mostly of carbon dioxide with no detectable oxygen. It is extremely thin, measuring less than 1 percent of the density and pressure of earth's atmosphere. You would have to climb twenty miles above the earth to find air so thin. Carbon dioxide is a gas which escapes from cracks in the surface and is a product of combustion, decay, fermentation, and, in the case of earth, breathing. We use carbonation in soft drinks and other beverages in order to have a bubbly drink. These bubbles gently rise to the surface and explode. So, too, is adrenalin released into the body causing an explosion of energy. However, in order to make a superior wine, the correct amount of fermentation is needed. An Aries individual has to learn not to release too much energy into his body or his nervous system will begin to "decay."

There are no mountain ranges or bodies of water. It appears to be much drier than earth's most arid deserts. However, some scientists believe that there is a layer of permafrost a few feet below the surface. This lack of water illustrates how difficult it is for an Aries person to understand how others feel. Water represents feelings. But the ability to be compassionate and understanding can be developed, as "water" is just below the surface and needs only to be tapped. Even though there are highlands and lowlands, the elevation is only eight miles at the most from the bottom to the top. These changes in elevation are gradual, and the slopes are gentle.

The sun casts only half as much solar energy on Mars as it does on earth. There is absolutely no protection from the sun's radiations, especially ultraviolet rays, which can quickly kill any unprotected earth life. Arians must take care not to "burn" themselves out. They would do well to remember to conserve their energy or their physical body will suffer the consequences.

Mars' dark regions are supposed to represent pitted terrain which

does not properly reflect light rays. Arians, also, can fail to analyze, or reflect, as to where their actions and words will lead them.

Mars has two satellites, or moons. Number two in numerology means the "peacemaker"—one who has tact, sensitivity, modesty, consideration, and is cooperative. These satellites are attempting to develop these positive attributes with Mars's characteristics. Phobos is shaped like a baked potato and is 11 by 14 miles in size. It is less than 4,000 miles away from Mars. Deimos is smaller and is only 5 miles in length.

Mars, then, denotes a drive to display energy. It is a positive, outgoing, out-thrusting energy, masculine in expression. It is fire. Without the fire of life and an enthusiasm and passion for living, there is no vitality. Mars is desire. If you have no desire, you won't reach out for anything. Desires can be physical, mental, emotional, or spiritual. If you want to learn to drive a car, you will find the energy necessary to learn how to drive. If you want a new record album, you will use your energy working for the amount of money needed to purchase it. If you desire knowledge about Buddhism, you will command your legs to take you to the library where you will spend energy reading about Buddhism. Thus, our desires activate our adrenal glands, providing us with the necessary energetic action to meet our requirements. In emergencies, people have been known to lift seemingly impossible weights. One woman single-handedly rescued her brand-new refrigerator when her home caught fire. Her desire to save her long-awaited refrigerator activated her adrenal glands, giving her the strength of two men. Another man ripped off a truck cab door in order to save another man's life.

Since Mars is reddish-hued, the colors red and orange have always been associated with passion and energy. If you are feeling tired, try wearing something red or orange that day. It is surprising how you will receive an energy lift to help carry you through the day.

We symbolize Mars by drawing a circle with an arrow. This is meant to symbolize the spirit of man (circle) held down by our desires for earth living (arrow). However, this arrow can be used to lift the spirit of man above his animal self. For example, we are in our animal self when we are waging war with others, but we have elevated it when we use this energy in sports for the pleasure of participating. Or, we are in our animal self when we deliberately set out to perform destructive acts, such as setting a fire, but we have elevated it when we use this energy to help put out a fire or to rescue someone from a fire.

All of us must learn to use our desires and energies to gain valuable experiences. These experiences will ultimately teach us to use our energies constructively. It is the use or misuse of this Martian energy that makes one man a saint and another man a devil.

Wherever Mars is located in the natal chart is where energy and

initiative is channeled. Mars stimulates a desire to expand the individuality through physical, emotional, mental, and/or spiritual activity in the house affairs.

MARS IN THE SIGNS

Mars in Aries: Increases physical and mental activities. Impulsive and enthusiastic. Lacks patience, self-control, and sympathetic understanding. Prone to accidents because of haste.

Mars in Taurus: Persistent and patient, but, also, possessive, stubborn, and jealous. Stimulates craftmanship. Money and possessions important. Should rethink their values. Sharing must be cultivated.

Mars in Gemini: Witty, keen mind, but tendency to sarcasm. Nervous energy that quickly disappears. Must learn to conserve energy or nervous system will cause difficulties. Restless. Find it difficult to complete projects or to keep promises. Powers of concentration must be developed. Possibility of writing talent.

Mars in Cancer: Ambitious, hard worker, sympathetic, moody, defensive, original, intuitive, sensitive, and overemotional. Difficulties with digestion due to emotions . . too much acidity in stomach. Should not eat when tired or upset as digestion affected by emotions.

Mars in Leo: Impulsive, lots of energy, enthusiastic, ambitious. Artistically creative. Can be quarrelsome and jealous. Can have heart trouble if overdoes physically when not in "condition." Should discipline energy and passion.

Mars in Virgo: Worrier, fusses over little things. Energetic worker. Practical, diplomatic. Kind, even-tempered as a rule. Often ambitious, but find it hard to accept a lot of responsibility. Too much responsibility causes stomach or skin troubles.

Mars in Libra: Persuasive, perceptive, enthusiastic, easygoing, can be argumentative. Intuitive mind. Fluctuation of energy. Diplomacy and patience need to be cultivated.

Mars in Scorpio: Perceptive, determined, strong-willed, stubborn, magnetic. Deep emotions. Must learn self-discipline or desires will rule their life.

Mars in Sagittarius: Friendly, optimistic, impulsive, enthusiastic, independent, argumentative. Active traveler. Energies need to be used in physical outlets. Tendency to exaggerate if Mars is afflicted.

Mars in Capricorn: Ambitious, persistent, patient, self-reliant, responsible. Slow in learning, but total assimilation of knowledge. Energy is carefully used. Success is very important. Quick irritability which should be controlled.

Mars in Aquarius: Intellectual, cautious, independent, enterprising. Respond well to emergencies. Gain friends through merit and ability.

Mars in Pisces: Intuitive, humorous, diplomatic. Quiet on the outside, but restless within. Not physically strong and can appear to be lazy. Alcohol and drugs can become "crutches." Good position for musicians. If afflicted, indecision and self-gratification strong.

MARS IN THE HOUSES

Mars in First House: A lot of physical activity due to energy vibrations in the physical body. Are assertive, independent, impulsive, and impatient. Organizing ability strong. Are usually self-confident. They should guard against accidents due to rushing around and their impulsiveness.

Mars in Second: Efficient. Money comes and goes in order to de-emphasize the importance of money and to focus energy into the development of talents instead.

Mars in Third: Alert, determined, enthusiastic with an abundance of mental energy. Analytical thinking is important, as impulsive thinking will bring difficulties. Can be problems with brothers or sisters. Probability of quarrels and irritations in early home environment which makes the person nervous and high-strung. Many short journeys.

Mars in Fourth: Strong constitution. Early striving for independence. Desire for security and a home of their own. There is tension in the soul which is reflected in their adult home environment. These persons must overcome their hidden antagonisms and quarrelsomeness. Strong emotions must be toned down.

Mars in Fifth: Desire to be creative. Can be gamblers. Sports loving,

enterprising, leadership ability, a loyal companion. May be karmic difficulties with their children due to soul's unlovingness in previous lifetimes.

Mars in Sixth: Industrious, efficient, dynamic, and active in work. Tendency to irritation and impatience with co-workers and employees who lack these qualities. Mechanically minded. Good vitality. Run fevers when ill.

Mars in Seventh: Independent. If Mars is well-aspected, the marriage partner is usually someone who is capable, industrious, who works to promote the welfare of the family, and who runs the household, but in a kindly manner. If adversely aspected, there is the likelihood of marital strife. This is a karmic placement, and the individual with Mars in this house must cultivate gentleness and diplomacy in order to avoid rubbing people the wrong way. There have been too many lifetimes of having their own way, and now they must give way to others.

Mars in Eighth: Enthusiasm for research and getting to the heart of things. If afflicted, financial problems in order to de-emphasize the importance of money. If unafflicted, financial benefit through marriage partner, legacy, or partnerships. There is a need to share willingly of personal resources in any cooperative relationship.

Mars in Ninth: Enthusiastic but restless mind, independent in thought. Religious zeal must be watched so that it doesn't turn into fanaticism. Strong desire to travel. Liberal, broad, and progressive philosophy about life. Possibility of strife with in-laws, if afflicted. Will fight for their convictions.

Mars in Tenth: Ambitious, enthusiastic nature with lots of energy. Good executive ability. Success through own enterprise. Do best in an occupation with variety. Self-reliance strong. Practical person. There is a karma of gossiping and maligning others in previous lifetimes which can/will be reaped in this life. If afflicted, some difficulty with father.

Mars in Eleventh: Strong desires and wishes, social leadership, many casual associations, energetic and enterprising friends. Important to seek right type of friendships. Need to learn caution and integrity. Need to learn to say "no" for they can be taken advantage of by friends. Or, they can take advantage of their friends.

Mars in Twelfth House: Impulsive, intense emotional reactions, repressed desires. There is a need to overcome inner resentments. False accusations by hidden enemies (a karmic relationship). Feels an aloneness. Energy should be directed toward gaining an understanding of the meaning of life and for the development of harmony and oneness with humanity.

FIRST HOUSE OR ASCENDANT

This is an angular house, indicating activity. It is considered an angular house because it corresponds to the cardinal signs.

The natural ruler of this house is Aries. What is the relationship between the sign and the house? Aries needs to gain a sense of identity through proving himself or by starting something new, and the First House is the new beginning of the individual.

The natural ruling planet is Mars. What is the relationship between the planet and the house? Mars represents your desires and aspirations which stimulate activity, and the First House is the manner in which you actively approach life.

If the sun were in this house, it would be approximately 4:00 A.M. to 6:00 A.M.

This is a house of life which corresponds to the fire signs. This means it is a house of enthusiasm and energy toward personal views on life.

This house rules: (1) self-awareness, (2) physical body (how we look), and (3) personality (how we wish to appear to other people).

This house is found in the First Quadrant below the horizon.

(1) *Self-Awareness* (Approach to life)

The first house represents a new beginning for the soul. The sign on the cusp indicates the traits or qualities the soul desires to use in order to develop a new personality. This sign also indicates the manner in which the individuals will react to the experiences they encounter in life. These experiences will force the ego to reevaluate their thinking patterns, their emotional responses, and their view of life. From this, self-awareness is born.

(2) *Physical Body* (How we look)

The type of physical body desired by the soul for this lifetime is indicated by this house. The planets in the house will reveal the health problems that have been selected for needed lessons and karmic fulfillment. It is possible to determine the zodiac sign on the ascendant by the body build and facial features. For example, a man with an Aries ascendant, or an Aries sun sign, will invariably have a prominent Adam's apple.

(3) *Personality* (How we wish to appear to other people)

This is the house that rules the personality. It shows the manner in which we allow others to see us. It is the thoughts, actions, and emotions that we are willing to reveal to others. This personality has very little depth, because the ego is afraid to reveal its innermost thoughts or emotions, for fear of being rejected.

When emotionally upset, the ego is unable to maintain this social personality and falls back into the character traits of its natal sun sign. If the shock or hurt received by the ego is great, the natal sun sign will be bypassed, and the ego will return to the personality it has become over many lifetimes as represented by the natal moon sign. The traits of the natal moon sign are so familiar to the ego that it has a feeling of returning home. Ideally, the ego should work on blending the positive character traits of all three of these zodiac signs. The natal sun sign and the ascendant sign were specifically selected to transform the negative characteristics of the natal moon sign that are still present in the personality.

TAURUS

Taurus is the second sign of the zodiac.

Its glyph looks like this ♉ .

Its glyph symbolizes a bull's head and horns.

The picture used to describe the sign is a bull. Why? Those born under this sign have some of the qualities of this animal. They are strong, quiet, deliberate, but when aroused, plunge ruthlessly to their goal.

The sun is in this sign from approximately April 21 to May 22.

The planetary ruler is Venus.

In the natural zodiac, it rules the Second House.

It is feminine, receptive (negative), and an earth sign. The element earth can be described as practical and exacting. Its quality is fixed, meaning determined and persistent. This can be combined to describe Taurus as "determined practicality."

The parts of the body that are ruled by this sign are: neck, throat, thyroid gland, and recuperative power.

Some of the things that Taurus rules are: architecture, banks, jewelry, music, purses, and wallets.

Five positive key words are: (1) persevering, (2) reliable, (3) compassionate, (4) loyal, and (5) trustworthy.

Five negative key words are: (1) possessive, (2) jealous, (3) lazy, (4) stubborn, and (5) extravagant.

Taurus people enjoy any routine work such as: accountants, farmers, consultants, real estate, artists, building, finance, architecture, and music.

39

The key phrase is "I have."
The key word is "stability."
Their basic nature is "the builder and accumulator."
The opposite sign of the zodiac is Scorpio.

Possessions and material things are of great significance to Taureans. This is because they don't feel emotionally secure unless they can see and touch the objects they own. This intense need to possess and enjoy with the senses can drive Taureans to be extremely productive.

Taurus people work at a slower pace than Aries, and, unlike Aries, always finish whatever projects they start. Because of this, they are trustworthy, reliable, careful, and steadfast. If you want a job done and done well, give it to a Taurus.

It takes a lot to really anger a Taurean. But when in a rage, they have a strong desire to throw things and to storm around the house. They remain angry for a long time. If you have aroused a Taurean, let them cool down and give them time to think over what you have said before you talk to them again on the same subject. Taureans do not like to be pushed and need time to assimilate new ideas. So, don't do an Aries thing by trying to "ram" your ideas down the Taurean's throat. Taurean's quiet appearance is very, very deceptive. He can be led, but not pushed.

These individuals have a talent for giving others a feeling of security. In times of crises, they are of great comfort, for they are willing to give advice which is practical, realistic, and to the point. Their calm, unruffled approach to crises soothes even the most frayed nerves.

Their homes reflect their sense of beauty and their desire for quality. Their yards, also, reflect this love of harmony and beauty. Many Taureans enjoy gardening and find emotional release in "turning" the soil. However, if they do not enjoy it, they make sure someone keeps their yards well groomed.

Taurus rules the throat and neck. This correlation gives a key to the endurance and stability of the Taurean. The neck holds the head which is the most important part of the body. Located inside the neck is the throat *chakra* which is called our compassion center. When our compassion center is activated, the sense of the oneness of humanity is felt. This is why you see so many Taureans extending a helping hand to others.

In love, a Taurean is extremely affectionate.

By misusing his positive traits, the Taurean can become possessive, jealous, lazy, stubborn, and extravagant. These negative qualities are motivated by their fear of loss. If you have no desire to possess anything or anyone, then you have no fear of loss. Mars activates our desires for things mental, spiritual, emotional, and physical. Taureans have to learn

to desire only mental and spiritual things and release their desire to possess emotionally and physically. This is one of the basic lessons that Taureans have incarnated to learn. The other lesson is to find a true sense of values. (Values—anything we appreciate and enjoy, whether it is mental, spiritual, emotional, or physical.) The following poem by Tagore best expresses what happens when one refuses to give up clingings.

Why did the flower fade?
I clutched it to my heart in excess of feeling and crushed it.
Why did the lamp go out?
I shielded it with my cloak and it got no air.

Thus, Taureans need to learn detachment. They must be willing to let people and things go.

As Parents:

Taureans like to follow a set routine. Because of this, they feel their children should also be willing to have a set discipline as guidance. All is well if the discipline isn't too strict, since children do like to have some guidelines. Taureans are concerned about their child's education and will make sure their child has the best possible chance to learn.

Children:

As a child, the Taurean is charming, biddable, and enjoys rules and a set routine. They usually do well in school, because they like the routine. Their mind works at a slower pace than an Aries person, so they will have to spend more time on their homework. However, once a concept is grasped, it is never forgotten.

Wherever you find the sign Taurus in your natal chart is where you need to learn a sense of values—where you are apt to be locked up in the world of matter. Here is where you have to be "productive," but productive in the realm beyond the material world.

The gem for Taurus is the emerald. In Sanskrit, its name means "verdant green." It is supposed to give a good memory, pleasant family life, and safe journeys. It is and expensive stone which has been used in a number of royal crowns. The flowers for Taurus are the lily-of-the-valley and the narcissus. Their metal is copper, and their colors are strong blues, deep orange, and yellow.

VENUS

This planet rules the signs Taurus and Libra.

Its natural houses are the Second House and the Seventh House.

Its orbit takes 225 days.

One complete revolution on its axis takes 243 days.

It is feminine and receptive (negative).

Its glyph looks like this ♀ .

This glyph symbolizes spirit overcoming materialistic living through love.

Five positive key words describing this planet are: (1) harmony, (2) devotion, (3) refinement, (4) affection, (5) responsiveness.

Five basic key words describing this planet are: (1) values, (2) love, (3) beauty, (4) sociability, (5) cooperation.

Five negative key words describing this planet are: (1) laziness, (2) indifference, (3) self-indulgence, (4) superficial, (5) flirtatious.

The basic personality function of this planet is to develop an awareness of others.

The parts of the body it rules are: blood circulation, kidneys, ovaries, throat, skin eruptions, and equilibrium.

Some of the things ruled by this planet are: jewelry, art, copper, music, voice, movable possessions, and Friday.

The people represented by this planet are women and children.

Some of the similarities between this planet and the sign it rules are responsiveness and harmony.

They differ because Taurus needs to work so they can see the visual results of their endeavors, while Venus gives an appreciation of visual things but not the energy to obtain it. Libra wants to share their solar energies (potential as a person) with someone else, while Venus retains all her solar energy (potential as a planet) for herself.

Venus retrograde indicates there is difficulty in projecting feelings. There is a reevaluation and reliving of past emotional satisfactions. They feel they lack emotional fulfillment.

Values = Anything you appreciate and enjoy whether it is mental, spiritual, emotional, or physical.

The planet Venus rules two sun signs—Taurus and Libra. Venus is called the goddess of beauty and love. She attracts to herself through the power of love. Mars reaches out vigorously to grab what it values, but Venus uses her subtle charm and magnetic persuasion. This is why the

symbol for Mars has come to represent men, and the symbol for Venus, women.

Love makes us conscious of others. Love awakens us to an appreciation of beautiful things—art, music, literature, and the world we live in. It inspires us to beautify ourselves, our appearance, our home, our environment, and the lives of others.

We *can* exist without love and beauty, but are we really *alive* without love, beauty, cooperation, harmony, and unity? There is a marvelous sense of well-being when you gaze at the world of nature or listen to voices singing in harmony.

When we misuse Venus' positive traits, we find laziness and self-indulgence.

Venus in size and mass is the twin of earth. But, instead of spinning counterclockwise, Venus rotates the other way—clockwise—with the sun rising in the west. A complete rotation on her axis takes 243 days. Sunrise occurs approximately every 117 days. We can see from this that Venus firmly believes in having a leisurely day. It is easy to see why Taureans and Librans can become lazy with this type of vibration.

Venus seethes with fumaroles (holes from which gases and vapors escape) and glowing lava. There are low mountain ranges on Venus, but it is generally thought to be quite gentle in slope.

She is encased in thick clouds which reach an altitude of thirty-five miles above the surface. In comparison, clouds on earth seldom reach above ten miles. At the top layer of the clouds, the temperature has been measured at about $-35°$ Farenheit. Venus' yellowish color emanates from this cloud covering. Yellow is the color of relaxation and soothes the nerves.

Venus has no satellites.

Her atmosphere is composed of extremely dense carbon dioxide with a surface pressure 100 times that of earth. Solar energy, filtering down through the clouds of Venus, is absorbed by the surface, then reradiated over the surface as heat. She literally boils at nearly $1,000°$ Fahrenheit. The carbon dioxide absorbs and traps the solar energy. Thus, Venus is receptive—she receives and retains the sun's radiation and stores it. She does not generate any energy herself. Since she does not release this energy in any way, she can be said to be possessive. It is easy to see the correlation here between Taurus and Venus. Taurus wants to hold onto things and people. They enjoy the warmth brought by these people and things. The storing of energy is similar to the Taureans' difficulty in losing weight. Their body has stored future energy in the form of fat tissues. The inability to release what they hold is again evident. Librans, on the other hand, have difficulty in making decisions. This is due to

their inability to get through to the source (surface) of the problem. Scientists have only recently been able to "see" through the thick cloud layers of Venus. They were able to "see" the surface by using invisible waves broadcasted by a mammoth radar instrument.

On earth, solar energy is used by leaves in a process called photosynthesis, which is the conversion of solar energy into simple carbohydrates. Carbohydrates are substances such as sugar and starch. This conversion of solar energy into carbohydrates ensures the survival of plant and animal life. Animals graze on the green leaves and store the energy in their meat. Then, we eat the meat of the animals and benefit from this energy. We also benefit in another way from photosynthesis. Oxygen is released into the air by the leaves. Humans and animals have to have oxygen in their bodies in order to burn carbohydrates for energy. When we refuse to release our possessiveness of other people, we are deliberately denying mankind the benefit of these individuals' unique energies (talents). The people we clutch have also been energized by the sun and incarnated to be of benefit to others. Their mission is lost when they become entrapped by possessive individuals. They are like the leaves. If we clutch a leaf in our hands, it dies, and no one benefits from its stored energy. If we release it, it is used by others in several ways for energy, and, eventually, it comes back to us through oxygen or as meat and is of far greater value for the strength and nourishment it gives us.

Earth, also, stores solar energy in fossil fuels like coal and oil. This energy can be likened to material possessions. If we use (bring from the ground) this fuel (possessions), we bring warmth and comfort to others.

Venus is not using her solar energy but is merely storing it. This is a waste of tremendous potential. Too many times, people stifle the creative potential of another human by being possessive and jealous. Or, they hide their possessions for fear of loss or breakage, and, thus, the potential of enjoyment is lost.

Solar energy correctly used benefits everyone. If we use the vibrations from Venus correctly, we bring warmth and energy to many.

There is no sin in the possession of beautiful things or in loving people, but we misuse the Venus quality when we are fearful of losing our possessions or our loved ones.

Venus glows in the sky as a brilliant white light that is interspersed with dark areas. White is the color of integration and harmony. Venus, then, is a constant reminder that we need to live in harmony, peace, and love with our fellowman. However, the dark areas represent man's desire to hold back givingness that the white areas so willingly send forth.

One of the signs Venus rules is Taurus. In the physical body, Taurus rules the neck and throat. The throat contains the thyroid gland which

is the heat regulator of the body. We find that some days we are too hot and other days we are too cold. So, too, do we respond to the vibrations from Venus by being friendly some days and indifferent on other days.

Venus rulership in connection with Taurus refers to inanimate objects, the five physical senses, and the psychic senses.

In connection with Libra, Venus refers to our values based on what we appreciate and enjoy in our relationships with other people.

Wherever Venus is located in the natal chart indicates that the house affairs concerned are of importance in the resolving of karmic obligations. Since these affairs need to be worked on and values reoriented, the placement of Venus in the house brings Venus's beneficial vibrations to the house through physical, emotional, mental, and/or spiritual appreciation.

VENUS IN THE SIGNS

Venus in Aries: Impulsive approach to love. Can be unconsciously inconsiderate of others. Easily hurt. Impatient. Tendency to be selfish must be overcome. Have to learn to consider other people's feelings. Can be a "love them, leave them" attitude, due to mistaking sexual attraction for love. This could result in a hasty marriage, but is a type of love that rarely lasts. These individuals will have to look for deeper qualities in their mates. Feelings of insecurity and frustration may cause them to seek sensual pleasures and/or fun and games. Can be in love with love.

Venus in Taurus: Are demonstrative and affectionate. Material possessions can be important. Like comfort and domestic life. Are stubborn in a quiet manner. Loyal when in love and to friends. Monetary gain through own efforts. Are generous, but not extravagant. Are sympathetic and encouraging. Strong feeling that the future will take care of itself. They like the world of nature. Can be artistically inclined. Must guard against possessiveness and jealousy.

Venus in Gemini: Charming, friendly, witty. Ability to express themselves well. Emotions ruled by the mind. Literary or artistic talent possible. Family ties strong. Have the ability to stand back and see other people for what they are and what makes them behave as they do. This gives them the ability to express this in writing or speaking, so that others experience the same emotions and behavior of the people described. Good at entertaining and amusing people. Enjoy the fun and excitement of love, but fear its obligations. They understand love, even though they may not necessarily feel it themselves. Need to learn steadfastness.

Venus in Cancer: Gentle, kind, shy. Quiet people with considerable charm. Have magnetism and sympathy. Can be changeable. Need security. If they feel unloved, are prone to debilitating diseases. Difficulties with their digestive organs. Are susceptible to flattery. Strong tie to family, especially mother. May allow loved ones to take advantage of them. Strong imagination. Desire for peace and quiet in their home. Occupations such as teaching or nursing are good fields to relieve their need to mother others. Like the arts (music, literature, etc.).

Venus in Leo: Strong will. Are honest, frank, generous, attractive, kind, and compassionate. Charming personality. Can be in love with love. Fun-loving people. Loyal and affectionate. Entertain in a grand manner. May expect too much of people. Are easily hurt. Make excellent actors, as they dramatize their emotions. Enjoy the theater. Must watch their tendency to become too preoccupied with their physical appearance, when they should be developing their inner potential.

Venus in Virgo: Difficult placement, as this indicates someone who has been unloving in past lives and now must learn to be loving. The tendency is still strong to be critical. Are excellent homemakers, teachers, and medical specialists, as they like everything to be clean and orderly. Are able to be kind and sympathetic without involvement. Relate well to employees and fellow workers. Can be overly concerned about their reputations. Learning to give themselves in service to others overcomes the desire to criticize and nag. Constantly encounter obstacles in expressing their affections, but this develops strength of character.

Venus in Libra: Magnetism, refinement. Relate well to others. May have musical or artistic ability. Good color sense. Are romantic but steadfast. There is a need to be wanted. Easily hurt. Marriage is a necessity for their personal fulfillment. Difficulty in living in a discordant atmosphere, which can cause health difficulties. Must watch their tendency to expect their spouse to conform to their idea of the perfect mate. Need a feeling of continuity and permanence.

Venus in Scorpio: Sultry charm. Stimulates creative ability. Promotes infatuations, love affairs, and misalliances. Difficulty in expressing affections. Unreasoning jealousy. This is a karmic placement, due to the misuse of the love principle. They can be passionate and inhibited at the same time. Need to learn the value of self-control. Gives a sense of deep religious devotion, which can serve as an outlet for their overcharged emotions.

46

Venus in Sagittarius: Sympathetic, kind, generous, optimistic. Idealizes love. Women with this placement do not care to be full-time homemakers, but want some type of work outside family life. A refined mind. Good imagination and intuition. Fun loving. May be extravagant. Possibility of great inner strength and idealism. Could be philosophical.

Venus in Capricorn: Loyal, trustworthy, patient, steadfast. Frequently rise to position of authority. Love is weighed with practical considerations. Men may marry for practical reasons, and like their spouse to work, also. Strong desire to protect themselves from hurt. Basic selfishness must be overcome.

Venus in Aquarius: Charming, happy, original, but also, cool, calm, and detached. This detachment is beneficial because these individuals, as a rule, are never possessive of people or things. Emotions are filtered through the mind. May have been born into a home where lovingness was never expressed. Need to learn warmth and understanding. Want their lover to be a friend who shares their interests. Do not like to be tied down to a marriage, as want to be free.

Venus in Pisces: Highly emotional and sensitive. Are gentle, solicitous, and compassionate. Fond of music and the arts in general. Can be too easygoing and submissive. Psychic. Attracted to underdog. Idealize their mates. Suffers through love, but does so willingly. Have to learn to love without thought of personal reward.

VENUS IN THE HOUSES

First House: Friendly, with a magnetic personality. Person is generally very attractive. Have an appreciation of beautiful things. Can be selfish. Grants benefits in the life. Have the ability to get what they want from life.

Second House: Natural talent for understanding finance. Ability to attract money when needed. Spends money as fast as they earn it, sometimes faster than they earn it. Hidden talents which can be beneficial to others.

Third House: Pleasant personality, artistic, and creative. Love of travel. Express themselves well in speech or writing. Harmonious environment and relationships with relatives and neighbors. Shun arguments.

Fourth House: Desire to have beautiful things and a nice home. Interested in people. Artistic nature. A talent for making people welcome in their home. Love of family and children. Latter part of life will be pleasant and comfortable.

Fifth House: Affectionate, creative, attractive to opposite sex. Talent in art or music. Delightful and expressive teacher. Benefit through their creative self-expression.

Sixth House: Diplomatic. Well liked by employees and/or fellow workers. Desire to bring about better working conditions for employees and/or fellow workers, so that working will be enjoyable. Fairly good position for health, unless the body is abused. Sugars and starches should be avoided. Should take care of the part of the body ruled by the sign Venus is in, because there is a weakness there.

Seventh House: Friendly with a loving nature. Generally, a happy marriage unless Venus is heavily afflicted. Spouse could be quite talented, attractive, and/or financially well off. However, they should take care they do not expect too much of others.

Eighth House: Desire to enjoy physical comforts and prosperity. Strong possibility of inheriting money. Apt to lack self-discipline and a tendency to laziness. There may also be a preoccupation with sex.

Ninth House: Diplomatic, kind, helpful individuals. Appreciation of the arts. Love of travel and the ability to enjoy and benefit from these travels. Sometimes, they move far away from their place of birth. Ability to promote understanding between two different cultural or aesthetic groups.

Tenth House: Individual has a loving and friendly approach to the world. General attitude of optimism. Favorable for public speaking and singing. The voice can be used to please and inspire people. Grants comfortable financial circumstances.

Eleventh House: Gregarious, tactful, friendly people. Many helpful friends. Ability to put people at ease. Enjoy cultural pursuits. Strong desire to relax with congenial companions. Can be imposed upon by friends because of their desire to do everything possible for the comfort and pleasure of their friends.

Twelfth House: These people are often content with their own company

and may seek to retreat from society through monasteries, etc. Strong compassion and a willingness to serve others. Success by social standards is unimportant. Interest in understanding the meaning of life. Tendency to keep relationships with the opposite sex a secret. Seldom reveal their innermost feelings. Self-indulgence through drink or drugs can cause problems. Dedicated to their principles.

SECOND HOUSE

This is a succedent house indicating stability. It is considered a succedent house because it corresponds to the fixed signs.

The natural ruler of this house is Taurus. What is the relationship between the sign and the house? Taurus has a need to be productive and to see tangible results. The second house refers to our personal resources which help us obtain possessions and money—the tangible results of our productivity.

The natural ruling planet is Venus. What is the relationship between the planet and the house? Venus is our ability to attract and appreciate the things of the physical world. The second house refers to the possessions and money we have and appreciate in the physical world.

If the sun were in this house, it would be approximately 2:00 A.M. to 4:00 A.M.

This is a house of substance which corresponds to the earth signs. This means it is a house of material and objective goals toward the accumulation of money and possessions.

This house rules: (1) personal resources (your hidden talents, sense of self-worth, self-esteem, and self-reliance), (2) money, and (3) movable possessions.

This house is found in the First Quadrant below the horizon.

This house rules personal possessions and money. Possessions refer not only to anything you own that can be carried, but to all your hidden talents and your inner resources (sense of self-worth, self-esteem, and self-reliance). Money is the symbol of our ability to buy whatever we need or desire.

Materialism and possessiveness abound in our society. The drive of modern man is for wealth, fame, love, prestige, objects, and social recognition. Everyone has some kind of object or love to which they cling. Clinging is the negative side of ownership, because it is based on pride, insecurity, and fear of loss.

The positive aspect of possessions is to use them. If you have beautiful

china, use it when you have company. If you can sing, share your voice for the enjoyment of others. Each and every one of us have some hidden talent that others do not know about. Learn to share this talent. By sharing and using your possessions, you add new value and new meaning to human society.

Physical possessions can be lost, broken, or deteriorate, while our inner talents continue to grow and expand. The higher use of these house affairs is the development of inner resources. This is best illustrated through one of Jesus' parables. In the "Parable of the Talents," Jesus told of a man who gave talents to his servants according to their abilities. To some he gave five, to others two, and to another one. After a long time, the man called his servants to him and asked them how they had used their talents. All of them had doubled their talents except the one who had received only one talent. He was afraid to use his talent for fear he would lose it, so he buried it in order to return it to his master. The master was exceedingly angry with the servant for wasting this precious talent. The talents referred to in this parable are our hidden talents which we bring in with us each lifetime. Some lifetimes we have many talents, and in others, only one. The number of talents is immaterial. The important point of this parable is to develop your talent or talents and not to bury them out of fear or laziness.

GEMINI

Gemini is the third sign of the zodiac.

Its glyph looks like this ♊.

Its glyph symbolizes two children.

The picture used to describe the sign is The Twins. Why? The twins represent a dual type of mind, someone who sees both sides of a question and jumps with interest to every new idea presented.

The sun is in this sign from approximately May 22 to June 21.

The planetary ruler is Mercury.

In the natural zodiac, it rules the Third House.

It is masculine, positive, and an air sign. The element air can be described as intellectual and communicative. Its quality is mutable, meaning flexible and adaptable. This can be combined to describe Gemini as "adaptable intellect."

The parts of the body that are ruled by this sign are: shoulders, arms, hands, lungs, bronchial tubes, thymus gland, and oxygenation of body through breathing.

Some of the things that Gemini rules are: automobiles, books, computers, messages, and post offices.

Five positive key words are: (1) friendly, (2) witty, (3) eloquent, (4) versatile, and (5) perceptive.

Five negative key words are : (1) contradictory, (2) restless, (3) two-faced, (4) critical, and (5) impatient.

Gemini people enjoy work with variety. They like anything to do with a number of different environments or travel. Some careers associated with this sign are: salesmen, diplomats, journalists, theater, transportation, communications, teaching, advertising, and secretaries.

The key phrase is "I think."

The key word is "variety."

Their basic nature is "the salesman, interpreter, or communicator."

The opposite sign of the zodiac is Sagittarius.

Gemini is called the butterfly of the zodiac because he flits from one experience to another, gathering in bits of information along the way. Their desire to communicate to all types of people causes them to divulge the information they have gathered. Unfortunately, they may not have stayed long enough in one place to gather all the facts. But since they are never at a loss for words, they will continue with their story as if they did have all the facts.

Their minds are thirsty for intellectual satisfaction. Mental stagnation is abhorrent to them, so they read extensively and communicate widely in order to satisfy this longing for mental stimulation. This discontent can make them either very ambitious, or it can incline them to jump from one thing to another, searching for the golden opportunity which never appears.

They think quickly on their feet and have the ability to use the right words in any situation. They have tremendous wit and a good sense of humor. Because of this, they are interesting conversationalists who always liven up any environment. But they must learn not to skim from topic to topic. Other people have difficulty in keeping up with their rapid change of subjects.

These individuals are perceptive, intuitive, and logical. They thrive on activity, new situations, and new people. Too many activities, however, may make them perpetually late to appointments.

The rapid speed of their thinking causes them to finish other people's sentences for them. This can be a most frustrating experience for the person trying to express their own thoughts. Many times they had no intention of completing the sentence in the way that their Gemini friend finished it. Geminians must learn to hold their tongue and allow slower thinking people to express their opinions and thoughts.

Geminians have the ability to see both sides of a question, which

often leads them to fluctuate back and forth between the two opposing views. They have the tendency to take the same view as the person they are with at the time, and then change their view when they are with the individual with the opposing view. Thus, they are often contradictory. They have to learn to decide which view best suits their philosophies and stick to it no matter what.

There is an emotional detachment about Geminians. This is due to the fact that they are basically unemotional. They use their mind rather than their heart. Logic and reason are their guidelines. They are able to understand what makes other people behave as they do, but they have difficulty in projecting themselves into the emotional reactions of the person involved.

They have great ability to use their hands and many times are ambidextrous.

Misuse of their positive traits causes them to be undependable, fickle, indecisive, naggers, and big dreamers. Concentration can become difficult.

Geminians do not like to be tied down by their spouses. They want the freedom to be themselves. Taurus wants to own and to be owned, but not Gemini. Geminians enjoy being important to someone, but they also want to be able to come and go whenever they desire.

In love, Geminians are coolly affectionate and expressive.

For all of us, getting the mind under control is a very difficult task, but for the Geminians it is essential. Their nervous system is highly geared. If they do not learn to control their nerves, they are apt to become neurotic. This leads to nervous breakdowns or hypochondria. The way out of this difficulty is to take the emphasis off themselves and lose it through service to others.

Since they are so high-strung, they may become chain smokers. If so, their lungs will pay a high price. Geminians need plenty of oxygen in their lungs. Smoking depletes this oxygen, and emphysema can be the end result.

Their manual dexterity and mental alertness gives them creative and writing ability. But haste makes waste, so they must learn to work at a slower pace so that they do not have to correct errors.

Above all, the Geminian needs to learn to channel (control) his energy and his mind. Instead of being a "jack-of-all-trades" and master of none, he can be the master of many.

As Parents:

Since they have such a broad interest in so many fields, Geminians

are a veritable walking encyclopedia for their children. They encourage their children to read at an early age. Their love of conversing draws their children into many lively discussions which can be extremely stimulating to the child.

Children:

Geminian children are lively and amusing in their talk. They quickly pick up ideas and are easy to teach if you can hold their attention. They have a tendency to skim the surface of knowledge and must be encouraged to study in depth. They become easily bored with projects and should learn to finish a project before starting another. They do not take kindly to discipline, especially when told to stop talking. Diplomacy is needed in teaching them to allow others a turn at speaking.

Wherever Gemini is found in your natal chart is where you need to obtain a variety of experiences. You need to be "curious" so that you will investigate the area of life ruled by Gemini. The saying that variety is the "spice of life" is applicable to the Gemini-ruled house.

The gem for Gemini is the agate. The agate comes in a variety of colors and designs and is the least expensive of the zodiacal gems. All of these traits are characteristic of the Geminians. The wearers are supposed to receive wisdom, eloquence, and protection from accidents.

The flowers are the violets, lavender, lily-of-the-valley, and bittersweets. Their colors are lemon yellow, slate blue, purple, violet, or any color that is shaded in tone. Their metal is mercury.

MERCURY

This planet rules the signs Gemini and Virgo.

Its natural houses are the Third House and the Sixth House.

Its orbit takes eighty-eight days.

One complete revolution on its axis takes fifty-nine days.

It is neuter—being neither masculine or feminine, nor positive or negative.

Its glyph looks like this ☿ .

This glyph symbolizes the uplifting of the spirit of man during his earth manifestation.

Five positive key words describing this planet are (1) brilliance, (2) alertness, (3) articulateness, (4) versatility, and (5) dexterity.

Five basic key words describing this planet are: (1) reason, (2) ex-

pressiveness, (3) agility, (4) activity, and (5) analysis.

Five negative key words describing this planet are: (1) skepticism, (2) nosiness, (3) indecision, (4) criticalness, and (5) restlessness.

The basic personality function of this planet is the opportunity for conscious advancement and growth. (Reason gives us freedom of choice.)

The parts of the body it rules are: nervous system, connective tubes, breathing, movement of tongue, hands, coordination, sense of perception, memory, and conscious mind.

Some of the things ruled by this planet are: messages, communications, reason, Wednesday, and quicksilver.

The people represented by this planet are men and women (masses).

Some of the similarities between this planet and the signs it rules are versatility, expressiveness, and analysis.

They differ because Mercury stimulates everyone's mind, but Gemini people have to learn to curtail and control this energy. Virgo people have to learn to overcome their innate reserve and shyness in order to express what Mercury stimulates.

Mercury retrograde indicates that the mind is introspective, tending to go back over previously learned lessons and experiences. The thought processes are in the subconscious mind rather than in the conscious mind. Details are not absorbed as much as the essence or theory of the subject matter. It is a different process of learning and thinking.

In Gemini, Mercury brings articulation and eloquence (use of the tongue).

In Virgo, Mercury brings dexterity (use of the hands).

In mythology, Mercury was the swift messenger of the gods. Because Mercury travels the fastest of all the planets and orbits the sun in eighty-eight days, it is associated in astrology with speed and mental agility. It has rulership over communications, the mind, intellect, and intelligence.

All communication, within ourselves and with others, is possible only through the vibrations of Mercury. With the reasoning mind, we are aware of the activities in the world about us. We are able to perceive and evaluate through thought and action.

Through reason, man has freedom of choice and must take responsibility for his own acts. He also has the opportunity for a conscious advancement and growth and to become aware of his divine origin and potentiality.

In physical size, Mercury is much smaller than earth and is closer in size to our moon. Unlike the moon, it has an atmosphere of argon, neon, and helium. Both Gemini and Virgo individuals have the ability

to reach levels of awareness and agility far beyond what seems humanly possible. The presence of helium indicates there is nothing to prevent one from realizing the full potential of the human mind. It is feelings of unworthiness and inadequacy that have placed limits on the expansion of our minds. Don't allow your mind to live in such a vacuum. Elevate your mind to the unlimited space beyond the planet's surface (conscious mind). Reach out to a higher awareness.

This lack of a dense atmosphere indicates Mercury has no shield to protect the planet's surface from being bombarded by meteors, comets, and asteroids. So too, do we suffer mentally from events and people, which leave scars upon our conscious and subconscious minds.

The surface of Mercury resembles the moon's and is a rocky, cratered, cinder which appears to be composed of 30 percent silicates (salt) or rock and 70 percent metals. It is 5½ times as dense as water.

When Mercury is at its farthest point away from the sun in its orbit, solar radiation is five times as intense as that on earth. When it is at its closest point to the sun, the solar radiation is ten times as intense as earth. This causes the side facing the sun to reach temperatures ranging from 650° Fahrenheit to 940° Fahrenheit. The dark side is frozen at − 350° Fahrenheit. This illustrates the difference between Gemini and Virgo. Geminians radiate tremendous warmth and are like the side that faces the sun. Virgonians, on the other hand, are excessively shy and reserved and appear to be more like the frozen side of Mercury. They, also, have a strong tendency to withdraw from people. This shyness is only thin ice and can easily be melted by using the heat of your own personality upon them. Your warmth and approval releases Virgonians to utilize their manual dexterity and to relate with others.

Radar proved in 1965 that the planet rotates on its axis every fifty-nine days. This means that it spins on its axis three times for every two orbit revolutions around the sun. This strange combination of rotation and orbit brings about a peculiar effect as to how the sun appears on Mercury. You would see the sun rise, hang there briefly, drop back below the horizon, and then rise again. Professor Bruce Hapke of the University of Pittsburgh calls Mercury "the Joshua planet." This is because of the story in the Old Testament where Joshua commanded the sun to stand still over Gibeon during the battle between the Israelites and the Amorites.

Mercury has no satellites.

Mercury appears to be shaded with light and dark areas ranging in coloration from white, tan, bright yellow, to brown. White is the color of harmony and integration. Tan and brown are walling-off colors. Bright yellow is the color of spontaneity, enthusiasm, and intellect. Gemini

people personify the colors white and bright yellow, while Virgo individuals have a tendency to relate to tan and brown.

Mercury, like the Moon, has no light of its own and reflects whatever is in its vicinity. Gemini's changeableness can be seen in this since they have the tendency to agree with the opinions of whoever they are with at the time. Virgo people are also affected by this as they have the tendency to reflect the moods of people they are with.

In a birth chart, if Mercury is positioned ahead of the sun, the mental energy has more eagerness.

In a birth chart, if Mercury is positioned behind the sun, the mental energy is more deliberate.

Mercury rulership in connection with Gemini gives articulation and eloquence (use of the tongue).

Mercury rulership in connection with Virgo gives manual dexterity (use of the hands). The rate of soul evolution on earth has been accelerating and, because of this, a new planet will be discovered which will be given rulership over Virgo. This planet may be called Vulcan.

Wherever Mercury is located in the natal chart is where the mind is very active. The mind is busy collecting, sorting, classifying, analyzing, discarding, and communicating what has been learned through experience in the house affairs.

MERCURY IN THE SIGNS

Mercury in Aries: Quick and impulsive in speech and thought. Active mind with spontaneous ideas, but lacks patience and concentration in carrying their ideas through to completion. Witty and entertaining. Can be quick-tempered. Do not like opposition or delays. Are interested in people and are, usually, broadminded.

Mercury in Taurus: Intuitive, practical, deliberative mind. These people assimilate material at a slower pace than fire signs, but once a concept is learned it is never forgotten. They enjoy learning all that can be learned about subjects that interest them. These people are not particularly interested in theories from textbooks, but learn more from their experiences and from their travels. These people work to develop ease and efficiency in their work. Must watch their tendency to mental lethargy.

Mercury in Gemini: Clear, rational mind. Humorous and witty. Are versatile but need to learn to persevere. Concepts are easily grasped, but may be impatient with others who are slower in learning concepts. They

56

want things explained in a logical manner. They have a need to communicate and exchange ideas with compatible thinkers. Since Gemini accelerates the activity of the mind, these individuals are prone to anxiety and overwork which could lead to a nervous breakdown.

Mercury in Cancer: The mind retains and absorbs knowledge easily. Are intuitive and psychic. Are sympathetic, but may become depressed over their own problems and the problems of the world. They have difficulty in getting to the source of a problem, because they so easily become involved emotionally with the people instead of the problem. They make excellent speakers, for they have the ability to arouse the sympathies of others. This trait must be used wisely.

Mercury in Leo: Warm, articulate, convincing speakers. Are creative. They have a distinctive style of expressing themselves. They wholeheartedly identify with their beliefs. Must watch that they don't become overly impressed with their own abilities. The tendency is strong to want appreciation for everything they do or say. This could lead to an ego-oriented mind.

Mercury in Virgo: The mind is logical, practical, and systematic. They learn quickly, but must concentrate in order to retain this knowledge. They can be good speakers if they don't become too enamored with copious data and references. Are adaptable and stable. May be a tendency to be intolerant or critical of the slower absorbing minds. Ability to cope with vast amounts of detail.

Mercury in Libra: Gives a persuasive, rational, well-balanced mind. Can be artistic. They are flexible, willing to listen to all sides. This leads to indecision as to which side has the most logical truths. They can be excellent speakers, with considerable organizing ability.

Mercury in Scorpio: Perceptive, quick mind. Intuitive. Have the ability to penetrate beneath the surface of problems and people. Abundant manual dexterity with the ability to repair anything. Have the gift of satire which can be turned into criticalness of others. They convey a "knowingness" without even speaking. Can strike wounds with their tongues.

Mercury in Sagittarius: Impulsive, versatile, keen mind. Have grandiose ideas, but find it difficult to concentrate long enough to carry their ideas through to completion. Tendency to study several similar subjects, to have more than one job, and to have several projects going all at the

same time. Their thoughts are sometimes disconnected and can be irrelevant to the occasion. Apt to say the first thing that pops into their heads. Thus, they have to learn to control their tongues and to think before speaking.

Mercury in Capricorn: Clear, practical, methodical mind. Knowledge is absorbed slowly, but is retained. Have a wry humor, but find it difficult to be lighthearted because of their tendency to take life seriously. Their ideas are well-timed and reasonable. Are excellent teachers and diplomats. They seldom indulge in foolish or silly chatter. Must watch their tendency to be intolerant of others.

Mercury in Aquarius: Versatile, disciplined, practical, and original mind. Intuitive, with the ability to penetrate the mask others wear. Witty. Have the ability to put their ideas to work in a practical manner. They follow their own convictions, regardless of what others think of them. Ability to express their ideas clearly so that others comprehend easily. Their ideas may be too progressive for their generation.

Mercury in Pisces: Impressionable, intuitive, diplomatic. Extremely sensitive. Psychic. Strong imaginations and love of fantasy. Poetic and writing ability. Love of music and could be excellent musicians. They follow their instinct rather than their reason. Dislike being pinned down to facts. Must learn to overcome their moodiness and desire to withdraw from society.

MERCURY IN THE HOUSES

First House: Adaptable, inquisitive, eloquent, and humorous. They want to know something about a lot of things. Their speeches and writings reflect their own personal opinions. Jittery nerves, which keep the body slim but could cause nervous disorders.

Second House: Are quick-witted and versatile. Ability to communicate ideas to others through writing and speaking. Have financial skill, but their money comes and goes. The mind is motivated toward making money. They usually like books and music.

Third House: Are alert, clever, adaptable, versatile, and studious. This placement stimulates the mind and the body. They can express their ideas fluently with the ability to bring their ideas to completion. Apt to be jack-of-all-trades. Many short journeys. Good position for teachers or

for detailed work. Apt to be tied to relatives karmically with some concern and worries about them.

Fourth House: Studious with literary interests. Like to study at home. Continual studying gives them a sense of inner security. Are high-strung and need to learn to relax. Can be many changes of residences due to their need to find a place for themselves. This is an excellent position for educators who live on campus where they teach.

Fifth House: A need to prove their intelligence. Desire to communicate their thoughts in a clever, inspiring manner. There is writing and speaking ability. As a teacher, they enjoy stimulating the minds of others and encouraging their students to greater things. Enjoy reading about celebrities and quoting their words. Any romance would involve someone with whom they could communicate intelligently.

Sixth House: Analytical ability with a love of computers and electronic devices. If they become too bogged down in details, their nerves become frayed causing health difficulties. Any ill health reflects wrong thinking with this placement. Could be restless and desire job changes if Mercury is in either a cardinal or mutable sign. Those with Mercury in this house should take the Vitamin B family to nourish their nervous system.

Seventh House: Enjoy relationships with people who are clever and articulate. They want their marriage or business partners to be quick-witted, keen, alert, so that they can exchange thoughts and ideas. Like to know what is happening in the world around them. Are excellent promoters of ideas. Must watch their tendency to argue with others.

Eighth House: Talent for analysis, research, and insight. Want to get to the bottom of who, what, and why. Are born investigators. Worry over fluctuating finances. Must watch tendency to become a gossip. A weakness in their lungs could bring difficulties. Their lungs need plenty of oxygen.

Ninth House: Flexible, adaptable mind with an interest in intellectual pursuits and philosophy. Many ideas and beliefs with the ability to express them verbally. Travel is particularly educational. There is the ability to learn languages easily and to be a translator. Excellent position for a teacher.

Tenth House: Adaptable, keen, alert mind with writing and speaking ability. The ability to communicate their ideas to others. Have manual

dexterity and mental alertness. May have several jobs, as they have a variety of talents. Possibility of travel in their profession.

Eleventh House: A comprehensive, adaptable, and intellectual mind. Their goals are obtained through persistence and through the use of their mind. Enjoy friends who stimulate their minds. Find it challenging to have friends with opposing views.

Twelfth House: Perceptive, intuitive, and subtle mind. Interested in the metaphysical world. They absorb knowledge intuitively and understand more than they wish to divulge. Are secretive and have the ability to analyze other people's problems because of their ability to understand voice shadings and hand gestures. They make excellent psychologists. There could be problems of being misunderstood by relatives and those in their environment. May lack confidence in themselves.

THIRD HOUSE

This is a cadent house, indicating adaptability. It is considered a cadent house because it corresponds to mutable signs.

The natural ruler of this house is Gemini. What is the relationship between the sign and the house? Gemini is the need to gain a variety of information through personal involvements in many experiences. In the third house, we receive a variety of experiences and knowledge through our education, our relatives, and our environment.

The natural ruling planet is Mercury. What is the relationship between the planet and the house? Mercury is the capacity to collect, sort, classify, and communicate the knowledge we gain through our experiences. The third house refers to the knowledge we gain from early education, relatives, and environment.

If the sun were in this house, it would be approximately 12:00 midnight to 2:00 A.M.

This is a house of relationships, which corresponds to air signs. This means it is a house of intellectual and social relationships with relatives and neighbors.

This house rules:

(1) *ENVIRONMENT*

 a) Community
 b) Neighbors
 c) Relatives

(2) *KNOWLEDGE (Concrete Evidence)*

 a) Scientific
 b) Mathematics

(3) *EARLY EDUCATION*

 a) Pre-School
 b) Grade School
 c) High School

(4) *SHORT JOURNEYS*

 a) Short Journeys
 b) Communications
 1) Letters
 2) Telegrams
 3) Newspapers
 4) Telephone

This house is found in the First Quadrant below the horizon.

(1) ENVIRONMENT

Astrologers speak of the third house as that of "brothers and sisters, and near relatives." What they are referring to is the *environment* of the person and his relationship to it. Environment is the community one lives in, your neighbors, and your relatives. A child is molded by this environment. He rapidly learns whether he is accepted or rejected by this environment. He also has to learn to cooperate with those around him, if he is to be accepted at all.

(2) KNOWLEDGE

Babies begin to gather knowledge from their first breath. They learn what sound brings food, love, or a diaper change. As they grow, they learn that certain things are out-of-bounds to them. When they begin to talk, their language is permeated with "whys," so that the answers can be filed away under the heading "knowledge." This knowledge is classified as *concrete evidence,* for it can be proven. If one persists in playing with a fragile vase, its breakability can be proven. And so, the knowledge gained as one grows and learns can be classified as *concrete evidence* because it can be backed by scientific proof or be proved by mathematics. Many grown-ups limit their knowledge to *concrete evidence* and, thus, hinder their soul growth.

61

(3) EARLY EDUCATION

Knowledge is further expanded through attendance at a formal school. In school, one receives further scientific proof of what has been learned in your immediate environment.

(4) SHORT JOURNEYS AND COMMUNICATIONS

Short journeys can be of significant aid in the broadening of knowledge. Much information is stored away for future use. Communication is placed under the heading of short journeys, because a communication has to travel in some form in order to reach the recipient. Communication can be through letters, telegrams, newspapers, or over wires which bring voices together through telephones. Communication, then, is another method of broadening knowledge.

In summary, the third house is our need to get along in our environment under a variety of conditions.

CHAPTER 3

Quadrant II

Cancer, Moon, Fourth House
Leo, Sun, Fifth House
Virgo, Sixth House

CANCER

Cancer is the fourth sign of the zodiac.

Its glyph looks like this ♋ .

Its glyph symbolizes the breasts.

The picture used to describe the sign is The Crab. Why? The crab carries his house on his back and moves through life in a curious zigzag way, sometimes snapping unnecessarily. Cancer people have these traits with their emotional ups and downs, and with their tendency to preach unnecessarily.

Cancer brings summer solstice on June 21 and leaves the sign on approximately July 21.

The planetary ruler is the Moon.

In the natural zodiac, it rules the Fourth House.

It is feminine, receptive (negative), and a water sign. The element water can be described as feelings, emotional, and responsive. Its quality is cardinal, meaning action-initiating and ambitious. This can be combined to describe Cancer as "active feelings."

The parts of the body that are ruled by this sign are: stomach, breasts, nutrition, digestion, and uterus.

Some of the things that Cancer rules are: bakeries, boats, buildings, lakes, and plumbing.

Five positive key words are: (1) sympathetic, (2) industrious, (3) sociable, (4) thrifty, and (5) protective.

Five negative key words are: (1) argumentive, (2) moody, (3) sensitive, (4) emotional, and (5) martyrs.

Cancer people enjoy any work connected with the sea, liquids, catering for public tastes, or supplying domestic needs. Some of the careers are social workers, doctors, antique dealers, comedians, plumbers, shopkeepers, food industry, laundry, commerce, hotels.

The key phrase is "I feel."

The key word is "sympathy."

Their basic nature is "the patriot (country, home, mom, and apple pie), the homemaker, and the family historian."

The opposite sign of the zodiac is Capricorn.

If you think of the tides of the ocean, you can understand the surging and ebbing of emotions that Cancers go through. All of us are influenced by the phases of the moon, but Cancerians are especially vulnerable. They respond to life through their emotions rather than their mind. Remember this the next time your Cancer friend is emotionally upset. It is extremely difficult for Cancerians to control their emotions. They are like psychic sponges, absorbing any atmosphere around them without realizing it. If they are in the company of happy people, they bloom. If they are in the company of depressed people, they droop and wilt and do not know why.

Since Cancer people live in their feelings and affections, they unconsciously seek sympathy from others. They want to be first with those they love or they are very unhappy. Like Taurus, they must learn to release their loved ones to live their own lives.

Their purposes, like their moods, are changeable. Sometimes their firmest decisions are abandoned without apparent reason.

As a rule, Cancerians are not active people. They have a slow-moving energy flow. In order to be active, they must first motivate their mind. In general, they dislike exercising. As a consequence, they may suffer from poor circulation in later life.

They are noted for their excellent memories. This causes them to reminisce about the past and how things were done then. This fondness for past inspires them to keep photo albums and souvenirs.

They are home loving, fond of family life, and domestic tranquility, but they also enjoy travel and adventure. They are quietly tenacious and work hard for the welfare of their family. No matter how far they roam, they still want a home to come back to. They may not be in it very much, but they still want a secure home base. Their home is warm and friendly with many antiques. They love objects that have a history. Both the men and women like to cook and are very good at it.

Basically, Cancerians are conservative. Unfortunately, they are, also, born worriers. Their tendency to keep all their problems and worries to themselves is the reason many of them suffer from ulcers.

They do not like to show emotions outwardly. But they unconsciously project how they are feeling without realizing it.

Men have a difficult time with this sun sign because of its extreme femininity. It causes some of them to actively seek to prove their masculinity through sports or aggressive behavior.

In love, the Cancer man is emotional and tender. The Cancer woman may also have a tendency to feel maternal towards her spouse.

Cancer rules the public, and the public has always been ruled by their emotions. This fact is well known by propagandists and advertising agencies who exploit it. The United States is a Cancer country. The Statue of Liberty in New York Harbor portrays the Cancer type at its best—a protective, yearning, sustaining quality.

Henry VIII is a good example of a Cancer type who became totally undisciplined and John Calvin, who founded the Presbyterian Church, is another who went to the other extreme.

The answer for all Cancer people is to seek their inner light (superconscious). These people are very psychic. If they would develop this gift to help others, their emotions would stabilize. A highly evolved Cancerian has the ability to inspire others.

As Parents:

Cancerians have difficulty in realizing when to loosen parental protection to that of parental guidance only. Even when their children are grown, they still have a strong desire to advise and protect them. They firmly believe in family unity and work to establish it.

Children:

As a child, the Cancerian is lovable for they are devoted to their home and family.

They love stories, for they have vivid imaginations. There is no need to punish them severely, since they do not like to be out of harmony with their parents. They may have moods of irritability, but try not to snap back. The hurt inflicted on them by others is brooded about again and again and hinders their development.

Wherever Cancer is found in your natal chart is where you need to

"nurture" your growth and development in the house affairs involved. The Cancer-ruled house is where our Zodiac sun sign expresses itself the most—either positively or negatively. The Cancer house is where we are unable to hide our sun sign traits, peculiarities, and talents from others, regardless of how secretive we try to be.

The gem for Cancer is the pearl. The pearl symbolizes tears of sorrow and of gladness. It personifies patience, purity of mind and soul, faithfulness, and an abhorrence of violence and temper.

The flowers are acanthus and wild flowers. Their colors are smoky grays and greens. Their metal is silver.

MOON

This planet rules the sign Cancer.

Its natural house is the Fourth House.

Its orbit takes 27.3 days to circle the earth.

One complete revolution on its axis takes 27.3 days.

It is feminine and receptive (negative).

Its glyph looks like this ☽ .

This glyph symbolizes the personality.

Five positive key words describing this planet are: (1) patience, (2) sympathy, (3) receptivity, (4) protective, and (5) good memory.

Five basic key words describing this planet are: (1) habits, (2) emotions, (3) moods, (4) receptivity, and (5) sensitivity.

Five negative key words describing this planet are: (1) touchiness, (2) worry, (3) emotional instability, (4) moodiness, and (5) smother love.

The basic personality function of this planet is to stimulate our responses to the conditions we live in.

The parts of the body it rules are: stomach, breasts, nutrition and digestion, brain lining, flow of body fluids, subconscious mind, and uterus.

Some of the things ruled by this planet are: liquid, water, public, silver, Monday, visible beauty (your features), your mother.

The people represented by this planet are women and babies.

Some of the similarities between this planet and the sign it rules are protectiveness, moodiness, and kindness.

They differ because the moon is the sum total of all our past lives' habits and experiences combined into our present personality, whereas Cancer people are souls seeking to learn the lessons of the Cancer zodiac sign, which is one of self-discipline and emotional stability.

The moon does not retrograde.

Its basic nature is our habit patterns from the past, including our past lives.

The earth is not a solitary traveler in space. It is accompanied by the moon, which is of planetary size, approximately 2,160 miles in diameter, or about ¼ the size of earth. The movements of the earth are affected by the presence of the moon. These two bodies move around a common center of gravity which is located within the earth's surface because of the greater size of earth. This center is known as the barycentre.

The average distance of the moon from earth is about 238,857 miles. It travels its orbit at the rate of 2,300 miles per hour.

Astrologers always refer to the moon as our personality and the sun as our individuality. To a layman, this doesn't make much sense. A better word for the sun would be our soul, or ego. The zodiac sign the sun occupies in this lifetime are positive traits to be incorporated into the soul. The moon is the sum total of all the personalities one has been from previous incarnations. We have seen many sun signs which have shaped and reshaped former personalities until they have melted into one distinct personality. This personality has all the characteristics of one of the twelve zodiac signs. To discover which zodiac sign, look to see what sign your natal moon is in.

To understand this concept, the following example is given. A person with a moon in Taurus would like beauty, harmony, and possessions—perhaps, to an insatiable degree. However, having a sun in Pisces would be telling them to be a giving person, not only of themselves, but of everything they have. Thus, conflict is present. Taureans enjoy things with their five senses—anything they can touch, taste, smell, hear, and see. But, beyond these five senses, there are senses which know intuitively the greater purpose of the universe. This person must allow either the moon to remain the dominant personality or for the sun to succeed in reshaping the moon. There can be no other way to live with the moon—sun conflict. If this person used their moon in Taurus' psychic intuition and the sun in Pisces' compassion and visionary gifts, they could help others by giving emotional encouragement and understanding.

Another example would be a person with their moon in Cancer. Cancer people are easily hurt and always seem to remember every snub or cross word spoken to them. But, with a sun in Capricorn, the sun is rejecting their Cancer self-pity and asking this person to go out and work for what they want. If they would use the moon in Cancer's sympathy and understanding, their sun in Capricorn would give them leadership, integrity, and the ability to give confidence to others.

The moon has no air, no water, no weather, no wind, and no erosion, making its features nearly permanent. The formations of features eons ago are still intact, standing with features formed in the recent past, such as Astronaut Armstrong's footprints. Thus, we can say that the moon's history is written upon its face. So, too, has the history and experiences of our many, many lives written themselves upon our faces to be revealed to others as our present personality.

Needless to say, this personality has negative qualities which should be reshaped into a new personality. This is the task that our solar sun sign has set for itself. No matter what your sun sign is, those positive traits are what your soul (individuality) wants to imprint upon the moon personality. In other words, your soul should shine through your personality, blending the positive traits of the moon sign and the positive traits of the sun sign.

The moon has no light of its own and needs the sun to illuminate it. It is a reflection reminding us that the full sun energy (our soul, or essence) is still alive and will return. Picture the moon as a mirror which has collected our feelings and experiences from our other lives and now reflects them to others through our personality. All our violent deaths, disappointments, sufferings, fears, and loves are stored in our subconscious and are reflected out to others through our personality. Fear of heights, fear of water, an instant dislike of someone, instant liking of someone, the way you like your furniture arranged, the way you want your paper towels to roll (forwards or backwards), all of these things are stored in your subconscious mind. Even though I have related this reflection characteristic to all of us, it is easy to see the distinct correlation between Cancerians and the moon. Cancerians reflect the moods of those they are with, just as the moon reflects whatever it is near.

There are mountain ranges on the moon, some of which are over 600 miles long with mountains reaching an elevation of 25,000 feet. There are, also, numerous craters ranging from 500 feet to 150 miles in diameter. The surface is similar to earth, with many gorges, cliffs, ravines, and valleys. But it has no atmosphere, no water, and no weather.

This absence of atmosphere is due to the moon's lack of any measurable gravity. Its gravity is about 1/6 of earth. In other words, if you weighed 100 pounds on earth, you would weigh 17 pounds on the moon. Since the moon has no atmosphere, it cannot protect itself from solar radiation or from meteors hitting its surface. Cancerians, like the moon, have no outer protection from attack. Because of this, they are easily hurt by others.

The side receiving the sun's solar radiation attains temperature readings up to 212° Fahrenheit. Without an atmosphere, however, it is unable

to "trap" this heat, and, thus, as part of the moon moves into shadow, the temperature gradually drops to below −240° Fahrenheit.

Since its axis revolution is the same length as its orbit around the earth, one side of the moon is always hidden from us. So, too, do Cancerians keep their innermost thoughts and worries to themselves.

The moon radiates as a luminous white light. During its orbit around earth, this illumination is slowly engulfed with blackness. White is the color of integration and harmony. Black is a color that contains all the colors, but it refuses to reveal any of them. Its presence indicates the desire to turn inward. We can see very clearly our own emotional responses to life through these two colors. At times, we seek integration and harmony with others, but there are also times when we feel a need to turn inward unto ourselves.

In whatever house the moon falls is where we have failed to show enough emotion in previous lives. Thus, the moon, with its pull on the emotions of our mind, can cause us to react overemotionally to those house affairs this lifetime. It is essential to bring reason into these house affairs, for too much emotion is as unbalanced as too little emotion.

MOON IN THE SIGNS

Moon in Aries: Impetuous, active, spontaneous, direct, and original. A quick temper due to impulsive thinking. Enjoy traveling. Creative ability causes them to trail-blaze in unusual ventures. Make friends easily, but apt to drop them as other interests become prominent. Difficulty in remaining calm. This can produce either a breakthrough in a pioneering endeavor or a breakdown. Must learn to control this nervous energy and to think before acting. Vitamin B family would help soothe their nervous system.

Moon in Taurus: Resourceful, determined, persistent, and intuitive. Are sympathetic to others and willing to give practical help. An attractive personality which can be extremely stubborn. Usually good-natured, but when aroused have a fiery temper. Strong desire to excel. Are generally not fond of changes in their lives. Enjoy material things. Work diligently for their ideals. Can be difficulties in overindulgence in food and drink.

Moon in Gemini: Versatile and receptive mind. Desire for knowledge. Are charming, witty, and warm-hearted. This placement activates, not only the mind, but the body as well. Thus, there is apt to be difficulties with nerves. Dislike arguments. But, a tendency to talk too much. May

tell people what that person wants to hear rather than the truth. Must learn to be honest with people. Considerable talent and should develop their abilities.

Moon in Cancer: Sympathetic, sensitive, and friendly. Introversion tendencies. Must learn to flow with their emotional ups and downs. Strong psychic ability. Retentive memory, but must learn to forget and forgive past hurts. Influenced by mother for good or ill. This influence gives them a desire to be of help to others or to the feeling that the world owes them something. Usually, they insist they want peace and quiet, but their vibration is such that they attract the spotlight instead.

Moon in Leo: Generous, dignified, loyal, and ambitious. A persevering, penetrating mind. Have leadership and creative ability qualities. Are easily hurt. Need to de-emphasize importance of money. A subconscious desire for recognition. A determination to overcome their own imperfections.

Moon in Virgo: Industrious, trustworthy, intuitive, reserved, and practical. Considerable talent and mental ability. Have the ability to analyze situations and, then, find the quickest method of accomplishing the necessary work or solution. This makes them excellent housekeepers and managers. They must, however, watch their tendencies to become overly fussy over small details. They like to serve others, but find it difficult to understand the feelings of others. Because of this, they are apt to be quite critical of people. Until they learn tolerance, they will have difficulties with indigestion and nerves.

Moon in Libra: Affectionate, friendly, and tolerant. Make friends easily. Artistic talents. Unsuited to menial physical labor. Their desire to be liked by everyone causes them to seek peace at any price. This tact and diplomacy can be used to good advantage, but they must also learn to stand up for their principles. Thus, they can be evasive on issues, due to their indecisiveness. Difficult for them to accept the consequences or credit for their actions or work. Strong need to develop a coherent program and to motivate themselves.

Moon in Scorpio: Magnetic, energetic, independent, aggressive, and determined. They are ambitious, but do not necessarily desire the spotlight. Willing to tackle any tasks. Prone to emotional extremes. Easily hurt and could be vindictive. Must learn to forget and forgive. Should channel these pent-up emotions into creative lines. Difficulties in life due to karmic obligations from past lives' misuse of Scorpio's positive traits.

Moon in Sagittarius: Humanitarian, sociable, optimistic, independent, enthusiastic, and outspoken. Want to understand life and to be engaged in meaningful activities. Are good teachers because of their gift of eloquence and because of their desire to stimulate the minds of others. Must learn to listen to their inner intuition when speaking or teaching. This placement tends to bring the individual out before the public in some manner.

Moon in Capricorn: Conservative, reliable, and ambitious. Ability to bring their plans to completion. Their intense desire to win recognition causes them to actively seek it in any way they can, whether it is through servility, martyrdom, fanaticism, or through their career. Often difficulties with one, or both, parents as a child, giving them a feeling of being a pawn of fate. Outwardly, they are serene and charming, but inwardly, they suffer from strong feelings of fear, frustration, and inadequacy.

Moon in Aquarius: Friendly, intuitive, humane, progressive, and independent. Are broad-minded. Desire to investigate all knowledge. Difficulty in understanding the emotional needs of others. They say what they think. Often express unusual ideas in order to shock or surprise others out of their complacency.

Moon in Pisces: Sensitive, shy, kindly, and imaginative. Are not afraid of difficult or hard work. They generally like to work for those less fortunate than themselves. Are good musicians, artists, writers, and speakers. They prefer to remain behind the scenes, as they are easily drained of their energies by others. Must learn to seal their energy (aura) field so that others cannot drain them. Feelings of discontent, due to not knowing what they want from their life. Can have feelings of battling life.

MOON IN THE HOUSES

First House: Extreme sensitivity to their environment. Are restless and impulsive. Apt to wish their life was different, but lack the courage to make it different. Must learn to take the emphasis off their emotional feelings and become genuinely sympathetic and responsive to the needs of others. Are influenced by their early life, especially by their mother, which eventually forms the cornerstone for their adult approach to life. The mother's influence is for good or ill.

Second House: A desire to possess both money and possessions for emotional security. Many financial ups and downs. Fluctuate between being careless and thrifty with their money.

71

Third House: Studious, adaptable, and curious. Are susceptible to environmental influences. A willingness to help their family and friends. Enjoy learning by listening to others rather than by reading. Dislike routine of any kind. The mind is highly emotional.

Fourth House: Intuitive. Inner feelings of insecurity and uncertainty. A desire for peace and security. Can be many changes of residences and/or redecorating inside the home, which is a reflection of their need to establish firmer inner foundations upon which to build their life. Their mother is a strong influence for good or ill.

Fifth House: A pleasure-seeking individual with a lot of charm. Extremely artistic, but may allow their fluctuating emotions to interfere with their creativity. Must watch their tendency to want to be the center of attention in social gatherings. Are affectionate when in love and with their children.

Sixth House: Worriers, which can cause emotional tension and digestive difficulties. Should not eat when overtired or upset. These individuals have the ability to repair, mend, improve, or reform anything. A desire to serve others in some manner.

Seventh House: A desire to be popular with others. Have the ability to fit into all situations. There is a strong need for companionship which causes them to marry.

Eighth House: Psychic sensitivity. Financial gain through business or marriage partner. Are interested in what motivates others. Their business partner or marriage partner could be someone who is sensitive and moody.

Ninth House: These individuals are seldom content with their life as it is and desire many new experiences. Have a variety of interests in sports, hobbies, and studies. Make stimulating teachers because of their own interest in the subject they teach. Have many precognitive dreams. Love to travel. Their many and varied experiences will help them develop a philosophy of life.

Tenth House: Ambitious. Have personal charisma which enables them to influence others. May have a tendency to change their occupation. Usually, they work with the public in some manner because of a need to be socially useful to society.

Eleventh House: Many friends, especially among women and unassuming people. These individuals are responsive to the feelings of others. They are willing to work for the benefit of the group rather than for self.

Twelfth House: These people have a private cross to bear, which others may not be aware of. They are learning karmic lessons through their suffering. Their release is in learning to serve others and to teach what they have learned through their own suffering. Some of them become involved in scandals perpetrated by past-life enemies.

FOURTH HOUSE

This is an angular house, indicating activity. It is considered an angular house because it corresponds to cardinal signs.

The natural ruler of this house is Cancer. What is the relationship between the sign and the house? Cancer needs emotional security, and the fourth house rules our inner emotional security.

The natural ruling planet is the moon. What is the relationship between the planet and the house? The moon is our emotional responses based on past experiences, and the fourth house is our inner emotional security based on past experiences.

If the sun were in this house, it would be approximately 10:00 P.M. to 12:00 midnight.

This is a House of Endings, which corresponds to water signs. This means it is a house of inner emotional levels pertaining to personal foundations.

This house rules:

 (1) Personal Foundations (inner emotional secu-
 rity and self-image)
 (2) Mother (her attitude and her ability to fulfill
 her commitment as a parent)
 (3) Home (the home you establish)
 (4) New Beginnings and End of Life

This house is found in the Second Quadrant below the horizon.

(1) PERSONAL FOUNDATIONS (Inner emotional security and self-image)

The fourth house is a dungeon of unconscious problems and psychological tensions built up from all our past experiences and relationships.

73

All of these experiences, from this life and other lives, have built a subconscious self-image and emotional foundations. We have learned to feel a certain way about ourselves because of the way people react to us. This self-image affects what we are able to accomplish in this life. Every person knows that there can be no secure foundation until one has found their own centeredness. When an individual reaches this center, he also discovers that he is at one with humanity.

This integration and stabilization of the personality attunes the individual to the needs of his family and the needs of mankind. By assimilating our knowledge and all our experiences, we build the blocks of our inner foundation. Whether we have a solid or uncertain foundation depends on our willingness to see all experiences as essential.

The sign on the cusp indicates the manner in which one attempts to find emotional stability. If the planetary ruler of the cusp has many inharmonious aspects to it, the self-image will be negative and much work must be done to rebuild this "uncertain" foundation.

(2) MOTHER (her attitude and her ability to fulfill her commitment as a parent)

A parent has the ability to strengthen or weaken the emotional security of an individual. A mother is instrumental in preparing the cornerstone of your inner foundations. The sign on the cusp is indicative of how you saw your mother, and the ruling planet of the cusp indicates what you saw her doing. For example, Gemini on the fourth house cusp indicates someone who would see their mother as an intellectual person. If there was a karmic relationship between the two and they were repaying past misdeeds, this individual could see his mother as a cold, unloving person. The ruler of Gemini is Mercury which is in the first house. Thus, the individual saw his mother as an intellectual person who approached life with logic and reason. If it was a karmic repayment, the individual would see his mother as a person who approached life in a selfish, cold, and unloving manner.

(3) HOME; (4) NEW BEGINNINGS AND END OF LIFE

Cancer has been described as a protective sign. So too, does the fourth house refer to anything which surrounds and protects, such as a home, or even a grave. From its position at the bottom of the chart comes its meaning as the "base" of operations. A home is a base from which one

establishes a way of life, and a grave is a base from which one abandons a physical body (end of life).

This house, also, refers to new beginnings, because when an individual seeks to establish firm personal foundations, many approaches (beginnings) will be investigated. As planets transit over the fourth house cusp, they trigger a desire to try something new. If you are already a centered individual, the transiting planets will merely strengthen your foundations.

KEY TO INTERPRETING ZODIACAL SIGNS ON THE FOURTH HOUSE CUSP

Aries: Emotional stability depends on the ability to prove your worth to yourself.

Taurus: Emotional stability depends on having material possessions, harmony, stability, and beauty in home surroundings.

Gemini: Emotional stability based on seeing yourself as a knowledgeable, intelligent person.

Cancer: Emotional stability based on the "mothering" you receive from others, because what they think of you determines what you think of yourself.

Leo: Emotional stability based on being the center of a home you can be proud of.

Virgo: Emotional stability based on a need to feel efficient.

Libra: Emotional stability based on seeing yourself as an equal to others. Dilemma in childhood due to being unequal to parents. May struggle to equalize the relationship.

Scorpio: Emotional stability based on a need to be deeply, emotionally, involved with your family and home, or anything else that would give you a feeling of belonging.

Sagittarius: Emotional stability based on whatever principles and values you are pursuing. Home is where you hang your hat.

Capricorn: Emotional stability based on the security of a respectable home so that you can feel a respected member of society.

Aquarius: Emotional stability based on your humanitarian ideas, your rebellious activites, or an innate need to be unique. Many children with this position are brought up in group situations, such as orphanages or foster homes.

Pisces: Emotional stability based on what others think of you.

LEO

Leo is the fifth sign of the zodiac.

Its glyph looks like this ♌ .

Its glyph symbolizes the heart with its two valves.

The picture used to describe the sign is the Lion. Why? The lion shows the regal nature of the sign—its dignity, courage, affection, and power.

The sun is in this sign from approximately July 21 to August 22.

The planetary ruler is the Sun.

In the natural zodiac, it rules the Fifth House.

It is masculine, positive, and a fire sign. The element fire can be described as enthusiastic and inspirational. Its quality is fixed, meaning determined and persistent. This can be combined to describe Leo as "persistent enthusiasm" (optimism).

The parts of the body that are ruled by this sign are: heart, back, spine, vitality, body heat, elimination of wastes through perspiration.

Some of the things that Leo rules are: cards, entertainment, forests, ovens, and stadiums.

Five positive key words are: (1) generous, (2) optimistic, (3) ambitious, (4) loyal, and (5) affectionate.

Five negative key words are: (1) demanding, (2) intolerant, (3) domineering, (4) lazy, and (5) self-centered.

Leo people enjoy work that gives them scope for their creativity, their organizing ability, or for self-exploitation. Some of the careers are leaders, professional sportsmen, military, actors, teachers, salesmen, and jewelers.

The key phrase is "I will."

The key word is "faith."

Their basic nature is "the ruler or entertainer."

The opposite sign of the zodiac is Aquarius.

In mythology, the lion ruling the Leo sign was the Nemean lion. The Nemean lion's skin was so strong, it could not be penetrated. Thus, he

seemed to be unconquerable. However, Hercules proved this false by breaking the lion's neck.

Like the Nemean lion, Leonians are courageous but not invulnerable. Surprisingly, they can be broken, too, but in a different manner. It is their feelings that get broken. In fact, Leos are extremely sensitive. This is very well hidden from their antagonists. The Leonians will merely leave the scene, either quietly or snarling, and lick their wounds in private.

Leos like to organize everyone else's life. They do this because of deep seated feelings that it is for that person's benefit. But not everyone takes too kindly to being told how to live their life, with the result that fur generally flies fast and thick.

If a Leo is angered, he immediately goes into his regal role. He "mounts his throne" and quickly puts the challenger in their proper place. They literally roar at people when they are angry. But once their tirade is over, they forgive and forget, and never hold a grudge.

At their best, Leonians are affectionate, cheerful, optimistic people who can be counted on to bring sunshine into other people's lives. They are exceptionally generous. Money appears to slip through their fingers as if it were grains of sand. And, like the sand, they have no idea where it has gone.

They have a pronounced flair for drama and enjoy telling stories and jokes at parties. A party is never dull if you have invited a Leo. They have a wide variety of jokes and instinctively know what type of jokes to use at each party. Leos love to have a good time. The theater, arts, and sports are of special interest to them.

Leos like to visualize broad schemes, even if they know they can't possibly afford them or that their ideas are not practical. However, if it does come down to making these schemes and ideas a reality, they usually succeed in persuading someone else to do all the paper work for them. Their leadership potential is hindered because of their dislike for paper work.

In the work world, Leos are ambitious but never ruthless. They are hard workers, especially if they admire and respect their employer. There is a need for them to express their enthusiasm for life in their work. For this reason, they can easily become deeply involved with their career.

They have vitality and good health, with strong recuperative powers. When they are ill, they have a tendency to run high fevers. They are seldom depressed, but when they are, they are devastated. Fortunately, their resilient powers are excellent, so they are soon sunny and happy again.

There is a need for them to receive attention, praise, and recognition from their fellowman. In love, they are affectionate, wanting to give

happiness to their loved one. But they have to admire their marriage partner. If they don't, the marriage may not last very long.

Their most frustrating trait is that they have closed minds. They cling to their opinions stubbornly and cannot be appealed to either emotionally or with reason. Any new idea must be mulled over privately. Then, they consider the pros and cons until they reach a conclusion. But, most of the time, they haven't changed their minds at all. You feel as if you have been hitting your head against a stone wall when trying to get a Leo to consider your ideas and opinions.

As Parents:

As a parent, a Leo expects a lot from his child. He is disappointed if the child does not measure up to his ideas. They are generous and enormously proud of their children. Most Leo parents thoroughly enjoy their children. If the children are energetic and eager, all is well. If, however, the child is timid and shy, the Leo parent must be very careful not to push this child beyond his capabilities.

Children:

As a child, the Leonian will be sunny and happy. Be sure to give them responsibilities early. They have a tendency to become "bossy" with other children and should be gently persuaded to take turns. They need plenty of rest, outdoor exercise, and protein.

Wherever Leo is found in your natal chart is where you need to focus your zodiac sun energy and positive traits. This house has not received enough attention in previous lives. Thus, the positive qualities of your sun sign should be used to fulfill the obligation owed to the house affairs ruled by Leo.

There are three gems for Leo—the ruby, the sardonyx, and the peridot.

The *ruby* is unusual in that it changes colors at times. This is supposed to indicate a time of unhappiness and/or ill-health for the wearer. Its normal color symbolizes loyalty, charity, and courage.

The *sardonyx* represents honesty. It consists of bands of red or medium brown alternating with white. The stone was supposed to cure venomous snakebites and wounds where there is a loss of blood. It was, also, used to protect against the "evil eye."

Legend mentions that the *peridot* could only be searched for at night and by royal command. It was believed to bestow eloquence and persuasiveness. If it was set in gold (Leo's metal), it was supposed to exert great powers over negative people.

The flowers are gladiolus, marigold, and zinnia. Their colors are orange, bright yellow, and gold. Their metal is gold.

SUN

This planet rules the sign Leo.

Its natural house is the Fifth House.

Its orbit takes 365 days, or one year.

One complete revolution on its axis takes twenty-five days.

It is masculine and positive.

Its glyph looks like this ☉ .

This glyph symbolizes the eternal self, with the dot representing the light at the center of every cell.

Five positive key words describing this planet are: (1) creativity, (2) vitality, (3) leadership, (4) confidence, and (5) generosity.

Five basic key words describing this planet are: (1) authority, (2) determination, (3) dignity, (4) confidence, and (5) vitality.

Five negative key words describing this planet are: (1) arrogance, (2) cruelty, (3) conceit, (4) pomposity, and (5) aggression.

The basic personality function of this planet is to illuminate, elevate, reshape, and integrate all past lifetime personalities with its new qualities.

The parts of the body it rules are: heart, back, spine, inherited physical stamina, and wrists.

Some of the things ruled by this planet are: sunbathing, Sunday, gold, crowns, theaters, and fires.

The people represented by this planet are men and children.

Some of the similarities between this planet and the sign it rules are determination, dignity, and vitality.

They differ because the sun represents our inner light, or soul, which seeks to illuminate us as to the purpose of physical life, while Leo people are here to learn the lessons of the Leo sign which is one of humility and adaptability.

The sun does not retrograde.

The sun is a huge sphere of luminous gas, composed of the same elements as the other planets, but in the sun these elements are heated

to a gaseous state of 99 percent hydrogen and helium. It is 109 times the size of earth. This tremendous weight puts great pressure on the sun's layers. It is kept in this gaseous state by the high temperature of its inner core with its thermonuclear reactions. There is a correlation here between the sun and Leos, as Leos tend to run high temperatures when their bodies are fighting bacteria or virus invasion.

There is no distinct "surface" to the sun. The apparent surface we observe is illusion only. The gases, themselves, prevent us from seeing into its interior to the inner core. These surface gases are similar to a seething, sloshing sea. Occasionally, this sea is disturbed by sunspots, prominences, and flares.

Sunspots are areas where the gases are cooler than those of the surrounding area. Their lifetime range is from a few hours to eleven years. So, too, can one be on the receiving end of cool apathy from a Leo if one has happened to wound them severely. They may get over it in a few days, and then again, it may take years before contact is re-established.

Prominences are eruptions of fire which shoot upward from the surface. This brief flare-up of energy is similar to Leo's sudden anger which just as quickly vanishes as if it had never been.

Flares are intensely bright spots on the surface. This is Leo's ability to bring warmth and laughter into the lives of others.

The cause of solar phenomena is unknown, but seems to have something to do with the sun's magnetic field. It has been proven that solar sunspots affect earth's magnetic field. It causes interference in shortwave radios, radio fade-outs, and magnetic storms.

The sun's inner core is the heart and starting point of all its power, just as our soul is the heart and starting power for us. This core contains hydrogen atoms which fuse into helium at a temperature of 25,000,000° Fahrenheit. This energy in the form of gamma rays pours toward the surface of the sun which is 300,000 miles above. Our inner light, the soul also sends forth tremendous energy to every part of our mind for the express purpose of illuminating us as to the real purpose behind physical incarnations. The inner core of the sun is sending forth energy to the outer surface, so that the resultant heat can be utilized by other planets and their inhabitants. Our inner core, the soul, wants to send forth its "light" to all who come in contact with it. Leonians have a great gift in their ability to "lighten" the hearts of others by bringing sunshine and gaiety to many.

Unfortunately, like the sun's outer surface which has cooled down considerably on its journey from the inner core, so, too, do we allow our physical bodies to cool down our soul's inner light. The sun's inner core

is 25,000,000° Fahrenheit, but by the time it reaches the surface, it is only 10,000° Fahrenheit. This is a drastic drop of energy force. On its journey from the core, its energy must go through three layers to reach the surface. The first layer is about 210,000 miles wide. Here the energy force is bombarded by gas atoms which turns the gamma rays into a slower-moving form, which automatically reduces the heat. The second layer, called the photosphere, is about 80,000 miles thick. The gamma rays are churned some more, causing further decrease in energy. The last layer, the chromosphere, is the thinnest, being only 10,000 miles in depth and consisting largely of hydrogen. When the energy reaches here, it is sometimes flung up from the surface as prominences. By this time, the energy is only 10,000° Fahrenheit.

The physical characteristic of the sun corresponds to the levels of our mind. The inner core is our soul. The first layer is our superconscious mind. The bombardment by gas atoms produces a form of anesthesia which blocks the impulses, or knowledge, coming from the soul. Thus, the soul's "light" is reduced. The second layer corresponds to our subconscious mind, which is the storehouse of all our past lives. The churning our "light" receives here stems from past lifetimes' fears, errors, guilts, and grievances. By the time it gets to the third and last layer, our conscious mind, we have considerably dimmed our soul's light so that sometimes only in sleep do we receive impressions of what our inner being is really like. This last layer, our conscious mind, also reduces our energy output because of the impact of people and events upon it. Some of our experiences are similar to hydrogen explosions, causing deep and piercing wounds to our ego. The need is great for us to bring forth our inner light at its fullest potential of 25,000,000° Fahrenheit, rather than a mere 10,000° Fahrenheit. This full potential would enable us to bring illumination and warmth to others.

The sun is a brilliant orange color trimmed with a bright red. Orange is the color of high aspiration, exuberance, and sociability. Since the inner portion of the sun correlates to our subconscious and superconscious minds, the color orange is most appropriate. The outer portion is red, which stimulates vitality, endurance, and the urge to achieve results.

Look at the drawing of the human body with the soul inside, on page 82. Doesn't it appear to you that, like the sun, our physical bodies are illusion, too? The light that ignites you deep inside has nothing whatsoever to do with your "surface" appearance. Some of the most beautiful people in the world appear to be ugly because of their warped souls. And, some of the most unattractive people in the world appear to be beautiful because of the beauty of their soul. Always look beneath the physical surface, for the soul is the true light.

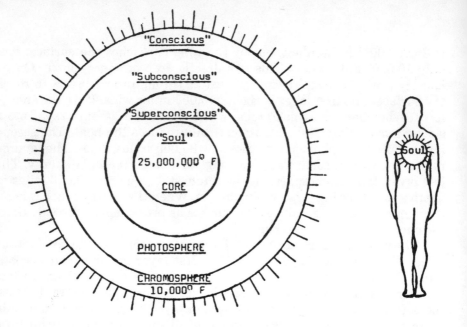

No one needs to be like the surface of the sun—a seething, sloshing sea of molten fire, ready to erupt at the slightest provocation. The hydrogen contained in our conscious mind can be used to penetrate through to the inner core. The energy potential of our soul is great.

Wherever the sun is located in the natal chart is where the affairs are being illuminated, so that the individual will "see" the need to fulfill his potential in the house affairs.

SUN IN THE HOUSES

First House: "To Become." Desire to develop a better approach to life; or, a desire to be in a position of dominance. Individual is confident, independent, and responsible. Must watch tendencies to be power-seeking or dictatorial. If the sun has stress aspects to it, their health may suffer. If the sun is harmoniously aspected, they usually have good health.

Second House: "To Develop." Desire to feel a sense of self-worth; or, a desire for power through personal possessions, talents, and money. Money comes and goes easily. They are generous and ambitious. Could be extravagant and grasping. Must watch tendency to be possessive of things and people.

Third House: "To Know." Desire of the conscious mind to know and understand through knowledge; or, the desire for scientific proof before

anything can be believed. Are creative, accomplished, and self-reliant. Could be arrogant and domineering. Can lack patience. May have mis-understandings with relatives and neighbors. A strong desire to learn. Enjoy relating their knowledge. Need to communicate with others. Can develop writing ability if the sun is in an air sign or in Leo.

Fourth House: "To Build." Desire to build strong inner foundations; or, a desire to retreat from society when life becomes difficult. Have a conservative outlook. The influence of the mother is strong for good or ill. Pride in home. Could be restless and have inner doubts.

Fifth House: "To Reveal." Desire to reveal their creativity, either constructively or destructively. Interested in all creative self-expression, such as sports, books, acting, games, etc. Have the ability to enjoy life and to give enjoyment to others. Happiness is derived from their artistic or creative pursuits. Must watch their tendency to be dictatorial or to take unnecessary risks.

Sixth House: "To Improve." Desire to improve relations with others by being of service; or, to wallow in self-pity seeking sympathy and service **from other through hypochondriac tendencies, etc. Are faithful and** conscientious employees. Take pride in their work achievements. Helpful to fellow workers. Can be an administrator, but prefers to be an employee. Good recuperative powers. Could be vain, uncooperative, and self-seeking. Are beset at times with worry and mental anxieties over the desire to do things perfectly.

Seventh House: "To Interact." Desire to interact with others in a "we" not "me" basis, by adjusting to demands of others rather than demanding for self; or, a desire to be first in any relationship. There is a need to feel a part of a family and of people in general. Interest lies in establishing harmonious relationships with others, so they do not necessarily strike out on their own. Make good arbitrators. A marriage or partnership is generally of a karmic relationship where this individual has to learn to relate on an equal basis. This karmic relationship will either strengthen or break them.

Eighth House: "To Change." Desire to transform a selfish oriented ego through the sharing of their personal resources with others on an equal basis; or, a desire to have others take care of them. Emotions are stable and usually never portrayed outwardly. A striving for self-improvement. Steady finances with the possibility of inheriting. An interest in the mystical, the occult, and psychic realm.

Ninth House: "To Understand." Desire to understand, to live, and accept a higher ideal and philosophy; or, to insist upon scientific proof before anything can be believed. Far-seeing thinkers. High ideals, tolerance of other people's views. Quest for truth and wisdom. Love of travel. Can have an aptitude for foreign languages.

Tenth House: "To Attain." Desire to attain success and power for the benefit of others; or, to seek success and power for self without thought of others. Strong motivation towards succeeding in a career and/or personal achievements. Ability to inspire others through their example. Could be ambitious toward the attainment of power and self-aggrandizement.

Eleventh House: "To Elevate." Desire to change goals to a higher level and to seek ideas which would be of benefit for the group; or, to place own goals and desires above the wishes of the group. Ability to make friends. Faithful and influential friends. Enjoy working with groups. Are responsible, liberal, and broad-minded. A humanitarian who would rather be popular than powerful. Organizing ability.

Twelfth House: "To Overcome." Desire to serve others because the personality has been destructive in past lifetimes; or, a desire to seek seclusion from the world and/or wallow in self-pity seeking sympathy and service from others through hypochondriac tendencies, etc. A contemplative life due to the need to reshape former lifetime personalities with their current zodiac sun sign. Gives an awareness of the oneness of life. Sometimes lack confidence in their abilities. A strong wish to retreat from society. An empathy with sick or mentally disturbed people making them excellent doctors and nurses. Have clairvoyant powers with the possibility of an interest in the occult and psychic realm.

FIFTH HOUSE

This is a succedent house, indicating stability. It is considered a succedent house because it corresponds to fixed signs.

The natural ruler of this house is Leo. What is the relationship between the sign and the house? Leo is the need for self-expression, and the fifth house is how we express our individual creativity.

The natural ruling planet is the sun. What is the relationship between the planet and the house? The sun (soul) enables you to exert your willpower, make decisions, and direct all the other parts (planets) of your

life. In the fifth house, we use our willpower and make decisions in order to express ourselves creatively.

If the sun were in this house, it would be approximately 8:00 P.M. to 10:00 P.M.

This is a House of Life which corresponds to fire signs. This means it is a house of enthusiam and energy toward personal interests.

This house rules:

(1) Personal Interests
(2) Creative Self-Expression
 (a) Physical (children of the body)
 (b) Mental (children of the mind)
(3) Gambling and Speculation (Involving risk)

This house is found in the Second Quadrant below the horizon.

This is a house where one must overcome his feelings of inadequacy so that he can bring forth his unique individuality. Everyone needs to discover his innermost capabilities so that he can find creative happiness and personal fulfillment.

(1) PERSONAL INTERESTS

This refers to anything that gives you pleasure and enjoyment, whether it is parties, games, sports, and/or love affairs.

(2) CREATIVE SELF-EXPRESSION (Physical or Mental)

Human nature is such that they have an intense desire to leave something of themselves for society. Children are the most common method of leaving a part of oneself to humanity. But the creative use of the mind is another method of living on in the hearts and minds of mankind. Thus, creativity of the mind can be as writers, speakers, actors, musicians, sportsmen, artists, designers, seamstresses, etc.

(3) GAMBLING AND SPECULATION (Involving Risk)

This is different from personal interests, because the individual is taking a risk. The risk can involve money or his physical life. Thus,

transactions in real estate, new enterprises, and any form of gambling are classified under this heading because they involve risk. Stunt men would, also, have to be classified under this heading, rather than *Personal Interests,* because they are risking their lives.

VIRGO

Virgo is the sixth sign of the zodiac.

Its glyph looks like this ♍.

Its glyph symbolizes the feminine sexual parts.

The picture used to describe the sign is the Virgin. In the older pictures of the Virgin, she had an ear of corn in one hand and a child on her lap, indicating fertility and the work necessary to produce them. The word "virgin" is a synonym for pure and unspoiled, showing Virgoans' desire for purity and perfection.

The sun is in this sign from approximately August 23 to September 22.

The planetary ruler is Mercury.

In the natural zodiac, it rules the Sixth House.

It is feminine, receptive (negative), and an earth sign. The element earth can be described as practical and exacting. Its quality is mutable, meaning adaptable and flexible. This can be combined to describe Virgo as "adaptable practicality."

The parts of the body that are ruled by this sign are: intestines, bowels, duodenum, food assimilation, and hands.

Some of the things that Virgo rules are: chemistry, craftsmanship, first aid, herbs, and libraries.

Five positive key words are: (1) analytical, (2) industrious, (3) systematic, (4) considerate, and (5) reliable.

Five negative key words are: (1) aloof, (2) skeptical, (3) finicky, (4) critical, and (5) self-centered.

Virgo people are happy in careers that demand technical or analytical skill or that affords the opportunity for service—often in a subordinate capacity. Some of the careers are medicine, chemists, craftsman, administrators, accountants, secretaries, teachers, and photographers.

The key phrase is "I analyze."

The key word is "service."

Their basic nature is "the critic or craftsman."

The opposite sign of the zodiac is Pisces.

In mythology, Virgo was the goddess of justice. She was the daughter

of Jupiter and Themis. Her reign was during the Golden Age of Leo. When humanity defied her rule in the Age of Cancer, she returned to the heavens in disgust.

Virgoans have inquiring minds, with keen analysis and remarkable memories. They enjoy analyzing problems. This is a major reason for their wanting to know how, why, when, and where.

They are hard workers who are practical, with a flair for detailed work. Their nervous energy causes them to become involved with a lot of activity. However, this nervous energy also causes them difficulties, for they find it hard to relax.

They can, usually, rise above defeats. Their ever-active mind seeks new ways to find success.

A Virgoan can generally be depended upon to fulfill a promise. They have a flair for organization and enjoy setting up schedules. There is an inborn love of order and harmony.

They are always subconsciously seeking perfection in whatever they attempt. Because they push themselves so hard to be perfect, they have a tendency to look for perfection in others. If they find it lacking, they can become critical and faultfinding.

As a general rule, Virgoans dislike anything crude or coarse. They prefer satire over smutty jokes.

They do not enter friendships lightly, but have a sincere interest and a loyalty to those they make their friends. A buddy-buddy relationship on first meeting is not for them. This may make them appear to be standoffish. In actual fact, they are very reserved, shy people who find it difficult to talk about their inner thoughts or feelings with comparative strangers. They have very few enemies because of their quiet, gentle manner.

Like Gemini, Virgo is a sign of worry. This tension can affect their health, causing intestinal disorders, skin eruptions, and ulcers. They need to develop a positive outlook on life, as this has a direct affect on their health. If they become too anxious about life, they can become hypochondriacs.

They are generally healthy and are always looking for new ways to take care of themselves. Whether young or old, all Virgoans need a quiet period each day in order to rest their active minds.

Their rulership over the sixth house causes them to feel that service to others is imperative. They do this willingly, thoroughly, and without fanfare.

In love, a Virgoan has difficulty in expressing himself as ardently as he desires. Although they may appear to be self-sufficient, they are really happier when they have someone to love and who loves them.

As Parents:

A Virgoan can be a difficult parent if they allow their love of neatness and tidiness to become all important. They must, also, watch their tendency to be over-critical. However, they are extremely helpful when it comes to assisting their children with homework or handiwork of any type. Because of their inability to express their affections easily, they must actively cultivate and project warmth to their children.

Children:

As a rule, Virgoan children are conscientious students. They enjoy the routine and discipline of school. They do, however, like to know "why" a certain procedure or routine is required. If the answer is acceptable, they willingly comply. Out of school, they enjoy working with their hands. The girls have a flair for sewing, and the boys enjoy tinkering with bicycles, wood products, and construction kits. They must be encouraged, however, not to be too tidy or fussy.

Wherever Virgo is found in your natal chart is where you need to "analyze" your attitudes and ideas regarding the house affairs. Past theories need re-thinking.

In Gemini, Mercury brings articulation and eloquence (use of the tongue).

In Virgo, Mercury brings dexterity (use of the hands).

The gem of Virgo is the sapphire. This stone comes in various colors, but is best known for its deep blue. The sapphire symbolizes truth, loyalty, and justice. It transmits peace and humility.

The flower for Virgo is the aster. Their colors are deep blues, dark grays, and browns. Their metal is mercury.

SIXTH HOUSE

This is a cadent house, indicating adaptability. It is considered a cadent house because it corresponds to mutable signs.

The natural ruler of this house is Virgo. What is the relationship between the sign and the house? Virgo needs to perfect personal development and soul growth through practical application. The Sixth House refers to personal development and soul growth through work, health,

and service where practical application is necessary.

The natural ruling planet is Mercury. What is the relationship between the planet and the house? Mercury's role is to analyze and discard what is unnecessary. In the Sixth House, it is necessary to analyze and discard unnecessary details in order to do your work efficiently and to keep your health in good order.

If the sun were in this house, it would be approximately 6:00 P.M. to 8:00 P.M.

This is a House of Substance which corresponds to earth signs. This means it is a house of material and objective goals dependent upon your physical ability to work.

This house rules: (1) Health
 (2) Work
 (3) Service

This house is found in the Second Quadrant below the horizon.

(1) HEALTH

This refers to our mental or physical problems brought about by our inability to establish emotional security.

Illness is the direct result of one of these five things:
1) A need to rest the body. (Ringing in your left ear is a good indication your body is in difficulty.)
2) A need to rethink your life-style. (There may be a need to be flat on your back in order to make you review your life-style.)
3) An inability to cope with a challenge or emergency.
4) An attempt by the soul to change an attitude.
5) The normal sign of bodily disintegration, due to old age.

The individual who remains totally satisfied with his life may one day learn that he is unable to meet life's challenges. Our journey through life sees us moving either forward or backward. At times, we may even fall because of inner instability, or because we have not as yet achieved self-transformation. When one's foot is off the ground, it would be extremely easy to move forward, backward, or to simply fall down. Conflicts such as pain, sickness, grief, and doubts show our inner feelings of inadequacy, fear, or frustration.

The real issue, here, is what an individual does with a crisis. The real self is revealed by the way you approach the emergency and the manner in which you act during the crisis. What counts spiritually is

what this effort develops in the person. What you achieve is only incidental. It may seem that an individual has suffered a severe setback during a crisis, but if the setback was faced with courage, optimism, and faith, he has achieved personal development. Another person facing a similar situation could appear to be facing the crisis successfully, but when the crisis appeared to be getting out-of-hand, the individual cries out against cruel fate.

All of us are forced to meet challenges and emergencies many times during a lifetime. Thus, we have to make a move in some direction. Perhaps it will be forward, or perhaps it will be backward, or perhaps we will fall flat on our faces. But, even if one falls flat occasionally, you shouldn't become so discouraged that you refuse to make a move at all for fear of falling again. Such people become static, with no personal development at all. They are classified as mentally unstable, because they constantly avoid facing challenges and emergencies by retreating into a dream world of their own making.

The sixth house indicates, by the planets occupying it, the sign the planets are in, and the sign on the cusp, the health problems that will occur when one is unable to face personal crises. The parts of the body ruled by the planets and the signs will indicate where health difficulties will occur.

Aries: Head, face (except nose), brains.

Taurus: Neck, throat, thyroid gland, recuperative power.

Gemini: Shoulders, arms, hands, lungs, bronchial tubes, thymus gland, oxygenation of body through breathing.

Cancer: Stomach, breasts, nutrition, digestion, uterus.

Leo: Heart, back, spine, vitality, body heat, perspiration.

Virgo: Intestines, bowels, duodenum, food assimilation, hands.

Libra: Kidneys, ovaries, filtration of body fluids or urine.

Scorpio: Nose, bladder, sex organs, adenoids, elimination of body wastes through bladder and bowels.

Sagittarius: Hips, thighs, muscles, sciatic (hip) nerves, motor nerve action.

Capricorn: Knees, joints, skin, chilling and cold, gall bladder.

Aquarius: Retina of the eye, calves of the legs and ankles, electricity of the body, blood circulation, anemia, elimination of carbon dioxide through breathing.

Pisces: Feet, toes, lymph glands, sweat glands, mucous secretions.

Sun: Organic complaints, poor recuperative powers.

Moon: Stomach trouble, sickness in infancy.

Mercury: Nervous respiratory or intestinal trouble.

Venus: Throat, kidney or generative troubles.

Mars: Feverish inflammatory diseases, operations, accidents.

Jupiter: Trouble through blood, liver, obesity.

Saturn: Colds, chills, rheumatism.

Uranus: Nervous disorders, strange accidents, incurable complaints.

Neptune: Contagious diseases, troubles through self-indulgence (drugs, alcohol, etc.).

Pluto: Infectious, deep-seated diseases.

(2) WORK

This refers to your working conditions: what they are like—pleasant, unpleasant, etc.

Personal development does not mean that you have to have an acute crisis or suffer a severe illness. Personal development can be gained through contributing to the productivity and growth of your community. This contribution could be in the form of employment or service. Employment gives one the opportunity of facing small crises daily, such as a daily drive through heavy traffic, or the effort of overcoming fatigue in the mornings. But, if the individual adopts the correct attitude, per-

sonal development is assured. If, however, the individual is resentful of the need to work or resentful of the type of work they have to do, they have taken several steps backward in their personal development. Everyone must come to understand that the world does not owe anyone a living.

(3) SERVICE

This refers to our capacity to serve others, as well as the character and qualities of those who serve us, either as our servants or employees.

a) *Our Capacity to Serve Others*
 We must be willing to serve others, because there is a need and not because of personal recognition or monetary reward. The deepest worth of an individual is revealed through his willingness to serve others. No one is so great that they cannot be of service. Jesus was considered a great master, and yet, he willingly washed the feet of his disciples because he knew they were tired from their long walk. A truly great person is humble, because he knows deep within himself that all men were created equal.
b) *Those Who Serve Us*
 1) "Servants" (repairmen, waitresses, grocery clerks, gas attendants, store clerks, etc.).
 2) Employees (individuals who are employed to work for you).

CONCLUSION

Health, work, and service are ruled by the same house, because one's state of health has a direct bearing on your ability to work and/or to be of service to others. Then, too, through work and service, we face many challenges and emergencies which must be handled in some manner.

Thus, we can see that the sixth house is a test of how the person handles conflicts in his life. It is a test of endurance toward all pain and suffering. Ultimately, he will learn patience. One must be able, through faith, to endure many crises, knowing that the crisis will help in gaining knowledge, experience, and growth.

Suffering, then, is the catalyst to transforming our thoughts and actions. Eventually, we learn to detach and are able to step aside in order to reevaluate what we have experienced. Detachment creates the necessary space needed for this reevaluation.

And so, this house forces us to come to terms with ourselves. The desire for ego-glorification must be eliminated. This may be brought

about through humiliation, fears, or illness, as life brings its challenges. These challenges may be devastating, heart-rendering experiences, or they can be illuminating and transforming experiences. Only you can decide.

CHAPTER 4

Quadrant III

Libra, Seventh House
Scorpio, Pluto, Eighth House
Sagittarius, Jupiter, Ninth House

LIBRA

Libra is the seventh sign of the zodiac.

Its glyph looks like this ♎ .

Its glyph symbolizes weighing scales, an oxen yoke, and the setting sun halfway below the horizon.

The picture used to describe the sign is The Balance. Why? The balance symbolizes Librans' trait of weighing the pros and cons of all situations before coming to a conclusion and their sense of fairness.

Libra brings fall equinox on September 23 and leaves the sign on approximately October 22.

The planetary ruler is Venus.

In the natural zodiac, it rules the Seventh House.

It is masculine, positive, and an air sign. The element air can be described as intellectual and communicative. Its quality is cardinal, meaning action-initiating and ambitious. This can be combined to describe Libra as "active intellectual."

The parts of the body that are ruled by this sign are: kidneys, ovaries, and urine.

Some of the things that Libra rules are: alliances, cosmetics, furniture, poetry, and social affairs.

Five positive key words are: (1) diplomatic, (2) cooperative, (3) helpful, (4) idealistic, and (5) sociable.

Five negative key words are: (1) indecisive, (2) dependent, (3) insincere, (4) lazy, and (5) self-indulgent.

Libra people are happiest in careers involving partnerships and the adjusting of human relationships. They, also, need to work in pleasant surroundings. Some of the careers are diplomat, artist, interior decorators, attorneys, and beauticians.

The key phrase is "I balance."

The key word is "harmony."

Their basic nature is "the diplomat or moderator."

The opposite sign of the zodiac is Aries.

In ancient Egypt, the Egyptians only weighed their harvest when there was a full moon in Libra. This seems to give some credence to my analogy that Libra is "harvest time," when we receive the fruits of our labor from our Aries house and reap the karma of past lifetimes' obligations.

Because of Librans' natural charm, they are excellent and thoughtful hosts. Their homes reflect their love of harmony and are comfortable and attractive. They enjoy people and hate to see them leave—usually urging them to stay just a little longer. It is easy to relax in their homes, for the atmosphere is one of peace and restfulness.

Since they enjoy people so much, Librans have a difficult time being alone. Because of this, they need to share their life with someone. Unfortunately, they have a tendency to be "in love with love," because of their romantic and sentimental natures.

Thus, they could easily rush into marriage without forethought and end up in a difficult relationship.

They find it almost impossible to remain emotionally stable if there is discord around them. This leads to their wanting peace at any price, which allows others to take advantage of them.

Indecisiveness is certainly one of the hardest problems for Librans to overcome. If they wait too long to make a decision, they may miss many excellent opportunities. Since they have the ability to see both sides of an argument, they generally do not like to choose either one. You rarely hear them say, "Yes, you're right." They usually say instead, "Let's wait and see what happens." Since they are able to see the entire issue, if they are asked for help, they can give sound, practical advice. But their attempt to be all things to all men can lead them into hot water. They cannot be a Republican for one friend and a Democrat for another, for it isn't long before their two friends have compared notes and discovered the discrepancy.

The other problem they find hard to handle is the desire to put off tasks for as long as they can. Because of this, they have a reputation for being lazy. This is not generally true, for when they are motivated, they can do anything quickly and efficiently.

Librans must guard against allowing others to sway them to their opinions. A stronger personality can easily dominate the gentler Libran, until the Libran becomes incapable of making a move without consulting the "mentor."

They are quite creative, which is reflected in their home and in their manner of dressing. They always try to look their best at all times. If they have purchased something new, they enjoy showing it to their friends. Not out of conceit, but because they genuinely want you to appreciate their new possession.

They are highly mental. This mental agility is usually not seen by others because of their easygoing, friendly appearance. Because of this mental ability, they tend to worry over health difficulties. They could suffer from blood impurities, cysts, swellings, varicose veins, kidney problems, headaches, and problems with the breasts, stomach, and knees. They should, also, be sure they get enough protein and natural sugar, such as the sugar found in fruit. Too many sweets and starches should be avoided.

They like to take charge in their own way. They may move with caution, but they steadily move towards their goal. When Librans want something, they know how to use subtle techniques to get it. Their intuition, diplomacy, and pleasing personality are valuable assets. This is what makes Librans exceptionally fine mediators and diplomats.

Although they are even-tempered and calm, if they are pushed too far, they will surprise you with their sudden violent temper.

When they get tense and uptight, they will find their outlet is through their creativity. Because they hate being upset or uptight, they tend to delude themselves as to the reasons why people do what they do. They find it hard to accept that some people may not like them. It is inevitable that Librans will also meet old enemies from past lifetimes. The matter will not resolve itself by refusing to acknowledge it. Forgiveness is always the key to injustices done by others.

In love, they are affectionate and loyal. They rarely quarrel unless they have a strong ascendant or moon sign.

As Parents:

Librans like their children to be affectionate and well-behaved. They have a tendency to be easygoing with their children, but expect them to be well-mannered in front of others. No one can justifiably call a Libran a disciplinarian. They may threaten all sorts of dire consequences to their children, but seldom ever carry them out. They make sure their children are neat, clean, and as well-dressed as they can afford.

Children:

The Libra child is pleasant, friendly, and charming. Unless they have a strong ascendant or moon sign, they come to rely on their parents or older brothers and sisters for decisions. They have to be encouraged to do their school work and chores. Most forms of art appeal to them, such as music, theater, etc. The boys do not like to fight and avoid it if they can. Teachers enjoy the friendliness of the Libra children.

Wherever Libra is found in a natal chart is where you have been "out-of-balance" in the house affairs. The scales were tipped too far to one extreme and must now be balanced. Here is where you "reap what you have sown in previous lifetimes." In other words, you see your former traits and attitudes concerning the house affairs being mirrored back to you by those in your environment.

In Taurus, Venus refers to material and physical things (inanimate objects, the five physical senses, and the three psychic senses) that you appreciate and enjoy.

In Libra, Venus refers to the things we appreciate and enjoy in our relationships with others.

The gem for Libra is the opal. It is said to impart finesse, friendship, legal success, and a happy marriage. It is fragile and easily marred. Its beauty lies in its glowing rainbow of colors that emanate from it.

The flowers for Libra are the daisy, calendula, dahlia, and lily-of-the-valley. Their colors are blue, pink, soft rose, and the pale shades of yellow and green. Their metal is copper.

SEVENTH HOUSE

This is an angular house, indicating activity. It is considered an angular house because it corresponds to cardinal signs.

The natural ruler of this house is Libra. What is the relationship between the sign and the house? Libra is the need to maintain balance and harmony in cooperative relationships, and the seventh house refers to cooperative relationships with other people.

The natural ruling planet is Venus. What is the relationship between the planet and the house? Venus indicates the type of people you attract and appreciate, based on your social values, and the seventh house refers to the people you become associated with in cooperative relationships.

If the sun were in this house, it would be approximately 4:00 P.M. to 6:00 P.M.

This is a House of Relationships which corresponds to air signs. This means it is a house of intellectual and social relationships with partners.

This house rules: (1) Cooperative Relationships
 (2) Partnerships
 (a) Personal (marriage or business)
 (b) Social (organizations, or groups, for a common purpose)

This house is found in the Third Quadrant above the horizon.
The opposite house is First.

What is the relationship between the first and seventh houses? Both refer to the ability to *relate*. The first house is how you relate to yourself as an individual, and the seventh house is how you relate to others.

How do the first house and the seventh house differ? The first house refers to *"self"*-awareness, and the seventh house refers to *"group"*-awareness.

The seventh house refers to our relationships with others where cooperation and sharing are needed. Unfortunately, to be willing to cooperate with another person, man wants a reason, or a purpose. The reason could be a simple one; such as to make money (business partners) or for personal happiness (marriage partners).

In the first house, we became aware of ourselves as individuals. As children, we took for granted our belonging to a family and an environment. Then, as we grew to adulthood, we came to realize that we were part of an even larger society. In high school and college, demands were made by this society. Decisions had to be made—what type of career we wanted, what subjects we wished to take, what political party we preferred, should we be "hawks" or "doves," etc. If we were fairly well-adjusted, we met these demands, but others were/are unprepared for such demands and escape into religious fervor or the drug cult.

So, whether we like it or not, we must learn to cooperate and share with others. "No man is an island." Several countries during World War II remained neutral, or isolationists. This may sound good in theory, but in practice, it creates tremendous ill will from the rest of society.

Our emotional stability and our personality are inevitably affected by our relations with others. If your marriage partner constantly belittles you, you either withdraw within yourself, or believe that men, or women, as the case may be, are intolerable.

If your business partner steals from you, you may refuse to trust anyone again, or you may decide to steal from your next partner so that you can make up for your first loss.

Thus, the way we react to others is the foundation upon which we will achieve, or fail to achieve, the purpose we set for ourselves before we reincarnated into this life. Jesus came to teach us love and compassion for our fellowman, so that we could end physical incarnations. If we do not have love and compassion for others, we will never end our cycle of reincarnation.

The seventh house rules cooperative relationships and partnerships (marriage, business, or social). In marriage, the partners are not consciously aware of why they have married, because they are totally involved in coming to know another human being. After they have settled into a daily routine, they may, then, seek to understand the reasons for their wanting to be together. Originally, the marriage ceremony was to publicly solemnize the "purpose of marriage" which was for procreation. Today, this concept of marriage is no longer the prime consideration. Marriages can now be for the purpose of personal happiness, security, and emotional fulfillment.

Our ceremonies of inaugurations and coronations are for the express aim of exalting the "purpose of the office." Since these ceremonies involve a ritual, they can be likened to a marriage where pledges are exchanged. The pledge given at inaugurations and coronations is that the individuals will use their personal resources (hidden talents, sense of self-esteem) in the fulfillment of the office. All seventh house relationships involve an unspoken pledge to use their personal resources for the mutual benefit of the parties concerned.

And so, experiences related to the seventh house, namely marriages and all forms of partnerships, can mean the cooperation of individuals, or it can mean participation in a group for a common purpose. It doesn't matter whether or not there is great love between these people, but there must be an interest and a concern for those in the group. Thus, we can see two types of partnerships.

1) *Personal,* such as marriage or business partnerships for your mutual satisfaction and personal growth.
2) *Social,* such as an organization for a common purpose, a foundation dedicated to scientific research, or a prayer group dedicated to faith healing of others.

No astrologer can tell how an individual will react in his relationships with others. He can tell, however, the qualities needed in his relationships with others, as this is indicated by the sign on the seventh house cusp. If the individual is having difficulties in his relationships, he is probably expressing the negative qualities of the sign on the seventh house cusp and should make an effort to bring out the positive qualities. For example, if you have Leo on the seventh house cusp and are having

99

difficulties in your relationships, perhaps, you are dictatorial, snobbish, intolerant, or conceited. An effort should be made to become generous, sunny, and optimistic when relating to others.

It is inevitable that in marriage and other kinds of partnerships, we experience tensions. Sometimes these tensions are unresolvable, but still, the experiences derived from these tensions can serve to develop personal growth. Certainly, life would be free of all turmoil and tensions if you could retreat from society. By isolating yourself, you avoid all the hurts and disappointments inflicted by others. But, alas, that is pure escapism. We have to learn to live, adapt, and get along with others. We need people, and they need us, so now is the time to learn to relate to others in love and compassion.

SCORPIO

Scorpio is the eighth sign of the zodiac.

Its glyph looks like this ♏.

Its glyph symbolizes the masculine sexual parts.

The pictures used to describe the sign are The Scorpion and The Eagle. Why? They represent the dual nature of the Scorpios. Scorpions are cunning and strike when least expected. The eagle is majestic and powerful with the ability to rise above the physical world.

The sun is in this sign from approximately October 23 to November 22.

The planetary ruler is Pluto.

In the natural zodiac, it rules the Eighth House.

It is feminine, negative (receptive), and a water sign. The element water can be described as feelings, emotional, and responsive. Its quality is fixed, meaning determined and persistent. This can be combined to describe Scorpio as "determined feelings."

The parts of the body that are ruled by this sign are: nose, bladder, sex organs, adenoids, elimination of body wastes through bladder and bowels.

Some of the things that Scorpio rules are: bathrooms, espionage, funerals, taxes, and laboratories.

Five positive key words are: (1) ambitious, (2) efficient, (3) courageous, (4) resourceful, and (5) intuitive.

Five negative key words are: (1) sarcastic, (2) resentful, (3) stubborn, (4) possessive, and (5) vindictive.

Scorpio people enjoy impossible tasks. They like work which demands determined effort and intense concentration. Work connected with the

100

underground, sea, liquids, or sanitation also appeal. Some of the careers are detectives, morticians, politicians, engineers, contractors, chemists, surgeons, scientists, archeologists, garbage collectors.

The key phrase is "I desire."

The keyword is "fortitude."

Their basic nature is "the detective or annihilator."

The opposite sign of the zodiac is Taurus.

Scorpio is one of the most powerful signs because of their strong will and determination to accomplish whatever they attempt to do. Their analytical mind, strong intuition, reasoning powers, perception, long-range planning ability, magnetism, and energy are assurances of success.

As a fixed sign, they have very definite opinions. These opinions can be so rigid that no amount of persuasion will make them change their minds. This is why they have earned the reputation as the most stubborn sign in the zodiac.

Habit patterns are formulated early in life. Unlike Gemini or Sagittarius, they do not flit from interest to interest, job to job, home to home, or community to community. Because of this, it is important for them to choose their environment, their career, and their friends carefully. If they are around negative people, their own negative tendencies are brought out.

They make friends easily. These friends are from all walks of life. Scorpios give unwavering loyalty to their friends. In these relationships, Scorpios usually have a "double standard," in that they like to know what your plans are, but because of their secretiveness, they do not necessarily want you to know what they are planning.

They are capable of extreme self-sacrifice for those they love. If any of their loved ones are threatened in any way, they feel that they, too, are being threatened. This causes them to instinctively strike out, either verbally or physically.

Since their unconscious mind is more in control than their conscious mind, they lose all sense of judgment under criticism. Under attack, they make effective use of both silence and sarcasm. Unfortunately, their sarcasm can become vindictive. They can, and will, wait a long time in order to get even. However, emotional maturity causes them to recognize this trait and to rechannel their emotions into forgiveness.

It is hard to deceive a Scorpio. Their intuition enables them to understand the motives of other people. This is a great asset to them. They receive very strong first impressions of others—experiencing either a liking or a dislike for the person involved. It is important for them to investigate their reactions behind these first impressions, for they stem from past life experiences.

Plans are made in advance for their activities, and they find it difficult to make last-minute changes. However, it is important for them to learn to be adaptable in all circumstances. Such situations occur in order to teach them to be flexible.

Any work a Scorpio becomes involved in must be important, or appear to be important. Trivialities bore them. They want to become totally engrossed in any task.

Like their element, water, they are deep and mysterious. There is a quiet strength about them that belies the intense emotions seething underneath.

Everyone describes Scorpio in sexual terms. They are considered the most highly sexed sign in the zodiac. It would be far more accurate to describe them as individuals whose intensity of feelings project them into whatever they are doing. This could be their work, their politics, their fun, or their love life. This emotional intensity, when properly channeled, gives Scorpio great endurance. They battle against seemingly severe odds. Sometimes, in their battles, they trample on others in the process. This is why they are classified as saints or sinners. If they use the scorpion symbol, they are using the lower Scorpio vibration. But, if they use the eagle symbol, they have the ability to rise above all worldly difficulties and to tap their higher consciousness.

They set themselves up as their own judge and jury and punish themselves unnecessarily.

Basically, they are self-sufficient, but not necessarily self-assured. They never actively seek applause or the limelight.

They are generally healthy, but can be inclined to overindulgence in food, drugs, sex, and alcohol.

In love, they are extremely affectionate and demonstrative. They are the happiest and most fulfilled with one partner with whom they can combine emotional and sexual love.

As Parents:

A Scorpio parent enjoys his children, but they can be too demanding and strict. They like to see their children busy. They find it hard to grant favors when asked. It is easier for them to grant a favor if it is their own idea. It would be wise for them to tell their child that they will "think about it and give an answer later." This gives them the opportunity of weighing the pros and cons of the favor before reaching a decision.

Children:

Scorpio youngsters need lots of love. They also need an opportunity of exercising their own ability to solve their problems. A helping hand should be extended only when the child asks for it. Give them plenty of things to do because of their emotional energy. Most of them enjoy swimming and find it very relaxing. They are also attracted to active sports. Because of their tendency to secretiveness, allow them to plan surprises for the family or others. They should be encouraged to help take care of younger children in order to develop their protective instincts. Otherwise, they are inclined to be jealous of younger brothers and sisters.

Wherever Scorpio is found in the natal chart is where you need "deep involvement." In other words, you should be intensely concerned about the affairs of the house, so that you investigate and get to the bottom of all aspects of the house affairs.

The gem for Scorpio is the topaz. The ancients called this stone the emblem of fidelity. It was said to impart good digestion and great strength.

The flowers for Scorpio are chrysanthemums, gentians, and red carnations. Their colors are gold, deep yellow, bright red, orange, wine, and purple. Their metal is iron.

PLUTO

This planet rules the sign Scorpio.

Its natural house is the Eighth House.

Its orbit takes 248 years.

One complete revolution on its axis takes six days and nine hours.

It is masculine and positive.

Its glyph looks like this ♀.

This glyph symbolizes matter overcome by an uplifted personality, with the eternal spirit risen above both of them.

Five positive key words describing this planet are: (1) rebirth, (2) integration, (3) transformation, (4) illumination, and (5) wisdom.

Five basic key words describing this planet are: (1) rebirth, (2) regeneration, (3) transformation, (4) illumination, and (5) wisdom.

Five negative key words describing this planet are: (1) destruction, (2) struggle, (3) obsession, (4) confusion, and (5) conflict.

The basic personality function of this planet is soul growth through painful experiences.

The parts of the body it rules are: prostrate glands, reproductive organs, allergies, insect bites, and nape of neck.

Some of the things ruled by this planet are: underworld, unions, taxes, estates, insurance, volcanoes, earthquakes, and inheritances.

The people represented by this planet are the masses.

The similarity between this planet and the sign it rules is that both possess the power necessary for the regeneration, or degeneration, of the soul. It is either/or, for both.

They differ because Scorpio's conscious aim in life is for personal enjoyment, while Pluto's aim is to stimulate our desires toward the obtainment of spiritual enlightenment, rather than personal enjoyment.

Pluto retrograde causes it to operate more deeply than usual in the superconscious, bringing about inner illumination and changes before it can be revealed to the outer world for all to see. It, also, is an indication of retained psychic powers from other lifetimes which may be used in this life, but these powers must be used positively. A debt is owed to humanity from the "zodiac age" Pluto is in. It can be redeemed in this lifetime through service to others.

Mythology relates that the king of the gods, Jupiter, had two brothers. They were Neptune and Pluto. Pluto was considered to be rather grim and unyielding. He was the most feared of the gods, but wasn't really considered an enemy. He was man's judge who punished when necessary. This trait is inherent in Scorpios, who, also, firmly believe in justice. They feel that good should be rewarded and evil punished.

Pluto's kingdom was underground. It was a flat, cloudy country. The inhabitants were supposed to be pale, shadowy figures. These inhabitants were the souls of people who had died in the physical world above. Through this dismal land wandered the River of Sighs and the River of Forgetfulness. Circling the walls of Tartarus was a flaming river called Phlegethon. From this river, endless waves of fire and sulfurous smoke arose. Inside the walls of Tartarus, the wicked groaned and clanked their chains. There the souls were brought before the three judges who weighed their good and evil deeds. If the good outweighed the evil, they were taken to a place of happiness called the Elysian Fields, which was next to Tartarus.

The gates to Pluto's kingdom were guarded by a fiendish dog with three heads. However, there were, also, a number of pathways leading to the upper world from which escaped the vapors from this world. Both Hercules and Orpheus went down to this inner world through caves in Greece.

The discovery of the planet Pluto was due to one man's dedication. Dr. Percival Lowell, head of the Lowell Observatory in Flagstaff, Arizona, was a philosopher as well as a mathematician. He made an extensive study of Mars and believed there were people living on it. The riddle of what was pulling the planets Saturn and Uranus became of interest to him, so that he set about trying to solve the riddle. This led to many years of working, studying, figuring, and watching, until, in 1905, his calculations made him certain that there was another planet out beyond Neptune which was causing the pull on Saturn and Uranus. He called it "Planet X."

His search for this planet began through the use of photographs. He set all his men in the observatory to work. The sky was divided into sections in the area that Lowell was certain the planet would be found. Then, several pictures were taken of each of these sections. Two or three nights later, a second set of pictures would be taken. By studying and comparing the two sets of pictures, they hoped to find a tiny point of light that would have moved from its place in the sky between the first and second photographs.

This was a long and tedious task, as each picture had to be exposed for three hours in order for the light from the faint stars to be recorded on the film. Then, Dr. Lowell examined and compared all these photographs. For about ten years, he patiently photographed, studied, and measured, hoping to find the planet which his figures told him was surely traveling around our sun beyond Neptune. In 1916 he died, and the search was stopped.

Thirteen years later, in 1929, the work of finding the planet was resumed by Clyde W. Tombaugh, an astronomer at the Lowell Observatory. Finally, one small object was seen which had shifted its position among the stars between the two photographs. The distance it moved showed it was very slow moving and very far away. They kept watching this new object and discovered it was yellowish in color, indicating a different type of air, or no air at all. They also found that it was about four billion miles from the sun and received very little heat.

Thus, they compiled their information on Pluto. This information showed that Pluto was a tiny, solid, yellowish sphere, apparently the size of Mercury. They estimated its diameter at 3,700 miles. Its orbit was eccentric, being at a 17° angle from the orbital planes of the other planets. This eccentric orbit sometimes brought it inside Neptune's orbit, although there is no danger of their colliding as they are at least 200 miles apart. Its orbit around the sun was estimated at 248 years, and its axis rotation at approximately 6½ days. There are no satellites. The temperature is around −360° Fahrenheit. It travels at a very slow rate of about 10,000 miles per hour, as compared to earth's speed of 110,000 miles per hour.

At this time, it is not known if Pluto has any gravity, water, or atmosphere.

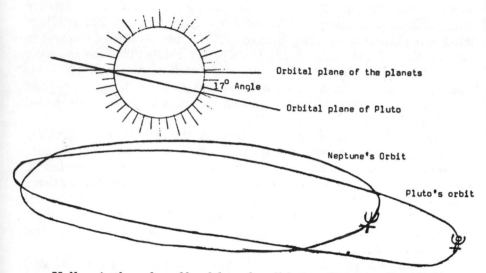

Yellow is the color of health and well-being. Bright yellow indicates spontaneity, enthusiasm, and intellect. These traits are characteristic of Scorpios. The eccentric orbit can be compared to Scorpio's battle against all opposition. They do not meekly follow other people's pathways, but seek to blaze their own trail. The slow speed indicates their need to assimilate material at their own pace. They feel that the speed one works at is unimportant. What is important is to attain your goal. The difficulty in locating the planet certainly parallels Scorpios' secretiveness and the difficulty some people have in understanding them. The moving of Pluto inside Neptune's orbit shows the ability of the Scorpios to penetrate their inner levels of awareness. This can be true of anyone who seeks to use Pluto's vibration correctly.

Pluto is arid, cold, and dark. It appears to be remote and hostile. Are we guilty of freezing others with our coldness, remoteness, and hostility? Like the world of the god Pluto and the planet Pluto, we must delve beneath the exterior to the soul within, in order to know and understand what others are like.

Until we penetrate our inner depths to find out who and what we are, and what we are searching for, we are trapped, like the River Phlegethon, to flow in an endless circle of incarnations, experiencing again and again remoteness and hostility in our environment until we have balanced our scales of experience. Then, we can be led to a place of happiness, such as the Elysian Fields in the underground kingdom of Pluto.

Over the past three centuries, three planets have been discovered. These planets represent messengers and aids in the long struggle for soul evolution. Uranus was discovered in the eighteenth century and heralded many changes in life-styles. Neptune made itself known in the nineteenth century. Finally, Pluto came into our vision in the twentieth century. Because of these additions, they had to be assigned to a zodiacal sign. Uranus was assigned to Aquarius. Neptune was given rulership over Pisces. When Pluto was discovered, there were many arguments as to who should receive this planet as its ruler. It was finally decided to assign the new planet to Scorpio.

There is much evidence that Pluto should be the ruler of Scorpio. When it was first discovered, it was in the second decanate of Cancer at 17° which is sub-ruled by Scorpio. Then, when this discovery was announced to the public on March 12, 1930, Scorpio was again in evidence. March 12 is in the third decanate of Pisces which is, also, sub-ruled by Scorpio. Then too, since death was associated with the god Pluto in ancient times, it seems logical to place the planet Pluto over the rulership of the eighth house which refers to death—either physical or symbolic.

Pluto brings about revolutionary change. Even though it destroys or wipes out with one hand, it is ready to build anew with the other. It has rulership over volcanoes from which molten lava erupts, destroying everything in its path. But, later, that very lava helps build a rich soil for plant growth. And so, Pluto may ring a death bell on old situations, but it is done in order to make way for an improvement. Most people fear Pluto, for they only see the dark side and are naturally reluctant to release the familiar in order to receive something new and different. (Everyone always says, "Rather the devil I know, than the devil I don't know.") Change is frequently difficult when it calls for emotional loss. But new projects can be stimulating, creative, and constructive. Too often, Pluto is thought of only as death and not as the life-giver it can be. How much of what anyone enjoys today would be possible without the death of the past on which it stands? The cycle of life and death and then life again is part of nature which always renews itself by natural means. Pluto is the instrument of this process.

In a natal chart, Pluto indicates where changes are going on. This change can be extremely difficult. A sacrifice is called for in order that something better may take its place. There is always a descent into the darkness of the underworld of ourselves before we can ascend into the light.

Since Pluto is the higher octave of Mars, there must be an elevation of all our desires (physical, mental, spiritual, and emotional) for inner illumination and spiritual enlightenment. Isabel Hickey calls for us to use the Minerva aspect of Pluto. Minerva in mythology was the goddess

of wisdom. Her wisdom taught her to fight only when it was necessary to establish a better and more lasting peace. Thus, it is up to us to use the upheavals caused by Pluto to gain inner wisdom.

PLUTO IN THE SIGNS

Pluto in Aries: (1822—1851) Pluto stimulated impulsiveness, individuality, and resourcefulness. During this time, reforms, new ideas, and inventions came into being. Pioneering, colonizing, and explorations went on. Peop'e begin to think in terms of the whole world rather than a small section of it. It, also, brought rebelliousness and violence. Militant communism was born. People felt a compelling need to achieve emancipation.

Pluto in Taurus: (1851—1882) Pluto stimulated endurance, but it also stimulated extremes in wealth, ideals, and emotions. Many individuals became grasping, defiant, dogmatic, and stubborn. The Industrial Revolution came into being. Resources below the earth were utilized. It brought forth industrialists, builders, and financiers with a desire to establish material wealth. Standards of living began to improve, but the rich got richer, and the working classes endured great hardship, poverty, and squalor, both at home and at work. People felt a compelling need to achieve some type of permanence.

Pluto in Gemini: (1882—1912) Pluto stimulated inventiveness. It brought about changes through communications and travel. People sought methods of moving and communicating faster. Thus, the automobile, airplane, telephone, and phonograph were invented during this era. Psychoanalysis became popular, as scientists probed the depths of the mind. People were motivated to speak and write about matters that were repressed in the Victorian "Taurus" era. Many cherished customs and taboos were eliminated. Individuals born with Pluto in Gemini have mental restlessness, but depth of character, as well. They should watch a tendency to fritter away their energy and to be critical. These individuals feel a compelling need to comprehend life.

Pluto in Cancer: (1912—1938) Pluto stimulated tenacity. It brought upheavals and changes in family life. This era saw one World War and the beginning of another. Many loved ones were killed. Broken homes became common. Divorces increased. Women were emancipated. Attention was turned to child-rearing techniques. Parents began to realize that children should be raised with love and kindness. Pluto in this sign causes a play

on the emotions, bringing sentimentality to the forefront. Patriotism to your country and a "cause" were the keynotes. There was a rise in dictators who swayed the masses through their emotions. There was much suffering, but from deep suffering comes soul growth. Individuals born with Pluto in Cancer have strong intuition and psychic tendencies. They can easily become egotists or feel a personal responsibility to the world. These individuals feel a compelling need to find emotional security.

Pluto in Leo: (1938—1957) Pluto stimulated self-confidence. This era saw the rise and fall of governments and dictators throughout the world. Thrones fell as kings were no longer wanted. Atomic energy was discovered. The United Nations was founded. Teenagers were more self-aware and began to act on their own initiative. The scientific revolution brought about more leisure time. The entertainment industry flourished with the development of television. Individuals born with Pluto in Leo have managing ability and faith in their ideas. There is a tendency for some to want to dominate others and for ruthlessness and violence. These souls will be called on to solve the problem of creating a central world government around the year 2000. These individuals feel a compelling need to be creative.

Pluto in Virgo: (1957—1972) Pluto stimulated analytical ability. This era brought about a critical review of social conditions with a desire to reform past methods. There was concern for unemployment and minority groups. The Common Market was founded. Free trade went into effect. Industries came to rely on the use of chemicals. Drugs flooded the market. Introverted Virgo precipitated the use of drugs to release the hidden powers of the mind. Interest was stimulated in vitamins and organic foods. New methods of healing were developed. Computers were invented. Man went to the moon and back safely. Individuals born with Pluto in Virgo are analytical, industrious, and self-critical. They tend to be critical of others, also. They find it difficult to be sacrificing for others. These individuals have a compelling need for perfection.

Pluto in Libra: (1972—1984) Pluto is stimulating a desire for justice. This era will bring changes in legal laws in such areas as birth control, death control, and marriage. Corruption will be brought to the surface to be dealt with. Since Libra is an air sign, Pluto in Libra will bring about a cleaning up of the air. There will be laws made against smog, gasoline fumes, and nuclear tests. There will, also, be a curtailing of violent shows on television. Ideas about marriage and sex will undergo a reevaluation. New concepts in art will come into being for the express purpose of uplift-

ing the public (psychic art). All of us will need to learn to cooperate and compromise. Our responsibilty to the entire world must be accepted. Individuals born with Pluto in Libra will be adaptable, cooperative, with a talent for compromising. They will have to watch their tendency to be insincere and evasive. These individuals have a compelling need to achieve harmony.

Pluto in Scorpio: (1984—1996) Pluto will stimulate fortitude and resourcefulness. Medicine will be revolutionized, bringing entirely new methods of healing. Cures for cancer will be found. New birth control measures will be discovered. Many will be born with great psychic ability already developed. Educational methods will be changed. Astrology will be taught in schools and colleges. Emphasis in education will be toward the development of the potential of the individual. Psychic research will be promoted by the government. Psychic healing will be commonplace. Corruption will continue to be brought out into the open. Criminals will be severely punished, but crime will continue. The lost continent of Atlantis will rise with many buildings and artifacts still intact. Earth changes will occur, along with spiritual illumination. Those souls who are not evolved enough at that time will be taken from earth and sent to another solar system to incarnate until they, too, have learned the lessons of love, compassion, and the oneness of humanity. How and where these earth changes will occur are unimportant for if you are to remain, you will do so regardless of where you are living at the time. Individuals who will be born with Pluto in Scorpio will be sensitive, intuitive, courageous, and resourceful. Many of these individuals will be ruthless and destructive. These individuals will have a compelling need for the regeneration of their personality.

Pluto in Sagittarius: (1995—2010) Pluto will stimulate enthusiasm, prophetic ability, and faith in human nature.

Pluto in Capricorn: Pluto will stimulate efficiency, perseverance, and self-discipline. During this era, the people will establish a world government.

Pluto in Aquarius: Pluto will stimulate ingenuity, originality, an understanding of life, brotherhood, and an awareness of the truth.

Pluto in Pisces: Pluto will stimulate understanding, compassion, self-sacrifice, and a sense of the universality of all.

PLUTO IN THE HOUSES

First House: Courageous, self-sufficient, strong will. Great potential, but lack confidence in themselves. Desire for experience. They have a magnetism which draws people to them. Tend to be loners who others find difficult to understand. Gentle and very sensitive, but if they become upset or panicky, they can become extremely angry. Have the ability to look into the past and to see into the future. Can also be a channel of healing. Can be skeptical, inconsiderate, and obstinate. This position indicates a need to transform their approach to life. If they are shy, they must face the world. If they are overbearing, they must be toned down. If they brood over hurts, the physical body will be affected by these emotions.

Second House: Financial ability. Keen judgment, patient, and energy. Have unusual talents. Usually gives a desire for money and possessions. Must watch a tendency to view loved ones as possessions. If Pluto is afflicted, the individual will see money coming and going in order to deemphasize its importance. The constructive use of Pluto here is the spontaneous sharing with others. Integrity in money matters is essential.

Third House: Versatile, original, inspired. Ability to evaluate situations and people. Unusual relationships with relatives. Need for self-expression. An inquisitive mind with good powers of concentration. Are good teachers and counselors. A searching for something to give meaning to life. Feel as if they are not on the same level as other people's minds. Tendency towards depression and negative thinking. Turmoil going on in the mind, as the soul seeks the answers to life. They should express themselves in writing or painting, bringing forth all their innermost thoughts. This acts as a purification. The material should then be destroyed for its purpose has been served.

Fourth House: Good imagination, intuitive ability. Desire for a loving home atmosphere. The influence of the mother is strong for good or ill. Explosive temper due to inner tension. Usually feel restless in birthplace, with a strong desire to explore the world.

Fifth House: Unusual talents. Usually a karmic situation with children. Unique children who may not be understood by the parent. Former lifetime selfishness is overcome in this house through the responsibilities that children bring. A need to be creative and to transform sexual desires.

This energy can be rechanneled into creative outlets such as painting, dancing, yoga, etc. If sex is predominant, the individual suffers emotionally, mentally, and physically.

Sixth House: Cooperative and thorough. Desire to be of service. Ability to work long hours on nervous energy until the body protests. Desire to reveal unfair situations. A troubleshooter who cleans up messes which others are unable to cope with. Good psychologists with the ability to encourage people to discuss deep-seated problems and then analyze the problems logically. Interest in healing. Can be a channel of healing or a hypochondriac. Must guard thoughts. Apt to unconsciously project criticalness to others without speaking. Deep feelings of insecurity and inferiority. High tension in the nervous system that must be understood and handled correctly, or the individual could suffer from a nervous breakdown. Difficulties through infectious, deep-seated diseases, and the colon area.

Seventh House: Meet many unusual types of people. Ability to see all sides of issues objectively which make them good mediators and diplomats. Difficult for them to establish close emotional relationships. A wise choice of a marriage or business partner will be extremely beneficial to these individuals. A strong will which might become combative. Need to learn to cooperate with other people.

Eighth House: Strong intuition. Good business sense. An analytical, logical mind. Courage and fortitude. Interest in metaphysical world. May have clairvoyant abilities. Possibility of inheriting. Concern over money through marriage or business partner. Can be financial upheavals. Search for the meaning of life. Develops insight, self-awareness, and independence. Tendency to dominate others must go.

Ninth House: Intuitive. May be clairvoyant. Desire to expand knowledge. Interest in philosophy and religion. Want to be a pioneer in abstract philosophies. Love of travel. Metaphysical experiences through dreams, etc. Must not overindulge in drugs or alcohol, as they could easily have a mental breakdown. Could suffer mental strain from studying too intensely. May become a religious fanatic.

Tenth House: Unforeseen developments in a career. Are self-assertive. Need to incorporate diplomacy and patience into their personalities. Pluto can operate in diverse ways in this house. It can give a desire for power, or a desire to retreat from society, or a desire to be of benefit to society.

Those that attempt to use Pluto for power will discover that it was all in vain, as they soon are toppled from their position through unforeseen circumstances. The highest use of this position is the active attempt to resolve their karmic obligations to society, so that they can release their soul from the wheel of physical incarnation.

Eleventh House: Have charisma. Are reformers and idealists. A dedication to principles and ideals that will benefit mankind. Leadership ability and the will to fight for "causes" that are beneficial to others. Desire for friends. Can influence friends for good or ill. They should choose their friends well, as the wrong friends will cause unexpected difficulties. Friends come and go in their life. The friends who remain are steadfast.

Twelfth House: A need to search for truth and wisdom so they can understand life. Feel life has enslaved them in some way, but the enslavement is within themselves due to their desire to fulfill karmic obligations. These individuals experience occasional upheavals in their life in order to bring them back to the correct pathway. They may feel a desire to retreat from society in order to reanalyze their life. Can become a champion of the downtrodden. This position forces the individual to serve mankind in some way, or they will become a victim of self-pity and psychological disorders.

EIGHTH HOUSE OUTLINE

(1) *Joint Resources** (Hidden talents, money, possessions, sense of self-worth)

 A) *Partner* (Resources your marriage or business partner contributes for your joint benefit)

 B) *Group* (Any group relationship involving a ritual—a set pattern of operating)

 1. Business (Corporations)

 2. Religious (All religions, Scouts, Masons, Y.M.C.A., Y.W.C.A., etc.)

 3. Political (P.T.A., cultural programs, governments, organized sports)

 4. Metaphysical (astrology, ESP, psychic work, white magic, black magic)

*Reasons for combining resources: 1) Money, 2) Group expansion, 3) Influencing others, 4) Self-transformation, 5) New depths of inner awareness
Before contributing your personal resources, be sure you consider: 1) Trust: Do you trust the participants? 2) Management: Is it properly managed? 3) Responsibility: What type of power is released? Positive or negative?

(2) *Death and Regeneration*

 A) *Death*
 1. Actual Physical Death
 2. Symbolic (Transformation of personality through changes and upheavals)
 B) *Regeneration*
 1. "Rebirth" through changes and upheavals
 2. "Recharging" of fatigued energy cells through:
 a) Heterosexual Experiences
 b) Other Activities (Sign on Eighth House Cusp)
 Aries: Physical labor on a project
 Taurus: Gardening, raising houseplants
 Gemini: New places, making things with their hands
 Cancer: Cooking, sewing, homemaking, browsing through antique shops
 Leo: Hiking, painting, acting, tennis, beach
 Virgo: Sculpture, painting, knitting, weaving, music
 Libra: Reading, TV, music, art, plays, museums
 Scorpio: Dancing, dining, robust sports, swimming, any type of racing
 Sagittarius: Archery, hunting, fishing, carpentry, music, sports, hikes
 Capricorn: Poetry, art forms, writing, reading, mild sports
 Aquarius: Travel, seaside, ocean sports, surfing, swimming
 Pisces: Reading, seashore art, museums, quiet times

(3) *Personal Sacrifice* (Your own and others for you)

 A) Taxes
 B) Legacies
 C) Inheritances

EIGHTH HOUSE

This is a succedent house, indicating stability. It is considered a succedent house because it corresponds to fixed signs.

The natural ruler of this house is Scorpio. What is the relationship between the sign and the house? Scorpio wants deep emotional involvements in everything, and the Eighth House refers to the need to become emotionally involved with causes and people and to be willing to share your personal resources with another person or group of people.

The natural ruling planet is Pluto. What is the relationship between the planet and the house? Pluto represents the need to transform (regenerate) personal desires to group desires, and the eighth house refers to the use of personal resources for the purpose of helping another person or group of people.

If the sun were in this house, it would be approximately 2:00 P.M. to 4:00 P.M.

This is a House of Endings which corresponds to water signs. This means it is a house of inner emotional levels pertaining to the death of the selfish ego and spiritual rebirth.

This house rules: (1) Joint Resources (yours and others)
 (2) Death and Regeneration (physical or symbolic)
 (3) Personal Sacrifice (your own and others for you)

This house is found in the Third Quadrant above the horizon.

The opposite house is Second.

What is the relationship between the second and eighth house? Both refer to resources (money, possessions, hidden talents, and sense of self-worth).

How do the second house and the eighth house differ? The second house refers to personal resources and the desires of the person, and the eighth house refers to joint resources and desires gained and shared with others.

Most astrologers speak of the eighth house as the house of "Death and Regeneration." This is more clearly understood when you realize that Scorpio occurs during the mid-autumn in the Northern Hemisphere. During this time, many plants are experiencing a form of "death." But, as these plants decay, they leave a part of themselves behind. Their seeds do not die. (They merely lie dormant until it is time for them to be "reborn" in the spring.) In the Southern Hemisphere, where Scorpio occurs during the spring season, the seeds are preparing to be regenerated, or "reborn." Some of these seeds may remain dormant and fail to grow. When people experience catastrophic changes in their life, they, too, remain dormant (in shock) until the value of their experience is made known to their conscious mind. Then, they begin to live (grow) again, and, thus, have been "reborn."

The eighth house has a number of seemingly unrelated meanings which can be correlated, if one looks deep enough. I have divided the house affairs into three main classifications which are further broken down into smaller classifications. (Refer to the outline sheet of the eighth house)

(1) JOINT RESOURCES (Money, Possessions, Hidden Talents, Sense of Self-Worth)

The eighth house is the polar opposite of the second house of personal resources. This gives us a clue as to the meaning of joint resources. In any opposition, there is always an invisible cord between them. (In the first house, we learned self-awareness, and in the seventh house, we were forced to realize that man must learn to cooperate and live with others.)

In dealing with joint resources, a balance must be achieved between what are your personal resources and what belongs to others, keeping them separate, but using the resources on an equal "give and take" basis with others. In other words, you bring your individual resources to another person or a group organization for the express purpose of helping to fulfill that group's goal. This goal could be to make money, for group expansion, to influence others, for self-transformation, or a personal desire to experience a new inner awareness.

Now, let's define what is meant by relationships. Relationships can be two partners in a business or marriage association. It can, also, be several partners, or a group. Such a group could be for business, religious, political, or metaphysical reasons.

All group relationships ruled by this house have some kind of ritual—a set pattern of operating. The reason for having a ritual is to strengthen the bond between the members of that particular group. It is meant to generate a special emotion when the group is together. When people touch and move together according to a set pattern, a feeling of togetherness is created.

Metaphysical (occult) groups have the same purpose as social or religious rituals. Incantations, mantras, symbolic gestures and objects are used to develop an intense emotional response from the group. This does not mean that the use of these is wrong. It depends entirely on what the purpose is of the group.

All of society uses rituals in one form or another. It is important, then, to keep in mind that any ritual you participate in should be inspiring and positive, rather than boring or destructive. In deciding on a group, or groups, that you wish to contribute your personal resources to, be sure to consider the following three things—trust, management, and responsibility.

1) *Trust:* To participate in a ritual group, you must trust the participants. If you do not, it could lead to disillusionment. It is no secret today that some politicians are a negation of trust. But, if we realize that a few rotten apples don't necessarily spoil the whole barrel, we can still live

116

in basic trust of our fellow politicians. Keep in mind that we are being taken on trust by stores and banks when we use credit card buying or obtain mortgages. None of us would receive any credit if the stores and banks judged us by the few who negated their trust.

2) *Management:* Through proper management, a couple or a group should produce various results, create new wealth, and release new energies. The eighth house is a succedent house and indicates stability. Thus, the final result of any group activity should be stability for the group participants, whether it is in marriage, a firm, or any other type of organization.

3) *Responsibility:* When two or more people are gathered together, much energy is generated and released. This energy may be positive, negative, or a little of both. It is up to each participant to decide what type of energy they desire to create and what they hope to gain from the groups they belong to.

(2) DEATH AND REGENERATION (Physical or Symbolic)

The term death can be an actual physical death, or it can be symbolic. A symbolic death is where there has been a transformation of the personality through changes and upheavals. This can be positive or negative, depending on the reaction of the individual to these changes and upheavals. There is no denying that it is a "death" to an old way of life.

"Regeneration" is another word for "rebirth." Rebirth comes through important changes in the person's life which he has positively reacted to. There may be many crises in the person's life, where the person was forced to pick up the pieces and carry on in a different way. This can be referred to as a symbolic "death and rebirth." You have been regenerated in order to better fulfill your purpose in life.

"Regeneration" can, also, mean the "recharging" of energy cells when you become chronically fatigued. The usual method is through sleep. However, there are two other methods of energizing fatigued energy cells. The first method is through heterosexual experiences. The reason sex is included in the eighth house is because in a marriage, each partner brings their ability (talent) for energizing the other partner. Sex becomes a fifth house classification when it becomes "fun and games." The spiritual side of sex is missing in the fifth-house rulership. When sex is sold as a business, it is ruled by the second house, and, again, the spiritual side is missing. The sign on the eighth-house cusp indicates the other method of recharging energy cells. Each zodiac sign enjoys different methods of achieving this. These are listed on the "Eighth House Outline."

(3) PERSONAL SACRIFICE (Your Own and Others for You)

The eighth house calls for personal sacrifice, whether it is your own or others. In any cooperative relationship, we must give of ourselves. Thus, in order to benefit through government programs, we have to share a portion of our income in the form of *taxes*. Then too, you can benefit by other people's sacrifices for you through *legacies* or through *inheritances*.

SAGITTARIUS

Sagittarius is the ninth sign of the zodiac.

Its glyph looks like this ↗

Its glyph symbolizes an arrow.

The pictures used to describe.the sign are The Archer and the Centaur. Why? They are representative of Sagittarians' attempt to liberate themselves from their lower nature.

The sun is in this sign from approximately November 22 to December 22.

The planetary ruler is Jupiter.

In the natural zodiac, it rules the Ninth House.

It is masculine, positive, and a fire sign. The element fire can be described as enthusiastic and inspirational. Its quality is mutable, meaning flexible and adaptable. This can be combined to describe Sagittarius as "adaptable enthusiasm."

The parts of the body that are ruled by this sign are: hips, thighs, muscles, sciatic (hip) nerves, and the motor nerve action.

Some of the things that Sagittarius rules are: altars, archery, dreams, foreign affairs, and travel.

Five positive key words are: (1) optimistic, (2) dependable, (3) friendly, (4) honest, and (5) versatile.

Five negative key words are: (1) tactless, (2) irresponsible, (3) boastful, (4) quarrelsome, and (5) dictatorial.

Sagittarius people like any work where foresight and a willingness to take a chance is offered. Some of the careers are psychiatrists, lawyers, veterinarians, ministers, interpreters, explorers, librarians, professional sportsmen, and travel occupations.

The key phrase is "I see."

The key word is "freedom."

Their basic nature is "the philosopher or gambler."

The opposite sign of the zodiac is Gemini.

The glyph for Sagittarius is the arrow, illustrative of Sagittarians' outspokenness, sometimes to the point of bluntness. However, there is seldom a "get even" edge to what they say. Usually, their zeal for the truth makes them blurt out just what they are thinking. Unfortunately, the "point" of the arrow can hurt, and it would be wise for Sagittarians to think before they speak. Nevertheless, even when they are being extremely outspoken, others do not necessarily take offense, simply because the Sagittarian manner generates a unique attraction that prompts people to like them, regardless of their undiplomatic remarks.

In the Northern Hemisphere, the sign Sagittarius comes at the time of the year when the days are growing shorter and colder. As life evolved on our planet, man learned to be a hunter and stored his food to be eaten later. He also learned that activity and movement kept him warm. In the Southern Hemisphere, the days are growing longer and warmer during the sun sign of Sagittarius. Because hunting and movement are inborn characteristics of most Sagittarians, many of them will feel the urge to pick up their guns and hiking gear and head for the wilderness areas.

Sagittarians are interested in many kinds of sports. Even when they don't actively participate, they enjoy watching. Long walks are also a favorite because of the feeling of freedom it gives them. The creation of heat through movement and activity is personified by the rapid rotation of Jupiter, and the storing of energy (food) for future use is symbolized by Jupiter's size.

When man returns to nature, he has a tendency to become philosophical. He searches for the meaning of life. This, too, is a natural trait of Sagittarians and is one of the affairs ruled by the ninth house.

Invariably enthusiastic and optimistic, Sagittarians go through life always looking for something else that will add new dimensions to their life. This can cause them to overextend themselves with too many activities and to use up their energy too rapidly. They should arrange to get sufficient rest periods, plenty of oxygen from their outdoor activities, and enough exercise each day to promote healthy sleep at night. If they still feel tired, it usually means they are bored.

If Sagittarians do not have any earth signs in their chart, an earth ascendant, or earth-shaped hands, they will have to concentrate on learning to be practical and persistent. Otherwise, they will show great enthusiasm at the beginning of a project, blowing hot and cold as it proceeds, only to throw everything over when they get bored or the going gets rough. In spite of this, it is important for them to have some type of goal or project in mind.

They are ordinarily healthy, but they can run into trouble due to overindulgence in food and drink. Their vulnerable spots are the hips, thighs, legs, arms, lungs, intestines, and the nervous system.

Sagittarians are noted for their friendliness, helpfulness, and subtle humor. They are good conversationalists and enjoy debating merely for the sake of debating. They have a real gift for making friends, and the typical Sagittarian can go anywhere in the world without ever feeling lonely, for they acquire friends along the route. They have humanitarian instincts and are practical in expressing them, rather than a lot of emotional sympathy. They will offer material help or put an opportunity into the hands of the person in need. Unless there are other factors in the birth chart, you can depend on their loyalty and honesty, for there is nothing devious or manipulative in their nature.

They nearly always have the desire to travel. Their physical restlessness impels them to get out and go somewhere, even if it is only to the store and back.

They are extremely independent, with a real need for personal freedom. They can experience claustrophobia, either physical (a room with no windows) or emotional (a marriage which they feel ties them down). This is why they are reluctant to get into total commitment situations and often shy away from marriage. If they feel trapped, they become moody and restless.

In love, they are highly romantic, but they want their partner to be intelligent. They abhor jealousy and possessiveness on the part of their partner, especially since both sexes are fond of flirting. They may indulge in extramarital affairs, for they are unable to see anything wrong in them. With their natural tendency for honesty, they usually end up telling their marriage partner all about their love affairs. This can be a rather shattering experience for their partner.

They are often very lucky in financial matters, even though they may not settle on a definite career early in life. They are reluctant to become tied down to a set schedule, so will experiment with a variety of jobs. They do best in careers that permit them to travel about, either locally or widely. They also like dealing directly with people, either selling or promoting ideas, products, etc. They are highly intuitive and should learn to use it.

Lack of concentration and too much restlessness can hold them back from realizing their full earning potential. But once they decide on a career and their approach to life, they will advance rapidly, often through favors from others, as well as their own abilities. Since they are versatile, it is not unusual for them to hold down two jobs.

The Sagittarian may overlook small details, but their overall sense

of planning is excellent. They have good memories. If disciplined, they are capable of great things. The challenge of a problem is what interests them, for it caters to their enjoyment in exploring the unknown.

As Parents:

As parents, the optimism of the Sagittarian gives them faith in the abilities of their children. They see parenthood as a challenge. They do, however, have a tendency to expect rapid intellectual progress from their child which may be too advanced for the child's age. The home environment they provide for their children is one of constant mental stimulation.

Children:

The Sagittarian child may tend to be mischievous, and the girls are somewhat tomboyish. But, this causes them to excel at all types of sports. Their innate love of freedom forces them to rebel if discipline is too restrictive. They like to be involved in something at all times, especially if it uses energy. The teenage boys, and some of the girls, enjoy driving fast with little regard for safety. They are overpleased with the sense of excitement it gives them. During this time, they can be somewhat unconventional, since they do not feel bound by society's dress or conduct codes.

Wherever Sagittarius is found in your natal chart is where you need to "expand" your knowledge and review your attitudes to the house affairs. This area of your life has been restricted in previous lifetimes through choice or through circumstances.

The gem for Sagittarius is the turquoise. This name is a corruption of the word "Turkish," because it was said that the stone was introduced to the world by Turkey. The ancients called it the symbol of love, protection, freedom, and affluence.

The flowers for Sagittarius are narcissus and goldenrod. Their colors are deep blue, seagreen, turquoise, and purples. Their metal is tin.

JUPITER

This planet rules the sign Sagittarius.

Its natural house is the Ninth House.

Its orbit takes twelve years.

One complete revolution on its axis takes nine hours fifty-five minutes.

It is masculine and positive.

Its glyph looks like this ♃.

This glyph symbolizes the personality has risen above matter and is no longer confined by it.

Five positive key words describing this planet are: (1) expansion, (2) opportunity, (3) understanding, (4) optimism, and (5) enthusiasm.

Five basic key words describing this planet are: (1) expansion, (2) opportunity, (3) righteousness, (4) optimism, and (5) tolerance.

Five negative key words describing this planet are: (1) extravagance, (2) bigotry, (3) indulgence, (4) fanaticism, and (5) smugness.

The basic personality function of this planet is to lift man out of material and physical desires and to stimulate growth on all levels.

The parts of the body it rules are: liver, pancreas, insulin, glycogen, hips, thighs, blood circulation, cell development, tumors, and growths.

Some of the things ruled by this planet are: legal affairs, foreign affairs, books, printing, publishing, tin, governments, organizations, and Thursday.

The people represented by this planet are the masses.

The similarities between this planet and the sign it rules are that both of them are outgoing, fast-moving, energetic, and busy.

They differ because Sagittarians seek to expand and broaden their intellectual viewpoints, while Jupiter expands, indiscriminately, in all areas, including the physical body.

Jupiter retrograde causes the planning and re-planning of thoughts and ideas, instead of actually experiencing. There is an expansion inwardly through religion or philosophy, instead of socializing. This inward expansion is not always obvious to others.

In mythology, Jupiter, the god, ruled during the Silver Age and was considered the greatest of the deities. He was known as the king of the gods and of mankind. He watched over governments and families. It was his hand that wielded the lightning and guided the stars. When mankind began to understand natural phenomena, Jupiter's reign ended.

In astrology, Jupiter is called the planet of expansion and opportunity. With a diameter of 88,700 miles, he can rightfully be considered

"expansive." This is eleven times as large as earth. If the correct combination were utilized, this planet has the "opportunity" of igniting into a nuclear furnace similar to our sun.

Even though Jupiter is massive in size, he is quite lightweight. Earth's density is 5.5 (water is 1). Jupiter's density is only 1.34. Like the sun, Jupiter has no apparent solid surface. He has four distinct refractive layers. The innermost core is thought to be composed of 84 percent hydrogen. The outermost atmosphere is composed largely of frozen and liquid ammonia compounds, which are constantly swirling and changing shapes. The inner atmosphere is composed of largely hydrogen, helium, and amino acids, causing storms, lightning, and thunderous sounds. (Any storm is a heat adjustment.) All of this noise and turbulence seems to be **representative of the frantic pace some Sagittarians are apt to keep. Sagittarians can, also, flare up at the slightest provocation with the fury of a hydrogen explosion. This can be devasting to the receiver, until** they remember that underneath all that bluster is a warm-hearted individual who is seldom vengeful.

The Pioneer 10 probe, launched in March 1972, revealed that Jupiter radiates at least three times as much heat as he receives from the sun. This heat is created through gravitational pressure. His large mass just falls short of enabling him, through gravitational contraction, to release enough energy to ignite and turn him into a nuclear furnace. This heat (energy) is reflected by Sagittarians through the friendliness and warmth they radiate to others and through their need for physical activity.

Jupiter's orbit around the sun takes twelve years. However, Jupiter sometimes slows down or speeds up his solar orbit, so that he has a longer stay in some zodiac signs than in others. He rotates on his axis at an incredible rate of speed, considering his massive size. A complete axis revolution is made in nine hours and fifty-five minutes. This rapid rotation causes him to bulge in the middle at his equator.

Astronomy books refer to Jupiter as the "Striped Giant." These stripes, bands of color, and spots which change in width and visibility, are caused by the tremendous activity and changes taking place within them and under them. These spots are similar to Sagittarians' tendency to boils and abscesses. Sagittarians are, also, known to like stripes, so Jupiter's rulership over them is even more appropriate. These stripes range in color from yellow, bluish, and a brownish gray. Bright yellow is the color of spontaneity and enthusiasm which Sagittarians have in abundance. Blue is the spiritual color of truth and understanding. Truth is certainly a trait of Sagittarians. Brownish-gray is the color of non-involvement. This is indicative of Sagittarians' ability for emotional detachment and lack of empathy. Empathy should be cultivated, if it is not

already present through other features in the natal chart or in the hands.

Jupiter's bands of color run parallel to the equator which is inclined only 3° to his plane of orbit. This makes him the most upright of all the planets, with no discernible seasonal changes. The word "upright" in English has come to mean "honesty" and "integrity," which are definitely Sagittarian traits.

One of the most distinct features is his mysterious Red Spot, which is approximately 25,000 miles long and 8,000 miles across. It varies in color from salmon pink to greenish white and appears to float over the "surface" in Jupiter's southern hemisphere. This Red Spot is a vortex of a gigantic storm that has raged for around 700 years—sometimes more violent than at other times. In 1883, the spot began to fade, although it was still visible. In 1959, it vanished from view, but in 1960 it appeared again and has been quite prominent since then. During the year the Red Spot vanished, international relations were less disturbed or troubled, except for a few episodes.

Since the Pioneer 10 probe, scientists have learned that the temperature on Jupiter at cloud level is approximately −220° Fahrenheit. It then rapidly increases in temperature until 600 miles below the clouds where it is 3,600° Fahrenheit. At 15,000 miles down, it is up to 10,000° Fahrenheit, with a pressure equal to three million earths' atmosphere. The innermost temperature is around 54,000° Fahrenheit.

Jupiter has the highest surface gravity of any of the planets. One would weigh 2.64 times as much as one would weigh on earth. For example, a 180-pound man would weigh almost 500 pounds on Jupiter.

There is a powerful magnetic field and radiation belt around Jupiter, similar to earth's Van Allen Belt. However, Jupiter's belt is eight times the strength of the Van Allen Belt, and its polarity is the exact opposite of earth's. No wonder Sagittarians have such a strong personal magnetism which attracts others!

Until September 20, 1974, Jupiter was known for having only twelve satellites. The vibrational influence of the number twelve is one of enjoyment and fulfillment. Twelve is the higher vibration of three, indicating creativity, artists, writers, musicians, expressiveness in writing, speech, teaching, etc. Since Jupiter's discovery in the 1600s, mankind has used the vibrational quality of twelve by being extremely creative and pleasure seeking. Jupiter's influence intensified these desires. On September 20, 1974, Charles T. Kowal, an astronomer at Hale Observatory, discovered a thirteenth satellite orbiting Jupiter. The number thirteen is associated with danger and indicates forces that can be used for good or evil, a crisis time, and a need to reevaluate life. After the discovery of the thirteenth satellite, earth experienced, (1) Hurricane Fifi which

flooded Honduras, killing 8,000 people, (2) the Watergate cover-up trial, (3) Dow-Jones Industrial Average closing below 600 for the first time in twelve years, (4) a World Food Council being established, (5) new wave of terror bombings in Ireland, and (6) extreme tension between Israel and the Arabs. These are just a few of the world events that occurred. The first part of October 1975, astronomer Kowal announced he had discovered a fourteenth satellite orbiting Jupiter. This satellite is about 3,000 miles in diameter and is larger than our moon, which is only 2,400 miles in diameter. The number fourteen is a perfected number five and indicates balanced thought, new change, and new mental foundations. Sometimes change can be painful, depending upon whether one has learned the necessary lessons in previous years. Some of the changes that may occur are (1) escalation of the Dow-Jones Industrial Average, (2) drop in unemployment, (3) earthquakes, and (4) drop in food prices.

Four of Jupiter's larger satellites have been found to have atmospheres with an average surface temperature on their sunlit sides of −230° Fahrenheit. These satellites are Io, Europa, Ganymede, and Callisto. Both Ganymede and Callisto are over 3,000 miles in diameter and are comparable in size to Mercury.

Jupiter has been given rulership over governments and organizations, and it is easy to see why, since Jupiter and his satellites could be classified as a solar system if Jupiter ignited and became a sun. Jupiter, also, has a strong influence on the asteroid belt. Many of the asteroidal bodies have the same orbit as Jupiter. This is illustrative of Jupiter acting as an administrator over these smaller bodies.

Wherever Jupiter is found in the natal chart is where there is a need and an opportunity for "expansion" and where one finds fulfillment. Aspects from Jupiter in the natal chart indicate that something "expansive" wants to happen. It is up to the individual to use it or reject it. The same thing is true of transiting Jupiter. For example, two people with the same ascendant had Jupiter transiting their first house. Both had large first houses because of an intercepted sign within. Thus, Jupiter's transit lasted approximately two years. One allowed Jupiter to expand the physical body until that person became overweight. The other person, knowing the effects of Jupiter transiting the first house, mentally decided to use Jupiter's expansion in other ways. The normal weight was maintained and concentration was on using Jupiter's expansion for a more clarified self-awareness.

JUPITER IN THE SIGNS

Jupiter in Aries: Enthusiastic, generous, assertive, energetic. They easily grasp the basics of anything. Enjoy active occupations. They are innovators, leaders, and executives. Can be crusaders. They need to learn patience and to think before they act. The danger with this placement is overoptimism or in becoming a militant idealist or crusading general.

Jupiter in Taurus: Sympathetic, charitable, a believer in the power of positive thinking. Love of beautiful things. Ability to make money. Can be stubborn without being aggressive. Must watch a tendency to extravagance and their desire for material possessions.

Jupiter in Gemini: Witty, cheerful. They enjoy traveling. Strong desire for knowledge giving them linguistic ability and expressiveness of speech. This placement, also, releases a lot of nervous energy which may cause them to be overly talkative, verbose, or agitated.

Jupiter in Cancer: Practical, friendly, sociable, sympathetic. This placement gives good financial judgment and benefits through inheritances. Have the ability to accumulate money and possessions. There may be weight problems. The full potential of these individuals is generally not reached until middle life. Must watch a tendency to be stingy.

Jupiter in Leo: Generous, compassionate, altruistic. Organizing abilities. Are capable leaders and executives. Optimistic belief in the future of mankind. Enjoyment of beautiful things. Generally a happy person. There is a desire for others to admire them. If this is carried to an extreme, the individuals can become egotists.

Jupiter in Virgo: Practical, cautious, intellectual. Strong desire to expand their field of knowledge and to develop technical skill. Apt to be cynical and/or critical. There is a tendency to become enmeshed in physical living and to forget the need to nourish the soul.

Jupiter in Libra: Philosophical, sympathetic, friendly. Desire for self-expansion through using their ability to be outgoing and well-liked. They are congenial hosts. Have the ability to encourage others to greater efforts. There is a love of beautiful things. Success in business. Must watch their tendency to self-indulgence. If afflicted, there can be difficulties with partners and legal problems.

Jupiter in Scorpio: Efficient, hard-working individuals. Flair for business and finance. They are resourceful and willing to do all the work necessary in the fulfillment of a task. They are secretive, but there is, also, great inner strength and courage. They have a magnetism that draws people to them. Scorpio digs deep and calls for one to unveil the inner depths of the mind. Thus, the higher use of this placement is to develop an expanded consciousness and self-transcendence. If they are using the higher vibrations of Scorpio, they can assist people to find their inner selves. Strong healing ability. If the lower vibrations of Scorpio are used, these individuals will seek unusual physical sensations and/or have a desire for reckless experimentation in drugs and alcohol.

Jupiter in Sagittarius: Loyal, generous, tolerant. Interest in religion and philosophy. Are prophetic and inspirational. They have the capacity to impress others as to what the future might hold. Strong desire to help others and to inspire them to help themselves. They are frequently in positions of power and prestige. Tend to be conservative, because of a desire for people to like them. Must watch tendency to justify themselves.

Jupiter in Capricorn: Practical, capable, steadfast. Tendency to be serious. Organizing ability. Strong self-control. This placement gives an individual the desire for material success, but it brings little happiness when it is obtained. Capricorn indicates the need to focus Jupiter's expansiveness toward the expansion of soul growth, rather than personal growth. Since soul growth is the aim with this placement, these individuals will be held accountable for whatever they do. Nothing will be allowed to be swept under a rug or hidden in a closet. Once this is understood, they will be allowed the abundance granted by Jupiter.

Jupiter in Aquarius: Humanitarian. Are intuitive, tolerant, sociable. Have inventive minds. An ideal diplomat, with a knack for handling different groups of people. These individuals are not allowed to live for themselves alone, but must pour their energies into some type of worthy cause. Because Jupiter is basically conservative, the revolutionary traits of Aquarius are toned down, so that philanthropic causes are obtained through peaceful means.

Jupiter in Pisces: Sympathetic, charitable, genial. Subtle sense of humor. Visionary and intuitive. They are interested in metaphysical issues, but want to find their own answers and to experience truth for themselves. They are usually less money-minded than most zodiac signs. There is a

need for these people to occasionally retreat from society back to nature. This restores frayed nerves. They should always have a quiet time each day. They have the ability to enjoy whatever pleasures that come their way, whether it is small or large. A strong desire to help the public in some way and an interest in healing. Can suffer from oversensitivity, which does not show on the surface. Must watch a tendency to exaggerate and/or to be self-indulgent.

JUPITER IN THE HOUSES

Jupiter in First House: Generous, optimistic, cheerful, confident, with good vitality. Usually, they like sports and are good at them. This placement brings many opportunities for personal growth. Jupiter's expansive qualities may cause a weight problem. Their confidence in themselves make them good leaders, because they have the ability to inspire the faith of others. They could become gullible, egotists, or self-indulgent.

Jupiter in Second House: Financially successful. Confidence and optimism in their abilities. Visionary ideas and speculations usually prosper, due to their intuitive appraisal of the situation. Enjoyment of material possessions. They inspire trust and often benefit from receiving financial assistance from others to develop their visionary ideas. Must guard against overextravagance.

Jupiter in Third House: Philosophical, optimistic, conventional, considerate. Intuition strong. This placement expands the mind, so that the individual is able to comprehend easily. Could become an excellent teacher or lecturer. Are well liked by the people in their environment (neighbors, relatives). There may be mental restlessness which can be helped through occupations that keep them moving. Must watch they do not scatter their energies. Apt to be impractical or self-satisfied.

Jupiter in Fourth House: Generous, hospitable, and self-confident. Prosperity increases in later years. Desire a home that is spacious and comfortable. Parental influence is strong in shaping their character. Usually, an inheritance from their parents. Strong soul powers that have been developed in previous lifetimes which can be used in mitigating their karmic obligations. Must guard against becoming ostentatious.

Jupiter in Fifth House: Sympathetic. Creative ability which brings success and happiness. Strong desire to make a significant contribution to

society through their creative self-expression. Children can be a source of pleasure. Must guard against rash gambling and speculation.

Jupiter in Sixth House: Good health. Helpful to others. Dependable worker with a sense of loyalty. Inspires cooperation among fellow workers. Enjoys his work and gives of his time willingly. Must watch so they do not overwork, or overindulge in eating or drinking. There could be difficulties in the liver and blood.

Jupiter in Seventh House: Sociable, tolerant, and good-natured. They benefit materially through marriage and partnerships. Usually a successful marriage, sometimes a second marriage.

Jupiter in Eight House: Optimistic, faith in fellowman. Gain through marriage, partnerships, or legacies. Are strongly emotional. Should use their emotional energies to tap their psychic abilities, so they can benefit and uplift mankind.

Jupiter in Ninth House: Optimistic, tolerant, considerate. Are prophetic, with strong intuition and good judgment. Interested in religion and philosophies. They have the ability to guide and inspire others as to what the future might bring. Benefit from their travels and dealings with foreigners. Their accomplishments are usually not recognized until the later part of their life.

Jupiter in Tenth House: Success, honor, congenial nature. Magnetic personality. Many opportunities arise which are of benefit to them and to society as a whole. There is a strong sense of responsibility toward their profession or toward a personal achievement.

Jupiter in Eleventh House: Intuitive, good judgment. Enjoyment of social life. Popular, with faithful and influential friends. Have a natural ability to organize and plan group activities. Strong supporter of foundations and philanthropies.

Jupiter in Twelfth House: Philanthropic. Faith in the future. Have been granted invisible protectors who assist them through any reversals. Love of humanity and a desire to help others. Success is in a quiet, unassuming manner in middle life. Can be unrealistic. Thus, it is important for them to think out all their ideas carefully before carrying them through.

Comparison of the Third and Ninth Houses

Third House

1. *Knowledge* (Concrete Evidence)
 a) Science
 b) Mathematics

2. *Environment*
 a) Community
 b) Neighbors
 c) Relatives
3. *Early Education*
 a) Pre-School
 b) Grade School
 c) High School
4. *Short Journeys*
 a) Physical Short Journeys
 b) Communications
 1. Letters
 2. Television
 3. Telegrams
 4. Telephones
 5. Newspapers

Ninth House

1. *Understanding & Wisdom*
 (Abstract Thoughts)
 a) Religion
 b) Philosophy
 c) Theories
 d) Metaphysical (Occult)
2. *Law*
 a) Society's Rules of Conduct
 b) Legal Affairs
 c) Relatives by Marriage (In-laws)
3. *Higher Education*
 a) College
 b) Graduate School
 c) Experiences
4. *Long Journeys*
 a) Physical Long Journeys
 b) Mental Journeys
 1. Dreams
 2. Visions
 3. Intuition
 4. Inspiration
 5. Writing of Books, Prose,
 Poetry

NINTH HOUSE

This is a cadent house, indicating adaptability. It is considered a cadent house because it corresponds to mutable signs.

The natural ruler of this house is Sagittarius. What is the relationship between the sign and the house? Sagittarians need to obtain understanding through broader viewpoints, set far-reaching goals, and to explore wider horizons. The ninth house refers to abstract thoughts, higher education, and long journeys.

The natural ruling planet is Jupiter. What is the relationship between the planet and the house? Jupiter represents the desire to expand on all levels, and the ninth house refers to the expansion of our mind through understanding and wisdom.

If the sun were in this house, it would be approximately 12:00 noon to 2:00 P.M.

This is a House of Life which corresponds to fire signs. This means it is a house of enthusiasm and energy toward spiritual urges.

This house rules: (1) Understanding and wisdom (abstract thoughts)
 (2) Law (society's rules of conduct, legal affairs, in-laws)
 (3) Higher Education (college, graduate school)
 (4) Long Journeys (physical and mental)

This house is found in the Third Quadrant above the horizon.

The opposite house is Third.

What is the relationship between the third and ninth house? Both refer to education, relatives, and journeys.

How do the third house and the ninth house differ? The third house refers to concrete knowledge, environment, short journeys, and relatives, and the ninth house refers to understanding of abstract thoughts, law, long journeys, and relatives by marriage.

The ninth house concerns the search for "understanding and wisdom." It represents a lifelong struggle to find out what one believes about the world, God, man, and life—basically, your outlook on life and what you feel is the meaning of life. Everyone needs something to believe in, and the ninth house in a natal chart shows what it is. It also indicates how that person approaches theories, abstract ideas, and philosophical questions.

A philosophy of life is much more than an abstract thing. It is the prime motivation behind one's approach to life, to situations, and to other people. Thus, the ninth house represents all experiences which expand the mind and help formulate a philosophy and understanding of life.

Perhaps the easiest method of "understanding" the ninth house is to correlate it with its polar opposite, the third house. (Refer to page on Comparison of the third and ninth house.) The third house rules (1) *Knowledge*—concrete evidence, (2) *Environment*—relatives, neighbors, the community, (3) *Early Education*—pre-school years, grade school, high school, and (4) *Short Journeys*—communications through letters, telephones, telegrams, newspapers, television. The ninth house rules (1) *Understanding & Wisdom*—abstract thoughts, such as religion, philosophy, theories, metaphysical, (2) *Law*—society's rules of conduct, legal affairs, in-laws, (3) *Higher Education*—college, graduate school, and (4) *Long Journeys*—physical or mental, such as dreams, visions, intuition, inspiration, and writings.

(1) KNOWLEDGE (THIRD HOUSE) AND UNDERSTANDING AND WISDOM (NINTH HOUSE)

Most people tend to think in terms of both concrete knowledge and abstract theories. But nearly everyone tends to favor one over the other. If you are scientifically bent, you would be operating from the third house, as Louis Pasteur did. On the other hand, a philosopher or a metaphysician operates from the ninth house. A good example of this is Albert Einstein who had Jupiter in Aquarius in the ninth house in opposition to Uranus in Leo in the third house, with Pluto in Taurus in the twelfth house forming a stress energy T-square. His famous formula made possible the atomic bomb. This bomb uses uranium and plutonium. When Einstein established his Theory of Relativity, plutonium was unknown. Einstein's Jupiter in the ninth house "expanded" his capacity for abstract thinking, while his Uranus in the third house gave him a sharp analytical mind with an impatience for old concepts. However, these planets also reflect mundane difficulties. Uranus in the third house is an indication of Einstein's disruptive environment in childhood which he eventually had to break away from.

There is a difference in meaning between the words "knowledge" and "understanding." "Knowing" implies a proven fact, such as man needing oxygen to breathe. The process of "knowing" is a third-house affair. "Understanding" comes when we have acquired wisdom through our associations with other people. It indicates you comprehend the reasons for the actions in any given situation or that you recognize and accept the motives of another person. The process of "understanding" is ruled by the ninth house.

The most difficult form of "understanding" is when one is personally involved with a person or an action. Many times we don't "understand" our own reasons behind certain actions, nor do we "understand," at all times, our behavior towards other people.

The complex nature of "understanding" and of the search for the meaning of life leads us along many pathways. The key, however, to developing "understanding" is the participation in group relationships and partnerships. These contacts broaden our vision and viewpoints. By the mutual sharing of personal resources with others in the eighth house, you can reevaluate your thoughts and ideas, so that in the ninth house a philosophy of life can be formulated.

In the eighth house, you may have joined either a religious, political, or metaphysical group. The ideas and philosophies of the group members are analyzed and, then, serve as a basis for your own philosophical views in the ninth house. This mutual sharing of "personal resources" is ex-

tremely important to the development of a philosophy of life. For example, if you had joined a Christian religious group in the eighth house, in the ninth house this could be expressed through being baptized, confirmed, or becoming a minister. If you had joined a political group in the eighth house, this could be expressed in the ninth house by further study of the workings of our laws and the political-party system. If you had joined a metaphysical group in the eighth house, this could be expressed in the ninth house by seeking further enlightenment through instruction, having your astrology chart interpreted, your palm read, your tarot cards read, a life reading, or through having your own personal occult experiences.

Of course, all of these experiences will be analyzed by the individual in terms of what he knows and how he feels. Two people may have identical experiences, but will react entirely different to them because of their different backgrounds and because of free will.

"Knowledge" and "understanding and wisdom" enables a person to accept their karma and/or to be successful in life. Unfortunately, "knowledge" and "understanding" are, also, the way to achieve power and money. When ambition is motivated by greed, the person uses their relationships with others to increase their own power and/or prestige. These people are merely seeking slaves for their purpose. Thus, the cooperative relationship is totally unbalanced. Joint resources must be shared *equally*.Hitler is a classic example of such a person. He used his "knowledge" and "wisdom" to gain control over his political party and reduced them to willing slaves.

To "understand" how an individual can become so destructive, let us follow a discordant life starting from the third house. In the early environment, such a person would have had to receive pressure and shocks to the mind and the nervous system which he was unable to handle. In the fourth house, his inner foundations are now built upon distrust and resentment, so that he is unable to express his creativity in the fifth house. By the time he reaches the sixth house, he is no longer able to see work as an employee and employer situation. He sees it as a choice between being either a slave or a master. Thus, in the seventh house, he is no longer able to experience love, sharing and trust. He begins working in cooperative relationships in terms of greed and of how he can benefit. In the eighth house, he actively seeks to gain from group relationships through any methods—false charm, intimidation, blackmail. By the time he gets to the ninth house, he is twisting society's laws to aid him in his rise to power.

In this example, there is no question of "understanding." This is merely a form of "wisdom" which serves ego ambition. It is a "wisdom"

that can be used by a criminal or by people who seek personal fame and money.

(2) HIGHER EDUCATION

This house rules higher education because of its rulership over "understanding and wisdom." However, there are many self-educated people who are wiser and deeper than many with doctorates. Thus, the term higher education should not be limited to those with college degrees.

(3) LAW

Law refers to legal affairs and to the rules established for our conduct within a society. It, also, refers to in-laws, since they are relatives by law and were gained through the cooperative partnership relationship of marriage. Experiences are obtained through associating with in-laws and further develop "understanding and wisdom." These experiences with in-laws may not necessarily be happy ones, but, nevertheless, they still add to one's "understanding and wisdom."

(4) LONG JOURNEYS

Long journeys are included in the affairs of the ninth house, since travel to another country or another area can give you "understanding and wisdom" of different cultures and societies. Thus, viewpoints are broadened. A long journey can be taken "mentally." This is done through dreams, visions, intuition, inspiration, and writings, where your subconscious mind takes over and tries to bring through "understanding and wisdom."

To summarize, the ninth house is your outlook on life and what you feel to be the meaning of life. These viewpoints have been broadened and expanded through your participation in cooperative group relationships and partnerships. If you refuse to participate in any type of group relationships or partnerships, you are operating from the third house. "Understanding and wisdom" can only be obtained from associating with other people in a sharing relationship. Even if you have ten doctorates, you will still not have "understanding and wisdom," because your mind remains analytical and is only assimilating concrete knowledge.

CHAPTER 5

Quadrant IV

Capricorn, Saturn, Tenth House
Aquarius, Uranus, Eleventh House
Pisces, Neptune, Twelfth House

CAPRICORN

Capricorn is the tenth sign of the zodiac.

Its glyph looks like this ♑.

Its glyph symbolizes an early type of goat with a twisted horn.

The picture used to describe the sign is a Mythical Sea-Goat. Why? This is symbolic of Capricorns' desire to cease to be a sheep and to stand on their own feet to work out their salvation.

Capricorn brings Winter Solstice on December 22 and leaves the sign on approximately January 21.

The planetary ruler is Saturn.

In the natural zodiac, it rules the Tenth House.

It is feminine, negative (receptive), and an earth sign. The element earth can be describe as practical and exacting. Its quality is cardinal, meaning action-initiating and ambitious. This can be combined to describe Capricorn as "active practicality."

The parts of the body that are ruled by this sign are: knees, joints, skin, gall bladder, chilling and cold.

Some of the things that Capricorn rules are: cement, government, ice, mathematics, mountains, and Saturday.

Five positive key words are: (1) ambitious, (2) responsible, (3) practical, (4) efficient, and (5) patient.

Five negative key words are: (1) worry, (2) retaliation, (3) suspicion, (4) stubbornness, and (5) intolerance.

Capricorn people are happiest in careers calling for organizing ability, integrity, and perseverance. Some of the careers are mathematician, civil servant, osteopath, politician, public administrator, government service, accountant, actors, teachers, and astrologers.

The key phrase is "I use."

The key word is "attainment."

Their basic nature is "the organizer, businessman, or conservationist."

The opposite sign of the zodiac is Cancer.

Because of their quiet exterior, Capricorns appear to be loners. This trait is similar to the mountain goat who stands quietly upon his lofty perch, surveying the world far below. The goat appears to be totally unaware of the winds howling around him. But he is not really unaware of the winds, merely impervious to them. Like the goat, Capricorns have built a wall of reserve around their innermost being, so that they, too, are impervious to the buffeting winds. But the wall the Capricorns have built is sometimes not strong enough to keep the howling winds from penetrating. Then worries and pessimism flood their being.

For all their quiet exterior, they enjoy the limelight. This is why many Capricorns are attracted to politics and acting careers.

Their strong desire to succeed at whatever they do enables them to be hard working and patient in the pursuit of their goals. If necessary, they will bear considerable hardship in obtaining these goals. Their inferiority complex demands they produce concrete results from their endeavors. Thus, their spare time is spent on practical projects.

Capricorns want to see all sides of an issue before reaching a conclusion. They like to plan in advance, weighing all the pros and cons. Decisions are never made rapidly. They rarely make mistakes. When they do, it is difficult for them to see where they went wrong, since they had carefully planned everything prior to starting the project.

They are dependable, particularly in a crisis. When asked, they give sound, practical advice.

They are, as a rule, not aggressive people, but only express hostility as a defense when attacked. Their sensitivity causes them to be deeply hurt from these attacks. When the earth is dug up, it takes time for it to flatten out and become smooth again. So it is with a Capricorn, when he is battered in any way. It takes a long time for the wound to heal. Because of this, they sometimes seek to pay back hurts.

They need people, but have a tendency to isolate themselves from people due to their reserve and fear of being hurt. Nevertheless, they never really like to be alone. They are very selective in choosing their

friends, with only a few intimate ones. These friends receive unswerving loyalty.

They are conservative in their thinking and attitudes, as well as in dress and social mannerisms. They believe in law and order and respect tradition. It is unusual for them to adopt radical ideas. They are seldom dishonest.

Their fear of being without necessitates their having a regular income. Their attainments in life are accomplished through steady progress rather than through speculation or get-rich-quick schemes.

They are natural organizers and have good leadership ability, which they can use to good advantage. They have a desire for recognition. Because of this, they find it difficult to do good deeds in secret, since they feel that their good deeds should receive some type of attention.

They have strong self-discipline and nothing will sway them from their course if their mind is made up. They will give up many enjoyments in order to reach their goal. Hard work invigorates them. But, they must not overdo, or they will suffer physical exhaustion.

They are ambitious. However, they do not feel a need to keep up with the people next door. Success is usually achieved later in life.

They are thrifty and like to collect things, but this is not a miserly tendency. They abhor waste, which causes them to see the possibilities of using the objects later. Periodically, the objects are discarded, if no practical use has been found for them.

They are quite creative, but can be very pessimistic and negative about their abilities. They must learn to believe in themselves and to develop optimism.

Capricorns seldom waste time talking needlessly. They speak only when they have something to say. Many people are quite surprised to discover that Capricorns have a dry sense of humor.

The thought patterns of their mind are rational and constructive. Unless other things in their natal chart mitigate this, most Capricorns do not grasp ideas rapidly, but must plod along, slowly absorbing knowledge. However, this attribute assures them of the retainment of everything they learn.

They can be troubled with arthritis of the bones and joints. Because of this, they should eat properly, take vitamins, and engage in some form of physical exercise every day. Calcium and Vitamin C are extremely important supplements.

Capricorns have a lot of patience. This is fortunate, for they are forced to see many of their aims meet with delays, setbacks, and obstacles. The stoicism of the Capricorns helps them face these objectively. If one path is blocked, they will try another. They know intuitively that work

137

is therapeutic. This trait develops their strength of character. And yet, at times, the obstacles will produce pessimism, and some of them will cease trying for fear of failing. Encouragement and praise are essential in motivating a Capricorn to continue.

They are thoughtful, self-contained people. They may not have the personal magnetism of some of the other zodiac signs, but they are tactful, compassionate, and warmhearted. Their own personal sufferings help them identify with the sufferings of others.

The reason for so much personal suffering in their lives is so that Capricorns will seek spiritual attainment rather than personal attainment. The mountaintop the goat climbs represents soul growth rather than personal growth. Once a Capricorn is made aware of this, setbacks and obstacles diminish.

In love, they are as romantic and emotional as anyone else, but they may feel inhibited in expressing their emotions. They are cautious in making a total commitment, until they know that the traits and lifestyle of the possible partner are compatible with theirs. Once married, they seldom divorce, for they feel that any situation can be worked out.

As Parents:

Capricorns are family oriented and enjoy their children. They must watch a tendency to want to dominate their children. Since it is easy for them to get sidetracked in their own work or projects, they must make a conscious effort to bring fun into their children's lives. It would help a Capricorn to set aside a certain time each day to do something with their children. Otherwise, time will elapse without their being aware of it. The children can learn much from a Capricorn parent because of their parent's sense of responsibility and from their dry sense of humor which makes life appear amusing. A Capricorn woman enjoys working but should, if possible, avoid going back to work until the child is in school.

Children:

Capricorn children benefit from being introduced to a variety of experiences. They should be praised for effort rather than for achievement. In time, their achievements will be as great, if not greater, than their efforts. Allow them to accept responsibilities early. They generally look older than they are. (In later life, they get younger looking.) Because they appear to be very wise for their age, it is easy for their parents to

unburden their troubles to them. This causes the child to lose their own small amount of optimism, since they are not old enough to help their parent solve the problem.

Wherever Capricorn is found in the natal chart is where we have to make "restitution." There is a need to improve and renovate our ideas about the house affairs. In previous lifetimes, we have sought personal recognition through the affairs of the house. Now, this house is one of frustration, until we no longer seek to obtain any recognition from the house affairs. It, certainly, does not deny personal recognition, but only if the correct attitude is "restored."

The gem for Capricorn is the garnet. The use of garnets goes back to the ancient Egyptians. At one point in history, only royalty were permitted to own and wear these stones. This stone represents loyalty, distinction, determination, and permanence. It is also supposed to protect the wearer against accidents and difficulties while traveling.

The flowers for Capricorn are the poppy, dark red carnations, and holly. Their colors are black, brown, dark green, gray, maroon, and purple. Their metal is lead.

SATURN

This planet rules the sign Capricorn.

Its natural house is the Tenth House.

Its orbit takes twenty-nine years.

One complete revolution on its axis takes ten hours fourteen minutes.

It is masculine and positive.

Its glyph looks like this ♄.

This glyph symbolizes the personality being held down by matter.

Five positive key words describing this planet are: (1) experience, (2) patience, (3) humility, (4) wisdom, and (5) compassion.

Five basic key words describing this planet are: (1) restraint, (2) limitation, (3) caution, (4) law, and (5) self-discipline.

Five negative key words describing this planet are: (1) testing, (2) sorrow, (3) delay, (4) disappointment, and (5) limitation.

The basic personality function of this planet is to test us until we learn man's purpose in life.

The parts of the body it rules are: teeth, bones, knees, skin, gall bladder, calcium balance, paralysis, right ear (ringing indicates a spiritual message).

Some of the things ruled by this planet are: mountains, stones, gates, doors, cold, falls, lead, Saturday, land, and biological father (or one who assumed the role).

The people represented by this planet are men.

The similarities between this planet and the sign it rules are that both of them show restraint, patience, and self-discipline.

They differ because Capricorns seek to expand outward and upward in their search for social recognition and acceptance, while Saturn seeks to restrain and limit the expansion of our society ego.

Saturn retrograde causes inner doubts regarding one's sense of worth and the ability to overcome problems. There will be difficulty in expressing themselves to large groups until they have reevaluated what type of social standing they want in society.

Saturn is the sixth planet from the sun. Its equatorial diameter is 75,021 miles. Of all the planets, it is the most picturesque. It appears as a shining yellow sphere, with a remarkable white, flat, ribbonlike ring.

The ring system of Saturn is unique among the planets in our solar system. The rings lie in the plane of Saturn's equator. The overall diameter of the planet and its rings is 172,600 miles. No one needs to be limited to the confines of the planet surface itself, but can go beyond to the outermost ring. This is symbolic of the abilities of Capricorns to go beyond what appears to be humanly possible. A mountain goat must leap chasms in order to reach the top of the mountain. For a Capricorn to leap from the planet surface to the rings, we see the necessity for great courage. Between each of these rings is a nightmare of emptiness. These yawning gaps represent the obstacles Capricorns are ever forced to face in their lifetime. Each time they overcome one, they are that much nearer to total success and integration.

The vertical thickness of the rings is less than ten miles. The rings are not a solid sheet, since background stars can be seen shining through them and the inner edge of the ring system revolves more swiftly than the outer edge. Scientists believe the rings are composed of either frozen ammonia or water which revolve as independent bodies around Saturn. However, Pioneer 11 proved they are made of ice or rock and may be space debris or shattered moons. These fine particles are held together in a ring formation by their common bonds of gravitational attraction to themselves and to Saturn.

There are five rings in Saturn's halo. Between the first and second outer rings is a gap called the Cassini Division, which is 2,200 miles wide. The faint fourth ring was discovered by French astronomer Pierre Guerin in 1969. The number four indicates a builder. It enhances con-

centration, practicality, and gives a strong sense of values. After the discovery of this fourth ring, Neil A. Armstrong on July 20, 1969, set foot on the moon. His first words on that occasion have since become famous. "That's one small step for man, one giant leap for mankind." The first part of November 1969 saw a new, revolutionary children's television program entitled "Sesame Street." All of Saturn's qualities were utilized in preparing this series. It was thoroughly researched for a year before presentation. Many people were asked to give advice on the format, including psychologists, educational specialists, writers of children's books, civil-rights workers, community leaders, television producers, film-makers, animators, child development experts, advertising experts, and mothers. The entire series is based on comparatively new educational theories. It has proved to be an outstanding show created around learning and social equality. On November 24, 1969, the United States and Russia signed the Nuclear Nonproliferation Treaty. All of these events indicate that we are striving to *build* new values.

The fifth ring was found in 1970 and is quite narrow. It orbits close to Saturn's surface. Number five is the number of progress through change. Any change can, occasionally, bring suffering and pain. Number 5 is, also, the number of restlessness, new ideas, and short journeys. Numerous events have occurred since 1970, but during the year of its discovery, the United States was rocked by 500 anti-war demonstrations from May until August. On May 4, 1970, four students were killed at Kent State University. Perhaps, these demonstrations had nothing whatsoever to do with our eventual withdrawal from Vietnam in 1973, but, then again, maybe peace could only be achieved through pain, suffering, and disillusionment. On November 12, 1970, a cyclone swept a huge tidal wave which hit East Pakistan, claiming from 200,000 to 1,000,000 lives. To this date, no one knows the exact death toll. From this disaster, people all over the world opened their billfolds to contribute to the Bangladesh Relief Fund. George Harrison, a former Beatle rock star, sponsored the "Concert of Bangladesh" and made over $2,000,000 for East Pakistan. Those who died during this year did experience a "short journey," but they are now preparing for future incarnations. The sufferings their deaths brought helped develop new attitudes in those left behind. Whether the new attitudes are good or bad, only each individual can say.

The swirling layers of atmosphere obscure whatever true surface lies below the apparent surface of Saturn. Like the sign it rules, Capricorn, one must probe beneath the surface exterior to find what lies within. Scientists have estimated that Saturn has an atmospheric depth of 16,000 miles, with a thin layer of ice covering a solid core of metallic rock. This great depth of atmosphere accounts for Saturn's low density of 0.6 (water

is 1). It is so light that Saturn could float, if there was an ocean big enough to hold it. Capricorns should keep this in mind when they think they are drowning in the sea of life.

Like Jupiter, Saturn churns with a violent atmosphere that swirls in bands around the planet. However, Saturn's cloud belts are fewer and less prominent. The bands slowly change colors in varying shades of yellow, with several thin bands of red. The surface on rare occasions erupts with mammoth white spots. A white spot appeared in 1933 in the equatorial zone and was almost as large as Jupiter's Red Spot. It soon dissipated and disappeared. In analyzing the different color meanings, one has to consider the varying shades of yellow. A light yellow is the color needed to soothe the nerves, the color of relaxation. Bright yellow is the color of spontaneity, enthusiasm, and intellect. Dark yellow indicates spitefulness. Red is an outward-expressing color, giving vitality and the urge to achieve results. White is the color of integration and harmony—Christ consciousness.

When Saturn's white spot appeared in 1933, Adolf Hitler had become the Reich Chancellor in Germany. The white spot seemed to be asking humanity to achieve harmony. Instead, Hitler was given dictatorial powers on March 23 and by July 1933 had established the Nazi party as the only political party. The persecution and destruction of the Jews were close at hand. And so, the white spot vanished.

This white spot again appeared in 1962, only to fade with extreme rapidity. That year saw the failure of the Geneva nuclear test ban talks.

Saturn's atmosphere is composed principally of methane and ammonia with some hydrogen. On the surface, the temperature reads around −243° Fahrenheit, indicating that some of the surface gases are frozen. This may account for the "cool" surface Capricorns appear to have. They can erupt in anger, but their anger is in self-defense.

Saturn has ten satellites. Number ten means courage. This number vibration also gives originality, initiative, leadership, and determination. All these traits belong to Saturn and are qualities inherent in Capricorns. One of the satellites, Titan, is nearly 3,000 miles across, with an atmosphere of methane. It is as large as Mercury, with the same color orange as Mars. Five of Saturn's satellites lie between Titan and Saturn. The other five lie beyond Titan. Two of those inside Titan's orbit appear to be smooth spheres of pure ice. Of the satellites that lie beyond Titan, the outermost one, Phoebe, revolves in the opposite direction from Saturn and the other satellites.

Its axis rotation is ten hours and fourteen minutes, and is in many ways similar to Jupiter. This rapid rotation also causes it to bulge at the equator with flattened poles. Both have frigid surface temperatures. Both

Phoebe

Titan

White Spot

have large retinues of satellites. But, even so, Saturn's influence is the exact opposite of Jupiter's. Jupiter expands and Saturn restricts. Saturn's vibrations force us to decide which area we want to focus Jupiter's vibration of expansion. This focus gives tremendous energy and potential to the area selected.

In ancient times, long before the discovery of the outer planets beyond Saturn, the planet Saturn represented the end of the line. Its twenty-nine-year orbit corresponded to a reasonable life span during those years, and it corresponded somewhat to the moon's twenty-eight-day orbit around earth. Saturn was called "Chronos," meaning time. Saturn represented man's time on earth. At the end of one's time on earth, you received your reward or your punishment. And so, Saturn represents our blessings and our disappointments.

Today, Saturn is seen as a teacher. A teacher who seeks to teach us responsibility and wisdom. The wisdom to understand that delay is sometimes necessary and that patience can bring great rewards. The obstacles that are strewn along life's pathway are lessons that we need to learn. Like "Father Time," Saturn's wisdom is boundless.

Saturn has rulership over one's biological father, or the man who assumed that role in one's life. Perhaps this is where the name "Father Time" came from.

Saturn is often referred to as "society's ego." This is the ego we develop from what society (people) think of us. It is extremely difficult for anyone in the public limelight not to have an inflated society ego, because of the adoration and praise they receive. It is Saturn's task to keep this ego in check, but still allow one to feel secure in the fact that you are accepted by society.

Think of Saturn's bands as his halo which he has earned because he has learned through patience and time that fulfillment comes from working for the benefit of humanity. If you have learned this lesson well, you will not get kicked in the rear. If not, accept your fate.

Wherever Saturn is in your natal chart is where you have to face tests and setbacks. In other words, you will be tested in the affairs the

143

house rules and will need to examine your motives toward those affairs. Since Saturn is in that particular house, you can be very sure that, in previous lifetimes, your attitude or approach to the house affairs has been incorrect.

Jupiter tells us to expand, and Saturn says, but, within limits. Saturn has restricted its own expansion with the placement of the rings around his middle. He demands that we, too, learn to conform to what is acceptable and for the good of society.

Saturn is not the cruel taskmaster many have made him. Jupiter gives us the urge to run out and explore all areas, to expand our knowledge and experiences. Saturn comes along and says, "Yes, expand my children, but within limits, within boundaries." You may desire your neighbor's forty-foot yacht, and certainly, you could expand your knowledge and experience if you took it, without permission, for a two-month cruise. But, Saturn says, "No, the yacht does not belong to you. You did not purchase it through hard work and patience." And so, there are many areas where one is not allowed to expand and explore, merely because you want to. Saturn teaches us that.

It takes 29 years for Saturn to orbit the sun, so it is in each sign approximately 2½ years in transit. Saturn is one of the most important planets to watch in transits, for he is always trying to teach you something. Until Saturn returns to its natal conjunction, approximately 28 or 29 years of age, his teachings are karmic in nature and seem to be difficult to use constructively; but it is not impossible. Being aware of it is half the battle.

SATURN IN THE SIGNS

Saturn in Aries: Strong sense of self-reliance. These individuals will struggle against tremendous odds. Must learn that freedom can only be obtained through responsibility and discipline. Often feel frustrated in their plans. Their impatience causes them to lack a sense of timing, so that they encounter troubles in putting their plans into operation. Because of this, they need to develop caution. They have good reasoning ability with strong powers of concentration. They want stability and security. Possessions give them a sense of security. Enjoy arguments and can be hard to please. There may be feelings of inadequacy. Circulation can bring difficulties, so they need to be physically active. Prone to having headaches. Kidneys can give problems, so should drink lots of water. Saturn in Aries calls for the individual to be *self-sacrificing*.

Saturn in Taurus: Determination, caution, and patience. These individuals are purposeful and, sometimes, stubborn in a quiet manner. They overcome obstacles through hard work. They are usually careful with their money. They have the ability to define problems and to concentrate on any task they undertake. Their feelings are generally controlled and serious. This placement indicates that these individuals have placed too much emphasis on material possessions. Saturn in Taurus calls for the individual to *re-evaluate their values.*

Saturn in Gemini: Thinking is deliberative. The mind is adaptable and versatile. They enjoy learning. These individuals are excellent teachers, lecturers, and writers. Must guard against becoming cynical or pessimistic. Can suffer from nervous tension. Lungs need plenty of oxygen. Saturn in Gemini calls for the individual to have *faith in the future.*

Saturn in Cancer: Protective and persevering. Psychic abilities strong. Worry over loved ones. Can be fearful and insecure. May have feelings of inadequacy toward their ability to be a parent. Have the ability to use the nurturing quality of Cancer to aid humanity in some manner. This will develop strength of character. There is a tendency to become emotionally depressed. Their unconscious fear of being hurt by others can cause them to withdraw from too close an emotional involvement with others. These people are kind, but may lack empathy. They can be so busy protecting themselves from hurts that they are unable to see the hurts of others. Saturn in Cancer calls for the individual to *seek self-transcendence.*

Saturn in Leo: Organizing ability. Strong will. Self-contained and conservative. Are extremely efficient. Tendency to be perfectionists and work hard to develop their creative talents. These individuals may have difficulty in expressing themselves which makes them appear to be cold and unloving. Thus, they tend to isolate themselves. They are strongly motivated by feelings of responsibilities. Saturn in Leo calls for the individual to *project their loving heart.*

Saturn in Virgo: Industrious, practical, and efficient. The mind is analytical. They are good workers who are neat and orderly. This is a good placement for Saturn, but it can cause the individual to be reserved with a desire for solitude. Are prone to moods of depression. They need to keep busy or they will worry unduly about everything, including their health. They must be careful they do not become critical of others. Saturn in Virgo calls for the individual to have *faith in the future.*

Saturn in Libra: Diplomatic, tactful, with balanced judgment which inspires trust. This placement calls for the individuals to cooperate and share in harmony, patience, and love with other people. The qualities these individuals have refused to see in their personalities in former lifetimes are now being mirrored back to them through friends, enemies, and their marriage partner. Marriage is a necessary discipline, because competitiveness must go and cooperation must take its place. These individuals have all the qualities to obtain harmony with others. It is up to them to use them or reject them. If they reject them, they will suffer loneliness and depression. Difficulties with the kidneys through impurities in the blood. Vitamin C daily is excellent for purifying the blood. Saturn in Libra calls for the individual *to relate to others cooperatively.*

Saturn in Scorpio: Self-discipline, executive ability. Are perceptive and extremely capable individuals. Psychic ability. These individuals are difficult to understand because of their reserved exterior and secretiveness. The desire for money and prestige must be restrained. They never expend their energies needlessly. They have strength of character, but if unevolved, they can be extremely destructive. They love and hate with the same intensity. There can be difficulties in the body with crystallization in the form of stones, arthritis, etc., because of their emotional and mental attitudes. Saturn in Scorpio calls for the individual to *transform their desires.*

Saturn in Sagittarius: Intuitive, philosophical, independent. Are persistent. Mental maturity comes late in life and promises success. These individuals are generous, with a sense of responsibility. Are good teachers and lecturers. Have administrative and scientific abilities. Would benefit from meditation and introspection. Poor circulation in the hips and legs. Physical exercise will assist this problem. Saturn in Sagittarius calls for the individual to *expand inwardly.*

Saturn in Capricorn: Ambitious, self-controlled. Organizing ability. They are patient, hard workers who eventually receive deserved rewards. Tendency to take life seriously. Are intuitively aware that time and suffering serve a purpose, and that happiness is not the final goal of existence. They find it difficult to divide their energies between work and play and need to apply themselves to one or the other. They have the ability to translate abstract concepts into concrete terms. Thus, they make excellent writers. They are, also, good administrators, financiers, scientists, or mathematicians. Teaching and lecturing are other abilities.

This placement will give the individual an added boost in whatever career they choose. There can be feelings of loneliness and inadequacy. May be troubled with arthritis of the bones and joints. If unevolved, prestige and social standing will be extremely important. Saturn in Capricorn calls for the individual *to be willing to serve others.*

Saturn in Aquarius: Practical common sense. Self-discipline. Inner sources of strength which provide stamina. They, generally, do not expend their energies needlessly. Their goals are carefully thought out and planned in advance. There is difficulty in understanding other people's goals. This is a difficult placement, because the individual must learn tolerance and understanding of other people. Any problems that may be encountered through others must be met with forgiveness. Past lifetime debts are being returned for redemption. Saturn in Aquarius calls for the individual to *transform their thoughts.*

Saturn in Pisces: Intuitive, sympathetic, sensitive, imaginative, self-sacrificing. Are practical idealists. Tendency to take life seriously. Can become indecisive and moody. React emotionally to negative conditions. They can become depressed when success eludes them, but if they persevere, they will ultimately accomplish their reward. These individuals are bound by their past lifetimes. They have to accept the consequences of what they have done in other lifetimes. Many times they suffer as a result of other people's actions and words. The soul must accept this karmic repayment willingly. This placement can be used to enlighten other people, once their inner feelings of guilt and sorrow are absorbed. They will, also, have to learn to disidentify from other people's troubles in order to help them. Saturn in Pisces calls for the individual to *disidentify from negativity.*

SATURN IN THE HOUSES

Saturn in First House: Reserved, serious person. Are industrious and self-controlled. Stubborn in a quiet way. Easily depressed. Suffer from feelings of insecurity and inadequacy. Inner feelings of being unloved in early part of life, due to sense of unworthiness. Many obstacles in life. The individual has to work hard with many responsibilities. There is a strong tendency to become pessimistic, due to the difficulties encountered in life. The body has a tendency to bruise easily. Difficult for the body to assimilate vitamins, so can suffer from malnutrition.

147

Saturn in Second House: Thrifty, practical, responsible. Tendency to become depressed. Possessions apt to bring worries rather than enjoyment, because the individual needs to learn to share with others. There has been too much emphasis on materialism in past lives. The individual needs to reevaluate his values. Attitudes of possessiveness toward others must go. This placement does not deny money, but the individual works hard for it.

Saturn in Third House: Conscientious. An exacting, orderly mind. Ability to retain knowledge. Will seek knowledge all their life. Enjoy time-consuming projects and organizing details. Often feel lonely. Feelings of being isolated with the people in their environment during their early life. Do not fully participate in any situations or with others, because of their unconscious fears of disappointments and delusion. Lungs need plenty of oxygen.

Saturn in Fourth House: Conservative. They dislike change because of an unconscious fear of the unknown. Usually a desire to accumulate possessions. Many responsibilities and problems in the home. Strong tie to their mother for good or ill. Inner worries may cause ulcers.

Saturn in Fifth House: The individual can feel emotionally and creatively inhibited. Because of their emotional restriction, they can appear to be cold and unloving. This prevents them from being as popular as they would like to be. There is a desire for others to look up to them. It is difficult for them to relax. Personal interests need to serve a practical purpose to be enjoyed. They may look upon parenthood as a burdensome responsibility and fail to gain understanding of their children. It is important for these individuals to forget themselves and to learn to project warmth to others. They should exercise sufficiently, so that the physical body is kept in good condition. Would benefit from taking at least 400 units of D-Alpha Vitamin E a day.

Saturn in Sixth House: Practical, conscientious, hard worker. Competence in any tasks that require attention to detail. There can be difficulties with employees or fellow workers because of the attitude of this individual toward others. They cannot expect others to work as hard as they do or to grasp details as rapidly as they do. This attitude, if present, must be transformed. The tendency to worry and to harbor anxieties will affect their health, causing depression and hypochondria. They must, also, watch a tendency to work themselves to the point of exhaustion, for the physical body will take a severe toll. Should take vitamins and eat wisely.

Saturn in Seventh House: Extremely sensitive. This placement indicates the need to relate to others. They have withdrawn from others in previous lifetimes and need to learn to cooperate with and to develop empathy for others. They are cautious about marriage but, when committed, seldom leave their marriage partner even if they are unhappy. May marry for security rather than love. Desire for a perfect mate. When this fails to materialize, they can become disillusioned.

Saturn in Eighth House: Hard workers, patient, and thrifty. Capacity for self-discipline. Their strong discipline can cause them to deny themselves a social and/or sexual life in their quest for monetary security. They should transform this desire into seeking soul growth through "understanding and wisdom," which can only be obtained through relating to others in group and partnership relationships. For what does it profit a man to gain the world and lose his soul?

Saturn in Ninth House: Orthodox and meditative. Philosophy and beliefs are approached in a serious manner. Good at detailed work. Strong powers of concentration. Early in life, their outlook is conservative and orthodox. Later in life, the meditative aspect of Saturn may stimulate a review of their philosophies. Are excellent teachers and lecturers. They can be intolerant and critical of others. There could be difficulties and frustrations in their plans for long journeys and in their travels. Must take care not to deplete their energy to the point of exhaustion through overconcentration.

Saturn in Tenth House: Self-reliant and independent. Good business ability. Success through perseverance. Feelings of discontent must be faced. This placement indicates a need to accept responsibilities; otherwise life will be a series of setbacks and failures. These individuals must develop humility. If they attempt to build a life based on power and prestige without compassion and integrity, they will be toppled from their throne. There will be difficulties with a dominant parent. There may be a lack of a father image in their growing-up years—parents may be divorced, the father dead, or the father engrossed in his own concerns.

Saturn in Eleventh House: Many acquaintances, but only a few friends. The friendships these individuals make endure for many years. They are attracted to groups which have a serious or necessary purpose. Tasks that are done for any groups will receive very little personal recognition. In order to obtain their goals or objectives, they have to be patient and willing to work hard. If their lessons are learned, the later part of their life will offer greater rewards.

Saturn in Twelfth House: Strong inner discipline and sensitivity. There can be feelings of doubt and lack of confidence in themselves. This placement indicates an individual who has been isolated from humanity in previous lifetimes. There is an unconscious desire to make restitution for wrongs committed in other incarnations. Thus, the person feels fated and may desire to retreat from society. Their strong inner discipline gives them the ability to repay their karmic debts and leave the wheel of incarnation. They have chosen to serve mankind in some manner, so serve they must or suffer chronic health problems.

TENTH HOUSE

This is an angular house, indicating activity. It is considered an angular house because it corresponds to cardinal signs.

The natural ruler of this house is Capricorn. What is the relationship between the sign and the house? Capricorns need to gain social recognition and respect from others. The tenth house refers to our social standing and achievements in the community.

The natural ruling planet is Saturn. What is the relationship between the planet and the house? Saturn represents our father and our society ego (what people think of us). The tenth house refers to our father (and all authority figures) and our social standing and achievements in the community.

If the sun were in this house, it would be approximately 10:00 A.M. to 12:00 noon.

This is a House of Substance which corresponds to earth signs. This means it is a house of material and objective goals obtained through profession, reputation, and honors.

This house rules: (1) *Professional Career* and
　　　　　　　　(2) *Personal Achievements* (Giving you—
　　　　　　　　　　　a) Social standing in community
　　　　　　　　　　　b) Social power in community in terms of—
　　　　　　　　　　　　　1) Money
　　　　　　　　　　　　　2) Prestige
　　　　　　　　　　　　　3) Honors
　　　　　　　　　　(3) *Authority*
　　　　　　　　　　　a) Parental (father figure)
　　　　　　　　　　　b) "Others" (teachers, policemen, fireman, employers, etc.)

This house is found in the Fourth Quadrant above the horizon.

The opposite house is Fourth.

What is the relationship between the fourth and tenth house? Both refer to foundations and the need for security.

How do the fourth house and the tenth house differ? The fourth house refers to our personal inner foundations and security through safety and happiness in the basic things of life, in particular through home surroundings. The tenth house refers to social foundations, where one strives to achieve security and honors through activities in the community.

PROFESSIONAL CAREER AND PERSONAL ACHIEVEMENTS:

The tenth house refers to our professional career and our achievements. It also shows our attitudes and expectations about a career and about success. Our attitudes have a great deal to do with our success or failure. Worldly success, of course, is not everyone's goal, and the tenth house shows what you really hope to achieve in society. Whether success is used for good or ill depends on how well integrated we are. Many will use their power to help mankind, while others will only crush and destroy many other human beings, as in the case of Hitler.

If you are a housewife and have never sought a career, your social standing and prestige in the community is still reflected in this house. Personal achievements refer to any endeavors that give you social recognition, but without monetary remuneration. This could be as a chairman of the "March of Dimes" drive, president of the P.T.A., an athlete at the Olympic Games, or any role where you assumed responsibility so that your name became known by others.

Everything we learn and all our experiences, whether they are pleasant or painful, are instrumental in the development of the personality we project to society. This means that we project what we have found to be a meaningful approach to life, based on our "understanding and wisdom."

A man may find what he calls his career, but this does not mean he has learned any of life's lessons along the way. In the tenth house, we are judged, not by our personality or appearance, but by our performance. A bad artistic performance does not hurt the community, but it does hurt the artist's sense of achievement and his ability to attract an audience. When this occurs, he must ask himself if he has chosen the right career, has he failed to listen to his teacher, or has he failed to practice enough? At this point, it would be easy for him to blame others for his failure, or he could review his life and take the necessary steps to correct his mistakes. There are other careers, however, which *do* harm the community

151

when performed in mediocrity or for self-gain. For instance, a politician is detrimental to society if he takes advantage of his position to gain favors for himself or to pad his expense account.

If we seek the limelight for selfish ego reasons, we have not learned our lessons properly. By being loving and compassionate in cooperative relationships, there would be no need to "feed" the ego with power. The ego would be too full of compassion and kindness instead.

AUTHORITY

The tenth is also traditionally associated with the father. This refers to the authority function of both parents and of any other authority figures in our lives. Certainly, the ability to deal with the necessary rules and laws of a society is a task we all must come to terms with.

If you look deeply, two of the tenth-house affairs, Career and Authority, are related in a very meaningful way. Like it or not, the person who hates authority often runs afoul of it and undermines his own success in the process. In order to be a success in any endeavor, we must have (1) *self-discipline,* (2) *self-control,* and (3) *a sense of responsibility*. These same attitudes are demanded by all authority figures. If we are rebellious against taking orders, these traits are obviously lacking in us. Success and achievement will often put us in a position of command over others. If we cannot handle leadership due to our own feelings against authority, we can jeopardize our own achievements. This relationship between authority and success deserves a great deal of thought. Many young people are frustrated by the sins of our governmental structures. Certainly, there is a need to reform and transform these structures. But how can these young people lead us if they have never accepted being led? How can you possibly be a football coach if you have never played on a team and learned the three attributes necessary for a team effort? How can you teach unless you have been willing to be taught?

Society cannot function without authoritative leaders. It never has, and it never will. A good leader is one who practices (1) *self-discipline,* (2) *self-control,* and (3) *a sense of responsibility*. Before you lash out at authoritative figures, you should first ask yourself, "Is the man doing the best job he can? Do I resent him because he has the power to tell me what to do? Would I do a better job in his place? How would I do it differently? How would I avoid mutinous uprisings against me? Would I practice self-discipline, self-control, and a sense of responsibility, or would I misuse the power the job gave me?"

IN CONCLUSION

As you mull those questions over, let us look at the polar opposite house, the fourth. The fourth refers to our inner personal foundations. There we learned to stabilize and organize our individuality from the depths of our inner being. Thus, inner personal foundations were built. In the tenth, the individual builds social foundations through a career and his personal achievements, which society can observe. He has a place in society and public status in the community. Because of this status, he has some degree of social power, which can mean anything from money, to honors and prestige.

Let us be sure that we don't build our social foundations on the shifting sands of ego glorification. For, by the time we reach the top, our castle will be collapsing. It is inevitable that if we seek the limelight for selfish ego reasons, we must eventually be prepared to pay the price. It may not be tomorrow, or the next day, but, inexorably, it will come, for "What you sow, so shall you reap."

AQUARIUS

Aquarius is the eleventh sign of the zodiac.

Its glyph looks like this ♒

Its glyph symbolizes waves of water—knowledge poured out upon the world.

The picture used to describe the sign is the Waterbearer. Why? This represents the pouring out of knowledge from the superconscious mind to be shared with humanity. Water represents intuition.

The sun is in this sign from approximately January 22 to February 21.

The planetary ruler is Uranus.

In the natural zodiac, it rules the Eleventh House.

It is masculine, positive, and an air sign. The element air can be described as intellectual and communicative. Its quality is fixed, meaning determined and persistent. This can be combined to describe Aquarius as "determined intellectual."

The parts of the body that are ruled by this sign are: retina of the eye, calves of the legs and ankles, electricity of the body, blood circulation, anemia, elimination of carbon dioxide through breathing.

Some of the things that Aquarius rules are: astrology, aviation, electricity, gases, inventions, and the wireless.

153

Five positive key words are: (1) friendly, (2) original, (3) intuitive, (4) broadminded, and (5) helpful.

Five negative key words are: (1) impersonal, (2) unpredictable, (3) tactless, (4) rebellious, and (5) eccentric.

Aquarius people like any work which allows scope for inventiveness and the detached application of special rules and formulae. Some of the careers are scientists, inventors, radiologists, photographers, radio and TV, civil service, electricians, lecturing, and public corporations.

The key phrase is "I know."

The key word is "truth."

Their basic nature is "the humanitarian or reformer."

The opposite sign of the zodiac is Leo.

The picture used to illustrate Aquarius is the Waterbearer. This confuses many people into thinking that Aquarius is a water sign, when its true element is air. Hebrew astrological law calls Aquarius by the name Delphi, which means atonement and baptism into spiritual life. The Waterbearer is shown pouring water from an urn, signifying the pouring of knowledge from the river of life so that it can be shared through serving humanity. In a sense, this can be considered an act of atonement, since Aquarians' goal is the figurative "baptizing" of others with their philosophy of life.

Even though Aquarius's glyph symbolizes waves of water, they also appear to resemble waves of electricity. Electricity is one of the things ruled by this sign. This is symbolic of the "electrifying" personalities of Aquarians because of their ability to attract others to them, even though they are often seldom understood. They are considered different, because they do not fall into any known pattern. They are friendly, but detached. They have warmth, yet they are distant.

Even though they appear to be aloof and detached, they are not really indifferent to others. However, they are far more concerned about humanity as a whole than any one particular individual. They rarely bother to exert themselves to win approval or compliments, since they are not ego-oriented nor are they pompous or stuffy.

Aquarius and its ruler, Uranus, want to change the world by bringing new ideas to old conditions. Both have a profound desire to bring about advances in art, science, politics, and literature, and to establish a new type of human understanding which would create friendships between communities, cities, states, and nations.

Aquarians have the determination and persistence to get ahead. Unfortunately, their energy level is relatively low, which can cause them to drop projects before they are completed.

Their minds are analytical and scientific. They have the ability to think things through to an accurate conclusion. They have good powers of concentration and are able to assimilate a lot of information. But there is a tendency to be absentminded.

Since they are philosophical, visionary, and idealists, they can make other people dissatisfied with what they are and make them see that there is something better.

They can be extremely stubborn. You may feel you have come up against a brick wall when they adhere to their ideas. No amount of persuasion will change their mind, once it is made up. If their reasoning is sound and their aims are positive, this trait is admirable.

Aquarians get along well with others and are gentle, creative people who try to use the principle of brother love. They are not gossips nor are they petty. They do not like arguments, unless they feel there is a need to defend a person, an ideal, or a principle. They can be very persuasive debaters, with the ability to back up their statements. People instinctively trust them. If asked, they will give good advice.

They are not frightened of the bizarre, the irrational, or the unknown. When confronted with them, they seek the answers to them. Since they are so willing to listen to the new and different, they have little patience with those who refuse to hear new theories or concepts.

If destructive, they will rebel for the pleasure of it, striking out blindly in all directions. They will deliberately do things in an attempt to shock people.

Aquarian women like to pursue other interests outside the home. For this reason, they are not classified as born homemakers, for they feel there is more to life than cooking, cleaning, washing, and ironing.

They are usually friendly, helpful, and gregarious. They like to participate in group activities, and are soon found changing the established structures of these groups for the better. They are, basically, nonconformists, but are not one of the more radical type of reformers—though there are some who are. Nevertheless, in one way or another, they will want to break with tradition and support new causes. They have the ability to look to the future, in terms of what could be possible.

They may, or may not, live routine, orderly lives. Most of them prefer not to be bound by schedules and regulations, but can easily adapt to them if they must. However, after working hours, you will find them involved in something new or unusual in the form of a study, hobby, or crusade. They are rarely found doing dull, routine work.

They have many friends, but only a few intimate ones. Some of their friends may be cautious, conservative, and material-minded types, and others can be extremely radical or bohemian. The typical Aquarian is not

155

easy to classify, for they are constantly adapting themselves to ever-changing circumstances. Some of them are extremely conservative, some are radicals, and others are found somewhere in between.

Unless other factors in their natal chart modify it, these people are among those rare individuals who treat others as they would like to be treated themselves. They do not care for people to be possessive of them, nor do they display this trait toward others. They will give those close to them a lot of personal freedom since they, too, desire the same privilege. They are, also, very broadminded about the way their friends live, expecting equal objectivity in return.

Since they are not concerned as to what other people think of them, they often do not bother forming opinions about other people's behavior. Unfortunately, this trait can deteriorate into not bothering to find out how other people think, so that in a discussion they may remark, "It doesn't concern me," or "It doesn't really matter to me one way or the other."

They should be sure to get sufficient exercise for good blood circulation, eat properly, and find some type of pastime to help them relax. They can have difficulties in the ankles, nervous and circulatory systems, the heart, spine, throat, bladder, and sex organs.

In love, they want an intellectual companion with whom they can communicate. They can be hesitant about making a total commitment such as marriage, or any other form of partnership, because of their desire for independence. However, when an Aquarian marries, the marriage is usually stable. They are loyal and faithful to their marriage partner, but are not prone to excessive displays of affection, especially in public.

As Parents:

They like their children to learn to be independent. Aquarian parents are firm believers in modern educational techniques. They enjoy discussing all types of subjects with their children, but may find themselves trying to impose their own personal views upon their offspring. They keep close contact with their children and like to know what is on their minds or what is troubling them. They are not harsh disciplinarians, for they do not like to create scenes.

Children:

Aquarian children are usually bright and quick to learn. Their school work can fluctuate, especially if they are too involved with outside ac-

tivities. They have natural creative abilities and are usually musical. Chemistry is a subject that appeals to most of them. They have a lot of charm, but their tendency to be domineering should be subtly stopped. They need plenty of outdoor exercise and should not snack on junk foods for meals.

Wherever Aquarius is in the natal chart is where you need to reform old ideas and concepts about the house affairs. New ideas and knowledge should be utilized in order to break down these old ideas and concepts from past lifetimes. The house affairs will receive abrupt changes as this reformulation takes place. The changes can be constructive or destructive, depending upon whether one is heading in the right direction.

The gem for Aquarius is the amethyst. This gem is the symbol of sincerity. It was the favorite stone of Saint Valentine, who was an Aquarian. He wore the amethyst engraved with a cupid and arrow, symbolizing lovers. Amethysts are found mostly in Asia and South America. They range in color from pale violet to deep purple, depending upon the amount of mineral in the stones. Ministers frequently use it in jewelry, such as rosaries. It is supposed to give the wearer prophetic ability, poise, and self-discipline.

The flowers for Aquarians are the daffodil, primrose, and mixed carnations. Their colors are white, pale yellow, pale green, and electric blue. Their metal is uranium.

URANUS

This planet rules the sign Aquarius.

Its natural house is the Eleventh House.

Its orbit takes eight-four years.

One complete revolution on its axis takes ten hours forty-five minutes.

It is masculine and positive.

Its glyph looks like this ♅ .

This glyph symbolizes our two personalities (physical and spiritual), joined by a cross of matter with the sun (essence) pushing them to higher levels.

Five positive key words describing this planet are: (1) awakener, (2) creativity, (3) originality, (4) perception, and (5) resourcefulness.

Five basic key words for this planet are: (1) awakener, (2) intuition, (3) originality, (4) reformer, and (5) idealism.

Five negative key words describing this planet are: (1) rebellious,

(2) destructive, (3) unpredictable, (4) irresponsible, and (5) eccentric.

The basic personality function of this planet is to bring changes into our lives for a new and better pattern.

The parts of the body it rules are: lower legs, ankles, calves, body electricity, spasms, tension, and nervous conditions.

Some of the things ruled by this planet are: astrology, earthquakes, light, space travel, inventions, electricity, rays, revolutions, rebellions, and science fiction.

The people represented by this planet are the masses.

The similarities between this planet and the sign it rules are that both of them are resourceful and unpredictable.

They differ because Aquarians use subtle or persuasive debate in order to bring about changes, while Uranus is intent upon causing chaotic or sudden disruptions in your life, in order to jog you out of your rut and bring about a new and better pattern.

Uranus retrograde causes a difficulty in being aware of or expressing the inner individuality. There is a rediscovery or renewal of ideas from the past or past lives. They experience karmic family and social difficulties in order to transform the unconscious mind, and/or they could be the source of a reforming idea that would help their community or humanity.

Uranus was the first of the outer planets to be discovered through the use of a telescope. On the night of March 13, 1781, William Herschel, surveying the sky with a seven-inch reflecting telescope, saw a greenish object. Continuing to observe the object, he noted that it possessed a slow movement among the stars. It was at first assumed to be a comet, but later observation and calculation proved it to be of planetary nature.

In accordance with the tradition of naming the major planets after mythological deities, the name "Uranus" was adopted. Uranus was a Greek god whose name meant "heavens." In legends, Uranus was the father of Saturn. Saturn became jealous and killed his father, so that no other offspring could appear. It is interesting to note that Uranus is 900,000,000 miles beyond Saturn's orbit. He certainly believes in keeping his distance from his offspring. Since Saturn is, himself, approximately 900,000,000 miles from the sun, Uranus is around 1,800,000,000 miles from the sun. Because of this, he receives very little heat from the sun, so his outer surface temperature is around $-300°$ Fahrenheit.

Uranus is a massive planet of approximately 29,000 miles in diameter. Even at that, Saturn is still twice his size. Uranus is thought to have a solid core of about 14,000 miles in diameter, an ice layer of about 6,000 miles, and an atmosphere of 3,000 miles, covered with a cloud layer.

Its greenish color symbolizes the need to balance, to persevere, no matter how difficult, and to be creative in order to heal both the physical and spiritual body.

Its orbit around the sun takes eighty-four years. It is difficult to spot Uranus with the naked eye, as it is usually just at or below our limit of visibility. This is like trying to find what the reaction will be of an Aquarian to any given situation. You certainly won't be able to "see" from their facial expressions what they may be feeling. So, relax, and enjoy the unexpected from your Aquarian friends.

Uranus makes a complete axis rotation in ten hours forty-five minutes. This is a similar rotation speed of Jupiter and Saturn, but unlike his neighbors, Uranus lies on his side with the poles tilted at a 98° angle. At certain times during its orbit of the sun, its poles point almost directly toward the sun. If one could live on Uranus at one of the poles, you would see the sun for forty-two years, and then live in darkness for another forty-two years. This, undoubtedly, accounts for the lack of vitality of Aquarians. Near the dark pole, daily rotation brings no succession of dawn and dusk, but only a constant parade of stars circling in the night sky.

AXIS ROTATION OF URANUS

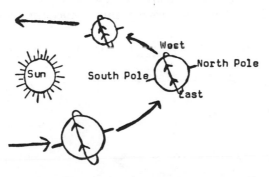

Even with the best telescopes, cameras rarely, if ever, record true surface features on Uranus. However, some observers have reported atmospheric bands vaguely striping the planet. Perhaps this is why we find such a wide range of personalities among Aquarians. The field is unlimited when it comes to different types of Aquarians. You find conservatives, moderates, "happy-go-lucky" types, humanitarians, bohemians, radicals, and the revolutionaries.

Uranus's diameter and rotation period are imperfectly known. But most scientists agree that its atmosphere is probably almost entirely methane. Uranus seems to have a greater density than Jupiter or Saturn.

This fact suggests that Uranus is not rich in hydrogen and helium, but must contain a higher proportion of water and ammonia ices. This, undoubtedly, accounts for the ability of Aquarians to be detached.

Uranus has five satellites. The fifth and innermost satellite was discovered in 1948. The satellites range in size from 200 miles to 1,800 miles in diameter. They are approximately 76,000 miles to 364,000 miles away from the planet surface. Number five is a "rolling stone" number. If you look back at the picture of Uranus's axis rotation, it does look like a round stone rolling on the ground. This is similar to the fact that Aquarians dislike being tied down to set routines or schedules. The old saying that "a rolling stone gathers no moss" could certainly apply to many Aquarians. Number five also means progress through change. It is an indication of changes in the life, new ideas, curiosity, and versatility. All of these traits apply to Aquarians, as well as Uranus.

Since Uranus's polar axis is tipped almost into the plane of the ecliptic, its satellites appear, from earth, to be revolving almost in a north-south plane. Actually, the satellites are revolving around Uranus in the same direction as its axis rotation. Uranus's axis rotation is east to west, rather than the traditional west to east of the other planets. This reversal emphasizes the unusual and unexpected, and are traits one can expect from the sign it rules, Aquarius. From our view on earth, both the satellites and Uranus appear to be retrograding, since they are rotating east to west.

ORBIT OF URANUS' SATELLITES AS THEY APPEAR FROM EARTH (Not to scale)

Visual Clarification Only

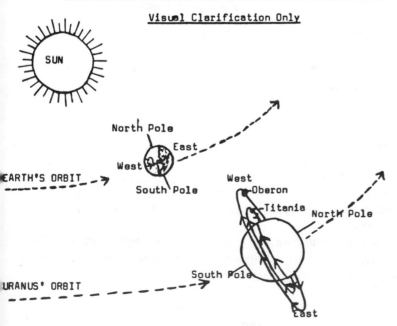

160

As illustrated in the picture, the earth appears to be rotating like a toy top. In fact, all of the other planets rotate like a top, too. It is only Uranus who does the unexpected. It was even discovered unexpectedly at time of the Industrial Revolution in Europe. Because of its discovery during a revolution and because of its unpredictability, there can be no question that it rightfully has rulership over Aquarius. Aquarians are noted for their unpredictability and their revolutionary ideas.

In the early months of 1978, five rings were discovered encircling Uranus's equator. The rings themselves are not solid and are much narrower than the rings of Saturn. In a typical Uranus fashion, the outermost ring, Epsilon, rotates the section closest to Uranus much more slowly than the farthest portion. The encircling of Uranus by rings indicates that its erratic energy is being restrained. However, the very fact of having five rings indicates we can still expect Uranus to trigger unusual happenings in the world and earthquakes, but not as severe as originally expected.

Uranus is full of surprises and the unexpected. Think of Uranus as a catalyst. In chemistry, a catalyst is a substance that causes or speeds up chemical reaction when added to other substances, yet at the same time retains its own qualities, unchanged.

This is a good description of Uranus, which causes changes, dissolutions, and new conditions. It brings with the speed of lightning a new development or condition in life, usually something entirely outside your own realm of control. Your reaction can mark a turning point in your life, for the better or for the worse.

Uranus tries to eliminate that which is outworn and unnecessary and lead us to new approaches and remarkable discoveries. In a minor way, Uranus can so disrupt your everyday life that you may be forced in self-defense to utilize previously unexpressed abilities and skills. In a major way, Uranus can totally sweep away the familiar foundations of your life, forcing you to call on all your reserves and resources in order to survive.

Because Uranus is related to all that is new, progressive, and future-oriented, there is a strong influence of creative force. True creativity invariably produces original work or ideas. Even when an established art form or literary format is used, the Uranian inspiration will give it a new slant. Whether or not you are a creative artist, writer, or musician, it is important to understand this creative force of Uranus and to direct and utilize it accordingly. Evangeline Adams wrote of Uranus: "If you will not allow him to create, he will devour," which is a reminder that the negative power of Uranus can lead to destruction, anarchy, and chaos, reflected in individual lives as well as in nations.

161

Uranus, then, can be said to be decisive, abrupt, sudden, unexpected, individualistic, and impersonal.

Uranus is the door between our conscious minds and our unconscious minds. Thus, it is called the "awakener." It is our intuition prodding us to break away from societies' structures to look for other meanings to life. It is the unconscious urge to become aware of your true inner individuality and the purpose behind this particular incarnation. This knowledge is buried in your subconscious. Uranus awakens you to the fact that there is more to life than eating, sleeping, and working. Because of this, it is very appropriate that Uranus rules astrology, since astrology can give you the key to unlock the door to your unconscious mind.

Wherever Uranus is found in a natal chart is where you experience changes, upsetting conditions, and sudden reversals. In the house affairs involved, you will find yourself either forced to utilize your abilities and skills in order to survive these earthquakes or you will be totally demolished. If you allow yourself to be totally demolished, you will need to rebuild on much firmer foundations, otherwise you will find yourself once again sitting among the ruins.

URANUS IN THE SIGNS

Uranus in Aries: Inventive, independent, impulsive, impetuous. Strong imagination. A desire to start new things and to express new ideas and concepts. (Mars' rulership over Aries gives them the energy they need to complete these projects if they so desire.) These individuals can suddenly change directions. Enthusiasm is spasmodic. Can be rebellious. Temper needs curbing. Possiblity of accidents occurring due to impulsiveness and/or anger. The nervous system is highly geared, which makes it hard for them to relax. There can be problems with headaches. *Their need* is to learn to exercise restraint.

Uranus in Taurus: Determined, constructive, resourceful. Practical creativity. Enjoy comforts of material possessions, with a tendency to want new and different things. Unexpected upsets and changes regarding loved ones. There is a strong magnetism and charm which could attract a loving partner and bring great happiness in marriage. *Their need* is to conquer their tendency to be obstinate.

Uranus in Gemini: Spontaneous and curious. An original thinker. They enjoy learning and are able to grasp concepts and ideas quickly and easily. This is a particularly good placement for Uranus. They have a flair for

writing. There may be difficulties with relatives due to Gemini's rulership over the third house. *Their need* is to learn not to overtax their physical body by operating on their nervous energy.

Uranus in Cancer: Strong imagination, patriotic, instinctive. Feelings of uncertainty and insecurity. There is a strong desire to protect their loved ones. Are swayed by their emotions. They have to learn not to be so susceptible to their emotional responses. *Their need* is to disidentify from their feelings.

Uranus in Leo: Organizing ability, strong desire for freedom. Good vitality. Excellent leadership ability. These individuals find it difficult to tolerate restrictions in any form. Thus, many of them can be defiant, arrogant, rebellious, or revolutionaries. This placement fosters the desire to be different from what is considered acceptable by society. Uranus in Leo brought in long hair for men, more colorful and flamboyant clothing for men, and long pants for women. *Their need* is to find a balance between being reserved and being brazen.

Uranus in Virgo: Subtle, discriminating, analytical. Keen mind. Can be a strong desire for perfection. Interest in natural methods of healing, such as psychic healing and herbs. Practical ideas. Ability to analyze problems and come up with sound, workable solutions. A cautious nature which likes to rethink all situations before making a decision. Could be critical. *Their need* is to learn to listen to their intuition.

Uranus in Libra: Charming personalities. Good judgment, cooperative, inventive. Desire for harmony and peace. This placement causes changes and upsets in their environment, as they struggle for freedom in their relationships with others. Because these individuals are not meek, they will fight for their right to be independent even at the cost of losing peace and harmony. *Their need* is to learn to be flexible.

Uranus in Scorpio: Deep powers of concentration. Strong will. Intense emotions which can be expressed constructively or destructively. Desire to investigate. They want to get to the bottom of all situations in their never-ending quest for understanding. *Their need* is to channel their intellectual energies.

Uranus in Sagittarius: Courageous, intuitive, prophetic, optimistic. Good judgment. Want to be able to freely express themselves in a unique manner. They seek to expand both inwardly and outwardly. Could become

rebels and revolutionaries if their ideals are thwarted. Can be desire for spiritual evolvement and enlightenment. *Their need* is to combine inward *"philosophical"* expansion with outward expression.

Uranus in Capricorn: Ambitious, shrewd, persevering, contemplative. Have organizing abilities. Power of self-discipline. Would make excellent leaders. There can be a desire to accumulate possessions. May be domineering. Are nervous and restless. Could be difficulties in the stomach and digestive system. *Their need* is to accept the responsibilities and the limitations brought on by their karmic obligations.

Uranus in Aquarius: Original, progressive thinkers. Friendly. Comprehend easily. These individuals are intelligent, creative people who prefer to work behind the scenes. Interested in establishing changes which would benefit humanity. Interest in the metaphysical. Their body needs plenty of physical exercise, to assure proper circulation of the blood. They have the ability to detach from other people's difficulties. *Their need* is to develop *"compassionate"* detachment from the problems of the world and humanity.

Uranus in Pisces: Humble, compassionate, sociable, psychic, intuitive. Extremely sensitive. Are self-sacrificing, with a desire to help humanity. Can be religiously inclined. Suffer from uncertainty and unsettled conditions in their life. Nervous system suffers from overwork. May seek to escape from the pressures of earthly living through alcohol, drugs, or sex. *Their need* is to develop a philosophy of life which will give them faith in humanity and in the future.

URANUS IN THE HOUSES

Uranus in First House: Strong-willed, independent, original, freedom-loving, and intuitive. Stimulating personality. Could be willful, high-strung. May be feelings of unrest and loneliness. They will seek new and unusual ways of expressing old ideas. Because the intuition is so strong, they should learn to listen to it. Are leaders who can blaze new trails for others to follow. Possibility of their paying very little attention to their physical appearance, due to other concerns occupying their mind.

Uranus in Second House: Independent. Excitable emotions. They earn their money in original and inventive ways. Unexpected changes in their financial conditions. They are seldom dominated by material consider-

ations, but merely value money for the freedom it gives them to pursue their inner talents. Have the ability to extricate themselves from financial difficulties.

Uranus in Third House: Independent and curious. Can be somewhat unconventional. The mind is inventive, with original and creative ideas. Mental restlessness gives the need to be on the move in order to seek new thoughts and ideas. Frequently change their minds. Would make good speakers and writers. There is a strong urge to travel, which may lead them to strange places. The relationship with relatives is unusual, which could cause difficulties and upsets. Usually a desire to be apart from them. This individual must learn that one has to make their peace with the people in their environment and to discontinue moving from place to place in search of Utopia.

Uranus in Fourth House: Unsettled home conditions. Restless. The relationship with the mother is unusual, which affects the person emotionally for good or ill. There will be many changes in their life, including different localities. Desire to remain free from commitments to either a home or a community. Can be unconventional people who are not concerned how others view them. Later in life, they may develop an interest in the metaphysical world.

Uranus in Fifth House: Creative originality. Have interesting and different hobbies. They have a tendency to want to be too independent, to the point that they can separate themselves from understanding their children. Their children will be unique, with the potential to be extremely constructive or destructive. It is up to these parents to channel their child, through interest and concern, into their creative potential. Are disinterested in society's social games and are more concerned about their own inclinations. Speculation is inadvisable, but they will find that they will receive unexpected gains without any effort on their part.

Uranus in Sixth House: These people have unique abilities and original methods. They suffer from extreme nervous tension and strange accidents. They like work which has irregular hours, is different, and is not routine. They are good workers, but must watch so they do not overwork. They come up with clever ideas which aid them in their work. They do their best work when they can be their own boss. Can be impatient with others and can appear to be abrupt to their fellow workers. If they do not learn to control their impatience and irritation, they will have difficulties through ill health. Will benefit from psychic healing treatments and herbs.

Uranus in Seventh House: Romantic. The marriage will be unusual, with either a rapport or a total lack of understanding between the partners. The individuals are generally conventional themselves, but they meet very interesting and unconventional people in their lifetime. Unexpected reactions of other people to them which they find perplexing. May feel that others do not understand them.

Uranus in Eighth House: Strong psychic feelings and keen intuition. Have unconventional ideas about life, sex, and death which they do not necessarily reveal. Are generally intrigued by the occult sciences. Difficulties through nervous tension. Partnerships should not be entered into without considerable forethought. Tendency to a quick temper. Should not drive when angry because accidents could happen at that time. There can be an unexpected legacy or financial gain through unusual sources. Lack of integrity will cause financial loss.

Uranus in Ninth House: Independent. Unorthodox philosophies, prophetic. Have an inventive mind. Desire to study metaphysics and other religions. Strong possibility of taking sudden unexpected journeys which are beneficial. Use of mental journeys can be cultivated (visions, dreams, intuition, prophecies). Make good teachers. Foreign affairs is also appealing. The mind is ever-inquiring, seeking to broaden their understanding through knowledge. Too much mental activity can cause a mental breakdown.

Uranus in Tenth House: Independent. Success through originality. Dislike routine work. Are humanitarians. Generally an interest in the metaphysical world. Are required to make rapid decisions in their career. They approach their profession in a different and original manner. Are farsighted. Enjoy working independently. Can be many changes in a career and/or in what they seek as a personal achievement.

Uranus in Eleventh House: Original goals and ideals. Unusual friendships. Make friends easily, but prefer many acquaintances with only a few intimate friends. Promoters of humanitarian ideals. Could become radicals. Tendency to change their goals many times. Swing from being sympathetic to feelings of antagonism. Have to learn to channel this erratic energy, so that it can be used constructively.

Uranus in Twelfth House: Highly intuitive and secretive. Humanitarian ideals. Feelings of loneliness. Difficulties with nerves. Interested in the

metaphysical. Have unique psychic experiences which they keep to themselves, for fear of being ridiculed. Constant questioning of the meaning of life and of the imperfections they see around them. There are unresolved difficulties in the unconscious mind that need to be brought out and dissolved. The answers to the meaning of life can only be obtained by reaching their higher self, which will then dissolve their impatience and frustration with "fate." Must learn to live in the here-and-now and to accept life as it is.

ELEVENTH HOUSE

This is a succedent house, indicating stability. It is considered a succedent house because it corresponds to fixed signs.

The natural ruler of this house is Aquarius. What is the relationship between the sign and the house? Aquarians need to gain new knowledge that will bring them freedom from old concepts. The eleventh house refers to new knowledge and new ideals gained through friends and social groups.

The natural ruling planet is Uranus. What is the relationship between the planet and the house? Uranus represents the unconscious urge to become aware of your true inner purpose, and the eleventh house refers to your inner goals and ambitions which are clarified through friends and social groups.

If the sun were in this house, it would be approximately 8:00 A.M. to 10:00 A.M.

This is a House of Relationships which corresponds to air signs. This means it is a house of intellectual and social relationships with friends and organizations.

This house rules: (1) Friends
 (2) Social Groups (non-ritual relationships)
 (3) Goals and Ambitions (sometimes called Hopes and Wishes)

This house is found in the Fourth Quadrant above the horizon.

The opposite house is Fifth.

What is the relationship between the fifth and eleventh house? Both refer to self-development and creative self-expression.

How do the fifth house and the eleventh house differ? The fifth house refers to the individual's self-development and creative self-expression, and the eleventh house refers to our development and creative expression through friends and social groups.

(1) FRIENDS

When a person decides to participate in society, he seeks individuals who have the same interests and values as his own. The opportunity to make friends occurs at work, at school, or in his neighborhood. The friends he makes in those areas will help him learn about different ideals and goals.

For the teenagers, friendship and their peer group can take over and rule their lives, seeming to be more important than any future goals or consequences. Many lives have been wasted by getting in with the wrong crowd. On the other hand, many groups of friends have served as boosters and inspirations to creative people. Rightly used, friendship can be a great source of strength, but wrongly used, it can be destructive.

Good friends are rare gifts who encourage and inspire us. Unfortunately, one can, also, experience the opposite. People you thought were your friends can appear to be displeased, or jealous, when you succeed or do something creative. Friendship must be based on equality, but the false friend wants to hold you down to his level. Many peer groups don't want you to be an individual, either, and will exert all kinds of subtle and turbulent group pressure on you to conform to their ways, no matter how foolish or nonproductive they are.

The eleventh is the polar opposite of the fifth, and any opposition always indicates the need to achieve balance between the two poles. The lesson of the eleventh is to learn to equalize the human need for friendship and socialization (eleventh house) with the need for self-development and creative self-expression (fifth house).

(2) SOCIAL GROUPS

(Groups where rituals are not necessary for membership)

Group membership is similar to friendship in both its positive and negative potential. Groups like Alcoholics Anonymous and Weight Watchers stand behind the person and help him develop—again, the eleventh encouraging the fifth. But too many people use group membership to run away from themselves and stifle their creative development—the eleventh pulling away from the fifth.

Some people spend all their time as officers and committee members and going to endless meetings where nothing happens but talk. Our socializing and our friendships can waste much of our time and dissipate our creative energies, unless we learn to make a positive selection of

friends who encourage us and who are also seeking to develop in a way that we need.

It is through friends and groups of people that we gain knowledge and new ideals. Through the sharing of their special creative spark with us, we are stimulated to analyze and to make further personal growth.

(3) GOALS AND AMBITIONS

(Sometimes referred to as Hopes and Wishes)

This house is often called the house of hopes and wishes, but, basically, its meaning dates back to the time when people *"hoped and wished"* for a better future. The only way they knew how to obtain this was through banding together with friends and companions with similar yearnings for a better world. This can be illustrated by the story of the Pilgrims in England. After many years of persecution by the Church of England, the Pilgrims kept alive the *"hope and wish"* that someday they could worship God in their own manner. This finally came about by the combining of the Pilgrims who had fled to Holland to escape persecution, and those still in England. Together, they purchased passage to the New World. Eventually, the first shipload arrived on the *Mayflower* in the area that we now know of as New England. There each of the Pilgrims used their creative talents to help in the development of the settlement, which flourished against great odds and many deaths.

Today, it seems more appropriate to refer to this house as the house of Goals and Ambitions. A person's goals and ambitions may not necessarily be positive, and the terms "hopes and wishes" have a constructive connotation. Consider, for instance, a man who has struggled eagerly and persistently to achieve something and has finally obtained his goal. Thus, he has fulfilled his ambition and is rewarded for his efforts by gaining prestige in the community (tenth house affair). He proudly shares this achievement with his friends and his group (eleventh house affairs). But if, on the other hand, this man failed in obtaining his goal, fearing "loss of face" with his friends and group, he seeks new friends among men and women who share his attitude of discontent and resentment. He has now become a rebel, perhaps a revolutionary.

IN CONCLUSION

All of us seek friends and groups where we have a common interest. The type of friends we gravitate to depends on what we are seeking in

life. In other words, what are our goals and ambitions?

Perhaps this house can be more clearly defined by using a personal example. In this lifetime, I have gravitated to a variety of friends and group experiences. As I changed within, so, too, did my friends and groups change. I was very church-oriented for many years and socialized with people from my church. As I grew to know my neighbors, I began to socialize with them. When my son, Michael, entered school, I became involved with P.T.A. and gained additional friends and group involvement.

But the biggest personal change came when I became interested in the metaphysical world. I found it increasingly difficult to attend Bible studies without interjecting my own ideas. Many may find this hard to believe, but the Bible is more meaningful to me now then it ever was in the thirty years I studied it. All the sorrows and injustices I saw were finally explained by reincarnation. I remember in college, at Pacific Lutheran, asking my New Testament professor why there were so many deformed and retarded children in the world. His answer was, "To teach us compassion." I cried out, "But why must *they* suffer for me to learn compassion?" His only answer to that was that it was "God's will." Can you imagine my joy now in knowing the answer? And it is so simple really. My professor was half-correct when he said it was to teach us compassion, but since he didn't believe in reincarnation, he didn't know that these souls were satisfying karma. Many destructive lives can be repaid through inhabiting an imperfect body. Sometimes a soul willingly accepts a deformed body, but other souls are required to do so because of their abuse of their physical body or bodies.

After dropping Bible studies, I soon became less interested in socializing with the church members. Not that they aren't beautiful people, for they are, but we no longer had a common interest. I still attend church services regularly, as there is still much truth and wisdom to be gained from each sermon.

I also used to play bridge at least once a month. I still do occasionally, for there is still love on my part for these friends.

Now that I have brought out my total commitment to the metaphysical world, I have been released as a friend by many who cannot understand my revolutionary ideas or mode of life. If you find this happening to you, accept it with love and release your former friends, so that they may seek their own inner illumination at their own pace. Never, never force your goals on to anyone else. It is not your right. So, if you are dropped from a special group to which you have belonged for a long time, accept this as a door closing. You will soon find another door opening that will bring you greater happiness. Above all, do not be bitter. It isn't

their fault. Mentally, send them your love and good wishes on their road through life.

PISCES

Pisces is the twelfth sign of the zodiac.

Its glyph looks like this ♓

Its glyph symbolizes two fish joined together by a cord.

The picture used to describe the sign is The Fishes. Why? One fish represents the personality and the other fish represents the soul. Although they are linked together by a cord, each fish is attempting to swim in the opposite direction. One of the fish must become the master in order to swim the waters of life.

The sun is in this sign from approximately February 21 to March 20.

The planetary ruler is Neptune.

In the natural zodiac, it rules the Twelfth House.

It is feminine, negative (receptive), and a water sign. The element water can be described as feelings, emotional, responsive. Its quality is mutable, meaning adaptable and flexible. This can be combined to describe Pisces as "adaptable feelings."

The parts of the body that are ruled by this sign are: feet, toes, lymph glands, sweat glands, and mucuous secretions.

Some of the things that Pisces rules are: anesthetics, drugs, hospitals, clouds, metaphysical world, and institutions.

Five positive key words are: (1) sympathetic, (2) compassionate, (3) unassuming, (4) imaginative, and (5) self-sacrificing.

Five negative key words are: (1) impressionable, (2) indecisive, (3) self-pity, (4) hypersensitive, and (5) changeable.

Pisces people are found in many different occupations, but most of them would enjoy work connected with animals, films, footwear, the sea, and materials. Some of the careers are musicians, doctors, actors, artists, poets, nurses, prison attendants, asylum attendants, psychiatrists, social workers, and teachers.

The key phrase is "I believe."

The key word is "unity."

Their basic nature is "the mystic or martyr."

The opposite sign of the zodiac is Virgo.

The symbol for Pisces gives a clue as to the reason for their emotional behavior. This symbol is of two fish joined together by a cord. Each fish

is trying to swim in the opposite direction. These opposing forces operate within a Piscean, causing insecurity and indecisiveness. It is extremely difficult for them to handle these forces constructively. Some will seek to escape these pressures through eating, alcohol, drugs, and other excesses. However, the two fish are, also, indications of the two ways open for them. The higher aspect would see them rising to great heights of self-denial and attainment.

Basically, they are creative, self-sufficient people. They have a natural ability for understanding complex material, but this is accomplished by "absorbing" the knowledge rather than studying it. Their minds are extremely active, due to their strong imagination. They sense and feel things that others are not aware of. This could be the general atmosphere in a group or someone to whom they are talking. This trait makes it very difficult for people to lie to them, for they intuitively know when they are being deceived.

Pisceans are congenial, adaptable, and versatile people, but they do not have strong willpowers or a dynamic approach to life. They can appear to be very determined on the outside, but underneath, inner doubts are seething. This insecurity causes them to seek reassurance from others.

Their greatest need is to learn to understand their emotional ups and downs. It is important for them to try to bring these emotions under control, for they not only make the Piscean unhappy, but they make those close to them unhappy, also.

The Neptunian side of Pisces has a way of deceiving others into believing that Pisceans are placid. But, like the other water signs, Cancer and Scorpio, they could stir up a hurricane if anything or anyone makes them deeply unhappy. Or, they could resort to silence. Sometimes a Piscean is silent for other vague reasons. If asked what the problem is, they usually respond that nothing is the matter. This is undoubtedly true in most cases, since a Piscean is never very sure as to what is disturbing them.

Pisceans are called mystics, as opposed to Aquarians, who are usually labeled occultists. Neptune gives the Piscean an elusive quality which is not easily explained. Once Pisceans learn how to use their prophetic gifts and to listen to their strong inner intuition, they will benefit immeasurably. But, since they have a tendency to doubt their own conclusions, they need to learn to believe in themselves. However, these gifts must be used for the benefit of others and not for self-gain.

They are generous with their time in helping other people. But, unless they are evolved, they will expect something in return. They always *feel* their best when they are serving others in some capacity. By using their compassion outwardly for others, they will not become moody and introverted.

Pisces are sensitive, sympathetic, usually gentle, with an inborn reluctance to hurt others or to face any sort of confrontations. Because of this, they can become involved in very difficult emotional situations which they find extremely difficult to break. They intuitively know they are being used, but seem unable to get themselves out of their predicament. This difficulty stems from the fact that Pisceans think with their heart rather than their head, so are easily "used" by others.

They are very sympathetic toward the helpless or downtrodden. They are inclined to adopt the waifs and strays of life (people and animals) on whom they lavish tender, loving care. They do not feel completely fulfilled unless they are involved in helping their fellowman.

While their sensitivity often results in fluctuating emotional moods, Pisceans are very capable of being the life of the party with their gaiety and wit. But they can also be standoffish at a party by withdrawing mentally.

Pisceans are highly secretive. But this can be very appealing to others, as they attempt different methods in order to discover what the Piscean is really thinking. Since Pisceans know how to keep secrets, most people feel they can confide their troubles to them. Even if the Piscean is unable to help them, the person involved usually feels better for having aired the difficulty.

They make friends easily and are quite loyal to them. They do not particularly like verbal or combative fights, but will defend their friends in subtle ways. Because Pisceans are sentimental, you will find your Piscean friend remembering your birthday and anniversary when others have forgotten.

They lack vitality unless other factors in the natal chart mitigate this. Thus, they need sufficient time each day to be alone, while they build back their fluctuating energies. Otherwise, they will become sluggish and sometimes lazy. The parts of the body that may need attention are the feet, toes, mucuous membrances, the arms, hands, lungs, intestines, nerves, and hips.

Pisceans have good clothes sense and usually like their homes to be neat and clean. They have a strong need for a congenial, happy home life, in order to lessen their emotional ups and downs. These emotional ups and downs are very confusing and tormenting to the Piscean. It takes tremendous willpower and concentration on their part to conquer these fluctuating emotional levels.

Their inborn desire to escape from physical living can be used constructively through creativity. All forms of art appeal to them—music, poetry, acting, dancing, reading, theater, etc. They instinctively know their own capabilities and their limitations. Unfortunately, their knowledge of their limitations is what has created their inferiority complex.

173

You will find many Pisceans who enjoy acting, because it gives them the opportunity of being someone else. This enables them to temporarily lose their inferiority complex.

Because of their hypersensitivity, they can become instantly depressed over little things that are said to them. If they feel they are being criticized, they suffer extreme embarrassment. If the criticism becomes too severe, they will panic, causing them to either flee or to become hysterical.

They can appear to be deceitful because of their inborn need to justify their words and actions. If in trouble, they may attempt to rationalize their way out, rather than face the consequences of their behavior.

In love, they are very sentimental and romantic. They like to receive unexpected presents from their loved ones, as well as giving unexpected gifts. They are usually faithful and loyal, with a strong tendency to place their loved one on a pedestal. This leads to disillusionment when they discover their loved one has faults, too.

As Parents:

Piscean parents will expose their children to cultural and art forms at an early age. They make warm, loving parents, but find it difficult to discipline their children. It is most unusual for Piscean parents to physically hit their child. They may, occasionally, snap at them, but will soon explain to the child that they were in a bad mood. These parents must be made to realize that their overpermissiveness will, in the long run, be detrimental to the child. By understanding this, they can correct this problem and be of considerable benefit to their children during their formative years.

Children:

The Piscean children need a lot of attention and security because of their troubled emotions. They are usually good students at school, although they dislike learning facts, except in history. They prefer subjects which stimulate their imagination. They are not particularly fond of active sports. Their natural inclination is toward music, painting, dancing, skating, etc. If they are constantly changing their minds about their goals, they should be assisted by their parents in learning the necessity of completing projects once they have been started. Above all, give them a lot of encouragement and praise for their efforts.

Wherever Pisces is in the natal chart is where you have to use your intuition toward the house affairs. You will need to believe in your hunches and intuitive insights, because there will be no guide lines to help you. Everything will appear to be confusing or misleading. This house, then, is where you must have "faith." "Faith" in the future and in yourself.

The gems for Pisces are the aquamarine and the bloodstone. Both stones represent courage. The aquamarine protects the wearer from the hazards of the sea and helps sharpen the intellect. The bloodstone gives courage and wisdom. The bloodstone is a dark green variety of quartz, which is spotted with red inclusions of jasper. Men particularly like this gem.

The flowers for Pisceans are the violets, orchids, mignonettes, water-lilies, and irises. Their colors are sea green, silver, violet, and purple. Their metal is tin.

NEPTUNE

This planet rules the sign Pisces.

Its natural house is the Twelfth House.

Its orbit takes 165 years.

One complete revolution on its axis takes fifteen hours forty-eight minutes.

It is feminine and negative (receptive).

Its glyph looks like this ♆

This glyph symbolizes matter piercing the personality, in order to set it free from selfish pursuits.

Five positive key words describing this planet are: (1) dissolver, (2) visionary, (3) spiritual wisdom, (4) responsiveness, and (5) creativeness.

Five basic key words describing this planet are: (1) spiritual wisdom, (2) inspiration, (3) compassion, (4) sacrifice, and (5) universal love.

Five negative key words describing this planet are: (1) chaos, (2) confusion, (3) delusion, (4) fear, and (5) escapism.

The basic personality function of this planet is the slow dissolving of old life patterns to bring a new and better pattern.

The parts of the body it rules are: feet, toes, malformations, leakage, toxic conditions, and infectious organisms.

Some of the things ruled by this planet are: secret affairs, divers, submarines, drugs, fraud, liquor, spiritualism, psychic research, fog, mist.

The people represented by this planet are the masses.

The similarity between this planet and the sign it rules is that both have subtle strength, are elusive, appear mysterious, and are little understood.

They differ because Pisceans are attempting to establish firm emotional foundations built on faith in the unknown, while Neptune's aim is to dissolve life patterns in order to try to bring about a new and better life.

Neptune retrograde causes a desire to unveil mysteries and/or to expose religious shams. There is an intuitive awareness of the subconscious mind, but difficulty in "tuning in" to it consciously.

In Greek mythology, Poseidon was the brother of Zeus and Pluto. Poseidon received the sea as his realm. His wife, Amphitrite, gave birth to a son called Triton. However, Poseidon was known to have had many love affairs and was the father of several children who were famed for their wildness and cruelty. The Romans called Poseidon Neptune. He was worshipped as the god of navigation, and temples were erected to him on headlands. Both the Romans and Greeks felt this god controlled the seas and when angry would cause storms and shipwrecks.

Today, the planet Neptune is known to cause confusion in man, chaos of his emotions, and self-deception. It is regarded as nebulous or vague, and true to this quality, was not immediately discovered. It was indirectly sensed because of the gravitational pull it exerted on Uranus, occasionally dragging Uranus out of its regular orbit. This irregularity was observed fifty-four years after Uranus was discovered.

In 1834, an amateur astronomer, the Reverend T. J. Hussey, suggested that the erratic motion of Uranus might be caused by the pull of an unknown planet. His theory was investigated by J. C. Adams in England and Urbain Le Verrier in France. Eventually, Le Verrier's calculations were taken up by the Berlin Observatory, and Neptune was finally located in 1846 when it was in a retrograde motion.

Neptune is similar in size to Uranus, with a diameter of approximately 27,700 miles. Neptune's vast size and its remoteness correspond well to its astrological vibrations of elusiveness and mystery. Pisceans, too, are said to be elusive and mysterious.

It is a beautiful bluish-green sphere. The color bluish-green is the main healing color. It is, also, the color vibration for helpfulness and reliability. In photographs, it sparkles like a four-pointed star.

Neptune is very nearly 2,800,000,000 miles from the sun and requires 165 years to orbit it. At this distance from the sun, Neptune receives only 1/900 of the light and heat received by us on earth. Thus, its surface temperature never rises above $-330°$ Fahrenheit. Its axis rotation is

fifteen hours forty-eight minutes, making it a slightly longer axis rotation period than Jupiter, Saturn, and Uranus. Perhaps this accounts for the difficulty Pisceans have in arriving anywhere on time.

Neptune's atmosphere is composed of mostly methane, with some hydrogen and probably a large amount of water. These elements suggest an elusive but subtle strength. Pisceans may seem elusive, but they, too, have a subtle strength which is not apparent at first. Its density of 2.2 (water is 1) is greater than Jupiter or Saturn, which seems to confirm the theory that Neptune has large quantities of water. Although it can not be stated for a certainty, it is suspected that Neptune, like Uranus, has faint atmospheric bands.

Scientists believe Neptune contains a rocky core of approximately 12,000 miles, an ice layer of 6,000 miles, and a 2,000-mile gas layer covered by clouds.

Neptune has two satellites. Triton, with a diameter of 3,000 miles, is larger than our moon. It rotates backwards in a circular orbit around Neptune. Nereid, which is smaller, was discovered in 1949. The orbit of Nereid is extremely eccentric. Triton orbits very closely to Neptune, which has caused scientists to believe that in 10 to 100 million years, it may be pulled into Neptune's atmosphere. Number two means peace-maker. The traits of number two are tact, diplomacy, cooperation, per-suasion, consideration, sensitivity, modesty, shyness, sincerity, and vague feelings. These traits can be applied to both Neptune and Pisceans.

Neptune seems to be a planet that is little understood. Many people use the word *nebulous* to describe it. Basically, nebulous means vague. Pisceans, too, are very seldom understood and are prone to vague feelings of unrest and turmoil. Neptune's area of influence seems to be more in the psychic realm than in the physical or material realms. It is mystic, working through feelings and imagination. It represents inspiration and feelings from deep within the unconscious mind. That is why it rules the next dimension, which we know of as the "astral plane." Many Pisceans astral travel in a semiconscious state without being aware of it.

Because it is mystic, Neptune finds it difficult to be "earthbound." If you use Neptune wisely, it can help you reach your highest conscious-ness. But if you do not, it will plunge you to your lowest depths. It is not easy to respond fully to the higher vibrations of Neptune, but as we head toward the Aquarian Age, more and more teachers are coming forth to help humanity respond to these higher vibrations.

It must be realized that just because Pisceans are ruled by Neptune, they cannot automatically respond to Neptune's higher vibrations. They, too, must be taught.

For all of us, Neptune's task is to dissolve self-interest in our search

for universal wisdom. The effects of Neptune's vibrations are always internal. They work beneath the surface and are unseen. This is similar to the perils of an iceberg which is hidden beneath the surface. You will experience chaos and confusion only if you attempt to resist the events being brought to the surface by Neptune. Resistance is what causes pain and suffering. Flow with the experiences. The word "dissolver" is a good descriptive word to apply to Neptune, because it slowly dissolves patterns from former lives.

Wherever Neptune falls in your natal chart is where you experience difficulties and can be deluded. At the same time, there is also a deep sense of obligation to the affairs of that house. You may feel internal pressure to plunge into the house affairs. Neptune teaches some unusual lessons in relationship to the house it is in. Self-interest must be replaced with humanitarian interest. This is the area where you have "taken" and must now "replace." You can expect to have problems that are unseen by other people. But, if you use Neptune's positive traits in the house affairs, you will receive unusual blessings.

If Neptune is an angular house (first, fourth, seventh, or tenth), you will have *to actively use* Neptune's positive traits. If it is in a succedent house (second, fifth, eighth, or eleventh), you have *to express* Neptune's positive traits *through your emotions*. And, if it is in a cadent house (third, sixth, ninth, or twelfth), you will have *to readjust your mind to accept* Neptune's positive traits.

Thus, we find that Neptune must dissolve our clarity of thinking in order to dissolve egotism and outdated life patterns, so that you are forced to search within for the truth as to the meaning of the universe.

NEPTUNE IN THE SIGNS

Neptune in Aries: (1861—1874) Strong self-awareness and ideals. These individuals felt they had a mission. They were inspired, sometimes with radical ideas. They also had the ability to promote their ideas. Some were fanatics or schemers who used subversive methods to obtain their goals. Certainly, serenity and complacency were not part of their lives. (Examples: Evangeline Adams, Henry Ford, Richard Strauss.)

Neptune in Taurus: (1874—1887) Artistically inspired with a love of beauty and music. Had good business abilities, with a desire for material comforts. They had discipline of thought, which insisted upon concrete proofs and statistical evidence. Psychic phenomena was either accepted or rejected, after careful and practical consideration. These individuals

had the capacity to heal others through the use of their mind. (Examples: Edgar Cayce, Dr. Carl Jung, Carl Sandburg.)

Neptune in Gemini: (1887—1901) Quick perception, with a desire for variety. Are extremely intuitive and sensitive. There is a restlessness within which causes difficulties in concentrating at times. Ability to write poetry. Can communicate telepathically. They have a gift of subtle persuasion. Could be influenced or misled by others. Tendency to worry and/or be narrow-minded. Many of these individuals had to sacrifice education in order to help their parents financially. (Examples: Charles Chaplin, Adolf Hitler, Ernest Hemingway.)

Neptune in Cancer: (1901—1915) Instinctual action. Are intuitive and psychic. A desire for social acceptance. These individuals are very susceptible to emotional appeals, with a tendency to become over-emotional and/or too negative. There also could be an inclination for self-indulgence through food, alcohol, drugs, or sex, because of their inability to face the world as it is. They have strong feelings toward home and family, particularly to their mother. If Neptune is heavily afflicted, the individual would have experienced upsetting karmic conditions through the home and mother. This placement gives these individuals the ability to look back into their subconscious minds and bring forth the wisdom stored there from previous incarnations. By using Neptune's vibrations correctly, they will show true compassion and a willingness to serve others without thought of self. (Examples: Bob Hope, Dag Hammarskjöld, Jonas Salk.)

Neptune in Leo: (1915—1929) Creative inspiration. Warmhearted individuals. They have the ability to lead and inspire others. They are easily susceptible to flattery, which could cause them to become conceited and egotistical. There is a love of physical pleasures of all kinds, such as socializing, traveling, eating, drinking, sex, etc. A strong desire to escape into a make-believe world. Thus, entertainment of all types appeals—movies, theater, TV, etc. This placement indicates a need for dissolving self-interest into universal interest. (Examples: Shirley Temple Black, Margot Fonteyn, Judy Garland, Billy Graham, Martin Luther King.)

Neptune in Virgo: (1929—1943) Practical intelligence. They have the ability to absorb and teach. Are scientifically oriented, which could cause them to be skeptical of psychic matters. They could also be critical or fault-finding of others. Interested in social conditions, of being of service

to others, and of healing through natural methods, such as herbs and mental healing. These individuals have the ability to heal psychically. This placement places great strain and tension between intuitive feelings and scientific reasoning. Many who are unable to blend these, suffer greatly from nervous tension, due to their inability to face the world as it is. The answer lies in giving themselves in service to others in some form, or they will fall victims to psychosomatic illnesses.

Neptune in Libra: (1943—1957) Humanitarian impulses. Artistic abilities in some form. Desire for harmony, peace, and justice. These individuals are easily deceived by others. Their lesson concerns cooperative relationships. There is a need for them to learn to compromise and to sacrifice, if necessary, in order to bring about an inner change of attitude. They have difficulty in maintaining mental stability when being deluged with external pressures. They must gain a sense of identity so that they can relate harmoniously to the world around them. Thus, the rational mind is replaced by the intuitive mind.

Neptune in Scorpio: (1957—1970) Emotional intensity which stimulates the desire to investigate, but also creates inner reserve and secretiveness. Are intuitive. An interest in the metaphysical world. Extremely sensitive, but this sensitivity can be used in understanding the emotions of those around them. There can be a desire for physical pleasures of all kinds, such as socializing, traveling, eating, drinking, drugs, sex, etc., which are used to escape the pressures of earthly living. Others will escape through long hours of daily meditation practices. Because of the intensity of the Scorpio sign, Neptune here indicates these individuals must choose either the high road or the low road, for there is no in-between. There are many who will choose the high road and will use their gifts in helping humanity. Others will choose the low road and will be unreliable, unstable, and totally irresponsible, with their lives revolving around obtaining as much physical pleasure as possible. If they constantly pursue this low road, it will eventually lead them to self-destruction.

Neptune in Sagittarius: (1970—1985) Philosophical, prophetic, and restless. These individuals will have a strong love of freedom and an optimism in the future. They could be extremely "far-sighted," with an ability to develop clairvoyance. Many of these souls will seek to dissolve dogmatic concepts of religion and morality. Others will be troubled with disturbing dreams and visions and will need special help in dissolving these "ghosts" that haunt them from past lives.

Neptune in Capricorn: (1985—2000) Ambitious and contemplative, with good business ability. Strong intuition, which will be used on practical affairs. Many evolved souls will elect to come at this time to serve humanity as educators, leaders, and spiritual teachers. They will seek to establish a perfect world.

Neptune in Aquarius: (2000—2015) Inspirational. Strong humanitarian ideals. Kindly, gentle individuals who will seek to blend philosophical, political, and social ideals into one doctrine. They will bring with them new knowledge concerning the healing of the mental body through breathing.

Neptune in Pisces: (2015—2030) Inspirational. Mystical, with the desire to be in an expanded state of consciousness. Capable of attaining harmony between the physical and the spiritual world. They will have a complete unification of the five bodies (physical, etheric, conscious, subconscious, and superconscious). These souls will help teach the complete unity and development of the illuminous body consciousness in a physical world, so that humanity will be in a permanent state of clarity and bliss.

NEPTUNE IN THE HOUSES

Neptune in First House: Visionary, artistic, and hypersensitive. Can become moody, frustrated, or unstable. They can lose themselves in a world of imagination. Strong desire to escape from the pressures of everyday living. Psychic sensitivity which could bring confusion, until the individual seeks spiritual evolvement. Discontent with life emotionally will cause a depleting of energies from the physical body. Medical knowledge will not be able to help these individuals if this occurs, because healing can only take place if they change their inner attitudes. This placement can be used constructively, because of the strong psychic sensitivity which would make them a healing agent for others.

Neptune in Second House: Strong imagination and psychic sensitivity which can be used to tap inner talents. Receive intuitive hunches. Apt to have vivid dreams. An appreciation of beautiful objects. They seldom worry about money, which is just as well since their finances are complicated and apt to be confusing at times. This placement can make the individual extremely generous or extremely dishonest. If dishonesty is present, they will experience losses through theft, fraud, and deception.

Neptune in Third House: Intuitive, idealistic, artistic, with flashes of inspiration. Their extrasensory perception gives them clairvoyance, which can be developed to its fullest capacity if so desired. They find difficulty in concentrating on academic work, but if they have self-discipline, they can do extremely well in school. There are karmic obligations with relatives that need to be reconciled. Feelings of insecurity in early life which causes them to suffer nervous disorders. This will dissolve when they understand their need to reorientate their thinking with regard to their relatives. They could be unreliable or negative. Unless their strong psychic gifts are channeled correctly, they can become prey to obsessions and hallucinations.

Neptune in Fourth House: Sense of inner uncertainty, fears, and anxieties. There is a tendency to idealize the home environment or to imagine it as they would like it to be. Could be an adopted child. There is a spiritual tie with the parents which has been reestablished so that it can be completed in proper perspective. Tendency to want to withdraw from life due to feelings that an ideal home is not possible. Therefore, they could become recluses, seek spiritual institutions, or communes where they would not be obliged to live a family life. This placement is challenging them to establish inner security based on reality and not on imagination. Thus, they will have to dissolve former past lives' attitudes about "perfect" home environments.

Neptune in Fifth House: Artistic, strong imagination. Enjoyment of the entertainment industry. Could become an entertainer. This placement can bring chaotic love affairs due to overidealizing their loved one, and/or because of the need to dissolve former lifetime relationships. The frustrations they experience in these love affairs may drive them to illicit and secretive sexual adventures. Their children will be unusual, sometimes with health problems which force the parent to give the child individual care. Their concern for their child will dissolve their own desires for personal pleasures by being of willing service to another. Thus, past lifetimes' selfishness is mitigated.

Neptune in Sixth House: Inspirational mind. Humanitarian ideals. This placement weakens the energy field, causing difficulty in concentrating on the organizing of details or in getting started with their work. In their work, they will encounter people who are "two-faced," causing them pain and suffering. Extremely sensitive, which opens them to unusual health difficulties. Are psychic sponges absorbing the atmosphere around them. Respond best to herbal methods of healing and to the transformation of

182

their thoughts. These individuals will make great sacrifices for their ideals.

Neptune in Seventh House: A quest for a "soul mate" which is denied in this life due to the need for tolerance and compassion in cooperative relationships. The marriage will require the individual to make sacrifices for the marriage partner. The marriage partner can be spiritually minded or artistic, but communication is a problem due to their concepts and ideals not coinciding. Thus, the individual with Neptune placed here must learn to be tolerant of other people's right to their views. They will, also, experience treachery and plotting from former lifetime enemies, which could lead to court trials and which are a source of much suffering and sorrow to the individual. These individuals must learn to forgive and forget, for they will be required to give much with very little given in return.

Neptune in Eighth House: Psychic and intuitive, with dreams and visions which are precognitive. There is extreme sensitivity to the feelings of others. If this individual is not honest, he will suffer financial reverses in order to prove the futility of seeking happiness through material possessions. Extremely easy for these individuals to astral travel while semiconscious. This should be utilized only for constructive reasons. Neptune here calls for the individual to channel his psychic abilities into creative endeavors to assist humanity.

Neptune in Ninth House: Idealistic, intuitive, and mystical. Will seek some type of philosophy of life based on the knowledge of life after death. These individuals could become religious fanatics. There can be a tendency to be either extravagant or to exaggerate. This placement has a tendency to cloud good judgment. Should think things through before proceeding. In their travels, they prefer to wander around on their own without too much planning. There can be difficulties with in-laws, due to lack of compassion and understanding. Neptune placed here can assist these individuals through many difficulties and troubles, if they use its higher vibrational influence of spiritual wisdom and understanding.

Neptune in Tenth House: Strong idealism. Neptune can be used constructively in work that is inspirational, artistic, or psychic. It is, also, a good placement for any type of humanitarian work. This person's public image will suffer ups and downs by forces beyond their control. This is a karmic debt, indicating they have been instrumental in causing others to lose public esteem through false innuendos. There is, also, a karmic debt

relationship with the father which must be resolved. These individuals will feel as if they have been rejected by their father and by others. This could lead to either resentment and dissatisfaction with life, or depression and self-doubts. These difficulties must be purified through forgiveness. Neptune will assist these individuals to transcend these difficulties, if they will allow its higher vibrational influence to dissolve these past lifetime debts through spiritual wisdom and understanding.

Neptune in Eleventh House: Idealistic and humanitarian. Strong hunches which are accurate. There is difficulty in deciding upon definite goals. Apt to dream about achieving a goal, rather than applying themselves to obtaining it. Attract Neptunian type of friends who can be inspirational, spiritual, loyal, or deceitful and unreliable. This placement calls for these individuals to pursue definite goals, trusting in the higher vibrational quality of Neptune to guide them intuitively to the fulfillment of their "dreams."

Neptune in Twelfth House: Reflective and intuitive. Have psychic ability which operates unconsciously, filtering through to the conscious mind which the individual may, or may not, be aware of as a psychic thought. Because of Neptune's placement in its own house, these individuals have intense feelings of loneliness and of being in bondage to a specific person or persons. This can be alleviated only through the attainment of spiritual wisdom, which will show that these individuals are secret enemies who have returned to them in order to obtain justice. Forgiveness, love, and understanding is the key here. These people are capable of extreme compassion and service to others if they do not become bogged down in the material world, resentment, or in self-pity. Many doctors and nurses have Neptune in this house, showing their desire to dissolve their karmic debt through serving those who suffer.

TWELFTH HOUSE RULERSHIP OUTLINE

SOUL GROWTH THROUGH FRUSTRATIONS, ATONEMENTS, SERVICE, AND ULTIMATE UNDERSTANDING:

(1) Self-Undoing, Frustrations, and Limitations

 a) *Memories of past lives* filtering through from the subconscious mind
 b) *Our secrets* we keep hidden from others
 c) The meeting of *past lifetimes' enemies*
 d) *Our silent suffering and sorrows* (mental pain)

(2) *Karma* (Law of "An eye for an eye, and a tooth for a tooth")

 a) *Atonement* required for past misdeeds from our present or past lifetimes
 b) *Rewards* given for past good deeds from our present or past lifetimes

(3) *Service*

 a) *Given* (service given freely *by you to others* "to atone" for your past misdeeds, or "out of love" for them.)
 b) *Received* (service given freely *to you by others* "to atone" for their past misdeeds to you, or "out of love" for you.)

(4) *Confinement* (Loss of identity through dressing alike, behaving alike, and being treated alike)

 a) *Institutions*—Mental or Prison
 b) *Hospitals*
 c) *Nunneries, Monasteries, Ashrams, etc.*

(5) *Ultimate Understanding*

 a) *Oneness With Humanity*
 b) *The Flowering of Your God Consciousness* (Those who retreat into monasteries, nunneries, or ashrams may find enlightenment and transcendence, but they must be able to retain it in daily living in society.)

SIXTH HOUSE RULERSHIP OUTLINE

(Compare with the twelfth house rulership outline above)
PERSONAL GROWTH THROUGH HEALTH, WORK, AND SERVICE:

(1) *Health* (Physical or mental problems indicate an inability to establish emotional security, so the soul seeks a respite or to escape.)

 a) *Good Health Indicates*
 1) Proper care of the physical body
 2) Ability to meet crises and challenges
 b) *Ill Health Indicates*
 1) Abuse of the body through excess, such as alcohol, drugs, tension, etc.
 2) Inability to cope with crises and challenges

3) Attempt by the soul to change an attitude or to repay Karma
4) Normal body disintegration due to old age

(2) Work (Your working conditions and how you react to these conditions)

a) *Contributing to productivity and growth of the community through*
1) Employment
2) Service (working in the community without thought of reward or remuneration)
b) *Adjusting to demands made by*
1) Employers
2) Fellow Workers
3) Society

(3) Service (Our reaction to others)

a) *Our capacity and willingness to serve others without reward or remuneration*
b) *Our treatment of those who serve us as*
1) Servants (such as clerks, waitresses, repairmen, bus drivers, etc.)
2) Employees (people we employ to work for us)

TWELFTH HOUSE

This is a cadent house, indicating adaptability. It is considered a cadent house because it corresponds to mutable signs.

The natural ruler of this house is Pisces. What is the relationship between the sign and the house? Pisces is the need to gain inner strength, unselfish love, and faith in the unknown. The twelfth house refers to soul growth through suffering, forgiveness, and faith in the unknown.

The natural ruling planet is Neptune. What is the relationship between the planet and the house? Neptune is the unconscious urge to dissolve past lifetime patterns for a new and better pattern, and the twelfth house is the need to atone for our past lifetime patterns so that a new and better life pattern may be formed.

If the sun were in this house, it would be approximately 6:00 A.M. to 8:00 A.M.

This is a House of Endings which corresponds to water signs. This means it is a house of inner emotional levels pertaining to the subconscious and the completion of karmic relationships.

This house rules: (1) Self-Undoing, Frustration, and Limitations

(2) Karma

(3) Service (given and received)

(4) Confinement

(5) Ultimate Understanding

This house is found in the Fourth Quadrant above the horizon.

The opposite house is Sixth.

What is the relationship between the sixth and twelfth house? Both refer to self-adjustment, health, and service to others.

How do the sixth house and the twelfth house differ? The sixth house refers to *personal growth* through personal adjustments, physical health, work, and service given to others without thought of reward or remuneration. The twelfth house refers to *soul growth* through atonement for past karma, mental health, and service to others out of love or atonement.

All of our past lives show up in the twelfth house for atonement or reward. All of our misdeeds and good deeds are revealed there. This is why it is called the house of self-undoing, frustrations, confinement, secret enemies, karma, and ultimate understanding. We have all taken from society in a variety of ways, and everything we have taken must be repaid. This is universal law and is irreversible. Some souls may be working on a heavy karmic repayment in this lifetime, while others may find they are only working on one particular phase of karma.

In the twelfth house, the individual meets the accumulated results of his past. This house is where man is confronted with his successes and failures from both his present life and his past lifetimes. These memories flow back and forth from the conscious mind to the unconscious mind. They can be memories which aid in obtaining ultimate understanding, or they can be memories of fears, frustrations, denials, and sins which continually disturb our tranquility. Each individual has to face these memories because he has created them. Eventually, the misdeeds must be atoned for, if there is to be any soul growth in this lifetime.

There is no escape from this confrontation. Many people in their new body feel they can escape their misdeeds from the past. They struggle desperately through their daily life, only to be assailed at night with memories that filter through in their dreams. Yet, this misery could be alleviated if man realized that he can redeem himself through love and forgiveness.

What one must always keep in mind is that you may be the injured party in this lifetime, but you have only attracted what was needed to atone for errors in previous lifetimes. In the Bible, Jesus constantly mentioned the need to forgive your fellowman. We read in Matthew, chapter 18, verses 21 through 22, "Then Peter came to Jesus and asked, 'Lord,

how many times can my brother sin against me, and I have to forgive him? Seven times?' 'No, not seven times,' answered Jesus, 'but seventy times seven.' " Jesus further explained his answer by telling the parable of the unforgiving servant and warned Peter at the end of the parable in verse 35, "That is how God in heaven will treat you if you do not forgive your brother, every one of you, from your heart." And so, each time you refuse to forgive your fellowman, a karmic debt is incurred between you. It is like an invisible cord that binds you together for eternity until one of you seeks to sever this karmic bondage of all the negative experiences you shared together. There is no need to find out what all these negative experiences have been. Forgive the other person and yourself from your heart. This severs the cord between you, and you are released. This is such a simple thing. But it isn't as easy to do as it sounds, because our suffering can bring forth the desire for revenge.

Then, too, not only must we face individual karma, but we are also faced with group, race, and nation karma. If we enjoyed and actively participated in pleasure-seeking or destructive groups, we must face the fate of that group in another lifetime. This entire group would have to incarnate together and suffer poverty, persecution, or destruction.

It is easy to see that the twelfth house forces us to face the law of cause and effect. Of course, there is always the possibility we could go to sleep spiritually this lifetime and allow life to roll by. But our soul is calling for us to balance our ledgers, so that we might share the rewards of the Golden Age of Aquarius. We have already had many lifetimes of spiritually sleeping, so it is time to wake up and begin to work. The right road to ultimate understanding is not an easy road, as it involves a lot of hard work and study. But any effort made is another step toward leaving the wheel of physical incarnation forever.

When we studied the sixth house, we saw the crises we have had to face, and still might, in this lifetime, in order to develop personal growth. In the twelfth house, the crises are very critical, because they are developing soul growth. Pain is experienced in both houses—physical pain in the sixth house and mental pain in the twelfth house. Mental pain is harder to bear, because the anguish of the mind can eventually cause physical pain to manifest in the body as well. However, we have no choice but to face our misdeeds from previous lifetimes. Try to accept each painful experience as yet another step along the pathway back to God.

Before a soul decides to be reborn, it must decide what type of karma it wishes to repay in this new life. Then, parents are selected who will help with this karma. Since physical incarnations are difficult, souls incarnate near or with some of their loved ones from previous lifetimes. These loved ones are lifelines who will encourage and help this soul.

When a woman is around six months pregnant, or even later, the soul will enter the fetus. Thus, when the right astrological time is near, the soul activates the fetus to begin labor so that it can be born at the exact moment in time for karmic obligations to be set in motion. Sometimes a soul is not sure as to whether the unborn fetus is the correct vehicle, so it will not enter the body until after birth. This still does not affect the astrological influences upon the body. Within three months of birth, the soul knows whether or not the parents and the environment will be conducive to repaying the karmic debts decided upon. If it is not, the soul will leave the body. Without a soul, the body dies, and the death is classified as a "sudden crib death syndrome." A soul cannot afford to waste a life, so if it appears that the environment will be either too easy or too difficult, it leaves.

When we are in the spirit realm, atoning karmic debts seems to be reasonably easy. But once we are in a physical body, we are once again assailed with pain, cold, heat, grief, fear, and physical limitations. As tiny babies, we are immediately frustrated by our inability to communicate or to move around. And so, what seemed easy in the spiritual realm is no longer easy. No wonder, then, that this new life may find itself stifled by too great a karmic load, so that it tends to forget what it set out to do. Then, the life becomes nothing more than a repeat of a former life, but with a different setting and situations. However, if this new life does meet the confrontations of the twelfth house successfully, this individual is on the road to ultimate understanding, oneness with humanity, and reunion with God. Thus, enlightenment and transcendence of our personal ego will free us from our cycle of physical rebirths and from our wheel of karma.

With the discovery of Pluto, the knowledge of reincarnation has merged from "underground." Eastern philosophies have always believed in reincarnation. It was only the Western World which didn't wish to accept the concept of more than one life. The trailblazer for the Western World was Edgar Cayce, the Sleeping Prophet, who died on January 3, 1945. His revelations showed that man need not fear death, for we were granted many lives in order to work our way back to God. Death is nothing more than the closing of another chapter in our evolvement. But finishing a chapter in our book of soul evolvement can be a difficult task. A successful and happy ending is always desirable to each chapter. We destroy much of our good works by fearing death and treating it as a tragedy. So, take control of your life and fulfill your repayment plan from your past lives, and bring this new chapter to a successful and happy conclusion.

Each of us has obviously left something undone from previous life-

times, or we would not be here today. The memories of what we didn't do or say haunts our subconscious. We must have the courage to realize that we cannot accomplish all that we would like to do. Let the chapter of this life reflect what you have accomplished and not what you wished you had. There will be another opportunity in a new life to write yet another chapter in your book. There is no time limit. And yet, in a sense, there is, because if you truly seek to end your personal sufferings and sorrows, you must place your feet firmly on the pathway to illumination and enlightenment, or it will never end.

So, in the twelfth house is found many karmic obligations, old enemies, and ultimate understanding. We have to make a decision as to whether or not we want to lay to rest these subconscious fears and guilts. Or, will we allow them to overwhelm us so that nothing is solved, and we are once again spiritually asleep? To awaken and meet the unknown, we must have courage, faith, compassion, and love.

> I sought my soul, but my soul I could not see.
> I sought my God, but my God eluded me.
> I sought my brother, and I found all three.

<div align="right">—Anonymous</div>

Moon Phases

Part of Fortune

MOON PHASES

1) New Moon Phase

Are acting instinctively to outside events and people. They operate in a spontaneous, unplanned way. They are a magnetic type of people, with Aries characteristics. They draw people to them Have a lot of physical charm. There is a lot of confusion around them, but they like it. They do not like to be too organized. They may cause distress for others by unconsciously projecting their negative emotions.

2) Crescent Moon Phase

Are acting instinctively to outside events and people. They are struggling out of past-life patterns and insecurities. They like to get new things started and are self-assertive when feeling confident. There are a lot of obstacles in their life. This is a karmic thing, because they are forced to meet many people from past lives. They feel haunted, as everything seems to repeat itself. It is essential for them to respond to events and people in a different manner in this life. Otherwise, it will be repeated again and again until the response is the correct one.

3) First Quarter Moon Phase

Are acting instinctively to outside events and people. They encounter resistance and crises from the people around them. They need to learn

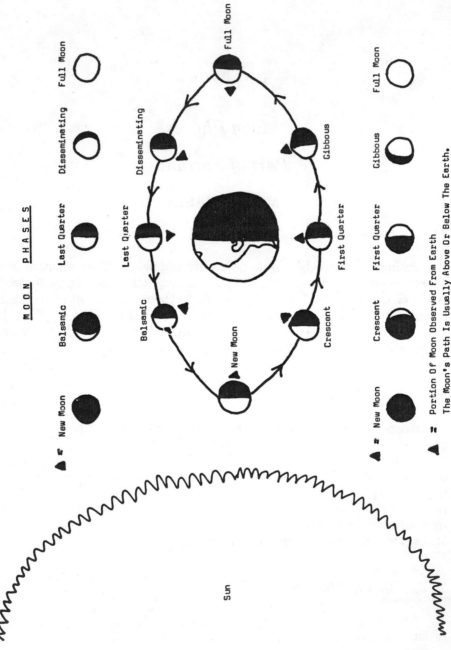

MOON PHASES

New Moon • Balsamic • Last Quarter • Disseminating • Full Moon

Full Moon

Disseminating • Last Quarter • Balsamic • New Moon • Crescent • First Quarter • Gibbous

Crescent • First Quarter • Gibbous • Full Moon

Sun

▲ = New Moon
◼ = Portion Of Moon Observed From Earth
▲ = The Moon's Path Is Usually Above Or Below The Earth.

to flow with these experiences, as people are helping them toward soul growth. There could be a tendency to bang around, drop or kick things, in their struggle with themselves, people, and events. There is good managing ability. Have cardinal quality tendencies. They are good at reforming old structures—things that are no longer needed. There is a desire to change people, too.

4) Gibbous Moon Phase

Are acting instinctively to outside events and people. They are searching for a goal through study and analysis. They need to know if what they are learning will help them grow as a person. There is a deep desire within to develop soul growth this lifetime. This is expressed consciously through the questioning of theories to see whether these theories could/would apply to their life. They are always relating one experience with another. Are good at analogies. Have prophetic abilities.

5) Full Moon Phase

Are acting consciously to outside events and people. Their reactions are under their full control and are from personal choice. They are learning to think before they act, in order for them to see how their actions will affect others. By thinking of how their actions will affect others, they are fulfilling karmic obligations through people. They have personal magnetism. This causes people to be drawn to them. However, this can be frustrating to the Full Moon Phase individual, since many of these people bring their problems to them to be solved. Full Moon Phase people have many difficulties of their own and feel they cannot handle any more problems. In their relationships with others, they run into every conceivable problem. These individuals want the perfect relationship and the perfect mate. If they are unable to accept the fact that there are no perfect people, they will retreat from society to become a recluse or to enter a religious monastic life.

6) Disseminating Moon Phase

Are acting consciously to outside events and people. Their reactions are under their full control and are from personal choice. These people share with others what they have found to be meaningful to themselves. They have the talent for promoting others and/or promoting the ideas of

others. They need to tell everything they have learned. Thus, they are the crusaders in religions, ideas, concepts, philosophies, etc.

7) Last Quarter Moon Phase

Are acting consciously to outside events and people. Their reactions are under their full control and are from personal choice. These people are going through crises and changes, in order to reorient their thinking. There is a strong crisis of consciousness, "Who am I?" They have strong principles. Sometimes, they get themselves into difficulties, because no one seems to understand these principles which appear to be contradictory. These individuals are the most strongly affected by Mercury phases, especially Mercury Retrograde. When Mercury is retrograde, they look inside themselves, and when it is direct, they look outward.

8) Balsamic Moon Phase

Are acting consciously to outside events and people. Their reactions are under their full control and are from personal choice. These people are changing personal desire into group desires or goals. From these people, something new emerges which will benefit others. The number who benefit is immaterial—a few or many. There is a feeling of being possessed by destiny. They could be the ones who get involved with causes, for they are very humanitarian people. They feel a draw to the metaphysical world, as they want to know about their past and the meaning of life. They have prophetic abilities.

New Moon Phase—Impulsive activity with no thought of consequences.
Crescent Phase—Internal struggle due to the repeating of events and the remeeting of old enemies from previous lifetimes and/or this life which must be resolved. Are given assistance from old friends from previous lifetimes and/or this life.
First Quarter Phase—Are outwardly blocked by people and events in order to push them onto the correct pathway.
Gibbous Phase—Desire to study and analyze because of a need to find a pathway which will develop soul growth.
Full Moon Phase—Difficulties in relationships with others. Must learn to think before they speak.
Disseminating Phase—Sharing with others what they have found to be meaningful.

PHASE WHEEL

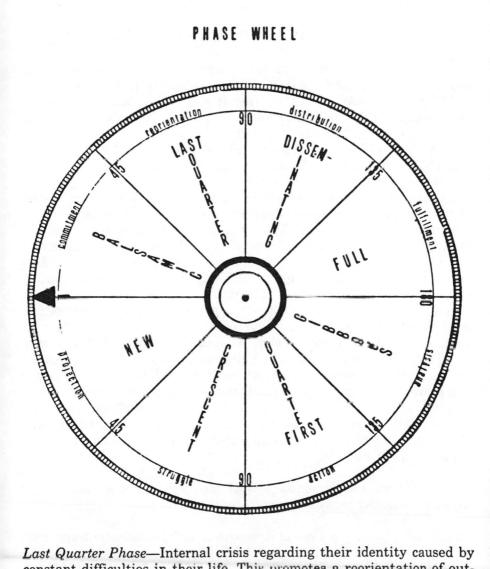

Last Quarter Phase—Internal crisis regarding their identity caused by constant difficulties in their life. This promotes a reorientation of outmoded thinking.
Balsamic Phase—Learning to share their personal resources with others in order to be of benefit.

PART OF FORTUNE

There are many "Arabian Parts," and all of them are formed by adding the degrees and the sign of the planet concerned to the degrees and the sign of the Ascendant, and from this sum, subtracting the degrees and the sign of the sun. Thus, an area in space is pinpointed. In the case of "Part of Fortune," the planet concerned is the moon.

The "Part of Fortune" is the most important of the "Arabian Parts," because it is the outlet for the stress energy of the Moon Phase. The house affairs where it is located are instinctively worked on by the individual in order to alleviate the distress from the Moon Phase. The sign the "Part of Fortune" falls in represents the traits that should be incorporated into their sun-moon personality. These traits must be used constructively toward the house affairs in order to mitigate the Moon Phase emotions.

It has been said that the "Part of Fortune" benefits the house it falls in, but I have found that this is true only in the sense that you are prodded to develop, cultivate, and learn about the affairs of the house it falls in. The happiness attributed to this part is really a search for freedom from the stress of the Moon Phase emotions. Aspects to the "Part of Fortune" from the planets will show what helps or hinders in this search.

Thus, it can be said that the affairs ruled by the house in which the "Part of Fortune" falls are those in which the individual is truly interested and in which he wants to find fulfillment—whatever he may say to the contrary. Unfortunately, many people instinctively work on the wrong affairs ruled by the house and, thus, continue to be buffeted by their Moon Phase emotions. It is essential to give them guidance as to what house affairs to work on.

The following is a guide as to which affairs should be worked on and what the individual may be doing instead:

First House: Develop a Correct Approach to Life (Inconsistent approach to life, face lifts, plastic surgery)

Second House: Develop Hidden Talents and a Sense of Self-Worth (Money, possessions)

Third House: Cultivate Community Involvement and Concern (Scientific knowledge, intense involvement with relatives)

Fourth House: Develop Secure Inner Foundations (Grandiose home, mother attachment)

Fifth House: Develop Creative Self-Expression (Love affairs, children, gambling)

Sixth House: Serving Others (Hard work, minor ailments, hypochondriac tendencies)

Seventh House: Relating to Others (Many marriages and/or partnerships)
Eighth House: Sharing With Others (Non-participation in organizations or partnerships, but a perpetual joiner of different organizations. Desire to use the personal resources of others.)
Ninth House: Studying Philosophies and Religions (Religious fanatic, "underdog" fanatic, intense involvement with in-laws)
Tenth House: Serving Society Through Personal Achievements and/or Career (Social prestige sought, power trip, egotist)
Eleventh House: Establishing Goals and Developing Friends (Name dropper, social butterfly, many acquaintances, but no depth to any of the relationships)
Twelfth House: Search for Truth and Wisdom (Retreat from society, lawlessness)

The following is a list of key words for the zodiac signs in which the "Part of Fortune" may fall. These are the qualities that should be incorporated into the Sun-Moon personality.

Aries: Courage, inspiration, patience
Taurus: Practicality, reliability, perseverance
Gemini: Versatility, curiosity, wit
Cancer: Industry, conscientiousness, sympathy
Leo: Ambition, optimism, generosity, enthusiasm
Virgo: Analytical thinking, reliability, tolerance
Libra: Diplomacy, cheerfulness, graciousness
Scorpio: Efficiency, ambition, organization
Sagittarius: Friendliness, dependability, honesty, optimism
Capricorn: Responsibility, efficiency, patience, practicality
Aquarius: Originality, helpfulness, friendliness, tolerance
Pisces: Compassion, modesty, industriousness

Instructions for determining your Part of Fortune:

	Zodiac Sign Number	Degrees	Minutes
Ascendant (Aquarius)	11	9	40
Moon (Taurus)	+2	+18	+18
Totals	13	27	58
Sun (Pisces)	−12	−18	−03
Totals = Part of Fortune	1	9°	55′

197

The first sign of the zodiac is Aries, so this "Part of Fortune" is 9° Aries 55'.

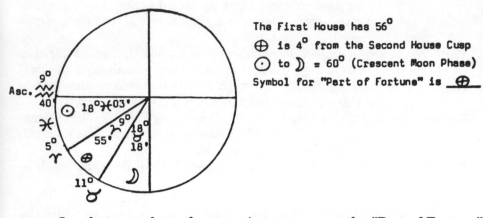

The First House has 56°

⊕ is 4° from the Second House Cusp

☉ to ☽ = 60° (Crescent Moon Phase)

Symbol for "Part of Fortune" is ⊕

In whatever phase the moon is to your sun, the "Part of Fortune" will be in the identical phase to the Ascendant. So, if the Moon is in a Crescent Phase at 60° ahead of the sun, the "Part of Fortune" will be approximately 60° ahead of the Ascendant. In other words, the "Part of Fortune" is an equal distance from the Ascendant as the moon is from the sun. If your natal sun were placed on the Ascendant and your moon in its correct phase relationship and zodiac sign, the moon would fall in the same house as your "Part of Fortune."

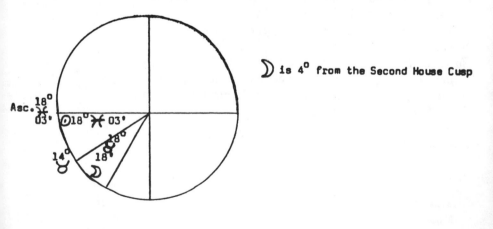

☽ is 4° from the Second House Cusp

CHAPTER 7

♌ Moon's Nodes ☋

MOON'S NODES

The Nodes tell us where we need to do some hard work. The North Node (♌) is the path of spiritual growth, and the South Node (☋) leads to personal growth, if the North Node house affairs are developed. In past lives, we have neglected the affairs of the North Node house and now the matter is of extreme importance. Certainly, you can refuse to do the hard work of that house, but in your next life, the North Node will appear in the same house again, with additional stress points in order to force you to do the work that is necessary. The South Node house has been used by us repeatedly to the point that certain traits are ingrained and need to be reevaluated through new ideas and thoughts from the North Node house affairs. The nodes are always in opposition to each other—on the same principle as the North and South poles.

The North Node (♌) is the point where the moon, on its way to earth's Northern Hemisphere, intercepts earth's orbit around the sun. It is a focus point similar to Aries and indicates where new growth is needed. So, in the house where your North Node falls is where you need to grow and learn, in order to share your knowledge and experiences with others through the affairs of the South Node house.

The South Node (☋) is the point where the moon, on its way to earth's Southern Hemisphere, intercepts earth's orbit around the sun. It is similar to Libra and where we reap the fruits of our harvest from the North Node house. In other words, the seeds we grew and cultivated in the North Node house can be harvested (analyzed) and shared (disseminated) with others through the South Node house affairs.

Think of the North Node (♌) as a hand (it looks something like one) that is reaching to grasp experience and knowledge. This hand can

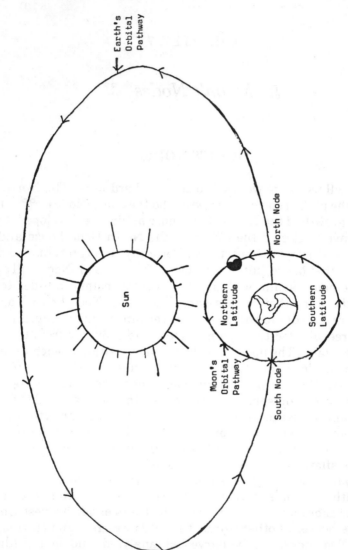

M O O N ' S N O D E S

Earth's Orbital Pathway

Sun

Moon's Orbital Pathway

Northern Latitude

Southern Latitude

North Node

South Node

North Node: The Exact Point Where The Moon Intercepts Earth's Orbital Pathway On Its Way To Earth's Northern Hemisphere.

South Node: The Exact Point Where The Moon Intercepts Earth's Orbital Pathway On Its Way To Earth's Southern Hemisphere.

plant seeds for mental growth, pick up books for knowledge, drive a car to a place of learning, pick up a phone to ask questions in your search for wisdom, etc. If you do not use the North Node, it atrophies, so that the individual concentrates more and more on the South Node house affairs. When this occurs, they begin to experience frustrations and losses in the South Node house affairs, because they have fallen back into former lifetimes' patterns. Thus, more and more of the negative traits of the South Node zodiac sign manifest.

The South Node (♈) is a cupped hand extended out to others, filled with gifts from your North Node harvest. However, some use the South Node cupped hand to say "fill it up, please" and expect others to provide them with all the answers of the North Node house. Certainly, a teacher is necessary to help you get started in correctly working on your North Node house affairs. But there comes a time when you must spread your wings and "fly" alone. No one should be allowed to be a perpetual student. The knowledge absorbed from a teacher must be put into practice and reformulated by your unique individuality. Then too, no one should become totally engrossed in the affairs of the South Node house that they do not bother to bring new nourishment from the North Node house. For, what does it profit you if you gain the "world," but lose "soul growth"?

The sign the nodes are in are also important as they tell you what qualities you should cultivate. The North Node (♌) is pointing out the need to develop the positive qualities of the sign, and the South Node (♈) is indicating that you have, unfortunately, developed the negative characteristics of the sign it is in with regard to the South Node house affairs.

Zodiac Signs:

NORTH NODE:

Aries: inspiring, courageous
Taurus: persevering, practical
Gemini: expressive, versatile
Cancer: industrious, sympathetic
Leo: ambitious, generous
Virgo: analytical, tolerant
Libra: diplomatic, cheerful
Scorpio: efficient, organized
Sagittarius: honest, optimistic
Capricorn: efficient, patient
Aquarius: original, helpful
Pisces: compassionate, industrious

SOUTH NODE:

Libra: indecisive, dependent
Scorpio: vindictive, resentful
Sagittarius: changeable, tactless
Capricorn: self-absorbed, pessimistic
Aquarius: rebellious, detached
Pisces: indecisive, overly sensitive
Aries: impulsive, rebellious
Taurus: stubborn, jealous
Gemini: inconsistent, impatient
Cancer: emotional, argumentive
Leo: intolerant, dictatorial
Virgo: critical, intolerant

Nodes in the Houses

First House and Seventh House

North Node in First House—South Node in Seventh House

There is a need to learn "to become" independent. They have allowed others to make their decisions for them and now must contribute to any relationship on an equal basis. Through their own efforts, they must develop their approach to life. Otherwise, they could once again allow themselves to be dominated by others and/or to be taken care of.

South Node in First House—North Node in Seventh House

There is a need "to interact" with others in cooperative relationships, as these individuals are extremely independent. They have a tendency to consider everything in terms of what would make them happy. Fulfillment will only be felt when they use their personal resources (talents, money, possessions, sense of self-esteem) in helping others on a cooperative, equalitarian basis.

Second House and Eighth House

North Node in Second House—South Node in Eighth House

There is a need "to develop" their personal resources (talents, money, possessions, sense of self-esteem) in order to share them in a partnership or group relationships. They should investigate and cultivate their potential so that they do not allow others to take care of their material needs, or to want to take care of others to the point that they do not allow others to develop their personal resources. There must be an equalitarian sharing of resources on the part of both partners or in any group relationships. They should not do all the work, nor should they allow others to do all the work.

South Node in Second House—North Node in Eighth House

There is a need "to change" past lifetimes' materialistic interests. By uniting their efforts and talents with others for a common goal, they will discover that people have more value than material possessions. Their love of possessions did not bring them happiness. Possessions should

enhance life rather than dominate it. Thus, they need to reorient their thinking and review their values (anything they appreciate and enjoy, whether it is physical, mental, spiritual, or emotional). They have a gift for helping others develop their inner talents and for helping them re-evaluate their values. These individuals could become too impressed with their personal resources (talents, money, possessions, sense of self-esteem), or they could fail to develop their personal resources to their full potential.

THIRD HOUSE AND NINTH HOUSE

North Node in Third House—South Node in Ninth House

There is a need of the conscious mind "to know" and understand through knowledge and to learn from the people in their environment (neighbors, relatives). The problems they encounter in their environment must be faced with logic and reason. They have been religious in past lifetimes, but in a blind way. They did not question why they were to believe a certain way. Now, they must use their intellect in order to see that there isn't any one religion that is "the" religion. Otherwise, they will continue to pursue the same dogmatic religion from previous lifetimes, believing blindly what they are told to believe. And/or, they should cultivate community involvement and concern, for they cannot escape the problems arising in their environment by moving from community to community.

South Node in Third House—North Node in Ninth House

There is a need "to understand," to live, and accept a higher ideal and philosophy. Scientific knowledge cannot answer all things. Thus, they need to pursue philosophies and different religions. Travel would also broaden their viewpoints. When they learn to tap their subconscious minds, they can communicate what they have found to be meaningful to those in their immediate environment (relatives, neighbors). There is a karmic obligation to the people in their environment. Relatives can be a source of difficulties until they develop a different inner philosophy through the North Node house. These people can become enmeshed in day-to-day living and forget they are here to develop soul growth. Or, they can become so fixed in their religious beliefs that they refuse to listen to any other philosophy.

FOURTH HOUSE AND TENTH HOUSE

North Node in Fourth House—South Node in Tenth House

There is a need "to build" inner foundations based on emotional stability gained through domestic surroundings and the controlling of the emotions. They have had power and prestige in former lifetimes, but now must concentrate on developing soul growth rather than ego growth. This placement could cause the individual to seek the public limelight. But, until firm inner foundations are established, they would not be able to stand up to the emotional pressures of the "limelight" (for example, Marilyn Monroe). Or, they could expect society to take care of their material and emotional needs.

South Node in Fourth House—North Node in Tenth House

There is a need "to attain" recognition through a profession or personal achievements. There is an unconscious desire to retreat from society to the safety of home surroundings. If they attempt to revolve their life around their home, it will disintegrate. Their inner talents need to be shared publicly through achievements or a career, because they have the ability to inspire and uplift others.

FIFTH HOUSE AND ELEVENTH HOUSE

North Node in Fifth House—South Node in Eleventh House

There is a need "to reveal" their creativity to others, whether it is children of the body, mind, or emotions. These individuals have allowed their friends to do the work for them in past lifetimes. The willingness of their friends to help them has created a dependence on others for assistance. Now, they have to develop their creativity and contribute them for the benefit of their friends and for the common good of the group. They could easily allow themselves to be absorbed by their friends and groups so that they do not develop their creativity, or use their friends and social groups to "applaud" their creativity and, thus, feed their ego.

South Node in Fifth House—North Node in Eleventh House

There is a need "to elevate" their goals and to seek ideas which would be for the common good of the group. These individuals need to use their creative abilities for the benefit of group endeavors or to be of service of

a universal nature. Their creative talents in previous lifetimes have been used for self-aggrandizement and ego-glorification. They could find themselves doing this again. Or, they could become so involved with their children and personal interests that they do not develop friends or participate in social groups. The way of spiritual integration is to learn the "oneness of humanity," which cannot be learned unless one establishes contact with others outside the home.

Sixth House and Twelfth House

North Node in Sixth House—South Node in Twelfth House

There is a need "to improve" relations with others by being of service. Effort must be made to accept routine responsibilities. These individuals have been isolated from humanity in some manner; such as, monasteries, prisons, mental hospitals, as recluses, etc. This isolation may have been from choice or enforced. Their thoughts tend to revolve around themselves. They need to meet their commitment to their fellowman through love, compassion, and service. Otherwise, they will seek to escape their responsibilities by "copping out" through drugs, alcohol, etc., and/or by expecting others to totally take care of them, either privately or in an institution.

South Node in Sixth House—North Node in Twelfth House

There is a need "to overcome" the tendency to be negative, which causes disharmony and disease in the physical body. By helping others achieve a happier outlook on life, these individuals find inner peace. They have the ability to clear many karmic debts from past lifetimes through unusual forms of service to others. These individuals must search for truth and wisdom, so that they can see the "oneness of humanity" and cease their desire to escape from their obligations.

CHAPTER 8

Chart Erection Procedures

THE SOLAR CALENDAR

All of us take the calendar and our twenty-four-hour day for granted. Yet, it took many years and a lot of work to perfect it to what it is today.

The first revolutionary change was made by Julius Caesar in 46 B.C. Upon returning to Rome from conquering Egypt, Julius Caesar intended to adopt the Egyptian Solar Calendar in place of the Roman Lunar Calendar. While Julius was in Egypt, he discovered that the Egyptian Solar Calendar was far more accurate than the Lunar Calendar. The Egyptians based their calendar on a 365-day year, although their astronomers knew that the solar year was closer to 365¼ days long. This caused their solar calendar to lose a full day every four years.

Caesar decided the Egyptian Solar Calendar needed to be refined to make it more accurate. To help him with this project, he brought a Greek astronomer from Egypt. In order for the Lunar Calendar to catch up with the sun, Julius decreed that the year 46 B.C. would be 445 days long. He also declared that the first of January would be the beginning of each new year, rather than the first day of the spring equinox. Then, he arbitrarily established the lengths of the months as they are today. February was to have 28 days in it and 29 days every fourth year, if the year could be divided by 400.

Even though all this work was done in refining the calendar, it still had problems. The Julian Calendar averaged 365¼ days long, but in reality the solar year is 365 days, 5 hours, 48 minutes, and 46.43 seconds long. This meant that the Julian Calendar was 11 minutes longer than the actual solar year. These 11 minutes continued to accumulate until, 128 years later, the Julian Year had gained a full day. By late medieval times, the discrepancy had grown to ten days.

No one really seemed to mind, but the Church began to worry that sometime in the distant future people would be celebrating Christmas during spring planting. Pope Gregory XIII was advised that he should have the calendar corrected to harmonize it with the sun. In order to accomplish this, Pope Gregory decreed that October 5, 1582, would be October 15, 1582, thus dropping ten days. To prevent a similar discrepancy from happening again, he changed the leap-year system. He added exceptions to all fourth years being leap years. Years that ended in a "00" were not to be leap years unless they could be divided by 400. This provided the dropping of the three days that would be gained in a 400-year time span. This new calendar became known as the Gregorian Calendar.

Although the Gregorian Calendar was adopted finally by the entire world, it is still twenty-five seconds longer than the actual solar year. At this rate, it will eventually gain a full day on the sun every 3,323 years.

WARTIME AND DAYLIGHT SAVINGS TIME

Both Wartime and Daylight Savings Time move the clock *ahead* one hour at 2:00 A.M. on the date that begins the time period. There is no difference between them, except that Wartime was used continuously during both World War I and World War II. The reasons for using Wartime and Daylight Savings Time were/are to help conserve electrical energy and to have a longer period of daylight at night.

Since the Greenwich Observatory uses "Standard Time," one hour must be subtracted from the local birthtime if the client were born during the months when Wartime or Daylight Savings Time has been observed. This will put their birthtime back to "Standard Time." If you remember the rhyme, "Spring ahead in the spring, and fall back in the fall," it will be easy to remember to subtract the one hour the clock was moved ahead. (For example, Pacific Standard Time is eight hours behind Greenwich, England. If Pacific Daylight Time is being observed, the time zone is only seven hours behind Greenwich. A child born at 9:00 A.M., Pacific Daylight Time, would actually be born at 8:00 A.M., Pacific Standard Time. Greenwich, for both of those times, would show the time to be 4:00 P.M. since they are using "Standard Time.") It is essential to convert the birthtime to "Standard Time" in order to unify the time in the calculations of the house cusps and planet positions. One hour makes a lot of difference since approximately every two hours a new zodiac sign moves up to the ascendant.

The books *Time Changes in the USA, Time Changes in Canada and*

Mexico, and *Time Changes in the World* by Doris Chase Doane show the days and years when either Wartime or Daylight Savings Time has been used. If you are in doubt as to whether Wartime or Daylight Savings Time was observed by a state or a country on the date involved, stop in at your local library. They will be glad to help you find this information.

It is very important to indicate on the natal chart the time zone for the birthtime. For instance, if the person were born during Wartime in the Pacific Standard Time Zone, you would use the initials P.W.T. (meaning Pacific Wartime). If they were born during Daylight Savings Time, use the initials P.D.T. (meaning Pacific Daylight Time). Or, if they were born during regular Standard Time, use the initials P.S.T. (meaning Pacific Standard Time). Thus, John Doe born in Seattle, Washington, on July 1, 1943 at 4:00 P.M. would use the initials P.W.T. after the birthtime (4:00 P.M., P.W.T.).

LATITUDES

The word *latitudes,* when referring to the geography of the earth, means the distance measured in degrees from the equator, either north or south. The equator is 0° Latitude, extending to 90° North and 90° South at the Poles.

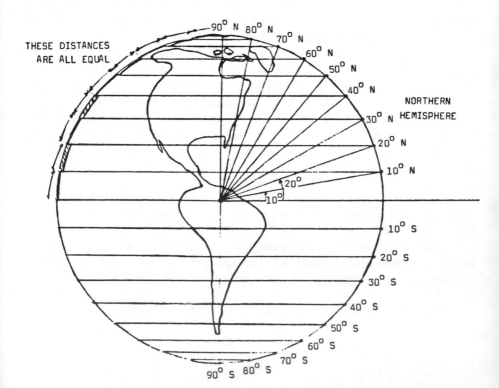

The establishment of house cusps is based on Northern Latitude, because astrologers in pre-biblical days lived in the Northern Hemisphere. However, by adding twelve sidereal hours (equivalent to six months) to the Adjusted Natal Sidereal Time, the Southern Latitudes will be placed in the identical position relative to the sun as the Northern Latitudes were six months before.

It is important to remember that latitudes have nothing to do with the location of the planets as reflected on the zodiac belt. That information is determined by the view from the birth longitudinal line. The reason it is necessary to know the latitude of birth is to be able to determine what zodiac degree and signs are on the house cusps of the natal chart. Rosicrucians' *Table of Houses* is one of the books available which indicates the house cusps for the different latitudes.

LONGITUDES AND THE CLOCK

Knowing the exact time of day was not essential to people living in the early 1800s. Their lives were simpler and more unhurried. But, with the development of railroad service, travelers had to know what time the trains would arrive and depart. Because of this problem, the railroads asked Sir Sanford Fleming, a Canadian civil engineer and scientist, to help establish a uniform time system. William Frederick Allen, an American, helped Fleming.

Sir Sanford decided to utilize the concept of meridian lines, which ancient Greek theologians had used on their maps of the world. Fleming suggested a twenty-four-meridian plan for the world. The twenty-four meridians would correspond to our twenty-four-hour day. Thus, each area containing a meridian line would differ by one hour. The meridian lines would be 15 degrees apart, in accordance with the geometric requirement of 360° in any size circle. Each degree would equal four minutes (4 minutes × 360° = 24 hours). Sir Sanford planned to have each meridian area legalize a single time of day, with all clocks in that particular area indicating the same time.

Fleming and Allen called their plan "Standard Time." The railroads in both Canada and the United States adopted "Standard Time" at noon, November 13, 1883. Since the United States Government did nothing about legalizing "Standard Time" across the country, most states adopted it on their own. From time to time over the years, the time zone areas have been revised.

In 1884, a conference was held in Washington, D.C., called the "Washington Meridian Conference" where the countries of the world agreed to

use the railroads' "Standard Time" zone system. It was at this conference that an agreement was reached to establish the Prime Meridian at Britain's Astronomical Observatory, in Greenwich, England.

To mark each degree of the 360° of the earth's circumference, vertical lines are drawn from the North and South poles. These vertical lines are called "Longitudinal Lines." Since Greenwich, England, is the Prime Meridian, it is designated as 0° Longitude. The vertical lines to the east of Greenwich are referred to as East Longitude, and the vertical lines to the west of Greenwich are referred to as West Longitude. East Longitude and West Longitude meet halfway round the world from Greenwich, England, at 180°. This meeting point is called the International Date

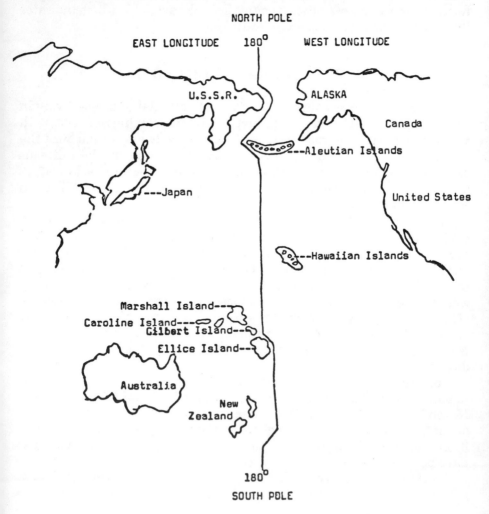

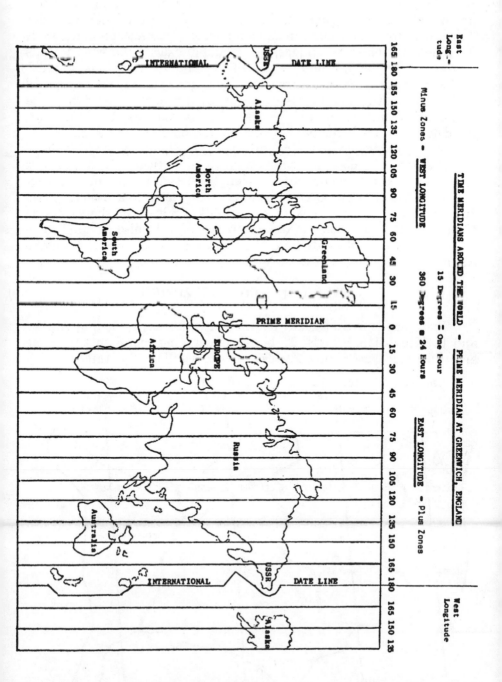

TIME MERIDIANS AROUND THE WORLD - PRIME MERIDIAN AT GREENWICH, ENGLAND

15 Degrees = One Hour

360 Degrees = 24 Hours

Minus Zones = **WEST LONGITUDE** **EAST LONGITUDE** - Plus Zones

East Longitude

West Longitude

INTERNATIONAL DATE LINE

PRIME MERIDIAN

INTERNATIONAL DATE LINE

USSR

Alaska

North America

South America

Greenland

Africa

EUROPE

Russia

Australia

USSR

Alaska

165 180 165 150 135 120 105 90 75 60 45 30 15 0 15 30 45 60 75 90 105 120 135 150 165 180 165 150 135

Line. If you were to stand on this date line, there might be some confusion as to the date, since one side would be observing one date and the other side would be observing another date. To clear up this confusion, consider that if the time at Greenwich, England, were 11:00 A.M. on January 1, the time being observed on Marshall Island at exactly the same time as Greenwich, England, would be 11:00 P.M., January 1. This is a "plus" twelve hours difference, because East Longitude time zones are *ahead* of Greenwich, England. However, on the other side of the date line, the Hawaiian Islands would, also, be observing the time as 11:00 P.M., but, the date would be December 31, because the hours must be "minused" for West Longitude, since their time zones are *behind* Greenwich time.

The date line does not follow a straight vertical line at 180° but zigzags approximately one-half of its length, so that it will not cross any land area. This was purposely done to avoid any land area observing two different dates. Russia preferred to keep all of Siberia on the west side of the date line, and some of the South Sea Islands, also, wanted to be on the west side of the date line. The United States decided to keep the Aleutian Islands on the east side of the date line.

UNITED STATES TIME ZONES

There are four time zones in the United States, excluding Alaska and the Hawaiian Islands. To better understand meridian time zone areas, the four basic United States time zones will be illustrated.

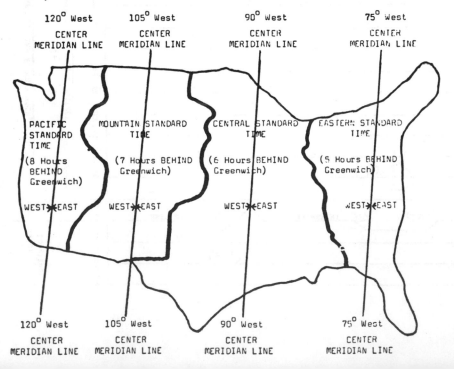

| 120° West | 105° West | 90° West | 75° West |
| CENTER MERIDIAN LINE | CENTER MERIDIAN LINE | CENTER MERIDIAN LINE | CENTER MERIDIAN LINE |

PACIFIC STANDARD TIME (8 Hours BEHIND Greenwich)

MOUNTAIN STANDARD TIME (7 Hours BEHIND Greenwich)

CENTRAL STANDARD TIME (6 Hours BEHIND Greenwich)

EASTERN STANDARD TIME (5 Hours BEHIND Greenwich)

WEST★EAST WEST★EAST WEST★EAST WEST★EAST

| 120° West | 105° West | 90° West | 75° West |
| CENTER MERIDIAN LINE | CENTER MERIDIAN LINE | CENTER MERIDIAN LINE | CENTER MERIDIAN LINE |

It is very easy to determine the time difference from Greenwich, England, the Prime Meridian, and the time zone areas on page 212. Multiply the longitudinal degrees of the Center Meridian Line by four minutes per each degree. This shows you how far *behind* that time zone area is from Greenwich, England. For example, the Center Meridian Line for Mountain Standard Time is 105° West Longitude. By multiplying 105° x 4 minutes, you find that Mountain Standard Time is seven hours *behind* Greenwich.

Looking at the map of the United States, p. 212, you will notice that there is an area to the east and to the west of the Center Meridian Lines. Both the east and west sections are either *ahead of* or *behind* the time indicated by the Center Meridian Line. In order to obtain an accurate natal chart, the minutes involved cannot be ignored. Since each longitudinal degree equals four minutes, it is imperative that an addition or subtraction be made to the natal birthtime to obtain a True Local Time of birth.

If the birthplace is to the east of the birth Center Meridian Line, the minutes must be *added*, since that area is *ahead* of the Center Meridian Line. If the birthplace is to the west of the birth Center Meridian Line, the minutes must be *subtracted*, since that area is *behind* the Center Meridian time zone.

SIDEREAL TIME

Sidereal Time gives an accurate axis rotation of the earth from a fixed point in space. In astrology, this fixed point is the zodiac belt, which is figuratively "nailed" in the sky. The Sidereal Clock moves very slowly, approximately four minutes per day, so that in one solar year, the Sidereal Clock will go from 0 Hours, 0 Minutes, 0 Seconds to just short of twenty-four hours. As soon as the sun lights 0° Aries around March 21, the Sidereal Clock is turned back again to 0 Hours, 0 Minutes, 0 Seconds. Sidereal Time is used to determine the Tenth House Cusp from the sun's noon position, as reflected on the zodiac belt for any day of any year from Greenwhich, England. This provides an accurate placement of the degree and sign of the Tenth House Cusp.

The *Zodiac Belt* is approximately 8° beyond the "apparent" pathway of the sun around the earth.

Special Note: The Sidereal times used for the chart on page 214 are from the year 1950. This chart is not meant to accurately portray each year's sidereal time.

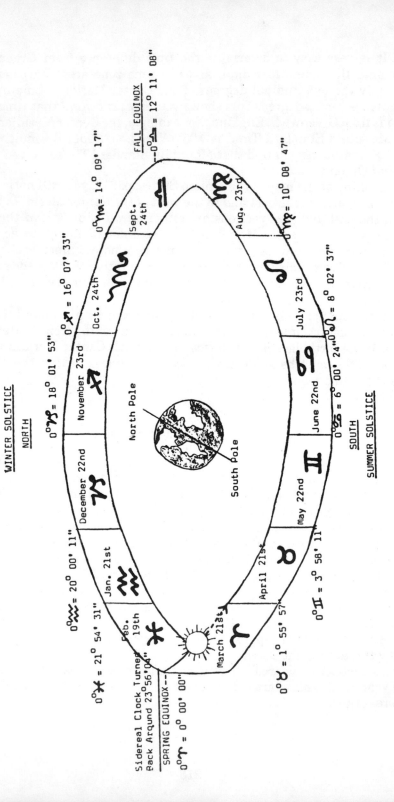

UNDERSTANDING THE USE OF SIDEREAL TIME

$0° \Upsilon = 0° \ 00' \ 00"$ $0° \, \text{♉} = 1° \ 55' \ 57"$

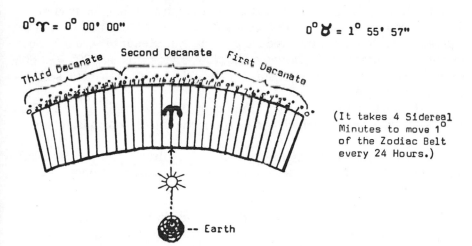

(It takes 4 Sidereal
Minutes to move 1°
of the Zodiac Belt
every 24 Hours.)

At the Prime Meridian (0° Longitude), the sun will be reflecting in succession each degree of the zodiac every twenty-four hours at 12:00 noon. The degree, for the particular day involved, becomes the Tenth House Cusp degree (Mid-Heaven). This is considered the sun's zenith, or high point, in a twenty-four hour day. By establishing the Tenth House Cusp, the other house cusps can be determined by using the birth latitude.

However, the sidereal time for the day of birth as listed in the birth year Ephemeris is for 12:00 noon at the Prime Meridian (0° Longitude). At the same time, the rest of the world is observing different hours. Thus, it is necessary to find out how much sidereal time is involved either before it *will be 12:00 noon* (in the case of Western Longitude) or, how much sidereal time is involved *since it was 12:00 noon* (in the case of Eastern Longitude).

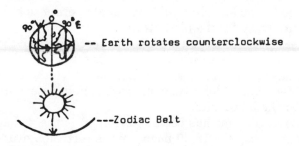

215

It takes approximately four minutes per day for the earth to rotate on its axis according to sidereal time. The earth is a geometric circle of 360°. To calculate how many seconds it takes to rotate one degree by sidereal time, we must first reduce the four minutes into seconds. Four minutes × 60 seconds = 240 seconds. Now, divide this by 360° = .6666 *seconds per degree.* Thus, according to sidereal time it takes .6666 seconds to rotate on degree.

If the birth longitude is 122°, multiply .6666 seconds by 122°. This equals *81.3252 seconds* which can be rounded off to 81 seconds, or 1 min. 21 seconds.

The reason so many astrologers always multiply ⅔ time the birth longitude is because .6666 is ⅔ of 1.0000 (or at least close enough to be rounded off to that figure).

.6666
+.3333
—————
.9999 (rounded off to 1.0000)

If the birth longitude is 122°, multiply it by ⅔.

81 seconds or 1 min. 21 secs.

122
× 2
———
244

3 / 244
 24
 ——
 4
 3
 ——
 1

The answer to a birth longitude of 122° is still the same, whether you use .6666 second per degree or ⅔. The choice is yours.

Since we have divided the earth into two sections of 180° each, we will have to either add or subtract the seconds figure to determine how far away the birth longitude is from the Prime Meridian (0° Longitude), according to sidereal time.

For Eastern Longitude, you must subtract the seconds from the birthday's sidereal time, because Eastern Longitude has already observed 12:00 noon for that day. By subtracting the seconds, you move the birth longitude to the Prime Meridian (0° longitude) in order to help determine the Tenth House Cusp for the birth date.

For Western Longitude, you must add the seconds from the birthday's sidereal time, because Western Longitude has not yet observed 12:00 noon for that day. By adding the seconds, you move the birth longitude to the Prime Meridian (0° longitude) in order to help determine the Tenth House Cusp for the birth date.

At this point, all that has been determined is the zodiac degree for the Tenth House Cusp for 12:00 noon for the birth longitude. It is now necessary to either add (P.M. birthtimes) or subtract (A.M. birthtimes) to find the Tenth House Cusp for the client's birthtime. Keep in mind that

it only takes approximately four minutes per day for the earth to rotate on its axis, according to sidereal time. Thus, adding, or subtracting, the birthtime will make the earth appear to be spinning very rapidly on its axis until it comes to rest at the noon sidereal time, indicated by the new sidereal time. This establishes an entirely different Tenth House Cusp degree and sign.

P.M. birthtimes are similar to Western Longitude and, thus, spin the earth counterclockwise (add). A.M. birthtimes are like Eastern Longitude, and spin the earth clockwise (subtract). The P.M. birthtimes already indicate the interval involved, since it was 12:00 noon. But, you must subtract from 12:00 noon to determine the interval remaining until it is 12:00 noon for A.M. birthtimes. Use the minutes only for all 12:00 to 12:59 birthtimes, whether they are A.M. or P.M.

<div align="center">

Birthday
NOON

</div>

Interval until it is 12:00 NOON——|——Interval since it was 12:00 NOON
 A.M. Birthtimes | P.M. Birthtimes

If someone was born at 5:00 P.M., you would add five hours to the birthday's sidereal time to which any longitudinal seconds correction change has been made. According to sidereal time, by adding five hours, it appears we have rapidly spun the earth counterclockwise seventy-five times.

$$5 \text{ hours} \times 60 \text{ minutes} = 300 \text{ minutes} \quad 4 \text{ mins. per day} \overline{\smash{)}300 \text{ minutes}} \begin{array}{c} 75 \text{ axis turns} \\ \hline 300 \text{ minutes} \\ \underline{28} \\ 20 \\ \underline{20} \end{array}$$

The 75 axis turns is equal to seventy-five days. Thus, seventy-five days have elapsed since the birthday's sidereal time. If the client were born on March 21, 1950, 0° Aries 19', this would move the sidereal time to approximately June 4. Since June 4th is in Gemini, our client would have to have a Gemini Tenth House Cusp.

<div align="center">

10 days left in March
30 days in April
31 days in May
 4 days in June
75 days (June 4th)

</div>

The final correction to the sidereal time is to adjust the twenty-four-hour axis clock to the sidereal clock. Our twenty-four-hour axis clock is too fast by approximately four minutes. Thus, it is necessary to determine what adjustment should be made. By converting the four minutes into seconds and dividing by our twenty-four-hour day, we can establish how many seconds the twenty-four-hour axis clock is off per hour. Four minutes × 60 seconds = 240 seconds.

$$\begin{array}{r} 10 \text{ seconds per hour} \\ 24\overline{)\ 240} \\ \underline{24} \\ 0 \\ \underline{0} \end{array}$$

The 24-hour axis clock is off by approximately 10 seconds per hour.

To determine the correction necessary, multiply by ten seconds each hour of the birthtime interval from 12:00 noon. This correction is added for P.M. birthtimes. For A.M. birthtimes, it must be subtracted.

This final figure is the adjusted sidereal time for your client's birth longitude and birthtime. This figure is then used in finding the closest sidereal time to it in the Table of Houses under the client's latitude. You will note that the Tenth House Cusp will remain the same for all latitudes, since it represents a longitudinal line. The same zodiac degree and sign will be highlighted by the sun along the entire length of the longitude line. However, the birth latitude will change the other house cusps degrees and signs.

For Example: Birthtime: 5:00 P.M. T.L.T.
 Born: March 21, 1950 (Sun at 0° Aries 19')

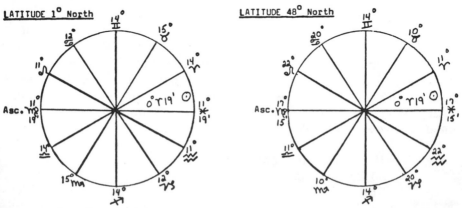

Be sure that the natal sun is in or near the house that rules the birthtime!

218

SIDEREAL TIME (STAR TIME)

Sidereal time is a concept often encountered in astrology, and all information given in the Ephemeris is based upon it. You can follow instructions on how to calculate sidereal time without bothering to find out what it really means, but you may want to know a little more about it than is usually explained in the books. A short presentation is therefore given below.

Sidereal time differs from our regular earth time in that it refers to a fixed point in space (universe), whereas earth time is linked to the sun. As the stars are so enormously distant from our solar system (the sun and planets), they appear to be located in fixed positions in the sky for thousands of years, as viewed from earth. We can therefore select a star of our choice to serve as a reference point, and relate all astronomical data in relation to the sidereal time. The zodiac belt has been chosen to serve as this fixed point, as it is permanently "fixed" in the sky.

Our regular twenty-four hours here on earth is the time it takes to complete one full rotation around the earth polar axis, with *respect to the sun*. In other words, it is the time between two consecutive peak elevations of the sun for a given point on earth (from local noon one day to local noon the next day) This in fact means a rotation of slightly more than 360° during twenty-four hours (closer to 361° as will be shown below), which in turn gives us less than twenty-four hours to rotate 360 degrees.

Confused? Try to follow the Virgo-treat below.

The earth orbits around the sun with a speed large enough in relation to the distance from the sun, to cause the difference between sidereal and regular time.

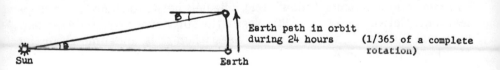

Earth path in orbit
during 24 hours (1/365 of a complete
 rotation)

Sun

Earth

The figures are exaggerated and not to scale, to facilitate the picture. Now look at the point "A," having noon in the bottom position and the top position.

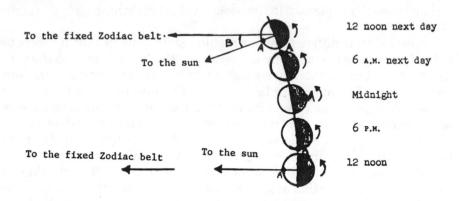

Additional angle "B" is 1/365.25 of 360° which is equal to 360°/365.25 or .985° which is practically equal to 1° rounded off. Similarly, the additional time to rotate this angle is 1/365.25 of 24 hours. This amounts to 24 × 60 minutes = 365.25 or 3′ 56″ approximately.

AXIS TILT OF THE EARTH

The sun will appear at its zenith between the tropics of Cancer (midsummer) and Capricorn (midwinter). The belt between them is the tropical zone. Between 66½° and 90° North, the sun never sets, and between 66½ and 90° South, the sun never rises when it is midsummer in the Northern Hemisphere.

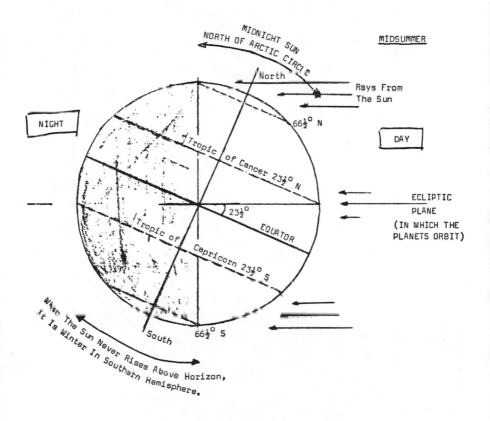

MIDNIGHT SUN
NORTH OF ARCTIC CIRCLE

North

Rays From
The Sun

$66\frac{1}{2}°$ N

NIGHT

DAY

Tropic of Cancer $23\frac{1}{2}°$ N

$23\frac{1}{2}°$

EQUATOR

ECLIPTIC
PLANE
(IN WHICH THE
PLANETS ORBIT)

Tropic of Capricorn $23\frac{1}{2}°$ S

Where The Sun Never Rises Above Horizon,
It Is Winter In Southern Hemisphere.

South $66\frac{1}{2}°$ S

During the spring and fall equinox, the earth polar axis appears at 90° relative to the sun; thus day and night are equal. Sun above and below the horizon at twelve hours each. Zenith above the equator.

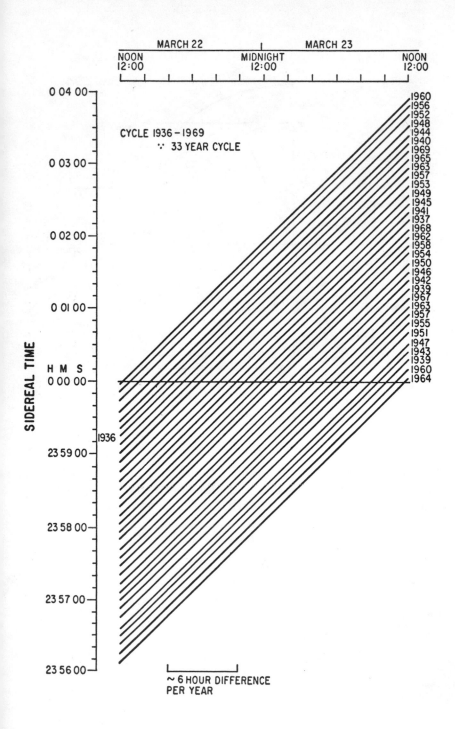

MARCH 22 MARCH 23

NOON MIDNIGHT NOON
12:00 12:00 12:00

CYCLE 1936–1969
∴ 33 YEAR CYCLE

SIDEREAL TIME

0 04 00 —
0 03 00 —
0 02 00 —
0 01 00 —
H M S
0 00 00 —
23 59 00 —
23 58 00 —
23 57 00 —
23 56 00 —

1960
1956
1952
1948
1944
1940
1969
1965
1963
1957
1953
1949
1945
1941
1937
1968
1962
1958
1954
1950
1946
1942
1939
1967
1963
1957
1955
1951
1947
1943
1939
1960
1964

1936

~ 6 HOUR DIFFERENCE
PER YEAR

222

SOUTHERN LATITUDES

In order to establish the Tenth House Cusp for Southern Latitudes, a twelve-hour sidereal correction must be added to the total of the "Sidereal Time" for the client. This symbolizes where the sun would be for the Southern Latitudes six months later. Thus, the twelve-hour correction is, basically, equal to a correction of six months. This, in turn, corresponds to the seasonal differences between the two hemispheres. (The sidereal clock takes one solar year to complete twenty-three hours, fifty-six minutes, and four seconds.) By adding twelve hours, the Southern Latitudes will be placed in the identical position relative to the sun, as the Northern Latitudes were six months before.

After making the twelve-hour addition, locate the closest sidereal time in the Table of Houses under the correct latitude for the client, and use the bottom line where the polar opposite houses are listed from those listed at the top for the Northern Latitudes. So, instead of Houses Ten, Eleven, Twelve, One, Two, and Three, you will find that the bottom line reads Four, Five, Six, Seven, Eight, and Nine. This means you will need to list the degree and sign for the tenth house cusp on the fourth house cusp instead. Do the same for the rest of the house cusps. Then, fill in the polar opposite signs, and you will know the ascendant. This procedure allows for the axis tilt of the earth which gives the Southern Latitudes a slightly different view to the zodiac belt for the house cusps' degrees and signs. The Tenth House Cusp, of course, will always remain the same the entire length of a longitudinal line, regardless of the latitude involved. Latitudes determine the other house cusps only.

Position A = Summer in Northern Latitudes, as the North Pole is tilted toward sun.

Position B = Projected Image of Southern Latitudes *six months later* when Southern Latitudes are in an identical position relative to the sun as in Position A. South Pole is tilted towards the sun, so it is summer in the Southern Latitudes.

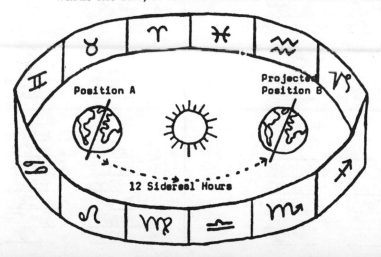

ILLUSTRATING HOUSE CUSPS FOR DIFFERENT LATITUDES

Let us assume that there are four people who were born June 21, 1950, with a T.L.T. time of 4:00 P.M. The birth longitude for all four is 90° West. But, their latitudes are different. Since their birthtime and birth longitude are the same for all four men, they will have the same zodiac sign and degree on the Tenth House Cusp (noon position). However, the other house cusps will vary according to their birth latitude. Bill was born at *1° N 90° W;* George was born at *1° S 90° W;* John was born at *51° N 90° W;* and Mike was born at *51° S 90° W.* The first thing we need to do is to determine their sidereal time.

			SIDEREAL TIME	
		H	*M*	*S*
Step (1)	Sidereal Time for Date of Birth	5	56	28
Step (2)	Birth Longitude Correction +		1	00
	Preliminary Total	5	57	28
Step (3)	T.L.T. Birthtime +	4	00	
	Preliminary Total	9	57	28
Step (4)	Birthtime Correction +			40
	Adjusted Sidereal Time Total for Northern Latitude	9	57	68
	Reduction of Figure		+ 1	− 60
	Adjusted Sidereal Time Total for Northern Latitude	9	58	08
	Six Months Southern Latitude Correction +	12	00	00
	Adjusted Sidereal Time Total for Southern Latitude	21	58	08

CLOSEST SIDEREAL TIME FOR NORTHERN LATITUDE IS 9-56-52

BILL

1° N Latitude

10	27° ♌	4	27° ♒
11	29° ♍	5	29° ♓
12	1° ♏	6	1° ♉
1	0° ♐ 59'	7	0° ♊ 59'
2	29° ♐	8	29° ♊
3	27° ♑	9	27° ♋

CLOSEST SIDEREAL TIME FOR SOUTHERN LATITUDE IS 21-56-52

GEORGE

1° S Latitude

10	27° ♌	4	27° ♒
11	29° ♍	5	29° ♓
12	2° ♏	6	2° ♉
1	1° ♐ 43'	7	1° ♊ 43'
2	0° ♑	8	0° ♋
3	27° ♑	9	27° ♋

JOHN

51° N Latitude

10	27° ♌	4	27° ♒
11	29° ♍	5	29° ♓
12	24° ♎	6	24° ♈
1	11° ♏ 48'	7	11° ♉ 48'
2	11° ♐	8	11° ♊
3	18° ♑	9	18° ♋

MIKE

51° S Latitude

10	27° ♌	4	27° ♒
11	28° ♍	5	28° ♓
12	15° ♏	6	15° ♉
1	1° ♑ 28'	7	1° ♋ 28'
2	18° ♑	8	18° ♋
3	6° ♒	9	6° ♌

USE OF LOGARITHMS

The word "logarithms" is derived from the Greek words "logos" meaning ratio and "arithmos" meaning number. Very simply put, logarithms are decimal fraction figures which convert multiplication and division to addition and subtraction. They were invented by Lord Napier of Scotland in 1614, and improved by Henry Briggs, professor of Geometry at Oxford in 1624.

Logarithms are used in astrology to assist in the calculations of the natal planetary positions. Before calculating the planetary positions, it is essential to establish what time it was in Greenwich, England, for the client's natal birthtime. That time is referred to as G.M.T. (Greenwich Mean Time). For example, if the birthtime was 2:00 P.M., P.S.T., the G.M.T. would have been 10:00 P.M., since Pacific Standard Time is eight hours *behind* Greenwich, England. This G.M.T. figure, 10:00 P.M., is the birthtime used when utilizing logarithms in the calculation of planetary positions. The reason for using the G.M.T. figure is because birth Ephemerides list only the noon planetary positions from the Greenwich Astronomical Observatory.

In locating the degree and sign of the different planets on the zodiac belt, the first step is to find out how far the planet has traveled during the twenty-four-hour period involving the birthdate. This procedure does not have to be done for the slower-moving outer planets from Jupiter on, because the outer planets move so slowly that the noon figure given by the Greenwich Astronomical Observatory in the Ephemeris can be used. After the twenty-four-hour travel time has been determined, the degrees and/or minutes are converted into a logarithm figure.

To illustrate this, the following is an example of calculating the sun's exact position on the zodiac belt for an A.M. birthtime and a P.M. birthtime. Both of these individuals were born on January 2, 1950 at Godthaab, Greenland. One was born at 1:30 A.M., T.L.T., and the other was born at 1:30 P.M., T.L.T. Since this is Greenland's "Standard Time," the G.M.T. time in Greenwich, England, must be established Greenland is three hours *behind* England, so the time at Greenwich, England, would have been 4:30 A.M., G.M.T., in the case of the A.M. birthtime and 4:30 P.M., G.M.T., in the case of the P.M. birthtime. The A.M. birthtime will be illustrated on the left side and the P.M. birthtime on the right.

| 24-Hour Interval | 24-Hour Interval |

| Jan. 1st | Jan. 2nd | Jan. 3rd |
| NOON | NOON | NOON |

Born 4:30 A.M., G.M.T.	Born 4:30 P.M., G.M.T.
(7 Hours 30 Minutes before it will be 12:00 Noon)	(4 Hours 30 Minutes since it has been 12:00 Noon)

To determine the Sun's 24-hour travel distance, subtract the noon figure *before* the G.M.T. birthtime from the noon figure *after* the G.M.T. birthtime. The twenty-four-hour period containing the A.M. birthtime involves Jan. 1 and Jan. 2. The twenty-four-hour period containing the P.M. birthtime involves Jan. 3 and Jan. 2.

4:30 A.M., G.M.T.			4:30 P.M., G.M.T.	
Jan. 2	11° 31'		Jan. 3	12° 33'
Jan. 1	−10° 30'		Jan. 2	−11° 31'
24-Hour Travel	1° 01'		24-Hour Travel	1° 02'

This twenty-four-hour travel figure is now converted into a logarithm. A logarithm table is always included at the back of each yearly Ephemeris. The hours, or degrees, are listed across the top, and the minutes are listed down the lefthand column. By converting the travel motion of the sun for the A.M. and P.M. birthtimes, the logarithm figures are as follows:

4:30 A.M., G.M.T.	4:30 P.M., G.M.T.
1.3730	1.3660

Because the daily planetary positions are listed in the Ephemeris for 12:00 noon only, it is imperative to establish if the time of birth indicates that the planets are approaching the noon position (A.M. birthtimes) or leaving the noon position (P.M. birthtimes). The interval before it will be noon, or since it has been noon, is converted into a logarithm and is referred to as the client's permanent logarithm. This permanent logarithm is added to the twenty-four hour travel logarithm and then reconverted back into degrees and minutes. Once it has been converted back into degrees and minutes, it will be *subtracted (*A.M. *birthtimes)* or *added (*P.M. *birthtimes)* to the planetary noon position of the birthdate.

12:00 noon, Jan. 2 − 4:30 A.M., G.M.T. 7:30 before it will be Noon (7 Hours 30 Minutes before Noon) .5051 Permanent Logarithm	4:30 P.M., G.M.T., Jan. 2 (4 Hours 30 Minutes since Noon) .7270 Permanent Logarithm

What the permanent logarithm figure represents in fractions is how many hours and minutes the birthtime is away from noon of the birthdate.

Now, add the logarithm for the sun's Twenty-four-Hour Travel and the client's permanent logarithm together.

1.3730 24-Hour Travel + .5051 Permanent Logarithm 1.8781	1.3660 24-Hour Travel + .7270 Permanent Logarithm 2.0930

At this point, the logarithms have accomplished their purpose and can be converted back into hours and minutes. Find the logarithm that is the closest to your figure on the logarithm table. Glance up to the top of the column and note the number of hours, and, then, look at the first column on the lefthand side for the minutes.

0 Hours 19 Minutes	0 Hours 12 Minutes

The first answer, in the case of the A.M. birthtime, indicates that the sun has to travel nineteen minutes before it will reach the noon position. Thus, the nineteen minutes must be *subtracted* from the Noon position of the birthdate. The second answer, in the case of the P.M. birthtime, indicates that the sun has traveled twelve minutes away from its noon position. These twelve minutes must be *added* to the noon birthdate position.

January 2 11° 31' − 19' 11° 12'	January 2 11° 31' + 12' 11° 43'

Thus, we have found that at 4:30 A.M., G.M.T., the sun was reflected on the zodiac belt at 11° Capricorn 12'.	Thus, we have found that at 4:30 P.M., G.M.T., the sun was reflected on the zodiac belt at 11° Capricorn 43'.

NAME ___(Practice Problem)___ BIRTHTIME _3:22 P.M._

BIRTHDATE _February 17, 1959_ PLACE OF BIRTH _Boston, Massachusetts_

LATITUDE _42°N_ LONGITUDE _71°W_ TIME ZONE _E.S.T._ CENTER MERIDIAN _75°W_

TRUE LOCAL TIME

FIRST: How many degrees is the birth longitude from the center meridian of the client's time zone? Answer: _4°_

SECOND: Since each degree of longitude is equal to 4 minutes, multiply the above answer by 4 minutes. Then, determine if the birth longitude is East or West of the client's center meridian. Answer: _4° × 4' = 16' East_

(1) Birthtime as furnished by client _3:22 P.M._

(2) Subtract 1 hour if daylight or wartime _____

 Preliminary Answer _3:22 P.M._

(3) Add or Subtract the minutes that the birth longitude is East or West of the client's center meridian. (East = Add, West = Subtract) _+ :16_

(4) TRUE LOCAL TIME _3:38 P.M._ (This figure is used in Step 3 below)

--

SIDEREAL TIME	H	M	S
(1) In the Ephemeris for the client's year of birth find the sidereal time for the birthdate.	21	46	52
(2) Multiply the birth longitude by .6666 (or 2/3rds) to determine how many sidereal seconds it will take for the birth longitude to either reach 12:00 NOON (Western Longitude), or since it was 12:00 NOON (Eastern Longitude). (Western Longitude=Add; Eastern Longitude=Subtract)	+		47
PRELIMINARY TOTAL:	21	46	99
(3) Using the T.L.T. determine the interval before it will be 12:00 NOON of the birthdate (A.M. birthtimes), or the interval since it has been 12:00 NOON (P.M. birthtimes). USE THE MINUTES ONLY FOR ALL 12:00 to 12:59 BIRTHTIMES. (A.M. Birthtimes = Subtract; P.M. Birthtimes = Add)	+ 3	38	
PRELIMINARY TOTAL:	24	84	99
(4) Make a 10 second correction for each hour listed in Step 3 in order to adjust the 24 hour clock to sidereal time. Be sure to consider the minutes, also. The following table will be helpful on the minutes. (A.M. Birthtimes = Subtract; P.M. Birthtimes = Add) 30"	+		37
PRELIMINARY TOTAL:	24	84	136
Reduce figures if necessary:		+2	-120
PRELIMINARY TOTAL:	24	86	16
	+1	-60	
If Southern Latitude, Add 12 Hours:	25	26	
	-24	00	00
ADJUSTED SIDEREAL TIME:	1	26	16

71°
×2
142

42"
3⟌142
 12
 22
 21
 1

+ 7"
37"

Minutes	Seconds
1 - 6 = 1 Second	
7 - 12 = 2 Seconds	
13 - 18 = 3 Seconds	
19 - 24 = 4 Seconds	
25 - 30 = 5 Seconds	
31 - 36 = 6 Seconds	
37 - 42 = 7 Seconds	
43 - 48 = 8 Seconds	
49 - 54 = 9 Seconds	
55 - 60 = 10 Seconds	

In the Table of Houses find the closest sidereal time to the Adjusted Sidereal Time under the client's birth latitude. Place the degrees and signs around the following chart.

GREENWICH MEAN TIME

To determine what time it was in Greenwich, England (Prime Meridian) at the exact time of the client's birth, multiply the client's birth longitude by 4 minutes. Remember each degree is equal to 4 minutes. Reduce your answer into hours and minutes.

Answer: $\frac{71°}{288'}$ $60'\overline{)288'}$ 4 Hrs. $\frac{4hrs.}{288'}$ 4 Hrs. 44 mins.

(1) True Local Time of birth as determined on Page 1 3:38 P.M. (17th)

(2) Using the answer above, either ADD for Western Longitude, or
 SUBTRACT for Eastern Longitude. +4:44

 PRELIMINARY TOTAL: 7:82

(3) Reduce the minutes if over 60 minutes and add to hour figure -60

(4) If the figure is over 12:00, you have passed into P.M. or A.M. +1
 If this happens, subtract your figure from 12:00 and then de- (17th)
 termine if you have gone to P.M. or A.M. and which day it is. 8 : 22 P.M. G.M.T.

Determine the interval before it will be 12:00 NOON for the G.M.T. date (A.M. birth-
times), or the interval since it has been 12:00 NOON (P.M. birthtimes). USE THE MIN-
UTES ONLY FOR ALL 12:00 to 12:59 BIRTHTIMES. Answer: 8 Hrs. 22 minutes

Using this interval figure establish their permanent logarithm. Answer: .4577

24 HOUR TRAVEL FOR THE FAST MOVING PLANETS

PLANETS	☉	☿	☿	☽	♂
(1) ZODIAC SIGN	♒	♓	♓	♊	♊
(2) Degrees and Minutes for the Noon AFTER the G.M.T. date (18th)	29° 05'	22° 38'	1° 96" 2° 36' 0°	28" 63' 29° 03	3° 33'
(3) Degrees and Minutes for the Noon BEFORE the G.M.T. date (17th) G.M.T. Day -	28° 05'	21° 24'	0° 45'	16° 43'	3° 05'
(4) Subtract Step 3 from Step 2. (If it is a retrograde planet, subtract the smaller figure from the larger figure.) This answer indicates the number of degrees and minutes the planet traveled during a 24 hour interval.	1° 00'	1° 14'	1° 51'	12° 20'	28'
(5) Convert the answer from Step 4 into a logarithm.	1.3802	1.2891	1.1130	.2891	1.7112
(6) The client's permanent logarithm from Page 2. +	.4577	.4577	.4577	.4577	.4577
(7) Add Step 5 and Step 6 together	1.8379	1.7468	1.5707	.7468	2.1689
(8) Convert the answer from Step 7 back into degrees and minutes by finding the nearest logarithm.	21'	26'	39'	4° 18'	10'
(9) Using the date of the G.M.T. write in the degrees and minutes for the noon position for each of these planets. Your figures will be from either Step 2 or Step 3. (17th)	28° 05'	21° 24'	0° 45'	16° 43'	3° 05'
(10) Write in your figures from Step 8. These figures will either be added, if the G.M.T. is P.M., OR, they will be subtracted, if the G.M.T. is A.M., from Step 9. (Reverse this procedure if the planet is retrograde.)	+ 21'	+ 26'	+ 39'	+4° 18'	+ 10'
(11) THIS IS THE EXACT POSITION OF THE PLANETS FOR THE TIME OF THE CLIENT'S BIRTH.	28° 26'	21° 50'	1° 24' 84' 0°	21° 01' 20° 61'	3° 15'

The other planets move so slowly that no calculations are necessary. Use the Noon figure for the date of the G.M.T. as listed in the Ephemeris of the birth year.

SATURN ♄ 4° ♑ 27' JUPITER ♃ 0° ♉ 41' URANUS ♅ ℞ 13° ♌ 43' NEPTUNE ♆ ℞ 6° ♏ 57'
PLUTO ♇ ℞ 3° ♍ 00' MOON'S NORTH NODE ☊ 15° ♎ 32' MOON'S SOUTH NODE ☋ 15° ♈ 32'
(The South Node is the Polar Opposite Zodiac Sign of the North Node.)

⊕ PART OF FORTUNE ----------→

⊕ 29° ♏ 09'

230

	Sign No.	Degrees	Mins.
Asc.	5	6	34
+ Moon	+ 3	21	01
Totals	19 8/8	57 27	35
- Sun	- 11	28	26
Totals	8	29°	09'

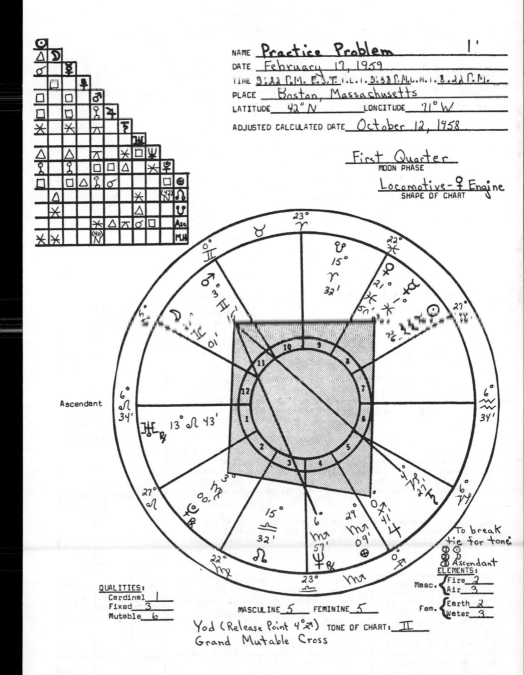

NAME *Practice Problem* 1'
DATE *February 17, 1959*
TIME 9:22 P.M. E.S.T. I.L.T. 9:38 P.M.L.M.T. 8:22 P.M.
PLACE *Boston, Massachusetts*
LATITUDE 42° N LONGITUDE 71° W
ADJUSTED CALCULATED DATE *October 12, 1958*

First Quarter
MOON PHASE

Locomotive-♀ Engine
SHAPE OF CHART

Ascendant

QUALITIES:
Cardinal 1
Fixed 3
Mutable 6

MASCULINE 5 FEMININE 5

To break
tie for tone:
⊙
☽
Ascendant

ELEMENTS:
Masc. { Fire 2
 { Air 3
Fem. { Earth 2
 { Water 3

Yod (Release Point 4° ♐) TONE OF CHART: ♊
Grand Mutable Cross

231

CHAPTER 9

Erecting a Chart for Northern Latitude, Western Longitude

NATAL CHART PROCEDURE

PAGE 1

NAME Northern Latitude, West Longitude. BIRTHTIME 11:28 P.M.

BIRTHDATE May 15, 1952 PLACE OF BIRTH Tacoma, Washington

LATITUDE 47°N LONGITUDE 122°W TIME ZONE P.S.T. CENTER MERIDIAN 120°W

TRUE LOCAL TIME

FIRST: How many degrees is the birth longitude from the center meridian of the client's time zone? Answer: 2°

SECOND: Since each degree of longitude is equal to 4 minutes, multiply the above answer by 4 minutes. Then, determine if the birth longitude is East or West of the client's center meridian. Answer: 2° X 4' = 8' West

(1) Birthtime as furnished by client _____ 11:28 P.M.

(2) Subtract 1 hour if daylight or wartime _____

Preliminary Answer _____ 11:28 P.M.

(3) Add or Subtract the minutes that the birth longitude is East or West of the client's center meridian. (East = Add, West = Subtract) _____ -:08

(4) TRUE LOCAL TIME _____ 11:20 P.M. (This figure is used in Step 3 below)

--

	SIDEREAL TIME	**H**	**M**	**S**
(1)	In the Ephemeris for the client's year of birth find the sidereal time for the birthdate.	3	32	37
(2)	Multiply the birth longitude by .6666 (or 2/3rds) to determine how many sidereal seconds it will take for the birth longitude to either reach 12:00 NOON (Western Longitude), or since it was 12:00 NOON (Eastern Longitude). (Western Longitude=Add; Eastern Longitude=Subtract) +		1	21
	PRELIMINARY TOTAL:	3	33	58
(3)	Using the T.L.T. determine the interval before it will be 12:00 NOON of the birthdate (A.M. birthtimes), or the interval since it has been 12:00 NOON (P.M. birthtimes). USE THE MINUTES ONLY FOR ALL 12:00 to 12:59 BIRTHTIMES. (A.M. Birthtimes = Subtract; P.M. Birthtimes = Add) +11	20		
	PRELIMINARY TOTAL:	14	53	58
(4)	Make a 10 second correction for each hour listed in Step 3 in order to adjust the 24 hour clock to sidereal time. Be sure to consider the minutes, also. The following table will be helpful on the minutes. (A.M. Birthtimes = Subtract; P.M. Birthtimes = Add) +		1	54

Minutes		Seconds				
1 - 6	=	1 Second	PRELIMINARY TOTAL:	14	54	112
7 - 12	=	2 Seconds	Reduce figures if necessary:		+1	-60
13 - 18	=	3 Seconds	PRELIMINARY TOTAL:	14	55	52
19 - 24	=	4 Seconds				
25 - 30	=	5 Seconds				
31 - 36	=	6 Seconds	If Southern Latitude, Add 12 Hours:			
37 - 42	=	7 Seconds				
43 - 48	=	8 Seconds				
49 - 54	=	9 Seconds	ADJUSTED SIDEREAL TIME:	14	55	52
55 - 60	=	10 Seconds				

232

In the Table of Houses find the closest sidereal time to the Adjusted Sidereal Time under the client's birth latitude. Place the degrees and signs around the following chart.

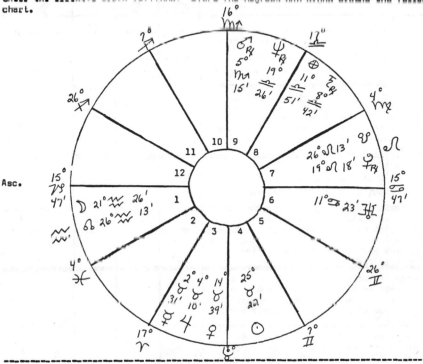

GREENWICH MEAN TIME

To determine what time it was in Greenwich, England (Prime Meridian) at the exact time of the client's birth, multiply the client's birth longitude by 4 minutes. Remember each degree is equal to 4 minutes. Reduce your answer into hours and minutes.

Answer: $122° \times 4' = 488'$ $60\overline{)488}$ 8 hrs. $\frac{480}{8}$ mins.

(1) True Local Time of birth as determined on Page 1 11:20 P.M. (15th)

(2) Using the answer above, either ADD for Western Longitude, or
 SUBTRACT for Eastern Longitude. + 8:08

 PRELIMINARY TOTAL: 19:28

(3) Reduce the minutes if over 60 minutes and add to hour figure _____

(4) If the figure is over 12:00, you have passed into P.M. or A.M. -12:00
 If this happens, subtract your figure from 12:00 and then de- (16th)
 termine if you have gone to P.M. or A.M. and which day it is. 7:28 A.M. G.M.T.

Determine the interval before it will be 12:00 NOON for the G.M.T. date (A.M. birth-
times), or the interval since it has been 12:00 NOON (P.M. birthtimes). USE THE MIN-
UTES ONLY FOR ALL 12:00 to 12:59 BIRTHTIMES. Answer: $\frac{11:60}{-7:28}$ 4 hrs. 32 mins.
 4:32

Using this interval figure establish their permanent logarithm. Answer: .7238

NATAL CHART PROCEDURE

24 HOUR TRAVEL FOR THE FAST MOVING PLANETS

PLANETS		☉	♀	☿	☽	♂℞
(1)	ZODIAC SIGN	♉	♉	♉	♒	♍℞
(2)	Degrees and Minutes for the Noon AFTER the G.M.T. date __16th__ G.M.T.	24° 93' 25° 33'	14° 53'	2° 48'	23° 66' 24° 06	5° 11'
(3)	Degrees and Minutes for the Noon BEFORE the G.M.T. date __15th__ −	24° 35'	13° 40	1° 19'	9° 57'	5° 30'
(4)	Subtract Step 3 from Step 2. (If it is a retrograde planet, subtract the smaller figure from the larger figure.) This answer indicates the number of degrees and minutes the planet traveled during a 24 hour interval.	58'	1° 13'	1° 29'	14° 09'	19'
(5)	Convert the answer from Step 4 into a logarithm.	1.3949	1.2950	1.2040	.2295	1.8796
(6)	The client's permanent logarithm from Page 2. +	.7238	.7238	.7238	.7238	.7238
(7)	Add Step 5 and Step 6 together	2.1187	2.0188	1.9328	.9533	2.6034
(8)	Convert the answer from Step 7 back into degrees and minutes by finding the nearest logarithm.	11'	14'	17'	2° 40'	04'
(9)	Using the date of the G.M.T. write in the degrees and minutes for the noon position for each of these planets. Your figures will be from either Step 2 or Step 3.	25° 33'	14° 53'	2° 48'	23° 66' 24° 06	5° 11'
(10)	Write in your figures from Step 8. These figures will either be added, if the G.M.T. is P.M., OR, they will be subtracted, if the G.M.T. is A.M., from Step 9. (Reverse this procedure if the planet is retrograde.)	− 11'	− 14'	− 17'	−2° 40'	+ 04'
(11)	THIS IS THE EXACT POSITION OF THE PLANETS FOR THE TIME OF THE CLIENT'S BIRTH.	25♉22'	14♉39'	2♉31'	21°♒36'	5♍15'

The other planets move so slowly that no calculations are necessary. Use the Noon figure for the date of the G.M.T. as listed in the Ephemeris of the birth year.

SATURN ♄℞ 8° ♎ 42' JUPITER ♃ 4° ♉ 10' URANUS ♅ 11° ♎ 23' NEPTUNE ♆℞ 19° ♎ 26'
PLUTO ♇℞ 19° ♌ 26' MOON'S NORTH NODE ☊ 26° ♒ 13' MOON'S SOUTH NODE ☋ 26° ♌ 13'
(The South Node is the Polar Opposite Zodiac Sign of the North Node.)

⊕ PART OF FORTUNE ----------→

⊕ 11° ♎ 51'

	Sign No.	Degrees	Mins.
Asc.	10	15	47
+ Moon	11	21	26
Totals	21	36	73
− Sun	2	25	22
Totals	19 −12 7	11	51

234

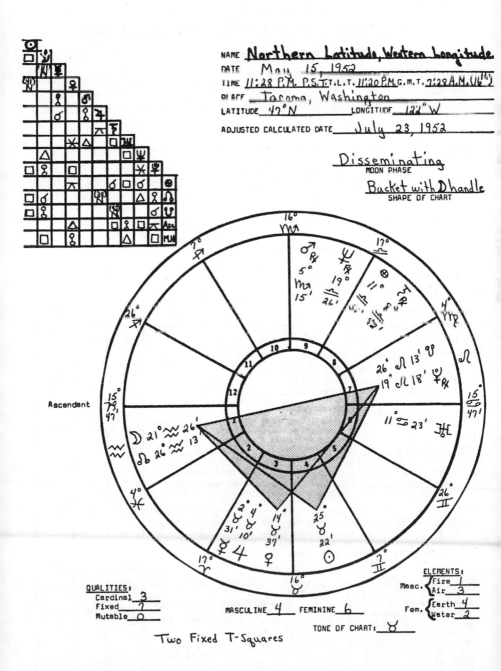

NAME **Northern Latitude, Western Longitude**
DATE **May 15, 1952**
TIME **11:28 P.M. P.S.T.** L.T. **11:20 P.M.** G.M.T. **7:28 A.M. (16ʰ)**
PLACE **Tacoma, Washington**
LATITUDE **47° N** LONGITUDE **122" W**

ADJUSTED CALCULATED DATE **July 23, 1952**

Disseminating
MOON PHASE

Bucket with ☾ handle
SHAPE OF CHART

Ascendant

QUALITIES:
Cardinal **3**
Fixed **7**
Mutable **O**

MASCULINE **4** FEMININE **6**

TONE OF CHART: **♉**

ELEMENTS:
Masc. { Fire **1**
Air **3**
Fem. { Earth **4**
Water **2**

Two Fixed T-Squares

235

CHAPTER 10

Erecting a Chart for Northern Latitude, Eastern Longitude

NAME __Northern Latitude, Eastern Longitude__ BIRTHTIME __6:00 A.M.__

BIRTHDATE __July 16, 1952__ PLACE OF BIRTH __Hiroshima, Japan__

LATITUDE __34° N__ LONGITUDE __132° E__ TIME ZONE __S.T.__ CENTER MERIDIAN __135° E__

TRUE LOCAL TIME

FIRST: How many degrees is the birth longitude from the center meridian of the client's time zone? Answer: __3°__

SECOND: Since each degree of longitude is equal to 4 minutes, multiply the above answer by 4 minutes. Then, determine if the birth longitude is East or West of the client's center meridian. Answer: __3° X 4' = 12' West__

(1) Birthtime as furnished by client __6:00 A.M.__

(2) Subtract 1 hour if daylight or wartime _____

 Preliminary Answer __6:00 A.M.__

(3) Add or Subtract the minutes that the birth longitude is East or West of the client's center meridian. (East = Add, West = Subtract) __5:60__

 __- :12__

(4) TRUE LOCAL TIME __5:48 A.M.__ (This figure is used in Step 3 below)

	SIDEREAL TIME	**H**	**M**	**S**
(1)	In the Ephemeris for the client's year of birth find the sidereal time for the birthdate.	7	39	04
(2)	Multiply the birth longitude by .6666 (or 2/3rds) to determine how many sidereal seconds it will take for the birth longitude to either reach 12:00 NOON (Western Longitude), or since it was 12:00 NOON (Eastern Longitude). (Western Longitude=Add; Eastern Longitude=Subtract)		36	64
		-	1	28
	PRELIMINARY TOTAL:	7	35	36
(3)	Using the T.L.T. determine the interval before it will be 12:00 NOON of the birthdate (A.M. birthtimes), or the interval since it has been 12:00 NOON (P.M. birthtimes). USE THE MINUTES ONLY FOR ALL 12:00 to 12:59 BIRTHTIMES. (A.M. Birthtimes = Subtract; P.M. Birthtimes = Add)	- 6	12	
	PRELIMINARY TOTAL:	1	23	36
(4)	Make a 10 second correction for each hour listed in Step 3 in order to adjust the 24 hour clock to sidereal time. Be sure to consider the minutes, also. The following table will be helpful on the minutes. (A.M. Birthtimes = Subtract; P.M. Birthtimes = Add)	-	1	02
	PRELIMINARY TOTAL:	1	22	34

Minutes		Seconds
1 - 6	=	1 Second
7 - 12	=	2 Seconds
13 - 18	=	3 Seconds
19 - 24	=	4 Seconds
25 - 30	=	5 Seconds
31 - 36	=	6 Seconds
37 - 42	=	7 Seconds
43 - 48	=	8 Seconds
49 - 54	=	9 Seconds
55 - 60	=	10 Seconds

Reduce figures if necessary:

PRELIMINARY TOTAL: _____

If Southern Latitude, Add 12 Hours: _____

ADJUSTED SIDEREAL TIME: 1 | 22 | 34

In the Table of Houses find the closest sidereal time to the Adjusted Sidereal Time under the client's birth latitude. Place the degrees and signs around the following chart.

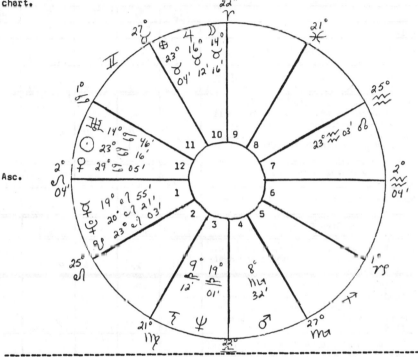

GREENWICH MEAN TIME

To determine what time it was in Greenwich, England (Prime Meridian) at the exact time of the client's birth, multiply the client's birth longitude by 4 minutes. Remember each degree is equal to 4 minutes. Reduce your answer into hours and minutes.

Answer: _____

(1) True Local Time of birth as determined on Page 1 8:48 A.M

(2) Using the answer above, either ADD for Western Longitude, or - 8:48
 SUBTRACT for Eastern Longitude.
 PRELIMINARY TOTAL: 9:00 P.M

(3) Reduce the minutes if over 60 minutes and add to hour figure _____

(4) If the figure is over 12:00, you have passed into P.M. or A.M.
 If this happens, subtract your figure from 12:00 and then de-
 termine if you have gone to P.M. or A.M. and which day it is. 9:00 P.M.(15th)G.M.T.

Determine the interval before it will be 12:00 NOON for the G.M.T. date (A.M. birth-times), or the interval since it has been 12:00 NOON (P.M. birthtimes). USE THE MIN-UTES ONLY FOR ALL 12:00 to 12:59 BIRTHTIMES. Answer: 9 hours

Using this interval figure establish their permanent logarithm. Answer: .4260

237

24 HOUR TRAVEL FOR THE FAST MOVING PLANETS

PLANETS		☉	♀	☿	☽	♂
(1)	ZODIAC SIGN	♋	♋	♌	♉	♏
(2)	Degrees and Minutes for the Noon AFTER the G.M.T. date 16th	23° 52'	29° 51'	20° 30'	22° 18'	8° 46'
(3)	Degrees and Minutes for the Noon BEFORE the G.M.T. date 15th G.M.T. −	22° 55'	28° 37'	19° 34'	9° 34'	8° 24'
(4)	Subtract Step 3 from Step 2. (If it is a retrograde planet, subtract the smaller figure from the larger figure.) This answer indicates the number of degrees and minutes the planet traveled during a 24 hour interval.	57'	1° 14'	56'	12° 52'	22'
(5)	Convert the answer from Step 4 into a logarithm.	1.4025	1.2891	1.4102	.2707	1.8159
(6)	The client's permanent logarithm from Page 2. +	.4260	.4260	.4260	.4260	.4260
(7)	Add Step 5 and Step 6 together	1.8285	1.7151	1.8362	.6967	2.2419
(8)	Convert the answer from Step 7 back into degrees and minutes by finding the nearest logarithm.	21'	28'	21'	4° 50'	08'
(9)	Using the date of the G.M.T. write in the degrees and minutes for the noon position for each of these planets. Your figures will be from either Step 2 or Step 3.	22° 55'	28° 37'	19° 34'	9° 26'	8° 24'
(10)	Write in your figures from Step 8. These figures will either be added, if the G.M.T. is P.M., OR, they will be subtracted, if the G.M.T. is A.M., from Step 9. (Reverse this procedure if the planet is retrograde.)	+ 21'	+ 28'	+ 21'	+4° 50'	+ 08'
(11)	THIS IS THE EXACT POSITION OF THE PLANETS FOR THE TIME OF THE CLIENT'S BIRTH.	23°♋16' 22° 34'	29°♋05' 28° 65'	14°♉16' 19♌55'	13° 46'	8♏32'

The other planets move so slowly that no calculations are necessary. Use the Noon figure for the date of the G.M.T. as listed in the Ephemeris of the birth year.

SATURN ♄ 9° ♎ 12' JUPITER ♃ 16° ♉ 12' URANUS ♅ 14° ♋ 46' NEPTUNE ♆ 19° ♎ 01'
PLUTO ♇ 20° ♌ 21' MOON'S NORTH NODE ☊ 23° ♒ 03' MOON'S SOUTH NODE ☋ 23° ♌ 03'
(The South Node is the Polar Opposite Zodiac Sign of the North Node.)

⊕ PART OF FORTUNE ─────────→

⊕ 23° ♉ 04'

	Sign No.	Degrees	Mins.
Asc.	5	2	04
+ Moon	+ 2	14	16
Totals	6 8	46 16	20
− Sun	− 4	23	16
Totals	2	23°	04'

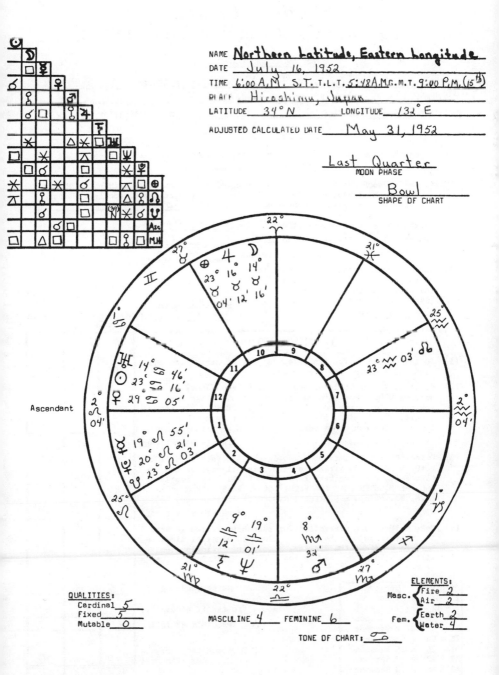

NAME *Northern Latitude, Eastern Longitude*
DATE *July 16, 1952*
TIME *6:00 A.M.* S.T. T.L.T. *5:48 A.M.* G.M.T. *9:00 P.M. (15ᵗʰ)*
PLACE *Hiroshima, Japan*
LATITUDE *34° N* LONGITUDE *132° E*
ADJUSTED CALCULATED DATE *May 31, 1952*

Last Quarter
MOON PHASE

Bowl
SHAPE OF CHART

Ascendant

QUALITIES:
Cardinal _5_
Fixed _5_
Mutable _0_

MASCULINE _4_ FEMININE _6_

TONE OF CHART: ☉☽

ELEMENTS:
Masc. { Fire _2_
 { Air _2_
Fem. { Earth _2_
 { Water _4_

239

Erecting a Chart for
Southern Latitude, Western Longitude

NAME _Southern Latitude, Western Longitude_ BIRTHTIME _9:30 P.M_

BIRTHDATE _March 14, 1955_ PLACE OF BIRTH _Rio de Janeiro, Brazel_

LATITUDE _23°S_ LONGITUDE _43°W_ TIME ZONE _S.T._ CENTER MERIDIAN _45°W_

TRUE LOCAL TIME

FIRST: How many degrees is the birth longitude from the center meridian of the client's time zone? Answer: _2°_

SECOND: Since each degree of longitude is equal to 4 minutes, multiply the above answer by 4 minutes. Then, determine if the birth longitude is East or West of the client's center meridian. Answer: _2° X 4' = 8' East_

(1) Birthtime as furnished by client _____9:30 P.M._____

(2) Subtract 1 hour if daylight or wartime _____

Preliminary Answer _____9:30 P.M._____

(3) Add or Subtract the minutes that the birth longitude is East or West of the client's center meridian. (East = Add, West = Subtract) _____+ :08_____

(4) TRUE LOCAL TIME _____9:38 P.M._____ (This figure is used in Step 3 below)

--

SIDEREAL TIME	H	M	S
(1) In the Ephemeris for the client's year of birth find the sidereal time for the birthdate.	23	25	20
(2) Multiply the birth longitude by .6666 (or 2/3rds) to determine how many sidereal seconds it will take for the birth longitude to either reach 12:00 NOON (Western Longitude), or since it was 12:00 NOON (Eastern Longitude). (Western Longitude=Add; Eastern Longitude=Subtract)	+		29
PRELIMINARY TOTAL:	23	25	49
(3) Using the T.L.T. determine the interval before it will be 12:00 NOON of the birthdate (A.M. birthtimes), or the interval since it has been 12:00 NOON (P.M. birthtimes). USE THE MINUTES ONLY FOR ALL 12:00 to 12:59 BIRTHTIMES. (A.M. Birthtimes = Subtract; P.M. Birthtimes = Add)	+ 9	38	
PRELIMINARY TOTAL:	32	63	49
(4) Make a 10 second correction for each hour listed in Step 3 in order to adjust the 24 hour clock to sidereal time. Be sure to consider the minutes, also. The following table will be helpful on the minutes. (A.M. Birthtimes = Subtract; P.M. Birthtimes = Add)	+ 1	-60	
	33	03	
	+	1	37

Minutes	Seconds
1 - 6 = 1 Second	
7 - 12 = 2 Seconds	
13 - 18 = 3 Seconds	
19 - 24 = 4 Seconds	
25 - 30 = 5 Seconds	
31 - 36 = 6 Seconds	
37 - 42 = 7 Seconds	
43 - 48 = 8 Seconds	
49 - 54 = 9 Seconds	
55 - 60 = 10 Seconds	

	H	M	S
PRELIMINARY TOTAL:	33	04	86
Reduce figures if necessary:		+1	-60
PRELIMINARY TOTAL:	33	05	26
If Southern Latitude, Add 12 Hours:	+12	00	00
	45	05	26
	-24	00	00
ADJUSTED SIDEREAL TIME:	21	05	26

In the Table of Houses find the closest sidereal time to the Adjusted Sidereal Time under the client's birth latitude. Place the degrees and signs around the following chart.

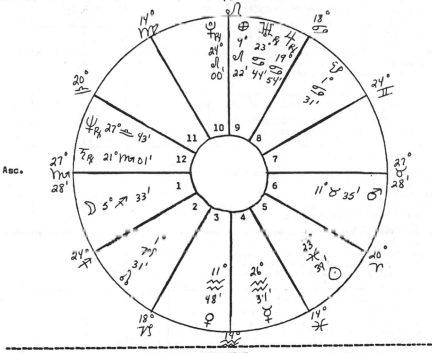

GREENWICH MEAN TIME

To determine what time it was in Greenwich, England (Prime Meridian) at the exact time of the client's birth, multiply the client's birth longitude by 4 minutes. Remember each degree is equal to 4 minutes. Reduce your answer into hours and minutes.

Answer:

(1) True Local Time of birth as determined on Page 1 9:38 P.M.

(2) Using the answer above, either ADD for Western Longitude, or + 2:52
 SUBTRACT for Eastern Longitude.

 PRELIMINARY TOTAL: 11:90

(3) Reduce the minutes if over 60 minutes and add to hour figure -1 60

(4) If the figure is over 12:00, you have passed into P.M. or A.M. 12 : 30 A.M.
 If this happens, subtract your figure from 12:00 and then de- 12:30 A.M. (15th)
 termine if you have gone to P.M. or A.M. and which day it is. G.M.T.

Determine the interval before it will be 12:00 NOON for the G.M.T. date (A.M. birth-times), or the interval since it has been 12:00 NOON (P.M. birthtimes). USE THE MIN-UTES ONLY FOR ALL 12:00 to 12:59 BIRTHTIMES. Answer: 11 hours 30 minutes

Using this interval figure establish their permanent logarithm. Answer: .3195

241

24 HOUR TRAVEL FOR THE FAST MOVING PLANETS

PLANETS		☉	♀	☿	☽	♂
(1)	ZODIAC SIGN	♓	♒	♒		♉
(2)	Degrees and Minutes for the Noon AFTER the G.M.T. date 15ᵗʰ G.M.T.	24° 08'	12° 22'	26° 68' 40° 27° 08' ♓ ✗ 73° 73'		11° 55'
(3)	Degrees and Minutes for the Noon BEFORE the G.M.T. date 14ᵗʰ	23° 08'	11° 12'	25° 58'	29° ♏ 32'	11° 13'
(4)	Subtract Step 3 from Step 2. (If it is a retrograde planet, subtract the smaller figure from the larger figure.) This answer indicates the number of degrees and minutes the planet traveled during a 24 hour interval.	1° 00'	1° 01'	1° 10'	11° 49'	42'
(5)	Convert the answer from Step 4 into a logarithm.	1.3802	1.3730	1.3133	.3077	1.5351
(6)	The client's permanent logarithm from Page 2. +	.3195	.3195	.3195	.3195	.3195
(7)	Add Step 5 and Step 6 together	1.6997	1.6925	1.6328	.6272	1.8546
(8)	Convert the answer from Step 7 back into degrees and minutes by finding the nearest logarithm.	29'	29'	33'	5° 40'	20'
(9)	Using the date of the G.M.T. write in the degrees and minutes for the noon position for each of these planets. Your figures will be from either Step 2 or Step 3.	24° 08'	12° 22'	27° 08'	11° ✗ 13'	11° 55'
(10)	Write in your figures from Step 8. These figures will either be added, if the G.M.T. is P.M., OR, they will be subtracted, if the G.M.T. is A.M., from Step 9. (Reverse this procedure if the planet is retrograde.)	− 29'	− 29'	− 33'	−5° 40'	− 20'
(11)	THIS IS THE EXACT POSITION OF THE PLANETS FOR THE TIME OF THE CLIENT'S BIRTH.	23♓ 39'	11° ♒ 48'	26° ♒ 34'	5° ✗ 33'	11° ♉ 35'

The other planets move so slowly that no calculations are necessary. Use the Noon figure for the date of the G.M.T. as listed in the Ephemeris of the birth year.

SATURN ♄ ℞ 21° ♏ 01' JUPITER ♃ 19° ♎ 54' URANUS ♅ 23° ♎ 44' NEPTUNE ♆ 27° ♎ 43'
PLUTO ♇ ℞ 24° ♌ 00' MOON'S NORTH NODE ☊ 1° ♑ 31' MOON'S SOUTH NODE ☋ 1° ♎ 31'
(The South Node is the Polar Opposite Zodiac Sign of the North Node.)

⊕ PART OF FORTUNE ----------→

⊕ 9° ♌ 22'

	Sign No.	Degrees	Mins.
Asc.	8	27	28
+ Moon	+ 9	5	33
Totals	17	32	61
− Sun	−12	23	39
Totals	5	9	22

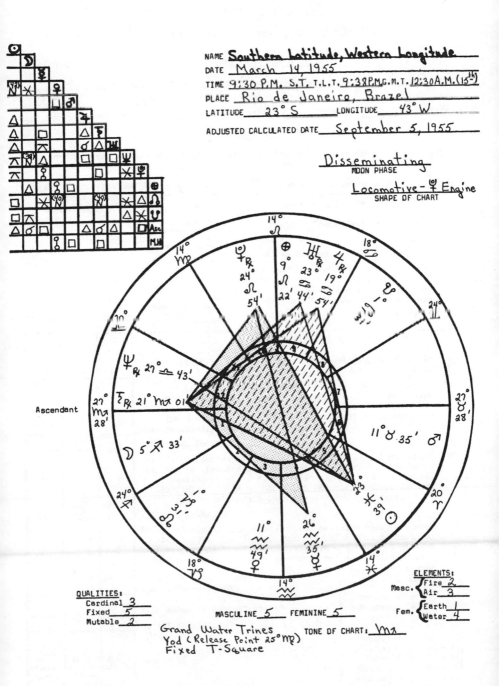

NAME **Southern Latitude, Western Longitude**
DATE **March 14, 1955**
TIME **9:30 P.M. S.T. T.L.T. 9:38 P.M. G.M.T. 12:30 A.M. (15ᵗʰ)**
PLACE **Rio de Janeiro, Brazil**
LATITUDE **23° S** LONGITUDE **43° W**
ADJUSTED CALCULATED DATE **September 5, 1955**

Disseminating
MOON PHASE

Locomotive - ♀ Engine
SHAPE OF CHART

Ascendant

QUALITIES:
Cardinal **3**
Fixed **5**
Mutable **2**

MASCULINE **5** FEMININE **5**

TONE OF CHART: ♏

ELEMENTS:
Masc. { Fire **2**
 { Air **3**
Fem. { Earth **1**
 { Water **4**

Grand Water Trines
Yod (Release Point 25° ♍)
Fixed T-Square

243

CHAPTER 12

Erecting a Chart for Southern Latitude, Eastern Longitude

NAME **Southern Latitude, Eastern Longitude** BIRTHTIME **7:30 A.M.**
BIRTHDATE **September 20, 1956** PLACE OF BIRTH **Sydney, Australia**
LATITUDE **34° S** LONGITUDE **151° E** TIME ZONE **S.T.** CENTER MERIDIAN **150° E**

TRUE LOCAL TIME

FIRST: How many degrees is the birth longitude from the center meridian of the client's time zone? Answer: **1°**

SECOND: Since each degree of longitude is equal to 4 minutes, multiply the above answer by 4 minutes. Then, determine if the birth longitude is East or West of the client's center meridian. Answer: **1° X 4' = 4' East**

(1) Birthtime as furnished by client **7:30 A.M.**

(2) Subtract 1 hour if daylight or wartime **—**

 Preliminary Answer **7:30 A.M.**

(3) Add or Subtract the minutes that the birth longitude is East or West of the client's center meridian. (East = Add, West = Subtract) **+ :04**

(4) TRUE LOCAL TIME **7:34 A.M.** (This figure is used in Step 3 below)

SIDEREAL TIME

	H	M	S
(1) In the Ephemeris for the client's year of birth find the sidereal time for the birthdate.	11	57 / 56	24 / 84
(2) Multiply the birth longitude by .6666 (or 2/3rds) to determine how many sidereal seconds it will take for the birth longitude to either reach 12:00 NOON (Western Longitude), or since it was 12:00 NOON (Eastern Longitude). (Western Longitude=Add; Eastern Longitude=Subtract)	−	1	41
PRELIMINARY TOTAL:	11	55	43
(3) Using the T.L.T. determine the interval before it will be 12:00 NOON of the birthdate (A.M. birthtimes), or the interval since it has been 12:00 NOON (P.M. birthtimes). USE THE MINUTES ONLY FOR ALL 12:00 to 12:59 BIRTHTIMES. (A.M. Birthtimes = Subtract; P.M. Birthtimes = Add)	− 4	26	
PRELIMINARY TOTAL:	7	29 / 28	43 / 103
(4) Make a 10 second correction for each hour listed in Step 3 in order to adjust the 24 hour clock to sidereal time. Be sure to consider the minutes, also. The following table will be helpful on the minutes. (A.M. Birthtimes = Subtract; P.M. Birthtimes = Add)	−		45
PRELIMINARY TOTAL:	7	28	58
Reduce figures if necessary:			
PRELIMINARY TOTAL:	7	28	58
If Southern Latitude, Add 12 Hours:	+ 12	00	00
ADJUSTED SIDEREAL TIME:	19	28	58

Minutes		Seconds
1 – 6	=	1 Second
7 – 12	=	2 Seconds
13 – 18	=	3 Seconds
19 – 24	=	4 Seconds
25 – 30	=	5 Seconds
31 – 36	=	6 Seconds
37 – 42	=	7 Seconds
43 – 48	=	8 Seconds
49 – 54	=	9 Seconds
55 – 60	=	10 Seconds

In the Table of Houses find the closest sidereal time to the Adjusted Sidereal Time under the client's birth latitude. Place the degrees and signs around the following chart.

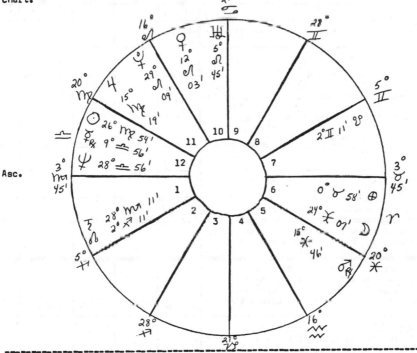

GREENWICH MEAN TIME

To determine what time it was in Greenwich, England (Prime Meridian) at the exact time of the client's birth, multiply the client's birth longitude by 4 minutes. Remember each degree is equal to 4 minutes. Reduce your answer into hours and minutes.

Answer:

(1) True Local Time of birth as determined on Page 1 8:34 A.M.

(2) Using the answer above, either ADD for Western Longitude, or SUBTRACT for Eastern Longitude. − 10:04

 PRELIMINARY TOTAL: 9:30 P.M.

(3) Reduce the minutes if over 60 minutes and add to hour figure

(4) If the figure is over 12:00, you have passed into P.M. or A.M. If this happens, subtract your figure from 12:00 and then determine if you have gone to P.M. or A.M. and which day it is. 9:30 P.M. (19th) G.M.T.

Determine the interval before it will be 12:00 NOON for the G.M.T. date (A.M. birthtimes), or the interval since it has been 12:00 NOON (P.M. birthtimes). USE THE MIN-UTES ONLY FOR ALL 12:00 to 12:59 BIRTHTIMES. Answer: 9 hours 30 minutes

Using this interval figure establish their permanent logarithm. Answer: .4025

245

24 HOUR TRAVEL FOR THE FAST MOVING PLANETS

PLANETS	☉	♀	☿ ℞	☽	♂ ℞
(1) ZODIAC SIGN	♍	♌	♎		♓
(2) Degrees and Minutes for the Noon <u>AFTER</u> the G.M.T. date 20th	26° 89' 27° 29'	12° 42'	9° 30'	31° χ ϒ 41	15° 38'
(3) Degrees and Minutes for the Noon <u>BEFORE</u> the G.M.T. date 19th G.M.T.	26° 31'	11° 37'	10° 13'	19° ♓ 10'	15° 52'
(4) Subtract Step 3 from Step 2. (If it is a retrograde planet, subtract the smaller figure from the larger figure.) This answer indicates the number of degrees and minutes the planet traveled during a 24 hour interval.	58'	1° 05'	43'	12° 31'	14'
(5) Convert the answer from Step 4 into a logarithm.	1.3949	1.3454	1.5249	.2827	2.012?
(6) The client's permanent logarithm from Page 2.	.4025	.4025	.4025	.4025	.4025
(7) Add Step 5 and Step 6 together	1.7974	1.7479	1.9274	.6852	2.4147
(8) Convert the answer from Step 7 back into degrees and minutes by finding the nearest logarithm.	23'	26'	17'	4° 57'	06'
(9) Using the date of the G.M.T. write in the degrees and minutes for the noon position for each of these planets. Your figures will be from either Step 2 or Step 3.	26° 31'	11° 37'	10° 12'	19° ♓ 10'	15° 52'
(10) Write in your figures from Step 8. These figures will either be added, if the G.M.T. is P.M., OR, they will be subtracted, if the G.M.T. is A.M., from Step 9. (Reverse this procedure if the planet is retrograde.)	+ 23'	+ 26'	9° 73' − 17'	18° 70' + 4° 57'	− 06'
(11) THIS IS THE EXACT POSITION OF THE PLANETS FOR THE TIME OF THE CLIENT'S BIRTH.	26° ♍ 54'	12° ♌ 03' 11° 63'	9° ♎ 56'	24° ♓ 07' 22° 122'	15° ♓ 46'

The other planets move so slowly that no calculations are necessary. Use the Noon figure for the date of the G.M.T. as listed in the Ephemeris of the birth year.

SATURN ♄ 28° ♏ 11' JUPITER ♃ 15° ♍ 19' URANUS ♅ 5° ♌ 45' NEPTUNE ♆ 28° ♎ 56'
PLUTO ♇ 29° ♌ 09' MOON'S NORTH NODE ☊ 2° ♐ 11' MOON'S SOUTH NODE ☋ 2° ♊ 11'
(The South Node is the Polar Opposite Zodiac Sign of the North Node.)

⊕ PART OF FORTUNE ----------->

⊕ 0° ♉ 58'

	Sign No.	Degrees	Mins.
Asc.	8	3	45
+ Moon	+ 12	24	07
Totals	20	26 27	112 52
− Sun	− 6	26	54
Totals	−14 2	0	58

246

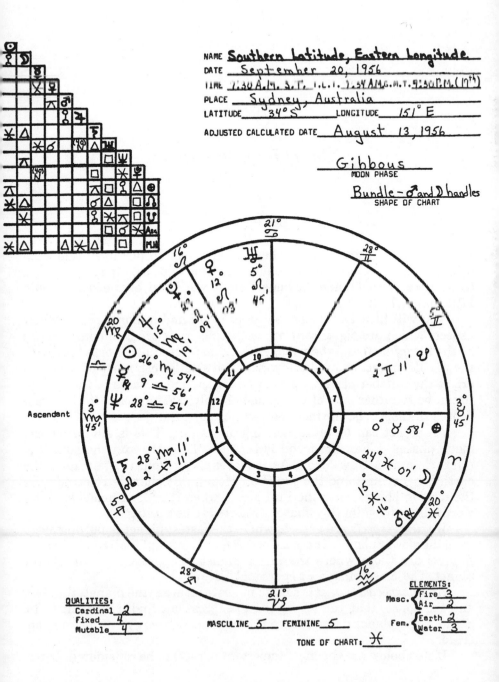

NAME **Southern Latitude, Eastern Longitude.**
DATE September 20, 1956
TIME 7:30 A.M. S.T. I.L.T. 7:34 A.M. G.M.T. 9:30 P.M. (19th)
PLACE Sydney, Australia
LATITUDE 34° S LONGITUDE 151° E
ADJUSTED CALCULATED DATE August 13, 1956

Gibbous
MOON PHASE

Bundle — ♂ and ☽ handles
SHAPE OF CHART

Ascendant

QUALITIES:
Cardinal 2
Fixed 4
Mutable 4

MASCULINE 5 FEMININE 5

TONE OF CHART: ♓

ELEMENTS:
Masc. { Fire 3
 { Air 2
Fem. { Earth 2
 { Water 3

247

CHAPTER 13

Chart Interpretation

ASPECTS

Planets are in "aspect" when they are at a certain distance from each other, as they "reflect" on the zodiac belt. This relationship reveals areas (the planet, the sign, and the house) where work is either needed or could be accomplished.

You will hear astrologers speak of major and minor aspects. Minor aspects which are significant are the *quincunx* (more commonly known as the *inconjunct*) and the *nonagen*. Most aspects allow 8° orbs, but with the sextile, quincunx, and the nonagen, a smaller orb must be used. An orb is the number of degrees allowed for the inexactness of the aspect. It can be to either side of the planets involved. The closer to the exact degree the aspect is, the more powerful it becomes.

An aspect can be either waxing or waning. This is similar to the moon phases. When the moon is between the earth and the sun, it is referred to as a New Moon. As it moves away from the sun until the earth is between it and the sun (Full Moon), this phase is referred to as the *waxing* phase. After the Full Moon, when the moon heads back towards the sun again, this phase is referred to as *waning*.

Waxing Aspects are aspects where the fastest planet is pulling away from the slower planet. These aspects refer to personal "activity." *Waning Aspects* are those where the faster planet is approaching the slower planet. These aspects refer to personal "ideas."

An *unaspected planet* is said to indicate an area (the planet, the sign, and the house) that you are trying to express but find it difficult to do, because the planet doesn't have the necessary "energy" to make it operate.

Listed below are the most important aspects to be considered. Later,

the lesser used aspects should also be interpreted. All of these aspects are within 8° orb, except the nonagen (2° orb), sextile (6° orb), quincunx (4° orb), and the parallel (1° orb).

☌	Conjunction	8°	—*Power, Energy, Emphasis*
Ν	Nonagen	40°	—*Bondage* in the houses and with the planets, because of the need for re-evaluating past-life attitudes
✳	Sextile	60°	—*Opportunity* to be productive and/or creative
☐	Square	90°	—*Obstacles, Stress.* Internal conflict to bring about a change
△	Trine	120°	—*Ease, Harmony.* Benefit without effort. Ability to express creativity
⚻	Quincunx (Inconjunct)	150°	—*Discord.* Adjustment needed, regarding the attributes of the planets involved. Need courage and the will to do so.
⚼	Opposition	180°	—*Awareness.* Cooperation and compromise necessary. Internal and external conflict caused by others to bring about change.
P	Parallel	1°	—*Power, Emphasis, Inner Activity*

In order to assist in aspecting a chart, memorize the following: Any sign in the same quality, if in "orb," will be square, unless it is its polar opposite sign. Then, it will be an opposition, if in "orb."

Qualities: Cardinal Signs (Aries—Libra, Cancer—Capricorn)
Fixed Signs (Taurus—Scorpio, Leo—Aquarius)
Mutable Signs (Gemini—Sagittarius, Virgo—Pisces)

All four elements will automatically be trine, if in "orb." When all three of the same element are trine, it is called a grand trine.

Elements: Fire Signs (Aries, Leo, Sagittarius)
Air Signs (Gemini, Libra, Aquarius)
Earth Signs (Taurus, Virgo, Capricorn)
Water Signs (Cancer, Scorpio, Pisces)

Masculine Signs (Fire and Air) will be sextile, if in "orb," unless it is its polar opposite sign. Then, it will be an opposition, if in "orb."

Masculine Signs: Fire Signs (Aries, Leo, Sagittarius)
 Air Signs (Gemini, Libra, Aquarius)

Feminine Signs (Earth and Water) will be sextile, if in "orb," unless it is its polar opposite sign. Then, it will be an opposition, if in "orb."

Feminine Signs: Earth Signs (Taurus, Virgo, Capricorn)
 Water Signs (Cancer, Scorpio, Pisces)

Quincunx (Inconjunct) occurs, if in "orb," in the zodiac sign either before or after the polar opposite sign of the planet involved.

Nonagens will have to be calculated if two planets appear to be more than 30 degrees apart.

Parallels (1° orb):
 In order to ascertain parallel aspects, the declination of the planets on the birthdate must be determined. This can be found in the "Ephemeris" of the birth year, on the page where the sidereal time is located. The word *declination* in astrology means terrestrial latitude.
 The establishment of the celestial hemispheres was made by projecting earth's equator into the sky, dividing the sky into Northern Terrestrial Latitude and Southern Terrestrial Latitude. Thus, the equator and its projected line are equal to 0° Celestial Latitude. Celestial Latitude extends to 90° North and 90° South, at which point the two poles are formed. The North Celestial Pole is easily discerned because the Pole Star, Polaris, is located at +89° North Terrestrial Latitude.
 Planets that orbit in the same Celestial Hemisphere within 1° latitude of each other are considered to be in a parallel aspect. Parallels are similar to conjunctions, but operate more internally.

Color Coding for Major Aspects

Grand Cross	Red Pencil	(This indicates stress, but, also, energy)
T-Square	Red Pencil	(This indicates stress, but, also, energy)
Grand Fire Trine	Orange Pencil	(Active energy)
Grand Air Trine	Yellow Pencil	(Mental energy)
Grand Earth Trine	Green Pencil	(Productive energy)
Grand Water Trine	Blue Pencil	(Psychic energy)

Conjunction: Emphasis, Power, Energy (Inharmonious or harmonious, depending on planets.

Nonagen: Bondage in the houses and with the planets, because of the need to reevaluate past-life attitudes.

Sextiles: Opportunity (Must use them to benefit.)

Quintile: 72° Exactly—Talent, Spiritual Aspect (Shows in what manner you may succeed in linking your inner and outer being. Ability to transform environment.)

Squares: Obstacles (Lessons we have failed to learn in other lives and now must face again to resolve them.)

Trines: Harmony, Benefits without effort (Good we have given out returning to us.)

Inconjuncts: Discord, Adjustment Needed (If in the sign before the opposition, it gives difficulties in health or work—according to the sign and planet involved. If in the sign after the opposition, it necessitates the regeneration of the personality concerning the planets involved.)

Oppositions: Awareness (Calls for cooperation and compromise, usually involves people.)

Aspects to ascendant: Determines the temperament and character of the individual.

Aspects to mid-heaven: Determines success and events in outer world.

Grand Crosses: Challenge.

Cardinal Cross: Outlet is action, must motivate yourself.

Fixed Cross: Outlet is emotional, but in a self-expressive way (singing, painting).

Mutable Cross: Outlet is being adaptable to changes in environment, but still remaining decisive.

T-Squares: Imbalance (Outlet is the same as listed for Grand Crosses.) The quality needed to develop is the sign of the missing leg. (For example, Capricorn as the missing leg—need to develop patience and practicality.) The house affairs which contain the missing leg must also be developed.

Fate Aspects: Powerful. Planets that are at the same degree (Example, 20° Leo trine 20° Sagittarius).

Critical Degrees (Planets or Cusps)

Cardinal Signs: 1° A new beginning.
 13° Frustration due to refusal to conform.
 26° A warning to reevaluate plans before rushing ahead.

Mutable Signs: 4° Overcoming all bias and the acceptance of the oneness of all.
 17° Rebirth due to emergence of knowledge from subconscious mind.

Fixed Signs: 9° Faith in ability to overcome all obstacles and difficulties.
 15° Tied to the Law of Karma = The potential of an evolved soul to fulfill his destiny and teach others.
 21° Agonies involved with the cleansing of an ego-oriented mind.

Any planets or cusps at 29° = Potential of completing the learning process of the sign.

YOD

A Yod has been called "the hand of God" and "the finger of destiny." It is formed when two planets are in a sextile relationship and inconjunct (quincunx) the same planet. A 6° orb is allowed for the sextile and a 4° orb for the inconjuncts.

Very little has been written about the Yod, and the general interpretation has been that it is a stress vibration similar to the crosses and T-squares. However, I feel its original purpose was to bestow upon the chart and the individual a special blessing if the conscious mind would remember its divinity and seek spiritual riches.

Yod is a Hebrew name for the Hebrew letters I, J, Y, and the Hebrew value ten. Esoterically, the name Yod means to experience a union with one's higher self. Because of this, it is apparent that those with a Yod, or Yods, in their chart have experienced this union in other lifetimes.

The number ten in numerology means to perfect something, to bring it to completion. It calls for an individual to be responsive to his higher self. Since "Yod" individuals have experienced their higher self in former lifetimes, the presence of a Yod indicates a desire of the soul to seek and perfect this union this lifetime.

In Tarot, the Yod is represented by the card the "Hermit" which means illumination from within. The symbol for this tarot card is the open hand. Its action is the union of the higher self with the conscious mind. Although the Hermit appears to be alone, he is really a leader with a gift for showing the way. He is not a recluse in the true sense of the word, but is driven by inner urges to explore the world. His path will be strewn with many obstacles so that he will want to learn the "whys" of these obstacles. (Perhaps this is why the Yod has received its stress

interpretation.) There is a strong need for these individuals to share their inner knowledge and spiritual insights with others. If he is a balanced Hermit, he will obtain material and spiritual progress. (So, too, will the individuals with a Yod, or Yods, obtain material and spiritual progress if their thoughts and emotions are correct.) The negative aspect of the Hermit card would be to withdraw from society in some manner.

The Yod has an affinity to the zodiac sign Virgo. In Virgo, the conscious mind is stimulated to continuously collect, sort, classify, analyze, discard, and, then, communicate what it has learned. This, too, is the need of those who have a Yod, or Yods.

Think of a Yod as a "dowsing rod" that draws the positive vibrations from the planets and signs involved. If the person will use these positive vibrations, they will be able to "find" their higher self. A planet that conjuncts the release point of the Yod is like the dowser who operates the "dowsing rod." The talents of the different dowsers (planets) aid in finding water, oil, etc. The Yod can, also, be visualized as the Tree of Life and Knowledge from which "blossoms" knowledge and spiritual wisdom. Individuals who have a Yod, or Yods, in their chart are very old souls who have acquired much knowledge and spiritual insights.

The two inconjuncts indicate a need for the individual to adjust his thinking and emotional responses to the planets, signs, and houses involved. If spiritual knowledge is not sought with the view of uniting the higher self, the inconjuncts will bring health and work difficulties according to the planets and signs involved. The sextile indicates an opportunity to be productive and/or creative. However, the energy must be consciously used in order to benefit.

A Yod indicates power, skill, dexterity, aptitude, and the potential of the person. It is a tool, or instrument, to be used by the individual. It is especially powerful when transiting or progressed planets aspect it, or conjunct the release point. The release point of a Yod is halfway between the two planets involved in the sextile aspect.

Wherever the Yod is placed within the chart, the houses, the planets, and the signs involved are given a promise of special spiritual blessings if the person chose to use the positive qualities of the planets and signs and if the person seeks spiritual truths.

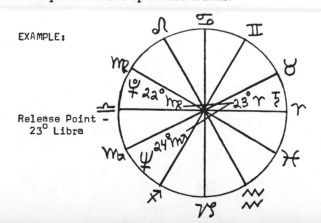

EXAMPLE:

Release Point –
23° Libra

This individual has developed and used his psychic abilities in a monastic environment where he endured hardships and experienced, on numerous occasions, a union of his higher self and conscious mind.

Pluto in the twelfth house indicates his desire to seek truth and wisdom. Neptune in the second house reveals his psychic sensitivity with the ability to tap these talents. Saturn in the seventh house shows he has withdrawn from society in former lifetimes and needs to learn to interact with others.

The Pluto sextile Neptune gives him the *opportunity* to use his psychic abilities for others, but some effort must be made to develop them. Saturn inconjunct Neptune shows a creative, hard worker who has feelings of unworthiness. The Saturn inconjunct Pluto indicates stoicism, inner tension, and a need to flow with his experiences.

ASPECTING A CHART

Qualities, if in "orb," will be *square* (90° apart), unless it is its polar opposite; then, if in "orb," it will be an *opposition* (180° apart).

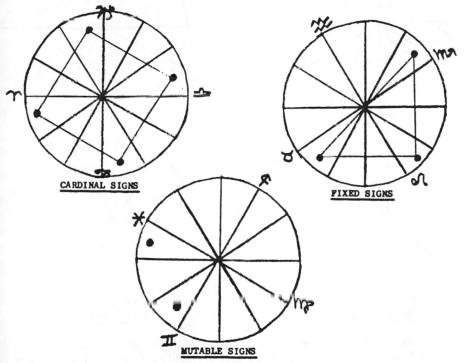

CARDINAL SIGNS

FIXED SIGNS

MUTABLE SIGNS

Allow an 8° "orb" for *squares* and *oppositions.* This can be on either side of the planets involved. To be in *square* aspect, it should have no less than 82° and no more than 98° between the two planets. To be in *opposition,* there should be no less than 172° and no more than 188° between the two planets.

--

QUINCUNX (INCONJUNCT) (150°)

Allow 4° "orb" only. It occurs in the zodiac sign, either before or after the polar opposite of the planet involved. Should be no more than 153° and no less than 147°.

NONAGEN (40°)

Allow 2° "orb" only. To be a *nonagen,* there should be no less than 38° and no more than 42° between the two planets.

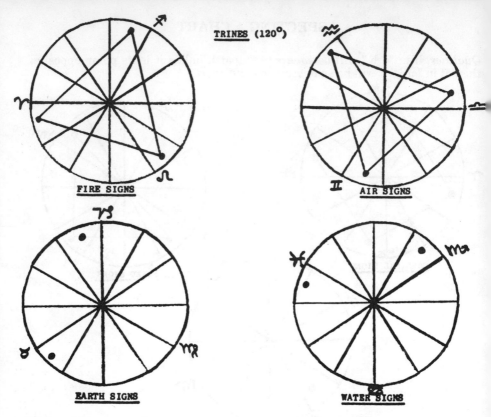

TRINES (120°)

FIRE SIGNS AIR SIGNS

EARTH SIGNS WATER SIGNS

All four elements will automatically be *trine* if they are within "orb." Allow 8° "orb" for *trines*. There should be no less than 112° and no more than 128° between the two planets. When all three of the same element have *trine* aspects, you have a *grand trine*.

Masculine Signs (Fire and Air) Feminine Signs (Earth and Water)
Sextile (60°) unless its polar opposite Sextile (60°) unless its polar opposite

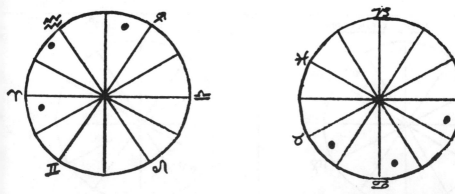

Allow 6° "orb" only. To be in a *sextile* aspect, there should be no less than 54° and no more than 66° between the two planets involved. If it is its polar opposite, then you automatically know it is an *opposition* if it is in "orb" of the 180°.

THE "SHAPING" OF CHARTS

(1) *The Splash* (Planets in ten or more zodiac signs.) The planets are scattered around the chart. These individuals have the capacity for a broad range of universal interests. But there is a tendency to scatter their energy and "resources."

(2) *The Bundle* (Planets in five consecutive zodiac signs.) The planets are concentrated within the space of a trine aspect (120°). These individuals find that their life is held to certain narrow opportunities. They are generally inhibited in comparison to someone with the splash-type chart.

(3) *The Locomotive* (Planets in eight or nine consecutive zodiac signs.) This is the reverse of the bundle, in that the planets are in the space of two trines (240°) leaving an empty trine. These individuals have an abundance of energy and drive. The important planet is the one which leads in clockwise direction. The planet, the house, and the sign it is in should be considered as an indication of the area and qualities to be developed.

(4) *The Bowl* (Planets in six consecutive zodiac signs.) The planets lie in any one-half of the chart. If the division is along the horizon or meridian line, a hemisphere emphasis is created. These individuals are self-contained, because they find it difficult to express themselves. Thus, they seek to assimilate information so they can teach others. The houses and the signs occupied are an indication of the areas and qualities they will instinctively work on.

(5) *The Bucket* (Planets in six consecutive zodiac signs with one singleton in the opposite section.) All planets but one are in one-half of the chart. The singleton gives a "handle" to the bowl-type chart. The singleton reveals an important direction, which should be developed according to the planet, the house, and the sign.

(6) *The See-Saw*. The planets lie in roughly two opposing groups. The tendency is to always consider each side of opposing views and opinions. There is great difficulty in choosing between these conflicting opinions, as they can see the validity of both sides.

(7) *The Splay*. The planets are scattered in small groupings, at irregular points around the chart. Sometimes there is a stellum of planets or a grand trine present. These individuals do not like to be regimented or to have a highly organized life.

ILLUSTRATION OF THE "SHAPING" OF THE CHARTS

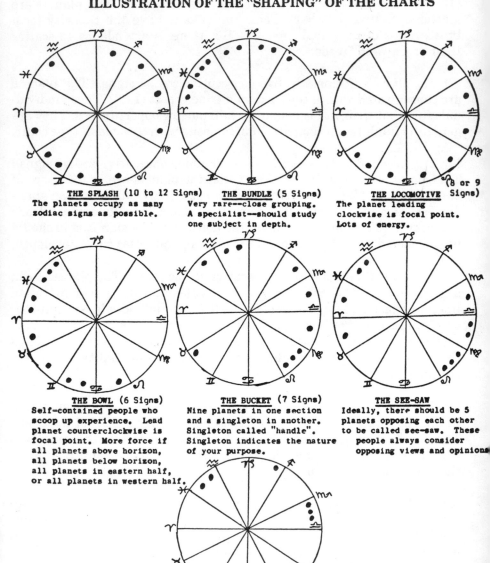

THE SPLASH (10 to 12 Signs)
The planets occupy as many
zodiac signs as possible.

THE BUNDLE (5 Signs)
Very rare--close grouping.
A specialist--should study
one subject in depth.

THE LOCOMOTIVE (8 or 9 Signs)
The planet leading
clockwise is focal point.
Lots of energy.

THE BOWL (6 Signs)
Self-contained people who
scoop up experience. Lead
planet counterclockwise is
focal point. More force if
all planets above horizon,
all planets below horizon,
all planets in eastern half,
or all planets in western half.

THE BUCKET (7 Signs)
Nine planets in one section
and a singleton in another.
Singleton called "handle".
Singleton indicates the nature
of your purpose.

THE SEE-SAW
Ideally, there should be 5
planets opposing each other
to be called see-saw. These
people always consider
opposing views and opinions

THE SPLAY
Hard to define. Can be a grand
trine present. Someone who does
not like an organized life or routine.

VISUAL PATTERNS OF A CHART

1. *Visual Shape of Planets, i.e. "Bucket," "Bowl," etc.* Refer to pages on these patterns.

2. *Eastern and Western Hemispheres.* (Majority of planets in one section)
 Eastern Hemisphere—They are in a "sowing" reincarnation where learning is done through their own initiative.
 (Left Side) Since there is more freedom of choice in a "sowing" incarnation, they are considered "self-starters." Others may interest them in different areas, but they feel a need to investigate for themselves.

 Western Hemisphere—They are in a "reaping" reincarnation. Other people cause them to learn many needed lessons in this life. Their karmic pattern is tied
 (Right Side) up with others, but people will be instrumental in teaching them so that they can grow spiritually.

3. *Northern and Southern Hemispheres.* (Majority of planets in one section)
 Northern Hemisphere (Lower Half)—An introverted person
 Southern Hemisphere (Upper Half)—An extroverted person

4. *Masculine Sign Planets.* (Majority of planets in masculine signs.) Planets in masculine signs indicate the degree to which anyone, regardless of sex, prefers to direct their affairs. Five or more planets in masculine signs is a good indication that the person prefers to initiate, to start, to command, and to control most, if not all, matters in their life.

5. *Feminine Sign Planets.* (Majority of planets in feminine signs.) Planets in feminine signs indicate a desire or inner preference to follow, to be more passive, and to react rather than initiate. These people prefer a less aggressive approach to life.

6. *Majority of Planets in First Quadrant.* "Reluctant Leaders." This gives the ability to lead but not a strong desire to do so, unless most of the planets are in masculine signs. These people find that they must lead and initiate much more than they desire. They are saddled with

numerous responsibilities and obligations. It is essential that they learn to survive the difficulties of everyday living by accepting each experience as necessary to their soul evolvement and flowing with it.

7. *Majority of Planets in Fourth Quadrant.* "Leadership Ability." If the majority of the planets in this quadrant are in masculine signs, there is a strong ability to lead, with the necessary inner determination to initiate and complete projects and concerns.

 If the majority of the planets in this quadrant are in feminine signs, these individuals are "reluctant leaders."

8. *Majority of Planets in Second and Third Quadrant.* These individuals are more likely to succeed by working in a partnership form. This is a necessary part of their personal and soul growth in this lifetime, so that they can learn to interact harmoniously with others.

9. *Majority of Planets in Fire Signs.* These individuals have been too impulsive in previous lifetimes, leaping into action and words without forethought and now must learn to think before they act.

10. *Majority of Planets in Air Signs.* These individuals have allowed their mind to rule all actions in previous lifetimes and now must blend mind and heart.

11. *Majority of Planets in Earth Signs.* These individuals have placed too much emphasis on material possessions in previous lifetimes and now must learn to place people before "things."

12. *Majority of Planets in Water Signs.* These individuals have placed too much emphasis on inner feelings in previous lifetimes and now must learn to relate to others.

MINI-INTERPRETATION BASED ON
THE FOUR CARDINAL SIGNS

ARIES
"Independent"

"New Growth." This is where we must grow and develop. Each seed planted must sprout on its own. It can choose to lie dormant, to wither away and die, or to bring forth new growth. We are like a seed and wherever Aries is found in our chart is where we must grow. Since a seed

can rely on no one but itself to begin growing, so, too, do we need to be "independent" in our Aries house.

First house—finding a new approach to life

Second house—developing inner resources, such as hidden talents, sense of self-worth

Third house—adjusting to our environment and its changes

Fourth house—finding our own sense of inner security. No one can prop us up.

CANCER
"Nurture"

"Peak of Achievement." In your Cancer house is where we need to strive to obtain our greatest achievement. In the affairs of that house is where we should be expressing the positive qualities of our natal sun sign and allowing the whole world to see the beauty of our soul shining forth. Here is where we need to nuture our seed growth through instruction and training.

LIBRA
"Balance"

"Harvest Time." Our Libra house is our "Harvest Time" house. Here we need to finish or complete projects started in other lifetimes. Our scales have not been balanced in previous lifetimes, so we must work to obtain the needed balance in the affairs of that house.

CAPRICORN
"Social Foundations"

"Restoration." The Capricorn house is where we want social recognition and respect from others. If we are doing the necessary work concerning the house affairs, we will receive this respect and recognition. If not, no amount of "beating our own drums" will gain the spotlight for us, concerning these house affairs.

WHERE TO BEGIN IN INTERPRETING A CHART

The big moment has arrived, and you are now ready to make the attempt to interpret the chart you have just prepared. So, let's plunge in and begin. The first thing is not to look at the whole chart, because, for some reason, all the symbols seem to jump at you, causing instant con-

fusion. There doesn't seem to be any rhyme or reason to the whole thing, and you may be tempted to dump it in the nearest garbage can and wash your hands of it.

Let's begin the proper way—step by step. You have already determined the Moon Phase, the Tone of the Chart, and a few other essentials. Make notations of what you want to tell your client. Listed below are some of the things to cover (it doesn't matter in what order).

1. *Tone of Chart*—State the traits of their "Tone" sign. Two positive traits are enough. Caution them about the negative traits. Always remember that if a person is consulting you about their chart, they, obviously, want to learn how to express the best of themselves in this life. All of us slip into negative characteristics every day. In other words, play down negative traits, but tell them to be on the alert for them.

2. *Visual Pattern of the Chart*—Give them a short description of the visual pattern of the chart, i.e., "Bucket," "Locomotive," etc. Tell them if they are an introvert (southern hemisphere) or an extrovert (northern hemisphere). (The first needs to be brought out, and the second may need to be toned down.) Then, state whether they are in a reaping reincarnation (western hemisphere) or sowing reincarnation (eastern hemisphere).

3. *Moon Phases*—All waxing phases (New Moon to Full Moon) create instinctive action. This instinctive action is caused by outside forces (events, people).

 New Moon—They operate in a spontaneous, unplanned way.
 Crescent—They are struggling out of past life patterns and insecurities.
 First Quarter—They encounter resistance and crises from the people around them.
 Gibbous—They are searching for a goal through study and analysis.

 All waning phases (Full Moon to Balsamic) create conscious actions from inside. These conscious actions are controlled by the person's own will.

 Full Moon—They are learning to think before they act, in order to determine how their actions will affect others. By thinking of others, they are fulfilling karmic patterns through people.

Disseminating—They share with others what they have found to be meaningful.

Last Quarter—They are going through crises and changes inside, in order to reorient their thinking.

Balsamic—They are changing personal desires into group-oriented desires or goals. From these people, something new emerges which will benefit others. Sometimes it is only one person. The number doesn't matter.

4. *Part of Fortune*—The house it falls in shows where they can help overcome the difficulties of their moon phase. The affairs of that house are important and indicate where they can use the stress energy of their moon phase. (This is similar to a T-Square aspect, where you look to the house with the empty leg. If you work on the affairs in the house with the empty leg, you establish a firm foundation for your "three-legged table.") By working on the affairs of the house with their Part of Fortune, they can establish a firm foundation for their moon phase emotions. In a sense, you can call the Part of Fortune beneficial, because you will instinctively work on the affairs of the house involved; whereas in a T-Square aspect, you do not necessarily work on the affairs of the empty-leg house unless something, or someone, causes you to do so.

5. *Major Aspects*—Grand Cross, T-Square, and Grand Trines are the major aspects. Explain the affairs of the houses involved. In the case of the Grand Cross and T-Square, those affairs have been mishandled and need to be handled better in this life. In the case of the Grand Trines, they will benefit from them according to the houses and the element involved (Fire—Active Energy, Air—Mental Energy, Earth—Productive Energy, and Water—Psychic Energy) but they have to actively use the Grand Trine, otherwise, this talent will lie dormant.

6. *House Cusp Interpretation*—Draw a circle on a blank sheet of paper and mark your client's house cusps on it. Now, write in the key words for the zodiac signs, as given on the keyword sheet. Do not put the planets in, but indicate their sun sign. Study the following zodiac houses first, for they are the key to the past lifetime, or lifetimes, that they are working on now.

 1) Libra—They were out-of-balance in these affairs in past lives.

 2) Aries—They need to grow and develop themselves in these affairs.

3) Sagittarius—They were restricted, or limited here, by conscious or unconscious choice, so they need to expand, explore, and broaden their viewpoints in the affairs of this house.

4) Intercepted Signs—Look at the houses and the zodiac signs involved. They indicate where and how they have gone astray. The intercepted sign's traits have been misused in the affairs of the house in which it is intercepted.

5) Major Aspects—Grand Crosses and T-Squares will indicate houses where work needs to be done because of misuse.

By studying these five areas, a pattern will slowly begin to emerge. Jot a few notes down as to what affairs need to be worked on. The pattern repeats itself in these five areas, so you will be able to decide which house affairs are involved.

House cusps are important, because the sign on the cusp indicates how you feel, or should feel, toward the affairs of the house. The planet that rules the cusp is your "ambassador," and you have sent him (or her) out to another house in order to learn about the affairs of that house. The sign the ruling planet is in, is the clothes you have designed for your "ambassador" to wear. In other words, if your "ambassador" is wearing fine clothes, you are using the positive traits of that sign, but if he is in rags, you are expressing the negative traits of that sign. Your "ambassador" has an influence over you, for, whatever he (or she) actively does in the affairs of the house in which he is posted, he will help you reformulate or rethink your ideas on the affairs of the house cusp involved.

7. *The Sun*—Indicate where their sun is and what its purpose is. (See the sheet on Sun in Houses.) Tell them the traits of their sun sign.

8. *The Moon*—Indicate that whatever house their moon is in, is where they will tend to be quite emotional concerning the affairs of the house. The sign it is in represents the personality that has been developed over their many lifetimes.

9. *Moon's Nodes*—The North Node is our "spiritual intake" and where we need to grow, study, and learn. The South Node is our "physical intake," and where we might be drawn back into the same life pattern as previously experienced. Since this pattern is no longer needed, you will feel drained physically if you begin to use the same life pattern as before. This is a trigger mechanism to tell you that you need to be working on the North Node house affairs. As you

work on the North Node house affairs, you will bring new experiences into the South Node house which will reshape your mode of behavior in the South Node house. The signs indicate the positive traits you should be expressing. It is very easy to slip back into the negative expression of the zodiac sign of the South Node, for we have developed a habit pattern in previous lifetimes.

10. *Stellum of Planets in a House*—A stellum of planets in a house indicates that you desire to grow, learn, and develop new ideas in the affairs of the house involved. You have sent a number of "ambassadors" to this house in order to hear many different viewpoints on the affairs in this house. People with stellums in a house usually use each planet separately in the affairs before they finally blend them together. For example, consider a stellum of four planets in the fifth house of creative self-expression—Mars, Mercury, Saturn, and the sun. The person may begin by using the Mars energy in competitive sports; then Saturn comes along and restricts the competitive sports by forcing the person to focus their self-expression. It will not be easy, now, to be number one in sports. Mercury, then, gives them the desire to express themselves through their mind—thinking games, like chess, are developed or stories are written for personal enjoyment. Finally, this person will bring their sun's positive traits into operation, and the person will find how best to express their creativity that is harmonious to the chart.

You could, of course, go through each planet separately. But the above outline is certainly an adequate interpretation. Since you could go on indefinitely with a chart, you must call a halt at some point.

CHAPTER 14

Progressions and Transits

PROGRESSIONS AND TRANSITS

Our entire universe is composed of many different vibrational patterns. All of us are aware that sounds can affect us, regardless of whether or not we hear them. This fact further substantiates astrology's premise that every vibration in our solar system affects us to some extent.

A natal horoscope reveals the vibrational pattern imprinted upon an incoming physical body. These natal vibrations register in the physical body itself and will last until the body dies.

Natal vibrations are influenced, or activated, by both transits and progressions. Transits refer to the current passage of planets in the heavens, as reflected on the zodiac belt. Progressions refer to the movement of the planets a predetermined number of days either before or after the birthdate. Both transits and progressions create a vibration to which one may, or may not, respond since some people have blocked their ability to respond. Others, unfortunately, respond to every vibration. If one is desirous of both personal and soul growth, both of these methods are unacceptable.

If you look at your fellowman, you will notice that those who fail to respond to vibrations usually have established set routines which they zealously adhere to each day. They get up at the same time every morning, eat much the same breakfast, work at the same job year after year, go to bed at the same time each night, socialize once a week, and retire at sixty-five without having made any noticeable progress, except materially. They may have had experiences forced upon them, but those experiences leave them more bewildered than illuminated, more puzzled and bitter than enlightened. On the other hand, there are those who respond to all vibrations, causing them to be devastated by their own

emotions. These individuals are highly nervous, excitable, and impetuous. However, the correct vibrational responses are from those who are interested in the "why" of their experiences and crises. They are the ones who seek the meaning of life, and of their own life in particular.

And so, the question is, how are we responding to the vibrational influences of transits and progressions? An experience can be beneficial or painful, depending upon our attitude when we face it.

TRANSITS

The term "transits" refers to the current movement of a planet in its orbit around the sun, and its position as reflected on the zodiac belt. Since the physical body is like a "tuning" fork, composed of the natal planetary vibrations, when a planet either makes an aspect to a natal planet or crosses the area where a natal planet was located at birth, it causes the body to vibrate. How strong the vibration depends upon the planets involved and our response to the planets. Transits are events that cause you to change and learn. They show inward growth due to conditions and experiences beyond your control.

PROGRESSIONS

There are two types of progressions most commonly used: Primary Progressions and Secondary Progressions. Both show inner growth.

To determine Primary Progressions, 1° is added to the natal planet's degree for each year of the age you are interested in. This is further evidence that as one grows older, one learns through one's experiences. These experiences shape and change one, both externally and internally.

Secondary Progressions use one day's planetary movement, either before or after birth, as corresponding to a one-year span in life. The movement of the planets in Secondary Progressions indicate internal changing and growth which may, or may not, be apparent to others.

Progressions are valid whether you move the planets *forward* or *backward* in the chart. It is difficult for some to understand the concept of how progressed planets can influence either the future or relate the past. But, since we are bound by the laws of karma, our future is inexorably the result of past lifetime thoughts and actions which have motivated us to program certain experiences to occur so that karmic repayment can be affected. How we react to these experiences determines whether or not we accomplish any karmic atonement. Thus, progressed

planets that are moved *forward* (counterclockwise) in a natal chart indicate "opportunities" to resolve karma and/or to receive rewards for our good deeds from other lifetimes. But our free will gives us the opportunity to accept or reject these "opportunities." Progressed planets that are moved *backward* (clockwise) in a natal chart indicate how we are "bound" by our karma. Since one is "bound," free will can not be used.

When one moves the planets *backward* (clockwise) in a chart, the term used is "conversed" planets. But most astrologers prefer to use the word "progressed" for both the forward and backward movement of the planets.

(1) TRANSITS

Transits are the current passage of planets in the heavens. To determine what is happening on a particular date, use the current year Ephemeris. The planets' positions can be taken out of the Ephemeris as listed, even though their positions are for 12:00 noon Greenwich Mean Time. If desired, the time can be easily converted to your time zone.

In transits, the slower-moving outer planets (Jupiter, Saturn, Uranus, Neptune, Pluto) have the greater effect, since they stay longer in each house and have more time to accomplish their work.

Use a black-colored pencil to indicate transits. Transits should be placed on the outside of the rings of the "Progressed Planet Form" which has the natal chart written in the innermost ring. The other two rings will be used for the Primary Progressions and the Secondary Progressions.

(2) PRIMARY PROGRESSIONS

In order to determine Primary Progressions, add 1° for each year of the age you are interested in. In other words, use the age you are interested in and add that amount to each of the planets.

Use a red-colored pencil to indicate Primary Progressions. These progressions should be placed in the second ring (middle) next to the natal chart on the "Progressed Planet Form." The outermost ring will be used for the Secondary Progressions.

(3) SECONDARY PROGRESSIONS

The first step in establishing Secondary Progressions is to determine the "progressed" ascendant and Mid-Heaven. This is important because

the progression of the ascendant shows the gradual and unconscious adoption of some of the traits of the new zodiac sign into the personality and into one's approach to life. For instance, a person with an Aries Ascendant will never lose his enthusiasm or impulsiveness, but when his ascendant progresses into Taurus, there will be more perseverance, stability, and practicality in his life. Events in this individual's life will have forced this change to occur.

The progression of the Mid-Heaven into a new sign influences the individual's attitude about what they want through their personal achievements and/or their career. What they once considered to be the ultimate fulfillment in a personal achievement may come to mean very little to them when their Mid-Heaven moves into an entirely different zodiac sign bringing them new values and ideals.

To establish the Progressed Ascendant and Mid-Heaven, you use the same procedure utilized in determining the Adjusted Sidereal Time for a natal chart. But, instead of using the Sidereal Time for the birth date, use the Sidereal Time for the day which corresponds to the age you are interested in. Then, proceed as usual in obtaining an Adjusted Sidereal Time.

Hours Minutes Seconds

(1) In the Ephemeris for the client's year of birth, find the sidereal time for the day which corresponds to the age you are interested in. _____ _____ _____

(2) Multiply the birth longitude by .6666 (or ⅔ to determine how many sidereal seconds it will take for the birth longitude to either reach 12:00 Noon (Western Longitude), or since it was 12:00 Noon (Eastern Longitude). (Western Longitude = Add; Eastern Longitude = Subtract) _____ _____ _____
Preliminary Total

(3) Using the T.L.T., determine the interval before it will be 12:00 Noon of the birth date (A.M. birth times), or the interval since it has been 12:00 Noon (P.M. birth times). Use the minutes only for all 12:00 to 12:59 birth times. (A.M. Birth times − Subtract; P.M. Birth times = Add) _____ _____ _____
Preliminary Total

(4) Make a ten-second correction for each hour listed in Step 3 in order to adjust the twenty-four-hour clock to sidereal time. Be sure to consider the minutes, also. (A.M. Birth times = Subtract; P.M. Birth times = Add) _____ _____ _____

(5) If Southern Latitude, add 12 hours. _____ _____ _____
Progressed Adjusted Sidereal Time _____ _____ _____

When the Progressed Adjusted Sidereal Time has been established, look up the birth latitude in the Table of Houses and find the closest sidereal time to your figure. This will give you the Progressed Ascendant and Progressed Mid-Heaven. Mark it on the "Progressed Planet Form" near the correct degree, with a dotted red line across the three circles. Write the degree and zodiac sign on this dotted red line.

To eliminate the work of recalculating all the planetary positions for the day which corresponds to the age interested in, a system was devised using an Adjusted Calculated Date (or "Symbolic" birth date). Obviously, the same planetary corrections as the natal chart would have to be made, unless the person was born at 12:00 Noon, Greenwich, England. Since this would eventually involve a number of hours of work over the years, using the Adjusted Calculated Date is far simpler and just as accurate. The basic principle of this system is that A.M. birth times have predicted events occurring *after* the actual birth date, and P.M. birth times have predicted events occurring *before* the actual birth date.

In order to understand this procedure more clearly, you will have to remember that one day equals one year. Thus, two hours would equal one month (twelve months divided into a twenty-four-hour day = two hours per month). If you were born at 10:00 A.M., Greenwich Mean Time, your progressions would go into effect one month *after* your birthdate. if you were born at 2:00 P.M., Greenwich Mean Time, your progressions would have already activated one month *before* your birthdate.

Visual Clarification of the Adjusted Calculated Date:

24 Hours		24 Hours
June 1, 1974 12:00 Noon—G.M.T.	June 2, 1974 12:00 Noon—G.M.T.	June 3, 1974 12:00 Noon—G.M.T.

Example 1: Born 6/2/74 10:00 A.M., G.M.T. 2 hours before it will be 12:00 Noon	*Example 2:* Born: 6/2/74 2:00 P.M., G.M.T. 2 hours since it was 12:00 Noon
Example 1: The 2 hours left before it will be 12:00 Noon equals 1 month. Thus, the Adjusted Calculated Date will be 1 month later—approximately, July 2, 1974	*Example 2:* The 2 hours since it has been 12:00 Noon equals 1 month. Thus, the Adjusted Calculated Date will be 1 month earlier—approximately, May 2, 1974

Determining the Adjusted Calculated Date:

Example 1: Born 6/2/74 at 10:00 A.M., G.M.T. *Hours Minutes Seconds*

Step 1: Sidereal Time for Greenwich
Noon of the birthday as given
in the birth year Ephemeris. 4 42 18

Step 2: The number of hours and min-
utes there are until it will be
12:00 Noon again. +2 00

Sidereal Time for Adjusted Calculated Date 6 42 18

Example 2: Born 6/2/74 at 2:00 P.M., G.M.T. *Hours Minutes Seconds*

Step 1: Sidereal Time for Greenwich
Noon of the birthday, as given
in the birth year Ephemeris 4 42 18

Step 2: The number of hours and min-
utes there are until it will be
12:00 Noon again. +22 00

*Sidereal Time for Adjusted Calculated
Date* 26 42 18

 − 24 Hour Clock
 2 42 18

A.M. *Birth Times:*

Count *forward* in the birth year Ephemeris from the date of the
birthday until you find a day having the closest sidereal time to
your figure. That day is the Adjusted Calculated Date and should
be listed at the top of the Natal Chart under A.C.D. date.

P.M. *Birth Times:*

Count *backward* in the birth year Ephemeris from the date of
the birthday until you find a day having the closest sidereal time
to your figure. That day is the Adjusted Calculated Date and should
be listed at the top of the Natal Chart under A.C.D. date.

Example 1 (A.M. Birth Time):

Starting at the birth date of June 2, 1974, move *forward* in the birth year Ephemeris until you come to a sidereal time that is the closest to our figure of 6-42-18. The date is—July 2, 1974.

Example 2 (P.M. Birth Time):

Beginning with the birth date of June 2, 1974, move *backward* in the birth year Ephemeris until you come to a sidereal time that is the closest to our figure of 2-42-18. The date is—May 3, 1974.

Once the Adjusted Calculated Date has been determined, you need never refigure it again. All planetary positions may, then, be taken directly from the Noon position in the Ephemeris without recalculation. However, since the moon moves very rapidly from day to day, you may want to calculate its monthly motion in order to have an accurate progressed chart for the year. Basically, you will be adding about 1° per month.

Calculating the Moon's Monthly Position:

June 3, 1974	24° Scorpio 05'	
June 2, 1974	− 13° Scorpio 22'	
	12° 43'	Progressed Moon's Motion for a One-Year Period (Approximately, 1° 04' per month)

Example 1 (A.M. Birth Time):
Progressed Moon July 2, 1974 = 13° Scorpio 22'
Progressed Moon August 2, 1974 = 14° Scorpio 26' etc.

Example 2 (P.M. Birth Time):
Progressed Moon May 3, 1974 = 13° Scorpio 22'
Progressed Moon June 3, 1974 = 14° Scorpio 26' etc.

In progressions, the faster-moving inner planets (Sun, Mercury, Venus, Mars, Moon) have the greater effect. The slower-moving outer planets will vary their original natal positions by only a few degrees.

Use a green-colored pencil to indicate Secondary Progressions. These progressions should be placed in the outside ring on the "Progressed Planet Form."

THE PROGRESSED SUN (PRIMARY AND SECONDARY):

Aspects from the Progressed Sun are the strongest. If the Progressed Sun moves from one zodiac sign to another, it influences the character traits of the individual. The new sign seems to give the individual an upsurging of feelings, desires, and traits which were either dormant or latent previously. Thus, new experiences are encountered which add to personal growth.

THE PROGRESSED MOON (PRIMARY AND SECONDARY):

The Progressed Moon acts like a transiting Saturn. It shows where the individual must learn to adapt. Changes and crises are experienced in the house affairs of the Progressed Moon, so that you are forced to adapt. It is a test of one's *emotional adaptability*. Usually, the individual will be more involved in the house affairs during the Progressed Moon's stay in that house. When the Progressed Moon crosses a cusp, something significant generally happens to the individual.

ADDITIONAL INFORMATION:

Transits and progressions are in aspect to natal planets when they are 1° forming (approaching), the exact degree, and 1° leaving a planet. It will be at its strongest when it is at the exact degree. Conjunctions are the most powerful, but squares, trines, and oppositions are influential, too. Aspects can also be made from progressed planets to transiting planets. When a transiting planet returns to its own natal conjunction, something new wants to happen.

The cusps of a chart are sensitive points, with the angles extremely important (first, fourth, seventh, and tenth house cusps). Transits and progressions are in aspect to a cusp 2° forming (approaching) and the exact degree. Once the planets have entered the house, their influence is no longer felt.

Cardinal Signs = When a planet moves into a cardinal sign, the individual usually begins some type of *action*. He, or she, will feel an urge to do something.

Fixed Signs = When a planet moves into a fixed sign, the individual feels more secure. He, or she, will feel an urge to become more *settled*.

Mutable Signs = When a planet moves into a mutable sign, the individual is *stimulated mentally*. He, or she, will begin to consider different ideas and aspirations.

AFFECTS OF TRANSITING AND PROGRESSED PLANETS:

Sun: The sun highlights whatever house it falls in. Thus, your attention is being focused on the house affairs, so that the work you have pre-programmed can be accomplished. The transiting sun stays only one month in each house, so it has very little time to energize the house affairs. The progressed sun does the main work.

Mercury: Mercury travels closely with the sun and is, usually, in the same house. Mercury stimulates the mind to probe into the house affairs.

Venus: Venus brings a beneficial influence to the house it falls in. It shows where the individual has the ability to flow with the experiences of the house affairs and is adaptable and cooperative.

Mars: Mars is our desires and our energy. Wherever Mars falls, the individual will be strongly motivated into some type of activity involving the house affairs.

Jupiter: Like Venus, Jupiter brings a beneficial influence to the house affairs where it falls. There is a feeling of optimism about the house affairs. But, one must be careful not to become overly optimistic.

Saturn: Since Saturn is our discipline in life, it brings responsibilities and demands wherever it falls. It calls for one to slow down, to learn, and to channel one's energy in the house affairs. Much growth can be made when Saturn passes through a house. This growth will remain for the rest of one's life. Thus, Saturn should be welcomed as a "teacher."

Uranus: Having Uranus in a house is like sitting on an earthquake fault. You never know when he will activate and shake you out of your complacency. As he travels through a house, many unusual and unexpected events will occur. Sometimes these events are illuminating and, at other times, discouraging.

Neptune: Neptune is the planet of deception, but, also, the planet of inspiration. When it passes through a house, it slowly dissolves former

and present lifetime attitudes concerning the house affairs. This feeling is similar to walking on quicksand. In these affairs, you will experience unusual situations and deception. This deception can be from others, but sometimes, we delude ourselves.

Pluto: If one thinks of Pluto as the planet that rules volcanoes, then, it is easy to understand what Pluto is doing in the house affairs. There is a slow buildup of pressure until finally events cause an explosion. This explosion can be intense activity and/or an annihilation of everything concerning the house affairs. These house affairs need to be cleansed and purified by the volcanic fire of Pluto's vibrations. Former and present lifetime attitudes need revising, and Pluto is the planet that guarantees that this will be done, regardless of the devastation he may cause doing so.

Transiting Moon: The moon travels around the natal chart too rapidly to begin any constructive work. It does, however, trigger major aspects, such as Grand Crosses, Grand Trines, T-Squares, and Yods. Sometimes, the vibration is so slight that the majority of individuals do not feel it. However, it is important to note the sign the transiting moon is in when considering surgery of any type. No one should have surgery when the moon is in Pisces, because during this time, there is difficulty in blood coagulating. Thus, there is danger from hemorhhaging. Then too, one should not have surgery in the sign ruled by the part of the body needing surgery. Cancer operations should be performed in non-fertile signs, such as Gemini or Sagittarius.

Aspects of Progressed and Transiting Planets to the Nodes:

North Node: When a planet conjuncts the North Node, you will meet people who pull you toward them for *your* soul growth.

South Node: When a planet conjuncts the South Node, you meet people who are an emotional drain on you. There is some type of karma that has to be worked out.

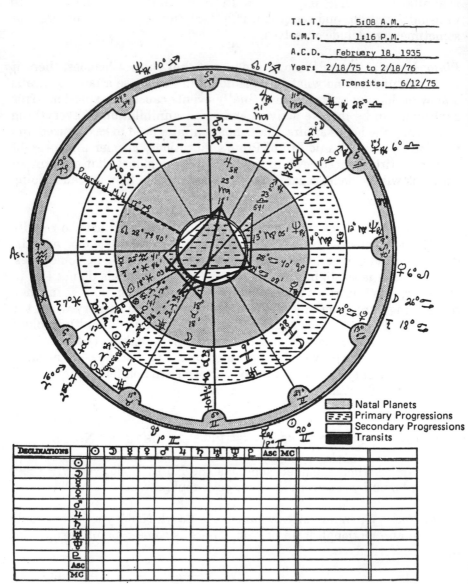

T.L.T. _____ 5:08 A.M.
G.M.T. _____ 1:16 P.M.
A.C.D. _____ February 18, 1935
Year: _____ 2/18/75 to 2/18/76
Transits: _____ 6/12/75

Natal Planets
Primary Progressions
Secondary Progressions
Transits

DECLINATIONS		☉	☽	☿	♀	♂	♃	♄	♅	♆	♇	ASC	MC		
	☉														
	☽														
	☿														
	♀														
	♂														
	♃														
	♄														
	♅														
	♆														
	♇														
	ASC														
	MC														

No. 7 MACOY - Richmond, Va.

276

CHAPTER 15

Comparing Natal Charts

COMPARING CHARTS: WHAT TO LOOK FOR

1. Note the house that the ruler of the Seventh House Cusp is located in. This house indicates an area of life where there is an emotional need that can/should be supplied by a marriage partner. Are the Seventh House signs compatible? What about the chart tones?

2. *Outer Planets*—Since outer planets move so slowly, whole generations are involved in the same zodiac sign. Look at the houses these planets fall in, in their partner's chart.
 a) In the house where *Jupiter* is found in a partner's chart is where they will benefit their partner.
 b) In the house where *Uranus* is found in a partner's chart is where they will bring out something from inside their partner which their partner is unaware of. Thus, they become a "catalyst" for their partner, by causing sudden changes to occur in the house affairs which help their partner to learn and grow. This is done more unconsciously than consciously.
 c) In the house where *Neptune* is found in a partner's chart is where they are dissolving their partner's attitudes toward the house affairs. This is done more unconsciously than consciously.
 d) In the house where *Pluto* is found in a partner's chart is where they will cause upheavals in the house affairs. These upheavals can be fruitful or devastating. This is done more unconsciously than consciously.

3. *Part of Marriage:* (Ascendant plus Seventh House Cusp minus Venus)

Example:

	Sign Number	Degree	Minutes
Ascendant 5° Libra 29'	7	5	29
Seventh House 5° Aries 29'	+1	5	29
	8	10	58
Venus 6° Cancer 12'	−4	6	12
	4	4	46

Part of Marriage: 4° Cancer 46'

In the house that the Part of Marriage falls in the partner's chart is where new approaches and new values will be stimulated in those house affairs.

4. *Comparison Aspects:* 3° orb allowed (Use conjunctions, sextiles, squares, trines, and oppositions only.)

Conjunctions are the strongest, producing a harmony in the relationship which brings friendship between the partners. Sextiles show opportunities for mutual growth. Squares are challenges that must be worked out together. Trines ease the way and are beneficial. Oppositions show where there is a need for give-and-take in the relationship, with regard to the houses and planets involved.

Aspects to take especial note of are:

Ascendant/Sun	— Indicates a strong tie, usually a lasting marriage
Sun/Moon	— Blending of polarities
Venus/Mars	— Physical attraction
Uranus/ Mars or Venus	— Unusual, magnetic attraction
Sun/Venus	— Love grows
Mercury/Mercury	— Ability to communicate, similar interests
Moon/ Moon	— Habit patterns same if in compatible signs
Saturn/Saturn	— Sense of responsibility toward each other
North Node Aspects	— Give stimulus needed for soul growth
South Node Aspects	— Indicate past-life ties. May be drawn into reliving a former lifetime when they were together.

5. Are there any planets in the Twelfth House of either chart? They indicate past lifetime links.

6. Look for any South Node aspects. Squares and Oppositions indicate unresolved problems carried over from previous lifetimes.

7. What house does their sun fall in, in their partner's chart? Since this house is illuminated by their natal Sun, they are seeking to be "seen" by their partner in the light of the house affairs. These house affairs indicate an emotional need which they unconsciously and/or consciously seek to receive from their partner.

8. *Venus and Mars:*
a) Women — The sign *Venus* is in indicates the qualities she is looking for in herself.
The sign *Mars* is in indicates the qualities she is looking for in a man.
b) Men — the sign *Mars* is in indicates the qualities he is looking for in himself.
The sign *Venus* indicates the qualities he is looking for in a woman.

COMPARISON ANALYSIS OF A HUSBAND'S AND WIFE'S NATAL CHARTS

1. The ruler of his Seventh House is in his Second House, indicating he needs someone to give him encouragement about his self-worth and his talents. The ruler of her Seventh House is in her Fifth House, indicating she needs someone to give her encouragement about her creative self-expression, her handling of her children, and her personal interests.

The sign Pisces is on his marriage house (Seventh) and the sign Leo is on her marriage house (Seventh). Leo is baffled and intrigued by the mysterious quality of Pisces. The relationship could have its ups and downs, but there is lots of "steam" (water and fire) created by this combination.

Her Pisces tone chart blends well with his Pisces on the Seventh House cusp of marriage.

2. *His Jupiter* falls in her Second House, so he benefits her monetarily and gives her an awareness of her own talents. *Her Jupiter* falls in his Fourth House, so she provides a warm, friendly home atmosphere and the inner security his Fourth House Scorpio desires. Their *Jupiters* are both in fire signs. Her Sagittarius' *Jupiter* is bringing him insights into what she is/has learned about religion and philosophies (Sagittarius), aiding him in establishing secure inner foundations (Fourth House). His Aries' *Jupiter* is giving her the courage and independence (Aries) needed to develop her personal resources (Second House).

His Uranus falls in her Third House, giving additional energy to her own Uranus which is in that house. He is helping to bring out a part of his wife that she does/did not know was there. In order for her to learn and grow, she has/will experience many changes in her environment, neighbors, knowledge, and in her relationships with relatives. *Her Uranus* falls in his Ninth House. She is bringing out a part of her husband that he does/did not know was there. She has/will cause changes in his philosophies and in the other affairs ruled by this house. These changes will bring growth and learning. Both Uranuses are in the zodiac sign of

279

HUSBAND AND WIFE COMPARISON CHARTS—3° ORB ALLOWED

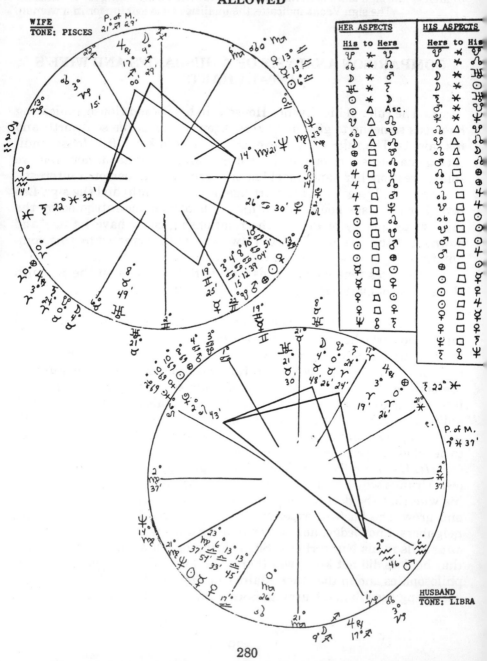

WIFE
TONE: PISCES

HUSBAND
TONE: LIBRA

HER ASPECTS			HIS ASPECTS		
His to Hers			**Hers to His**		
♅	✳	♅	♅	✳	♅
☊	✳	☊	☊	✳	♅
☽	✳	♂	☽	✳	♅
♃	✳	♄	♃	✳	♅
⊕	△	Asc.	⊕	✳	♅
♆	△	☊	♆	△	♅
☊	△	♆	☊	△	☊
☽	△	♅	☽	△	☊
⊕	□	☊	⊕	□	⊕
♃	□	♆	♃	□	♄
♃	□	☊	♃	□	⊙
♄	□	♅	♄	□	♃
⊙	□	☊	⊙	□	⊙
⊙	□	♆	⊙	□	♃
⊙	□	♅	⊙	□	⊙
⊙	□	⊕	⊙	□	⊕
⊙	□	⊙	⊙	□	♃
☿	□	♀	☿	□	⊙
♀	□	☿	♀	□	♃
♆	☌	♄	♆	□	♅

280

Taurus, indicating they have both had fixed opinions toward these house affairs, so Uranus is assisting in breaking up this fixity in order for new growth and learning to take place.

His Neptune falls in her Seventh House. He is helping her dissolve past lifetime critical (Virgo) habit patterns in cooperative relationships. *Her Neptune* falls in his First House. She is helping to dissolve his analytical (Virgo) approach to life.

Their *Plutos* fall in the same houses as the partners, causing additional upheavals in these house affairs (Sixth and Eleventh Houses). *His Pluto* falls in her Sixth House of work, health, and service, indicating he is causing additional upheavals in her thinking pattern as to what her working environment should be and the type of service she wishes to render. His zodiac sign, Leo, calls for her to have self-confidence. *Her Pluto* falls in his Eleventh House of friends, social groups, and personal goals, indicating she is causing additional upheavals in his thinking pattern as to who his friends should be and what his personal goals should be. Her zodiac sign, Cancer, indicates she is to bring him social awareness of his responsibilities to others so that personal goals become group goals.

3. *His part of marriage* falls in her Tenth House of professional careers and personal achievements, indicating he will stimulate new approaches and new values in these house affairs. He will encourage her to expand (Sagittarius) her personal achievements or develop a career.

Her part of marriage falls in his Seventh House of marriage and cooperative relationships, indicating she will stimulate new approaches and new values in these affairs. She will teach him to be more compassionate and understanding (Pisces) in these relationships.

4. The husband's sun is trine to the wife's ascendant, indicating a strong tie. This should make for a lasting marriage. Since both are in Air signs, they will be able to communicate and share ideas and common interests.

Her sun in Cancer and his moon in Taurus are sextile. She shows him how to express his emotions, and he shows her how to be practical. His sun in Libra and her moon in Sagittarius are sextile. She shows the need for expansion, and he shows the need for weighing the pros and cons.

Her Venus in Cancer and his Mars in Aquarius are in incompatible signs. She has romantic, emotional leanings, and he looks at life intellectually. His Venus in Libra and her Mars in Cancer are, also, incompatible. He is approaching life from an intellectual viewpoint, and she has romantic desires. This presents a challenge to be worked out together.

Her Cancer sun is square his Libra Venus. He was a challenge to her, stimulating a desire to learn more about him. From this, love grew.

Her Gemini Mercury and his Libra Mercury indicate an ability to communicate and share ideas, since both are in compatible signs (air).

Her moon in Sagittarius and his moon in Taurus are incompatible. Taurus is practical, and Sagittarius is more expansive. This is similar to a waxing inconjunct. They both will need to develop the positive traits of their moon and sun signs. Otherwise, they will create stress needlessly. Feelings can be hurt with this type of aspect.

Her Saturn in Pisces and his Saturn in Aries are in a semi-sextile aspect and can be productive if they use the energy correctly. Fire and water don't mix, but they can create lots of "steam" energy. Her Saturn falls in his Eighth House of Joint Resources, and his Saturn falls in her Second House of Personal Resources. She gives him a sense of responsibility toward the sharing of his joint resources (money, possessions, talents, self-esteem), and he gives her a sense of responsibility toward developing her personal resources.

His Stellum of Planets falls in her Eighth House, giving her needed strength toward working for joint purposes in all types of cooperative relationships. Her Stellum of Planets falls in his Eleventh House, giving him the incentive to transform (Pluto) his self-interest (Leo) so that his goals are directed toward the benefit of friends and social groups.

5. His Mars falls in her Twelfth House, causing him to be instantly attracted to her. This is a spiritual link from previous lifetimes that drew them together, in order to resolve problems carried over from those lifetimes.

6. There are a number of South Node Aspects, indicating past life ties.

7. *His Sun* falls in her Eighth House, indicating the need to share his personal resources with her in this lifetime—he failed to do so in a past lifetime. *Her Sun* falls in his Eleventh House, indicating a need for a friend who would understand and love her and with whom she could communicate.

CHAPTER 16

The Meaning of Aspects

THE MEANING OF ASPECTS

☌ Conjunctions: *Power* (Energy from the planets' vibrations)

N Nonagens: *Restriction* in the houses and with the planets, because of a need to reevaluate past-life attitudes regarding the houses and the planets they reside in. (This restriction releases between thirty-eight and forty-two years of age, depending on how many degrees are separating the two planets involved.)

✳ Sextiles: *Opportunity* (The energy must be consciously used in order to be beneficial.)

☐ Squares: *Challenge* (Lessons we have failed to learn in former lifetimes and now must face again in order to learn them.)

△ Trines: *Benefits* without effort. (Good being returned from former lifetimes.)

⚻ Inconjuncts: *Adjustment* (Conscious effort to change their thinking and to control their willpower with regard to the planets involved.)

☍ Oppositions: *Awareness* (Calls for compromise and cooperation, usually involving people.)

ASPECTS TO THE SUN

☉ ☌ ☽ These individuals react similarly to New Moon personalities in that they are impulsive and have to learn to use their willpower in order to control the fluctuating emotional

283

turmoils that seethe underneath. They are extremely sensitive individuals but, unfortunately, do not always take into consideration how their own actions may affect other people. They have strong vitality and utilize it to the fullest with many different projects, some of them going on at the same time. Because of their vitality, they may sometimes lack patience with other mortals who do not have their energy level.

⊙ N ☽ These individuals feel *restricted* in expressing their emotions to their children, their lovers, through their creativity, to their parents (especially their mother), and/or to those who live in the home they establish away from their parental home. They should look to the houses these planets reside in to determine what past attitudes need revising.

⊙ ✳ ☽ There is the *opportunity* for these individuals to eliminate the negative traits of their conscious mind's personality, as represented by the zodiac sign their natal moon is in with the positive traits of their natal zodiac sun sign. They are independent and self-reliant, with a number of creative talents which could be developed to their fullest. If these individuals work at it, they can develop harmonious relationships with others and can establish a tranquil atmosphere in the home they establish away from the parental home.

⊙ □ ☽ This *challenge* is one of perfecting the conscious mind's personality, as represented by the zodiac sign their natal moon is in. By utilizing the positive traits of their natal zodiac sun sign, they can overcome the negative traits of the natal zodiac moon sign. Until they begin to work toward this goal, they will experience inner conflicts between their emotions and their will. These individuals may experience emotional upheavals with their children, their lovers, over their creative endeavors, with their parents (especially their mothers), and/or with those who live in the home they establish away from the parental home.

⊙ △ ☽ In other lifetimes, these individuals have worked toward eliminating the negative traits of their conscious mind's personality. Thus, their willpower can bring their emotions into harmony. They are popular with others, independent, self-reliant, and, most of the time, are peaceful and tranquil. These individuals have a number of creative talents which could be explored.

⊙ ⊼ ☽ An *adjustment* is needed in regard to the controlling of their emotions through the use of their willpower. They have to learn to utilize the positive traits of their natal zodiac sun sign to overcome the negative emotional reactions of their natal zodiac moon sign. These individuals need to learn to exercise more logical reasoning in their relationships with their children, their lovers, over their creative endeavors, with their parents (especially their mothers), and/or with those who live in the home they establish away from the parental home.

⊙ ⚻ ☽ An *awareness* should be developed by these individuals that their energy flow fluctuates like the ebb and flow of the tide. When their energy is at a high, they should make haste to accomplish as much as possible during that time. When their energy is at a low, they should pace themselves accordingly and not overtax the physical body. There is a conflict in the personality, causing either the emotional nature of the moon or the logical will of the sun to reign supreme. Their need is to bring these two opposing reactions into a harmonious oneness, by utilizing the positive traits of their natal zodiac moon sign and the positive traits of their natal zodiac sun sign. These individuals often fluctuate from being extremely logical to being extremely sensitive. Too often, they are unaware of other people's emotional needs and fail to respond to those needs. They may experience difficulties with their children, their lovers, over their creative endeavors, with their parents (especially their mothers), and/or with those who live in the home they establish away from the parental home. ●

(Mercury is never more than 28 degrees away from the sun at any time.)

☉ ☌ ☿ This aspect causes physical energy to also be channeled into the conscious mind, giving an intelligent mind with a quick wit. They have the ability to communicate their ideas to others, but must watch their tendency to tune out what other people are saying. This occurs because their mind is busily thinking about what they are going to say next. They are high-strung and may resort to nail biting, cracking of knuckles or other nervous types of habits. These individuals make excellent teachers because they have the ability to communicate on any subject they are interested in. They should have some type of hobby that would occupy their hands in order to quiet their nervous hand movements. On the negative side, the force of this conjunction could cause some of these individuals to be self-centered.

(Venus is never more than 48 degrees away from the sun at any time.)

☉ ☌ ♀ The *power* of this conjunction attracts benefits to these individuals. They need harmonious, comfortable, and attractive surroundings. Many of them have artistic talents or at least a strong appreciation of the arts, such as music, paintings, and books. They have the ability to make friends easily because of their own friendliness and graciousness. These individuals are affectionate, but may not be demonstrative unless they receive affection in return.

☉ N ♀ These individuals feel *restricted* in expressing their love and affection to others. They should look to the houses these planets reside in to determine what past attitudes need revising.

☉ ☌ ♂ The *power* of this conjunction gives tremendous physical vitality, but, also, the tendency towards self-interest. Because of this, they can be argumentative and combative.

286

Since they are physically alert, quick to make decisions, and confident, they have the potential to become greatly successful in life. Their magnetic personality draws people to them. They make excellent leaders because of their convictions, enthusiasm, and strength of will. They are seldom ill. This aspect favors those who are athletically inclined, where strength and muscular exertion are needed. These individuals must not allow themselves to become egotists which could easily occur, with such a powerful aspect assisting them so strongly in their life.

⊙ N ♂ These individuals feel *restricted* in expressing their desires and wishes (anything they appreciate and enjoy, whether it is physical, emotional, mental, or spiritual) to others. They should look to the houses these planets reside in to determine what past attitudes need revising.

(⊙) ⚹ ♂ There is the *opportunity* for these individuals to control their desires (anything which they enjoy and appreciate, whether it is physical, emotional, mental, or spiritual) by using their willpower. They have not only good physical vitality, but an active mind as well. In order to release their excess physical energy, they need to engage in some type of physical activity. They enjoy sports and have a strong sense of fair play.

⊙ □ ♂ This *challenge* is to learn to use their abundant energy constructively. They have a need to think before they act. Their impulsive actions can lead them into many difficulties, including becoming compulsive gamblers. They become frustrated easily, which triggers impatience and anger. These individuals may experience inner distress from their children, their lovers, over their creative endeavors, and/or with other people's approaches to life.

⊙ △ ♂ In other lifetimes, these individuals have worked toward bringing their desires (anything which they enjoy and appreciate, whether it is physical, emotional, mental, or spiritual) under the full control of their willpower. They

287

have physical vitality as well as an active mind. Although they enjoy physical activity, it may be as a spectator rather than as a competitor. These individuals are self-assertive with inborn courage, making them excellent leaders. However, they do not always exert themselves to become leaders. Since they are basically noncombative individuals, they enjoy competitive sports that are played by the rules and are nonviolent.

☉ ⚻ ♂ An *adjustment* is needed in learning to control their desires (anything which they enjoy and appreciate, whether it is physical, emotional, mental, or spiritual) through the use of their willpower. They act impulsively out of anger and frustration. Because of this, they need to learn to calmly talk about their frustrations before these frustrations reach the point of anger. These individuals may experience discord with their children, their lovers, over their creative endeavors, and/or with other people's approaches to life.

☉ ⚼ ♂ An *awareness* should be developed by these individuals that their desires (anything which they enjoy and appreciate, whether it is physical, emotional, mental, or spiritual) may not be in agreement with their soul's desires. Because of this, their desires should be analyzed and should be brought under control of their willpower. Obstacles that occur concerning the obtaining of their desires are to help them remain in agreement with their soul's desires. These individuals have confidence and courage which are of considerable help to them in flowing with the obstacles that this aspect brings into their lives. They have a strong need to find constructive outlets for their energy. Otherwise this energy becomes frustration and inner anger, which may be released as an uncontrollable rage. They may experience difficulties with their children, their lovers, over their creative endeavors, and/or in understanding other people's approaches to life.

☉ ♂ ♃ The *power* of this conjunction gives a yearning to know their inner self. These individuals are optimistic and generous, with cultured minds. Their physical vitality is strong.

They are noncombative individuals who would rather help others than fight. This aspect attracts benefits to these individuals which they have earned in other lifetimes. It also indicates that many of them will travel a lot.

⊙ N ♃　These individuals feel *restricted* in their relationships with other people, because it is hard for them to express their individuality, especially in large groups of people. They should look to the houses these planets reside in to determine what past attitudes need revising.

⊙ ⚹ ♃　There is the *opportunity* for these individuals to expand and know themselves through some type of philosophy. They are generous, warmhearted, and idealistic people, with a strong sense of fairness and justice. They work hard to bring their ideals into reality. This aspect attracts benefits from time to time which has been earned in other lifetimes and in this lifetime. It also assists them in overcoming obstacles they may encounter in their life.

⊙ □ ♃　This *challenge* is one of learning not to overexpand their self-confidence so that they become egotists. There is a restlessness inside until they seek to know themselves through some type of philosophy. They may have difficulties in revealing their true personality to their children, their lovers, and/or their in-laws, which causes inner distress. This inner distress may cause them to become critical of these people. They also have a tendency to criticize their own creative endeavors in their efforts to control their egos.

⊙ △ ♃　In other lifetimes, these individuals have worked toward controlling their egos through a religious philosophy so that, in this lifetime, experiences are attracted to them which will continue the work they started. They are idealistic, generous, friendly individuals who are reliable, sincere, and honest. As in the sextile, these individuals will receive benefits from time to time which they have earned in other lifetimes. They have great courage in overcoming the many obstacles they encounter in their lives. In order

289

to bring their ideals into reality, they will work incredibly hard.

☉ ⊼ ♃ An *adjustment* is needed in learning to control their yearnings for the good things in life without having earned them. Their tendency to envy the good fortune of others must be dissolved. Everything has to be "earned," whether it is in this lifetime or in past lifetimes. Once this concept is accepted, these individuals will cease to take advantage of the generosity of their children, their lovers, and/or their in-laws in order to obtain their material desires. If they do not, they will eventually experience discord and disharmony when those involved begin to feel "used."

☉ ☿ ♃ An *awareness* is needed to determine when self-confidence becomes egotism. These individuals have a very strong need to feel important, which could easily tip the scales into egotism. All actions should be carefully thought out, so that they do not experience severe losses due to overspeculation, loans, investments, etc. They have a tendency to swing from being overextravagant to overmiserly. A good financial adviser would be very helpful for these individuals. They may experience difficulties with their children, their lovers, over their creative endeavors, with their in-laws, and/or in law courts.

☉ ☌ ♄ The *power* of this conjunction causes intense shyness and self-restraint. These individuals view life as a serious business and, when young, appear to be much older than they really are. Because of the difficulty in expressing the enthusiasm of their sun's energy, they feel lonely and cut off from people, since they find it hard to show their emotions. They are very disciplined individuals and very hard workers. Some of them may have experienced an unhappy childhood, due to the severity of the father's discipline. This, in turn, may cause them to become stern disciplinarians unless they allow the sun to overrule Saturn's influence. They are patient, persistent, and organized, with strong opinions which are difficult to change, but not impossible.

⊙ N ♄ These individuals feel *restricted* in expressing their true personality in their professional career, to their parents (especially their fathers), and to society in general. They should look to the houses these planets reside in to determine what past attitudes need revising.

⊙ ✶ ♄ There is the *opportunity* to overcome their shyness and reserve. These individuals dislike making a "spectacle" of themselves. They are serious, responsible, meticulous workers who are capable of seeing projects through to their completion. Their organizational abilities cause them to dislike disorder in their home or work environment.

⊙ □ ♄ This *challenge* is to overcome their self-criticalness. These individuals have a very high standard of what constitutes achievement and perfection which they want to live up to and which they, also, want others to live up to. Since this attitude is totally unrealistic and impossible to obtain, they suffer greatly from internal stress. Because of this stress, they may feel that others are working against their achieving this perfection, when in reality, it is their soul which is attracting inefficiency around them in order to force them to stop judging themselves and others. They may suffer from inner distress over their children, their lovers, their creative endeavors, those who work in their professional career environment, society in general, and/or their parents (especially their fathers).

⊙ △ ♄ In other lifetimes, these individuals have worked toward balancing the vibrations of these two planets, so that they are born leaders with the ability to concentrate, appraise, organize, and coordinate the efforts needed to obtain their objectives. Their mind is practical, contemplative, and authoritative. They find it difficult, however, to take directions from others because of their own methodical analysis of all situations. These individuals are practical, reliable, and confident, with the drive necessary to succeed in whatever goals they desire. They work hard for the benefits they receive.

⊙ ⤳ ♄ An *adjustment* is needed in learning to control their desire for perfection from themselves and from others. They have a tendency to judge themselves and others too harshly. Because of this, they may experience discord with their children, their lovers, over their creative endeavors, with those who work in their professional career environment, society in general, and/or their parents (especially their fathers).

⊙ ☍ ♄ An *awareness* should be developed by these individuals so that they do not focus their energy toward self alone. They are being asked to compromise with others in order to remove any tendency towards self-interest. Thus, they may encounter difficulties with their children, their lovers, over their creative endeavors, with those who work in their professional career environment, society in general, and/or their parents (especially their fathers).

⊙ ☌ ♅ The *power* of this conjunction gives a magnetic, original, and independent nature. They have a strong need to be free and become frustrated and angry if they feel they are being controlled in any manner. For all their rebelliousness, they are extremely sensitive and highly intuitive. These individuals are innovative and creative and can see new ways of doing things, which are a vast improvement over the old methods.

⊙ N ♅ These individuals feel *restricted* in getting anyone to listen to their innovative ideas and concepts. They should look to the houses these planets reside in to determine what past attitudes need revising.

⊙ ⚹ ♅ There is the *opportunity* for these individuals to awaken an awareness of their inner self. They are original, independent, and highly intuitive.

⊙ □ ♅ This *challenge* is to learn to control their impulsive behavior. These individuals like to shock other people, in order to shake them out of their antiquated attitudes. However,

this is not the manner in which to change other people's attitudes. There will be inner stress until these individuals learn to listen to the ideas of others. This aspect, also, indicates impulsiveness, and they must guard against accidents when they are feeling frustrated or nervous. There will be sudden changes in their lives to promote soul growth. They may experience Inner distress from their children, their lovers, over their creative endeavors, from their friends, and/or social groups.

☉ △ ♅ In other lifetimes, these individuals harmonized the vibrations of these two planets so that they are highly intuitive and original. There is a strong desire to be independent. This aspect gives strong electrical healing abilities because of Uranus's rulership of lightning.

☉ ⛎ ♅ An *adjustment* is needed in learning to control impulsive actions which hurt others. There is a strong desire for independence and leadership, but they must first be willing to listen to the ideas of others with an open mind if they wish to be an effective leader. There are sudden changes in their lives in order to promote soul growth. They may experience discord with their children, their lovers, over their creative endeavors, with their friends, and/or social groups.

☉ ☍ ♅ An *awareness* should be developed concerning the needs of others. These individuals have a tendency to think about their own desires first. They should learn to listen to the ideas of others with an open mind before making any decisions. Opposition from others has a tendency to bring out the negative traits of their natal zodiac sun sign. They are easily bored and need excitement in their lives. For this reason, they like challenges. These individuals may experience difficulties with their children, their lovers, over their creative endeavors, with their friends, and/or social groups.

☉ ☌ ♆ The *power* of this conjunction makes these individuals sensitive and emotional. They are psychically attuned, and when around others who are in negative moods, may also

become negative. This strong empathy for others creates a kind and gentle nature. They are extremely sentimental and have a tendency to daydream. They must learn to recognize reality from non-reality. This daydreaming causes many of them to prevaricate. They are not easy to understand, since they don't particularly understand themselves. They are attracted to music, art, dancing, painting, and the mystic.

⊙ N ♆ These individuals feel *restricted* in developing their psychic abilities. They should look to the houses these planets reside in to determine what past attitudes need revising.

⊙ ⚹ ♆ There is the *opportunity* for these individuals to tap the inner wisdom stored in their superconscious mind. This wisdom was learned in former lifetimes. Developing this ability would help them bring ideas, inspiration, and artistic potential from their inner mind to successful fruition.

⊙ □ ♆ This *challenge* is to learn to dissolve past lifetime domineering tendencies. This stress energy can be utilized constructively to dissolve the veil between the conscious and unconscious minds, so that the wisdom learned in former lifetimes can be tapped. This will result in the gaining of much knowledge and understanding. They may experience inner distress with their children, their lovers, over their creative endeavors, and/or with friends who are in actuality hidden enemies from former lives.

⊙ △ ♆ In other lifetimes, these individuals have developed and used their psychic abilities and psychic healing powers. They are idealistic people with the ability to listen to their inner mind. Many of them are capable of hearing the music of the spheres. They have a love of art, music, and painting, and appreciate refinement and high ideals. They receive visions, which they do not necessarily understand. Because of their extreme sensitivity, these individuals avoid direct confrontations with others.

☉ ⊼ ♆ An *adjustment* is needed in learning to express their desires to others so that they are not continually manipulated by other people against their own wishes. The non-combativeness of Neptune makes it difficult for these individuals to express their own desires forcibly enough, so that they usually become a helpless victim of others. They are particularly vulnerable to their children, their lovers, in regard to their creative endeavors, and/or to friends who are in actuality hidden enemies from former lives.

☉ ⚹ ♆ An *awareness* should be developed by these individuals that they will have to stand up for their spiritual convictions, even though it may involve conflict. These individuals are very sensitive people who are easily hurt by what others say and may wish to take the easy way out by being noncontroversial. Since they are idealists who would like to see the world a different place, they must not get discouraged too easily when circumstances are against them. They have to learn not to idealize others, but to accept and appreciate people as they are and not as they wish them to be. They have a sensitive mind which may suffer from deception and disillusionment with their children, their lovers, over their creative endeavors, and/or with their friends who are in actuality hidden enemies from former lives.

☉ ☌ ♅ The *power* of this conjunction gives a desire for recognition from others. These individuals will work hard to obtain some type of significance in society's eyes. They are strong-willed and like to have their own way, but should learn to compromise. They have natural leadership qualities, but their tendency to be secretive about their motives should be abolished. A good leader is one who is open with his people at all times. Most people can accept human frailities in their leaders, but abhor hidden truths.

☉ N ♅ These individuals feel *restricted* in obtaining recognition of their achievements from others. They should look to the houses these planets reside in to determine what past attitudes need revising.

☉ ✳ ♇ There is the *opportunity* for these individuals to transform their conscious mind's personality, as represented by the zodiac sign their natal moon is in, through the incorporation of the positive traits of their natal zodiac sun sign. They recognize their need to dissolve negative attitudes and thought patterns, but not necessarily the drive to cleanse the personality of all negative traits. This aspect gives intuitive perception.

☉ □ ♇ This *challenge* is to begin the work of transforming their conscious mind's personality, as represented by the zodiac sign their natal moon is in, by utilizing the positive traits of their natal zodiac sun sign. There is a need to dissolve negative attitudes and thought patterns. They suffer from strain and tension within. These individuals have difficulty in expressing or revealing their true personality to others. They are never satisfied with their creative talents and are always either redoing or destroying their efforts. These individuals may suffer inner distress with their children, their lovers, over their creative endeavors, and/or with the people in their organizational groups.

☉ △ ♇ In other lifetimes, these individuals began the work of transforming their conscious mind's personality, as represented by the zodiac sign their natal moon is in. They recognize their need to dissolve their negative attitudes and thought patterns. This aspect gives them courage and intuitive perception, with the desire to strip themselves of all self-delusion so that their personality and soul can become one.

☉ ⊼ ♇ An *adjustment* is needed in learning to compromise with others. There is a fear of being manipulated by others which causes them to be either excessively stubborn or to be a manipulator themselves. Their need for recognition is not worth the price of walking over others to receive it. They may experience discord with their children, their lovers, over their creative endeavors, and/or with the people in their organizational groups.

296

☉ ⚲ ♇ An *awareness* should be developed that their strong will and stubbornness are creating difficulties for them, because they are not allowing others to teach them. In order to assist them in perceiving the rigidity that has set into their conscious mind's personality, as represented by the zodiac sign their natal moon is in, other people are brought into their life to mirror their negative traits. If these individuals refuse to recognize the need to transform their ego, they will seek other people and other environments in order to run away from themselves. But to no avail. The same type of people and events will occur all over again. They may experience difficulties with their children, their lovers, over their creative endeavors, and/or with the people in their organizational groups.

☉ ♂ ⊕ The *power* of this conjunction balances the emotions and the intellect to the sun's vibrations so that these individuals can achieve soul growth.

☉ N ⊕ There is a *restriction* on achieving soul growth until these individuals revise past life attitudes regarding the houses these planets reside in.

☉ ✳ ⊕ An *opportunity* this lifetime to work on soul growth.

☉ □ ⊕ *Internal conflict* between the ego's desire for personal recognition in society's eyes and the soul's desire for soul growth.

☉ △ ⊕ In other lifetimes, these individuals worked to achieve soul growth and will continue to attract experiences which will assist further soul growth this lifetime.

☉ ⚻ ⊕ An *adjustment* in thinking is needed so that they exercise discernment concerning spiritual truths, because a previous lifetime spiritual pathway led away from soul growth.

☉ ⚷ ⊕ An *awareness* should be developed that personal growth and soul growth are not in disharmony, but can be achieved at the same time.

☉ ♂ ☊ The *power* of this conjunction will attract spiritual teachers to assist in ego purification.

☉ N ☊ There is a *restriction* on attracting spiritual teachers to assist in ego purification, because of a need to revise past attitudes concerning the houses these planets reside in.

☉ ✶ ☊ There is an *opportunity* for spiritual teachers to enter their lives to help them in ego purification.

☉ □ ☊ There is *internal conflict* regarding the value of spiritual teachers to assist in ego purification, because of their own problems as a spiritual teacher in a past lifetime.

☉ △ ☊ These individuals will attract spiritual teachers who they have been close to in other lifetimes and who have helped them toward ego purification.

☉ ⚻ ☊ An *adjustment* is needed in thinking regarding the human frailties of spiritual teachers. These human frailities do not make their spiritual insights any less valid.

☉ ⚷ ☊ An *awareness* should be developed concerning their need to find a spiritual teacher to assist in the purification of their ego.

☉ ♂ ☋ The *power* of this conjunction will attract karmic situations to assist in ego purification.

⊙ N ℧ There is a *restriction* on attracting karmic situations to assist in ego purification, because of a need to revise past attitudes concerning the houses these planets reside in.

⊙ ✳ ℧ There is an *opportunity* for karmic situations to occur which will help them toward ego purification.

⊙ □ ℧ There is *internal conflict* because of the inability to accept karmic situations as teaching experiences for ego purification.

⊙ △ ℧ These individuals willingly attract karmic situations which will help them toward ego purification.

⊙ ⊼ ℧ An *adjustment* is needed in thinking, for these individuals have difficulty in accepting the necessity of karmic situations occurring for ego purification.

⊙ ⚻ ℧ An *awareness* should be developed that karmic situations must, and will, occur for ego purification.

ASPECTS TO THE MOON

☽ ☌ ☿ The *power* of this conjunction gives a perceptive, keen mind. The mind responds readily to new ideas and likes change and variety. Because the emotions and rational thinking are so closely joined, these individuals fluctuate from being extremely logical to one that is emotional. However, they are never as emotional as the water signs because of their link with their rational mind. There is a need for freedom, so that they dislike being possessed by anyone, especially, if heavy emotional demands are made on them. Emotional demands are seen as a threat to their freedom.

☽ N ☿ These individuals feel *restricted* in expressing their opinions to others. They should look to the houses these planets reside in to determine what past attitudes need revising.

☽ ⚹ ☿ There is the *opportunity* to think logically and clearly, since the emotions and thinking are in harmony. They are sensitive to other people's feelings, which enables them to verbalize the other person's needs before they have spoken. These individuals have the ability to communicate ideas and concepts to others, either verbally or in writing.

☽ □ ☿ This *challenge* is one of bringing reason to their emotional reactions. They have a great need to be understood and loved. The positive use of the house affairs that Mercury resides in will help them to conquer their emotional intensity. They may experience emotional and communication difficulties with their parents (especially their mothers), those who live in the home they establish away from the parental home, relatives, neighbors, fellow workers, and/or those who serve them. These difficulties cause inner distress.

☽ △ ☿ In other lifetimes, these individuals have learned to balance their emotions and their thinking. They are extremely sensitive to other people's feelings. So much so, that they may have writing talent. These individuals are receptive listeners to other people's problems. They have the ability to communicate their ideas and concepts clearly and concisely.

☽ ⚻ ☿ An *adjustment* is needed in learning to express their emotions in words. They know how they feel, but have difficulty in explaining it in words. Their strongest need is to learn to tune in to their intuitive self. Learning to meditate would help bring an intuitive flow of words, so that they could express what they are feeling. They may find themselves inarticulate with their parents (especially their mothers), those who live in the home they establish away from

the parental home, relatives, neighbors, fellow workers, and/or those who serve them.

☽ ☌ ☿ An *awareness* should be developed that the mind and emotions must be balanced. These individuals tend to be totally logical at times or totally emotional. They have a keen mind, but can have a sharp tongue which hurts other people. They should hesitate before speaking, to make sure that their words are a blend of feelings and reason. They are high-strung, restless, nervous individuals, who can be irritable at times.

☽ ♂ ♀ The *power* of this conjunction calms the emotions because of the tranquillity of Venus's vibrations. These individuals have a warm, friendly personality which leads to popularity, even though they are basically shy. They have a love of beauty and harmony. Their artistic talents can find expression in such crafts as dressmaking or flower arrangements.

☽ N ♀ These individuals feel *restricted* in giving love and affection to others and in receiving love and affection from others. They should look to the houses these planets reside in to determine what past attitudes need revising.

☽ ⚹ ♀ There is the *opportunity* for these individuals to be emotionally fulfilled through artistic expression. They have a love of beauty and harmony, which is invariably reflected in their home environment.

☽ □ ♀ This *challenge* is to develop the courage to voice their convictions. They have such a strong emotional need to be liked and accepted that they avoid making waves. This stems from their feeling that if people like them, then there has to be something within them to like. By standing up for their personal convictions, they will build strength of character and will be free to be themselves. They may suffer

301

inner distress from their parents (especially their mothers), from those who live in the home they establish away from the parental home, over their personal resources (money, possessions, talents, sense of self-worth), from their marriage partner, and/or from any other cooperative relationships.

☽ △ ♀ In other lifetimes, these individuals have balanced their emotional needs so that they no longer have a desire to possess those they love. Because they have an attractive personality and enjoy helping others feel at ease, they are very popular and well-liked. They enjoy the arts and like their surroundings to be pleasant.

☽ ⚻ ♀ An *adjustment* is needed in learning to give as well as receive love from others. There is deep insecurity within these individuals, which they seek to dissipate by wanting others to love them totally and completely. They mistake constructive advice for withdrawal of love, causing them to suffer intensely. By learning that love is not turned off-and-on by a valve because of personality defects, these individuals will finally be able to gain self-confidence in themselves and learn to accept and give love freely and willingly. They can be emotionally hurt by their parents (especially their mothers), by those who live in the home they establish away from the parental home, over their personal resources (money, possessions, talents, sense of self-worth), by their marriage partner, and/or by any other cooperative relationships.

☽ ☊ ♀ An *awareness* should be developed that they have to learn to stand emotionally alone. These individuals want the love of others in order to feel secure. If that love is taken away, they crumble. They are very warm, loving individuals, but must learn that they cannot possess anyone. We have traveled the earth planes for many eons and have loved countless souls. There is never a final farewell. True love is a universal love that encompasses all living things and recognizes that we will meet again.

302

☽ ♂ ♂ The *power* of this conjunction gives these individuals an abundance of emotional energy which should be utilized in constructive channels. Their impulsiveness must be brought under control. They have inner courage which allows them to live in the here and now, letting the future take care of itself. They are warm, loving individuals, but could become too opinionated and/or irritated with others, because of their habit of self-appraisal and of their critical appraisal of others.

☽ N ♂ These individuals feel *restricted* in emotionally standing up for their convictions and beliefs. They should look to the houses these planets reside in to determine what past attitudes need revising.

☽ ✱ ♂ There is the *opportunity* to learn to control their emotions and desires (anything which they enjoy and appreciate, whether it is physical, spiritual, mental, or emotional) so that their energies can be utilized in creative and constructive channels. They have good vitality and strong recuperative powers.

☽ □ ♂ This *challenge* is to learn to control their temper. These individuals are apt to become angry when they are emotionally upset. Their need is to learn to analyze the situation before allowing their emotions to overwhelm them. This energy should be used in some type of constructive channel, such as competitive athletics, which would give an outlet for their emotions and energy. These individuals may experience inner distress from their parents (especially their mothers), from those who live in the home they establish away from the parental home, and/or over other people's approaches to life.

☽ △ ♂ In other lifetimes, these individuals have begun the work of balancing their emotions and desires (anything which they enjoy and appreciate, whether it is physical, spiritual, mental, or emotional) so that these energies can

now be utilized in creative and constructive areas. This aspect gives good recuperative powers when ill. They are resourceful and courageous, with strong vitality.

☽ ⊼ ♂ An *adjustment* is needed in learning to handle their emotions so that they don't fly into emotional rages. These individuals are very sensitive about their opinions and their possessions. This attitude causes them to be on the defensive, and they may make unmerited verbal attacks if they feel they are being criticized. It is important for them to learn to release their possessiveness of ideas, people, and possessions, and open their minds to new ideas and concepts. These individuals may experience discord with their parents (especially their mothers), from those who live in the home they establish away from the parental home, and/or over other people's approaches to life.

☽ ⚷ ♂ An *awareness* should be developed by these individuals that they need to learn self-restraint. They are extremely competitive individuals who have a strong need to outdo everyone else. For this reason, they make exceptionally fine competitive athletes. But, until they do develop self-restraint, they would be better off competing in individual sporting events. Otherwise, they could take out their emotional frustrations of losing by unjustified anger at their fellow teammates. These individuals are very hard workers with a great amount of energy and courage. By learning that everyone makes mistakes and accepting their own mistakes calmly, they will be able to use this energy extremely constructively. They may experience difficulties with their parents (especially their mothers), from those who live in the home they establish away from the parental home, and/or over other people's approaches to life.

☽ ☌ ♃ The *power* of this conjunction gives a pleasant, generous personality who is generally well-liked. They are sympathetic and have the ability of making others feel better. They enjoy having a good time and may forget there is a need to work, also. Their best trait is their ability to laugh at them-

selves and to see the humor in even the worst situations. Although they have excellent health, they should take care that they don't overdo physically.

☽ N ♃ These individuals feel *restricted* in expressing their outgoing personality. They should look to the houses these planets reside in to determine what past attitudes need revising.

☽ ✳ ♃ There is an *opportunity* of dissolving the negative traits in their conscious mind's personality, as represented by the zodiac sign the moon is in. The development of a good philosophy of life will help these individuals in being willing to work on overcoming their negative traits. They are cheerful, optimistic individuals who recover rapidly from bad moods.

☽ ☐ ♃ This *challenge* is one of dissolving pride. They have an internal fear about facing any negative traits in their personality. This emotional fear can be overcome by developing a good philosophy of life and by recognizing that everyone has imperfections. They may suffer inner distress from their parents (especially their mothers), from those who live in the home they establish away from the parental home, from in-laws, and, possibly, from lawsuits.

☽ △ ♃ In other lifetimes, these individuals have begun the work of balancing their emotions and their pride which makes them self-confident and emotionally secure. They are generous and great respecters of honor and honesty in themselves and others. They are not afraid to reveal themselves as they really are and are generally admired for this trait, even if their way of life is disapproved. Like the conjunction, these individuals can laugh at themselves and see the humor in the worst situation. They have a strong desire to help other people move forward in life. This help may be financial or spiritual.

☽ ⊼ ♃ An *adjustment* is needed in regard to their feelings of insecurity which may cause them to be more concerned about themselves than others. This insecurity may lead them to eat too much, covet what others have, or demand constant reassurances of love. Studying a good philosophy of life will assist their emotional uncertainty. They may suffer emotional distress from their parents (especially their mothers), from those who live in the home they establish away from the parental home, from in-laws, and, possibly, from lawsuits.

☽ ⚸ ♃ An *awareness* should be developed in learning to control their intense emotions. They have great difficulty in controlling their feelings in their relationships with others. As a general rule, they are cheerful people. They are plagued with a frantic type of nervous energy that doesn't know when to stop, until they have completely exhausted themselves physically and emotionally. Their lives seem to be one of frantic haste. It would be wise for these individuals to take the time each day, for at least fifteen minutes, to meditate in order to soothe the nervous energy that flows so furiously through their physical body. Developing a good philosophy of life would, also, help immeasurably. These individuals may experience emotional distresses from their parents (especially their mothers), from those who live in the home they establish away from the parental home, from in-laws, and, possibly, from lawsuits.

☽ ☌ ♄ The *power* of this conjunction gives these individuals a strong sense of responsibility and perseverance. However, their emotions are somewhat inhibited by Saturn's vibrations, so that they are shy with a tendency toward depressive moods. They easily doubt their own abilities. Their need for constant reassurance from others might soon drive friends away. They have strong organizational abilities. They are extremely sensitive and suffer inner distress about what others think of them.

☽ N ♄ These individuals feel *restricted* in finding emotional security in their professional career and with their parents. They should look to the houses these planets reside in to determine what past attitudes need revising.

☽ ✳ ♄ There is the *opportunity* for these individuals to balance their emotions and logical reasoning. In difficult situations, they are able to remain calm and find a solution. They like to keep busy and to see the visible results of their work. At times, they have difficulty in expressing their affections for others.

☽ □ ♄ This *challenge* is to overcome feelings of aloneness. These individuals need constant reassurance from others that they are loved, so much so that it may eventually become a burden upon their loved ones. They feel they are worthy only if their parents love them enough. If they do not receive enough emotional support, or if they imagine they have not received enough emotional support from their parents, they have great difficulty in expressing any love to anyone else. There is a strong need for them to reevaluate the meaning of emotional security. A good philosophy of life would help give them emotional security and dissolve their feelings of aloneness. These individuals may suffer inner distress from their parents, from those who live in the home they establish away from the parental home, from those in their professional career environment, over their personal achievements, and/or society in general.

☽ △ ♄ In other lifetimes, these individuals have begun the work of balancing their emotions and logical reasoning. Because of this, they seem to be more serious than most people. They have a strong sense of responsibility and good organizational abilities which they can put to excellent use. They would make fine teachers. However, they do need to learn to project the warmth and affection they have for others.

) � ♄ An *adjustment* is needed in regard to emotional security. On the one hand, these individuals want to be loved and cherished and, on the other hand, they want to make their mark in society. To be a leader in society requires the ability to withstand criticism. These individuals are too sensitive and will have to realize that they will not be liked by everyone. They may suffer distress over what their parents think about them, what those who live in the home they establish away from the parental home think about them, what those in their professional career environment think about them, and/or what society in general thinks about them.

) ☊ ♄ An *awareness* should be developed in learning to overcome their feelings of being totally alone in life. This is not true. However, these feelings come from their inability to express their emotions, so that they feel separated from others. In former lifetimes, these individuals have reached out in love and affection and been rejected, so that in this lifetime, they are extremely fearful to love in case they are rejected. If their childhood was filled with warmth and affection, these individuals have a better chance of overcoming this inhibition. However, even if they had an unhappy childhood, they can still learn to overcome this inhibition by understanding that emotional security is based on a good philosophy of life and not on other people. Even though they are controlled, practical individuals, locked within them is a warm and affectionate person. They may experience emotional distress from their parents, from those who live in the home they establish away from the parental home, from those in their professional career environment, over their personal achievements, and/or society in general.

) ☌ ♅ The *power* of this conjunction gives a strong magnetic personality. They are emotionally impulsive people who can at times act too hastily, which they immediately regret. They like life to be exciting, so they make it so. They are highly emotional and extremely sensitive. These individuals are very independent, with strong intuition and good minds. They can be quite stubborn. There is a need for them to

learn to control their emotions, or their nervous system will suffer. They may experience some difficulties with their parents (especially their mothers), from those who live in the home they establish away from the parental home, with their friends, and/or social groups.

☽ ⚹ ♅ These individuals feel *restricted* in expressing their innovative ideas and concepts. They should look to the houses these planets reside in to determine what past attitudes need revising.

☽ ⚹ ♅ There is the *opportunity* for these individuals to bring unusual ideas and concepts into fruition. They have keen intuitive powers with an alert mind. They are attracted to anything that is new and different, as long as it will bring excitement into their world. These individuals recognize the necessity of controlling their emotional outbursts.

☽ □ ♅ This *challenge* is to learn to control their sudden, unpredictable emotional storms. When they are emotionally upset, they act without thinking. They are very high-strung, nervous individuals who have trouble sitting still for any length of time. They enjoy unusual experiences and like to shock conventional people, even though they may be conventional themselves. Their desire for freedom makes it difficult for them to stay in any place for very long. These individuals need to learn to count to ten before blowing their cool, in order to help themselves control their unpredictable outbursts. They may experience inner distress from their parents (especially their mothers), from those who live in the home they establish away from the parental home, from friends, and/or from their social groups.

☽ △ ♅ In other lifetimes, these individuals have begun the work of balancing their emotional thought patterns and unpredictable behavior. Because of this, they have a heightened intuitive awareness and an alert mind. This aspect gives them an unusual life with many types of experiences,

which bring changes that are sudden and unexpected. They have original ideas, concepts, and goals which can be beneficial to others.

☽ ⊼ ♅ An *adjustment* is needed in regard to learning to control their sudden outbursts of emotional anger, during times of intense distress. They have the ability to keep their emotional anger under control, except under duress. When under duress, they would benefit by withdrawing from the scene until they have brought themselves under control. Meditating during this time would release their pent-up hostility. These individuals may experience emotional distress with their parents (especially their mothers), from those who live in the home they establish away from the parental home, from friends, and/or from their social groups.

☽ ☍ ♅ An *awareness* should be developed to control their fluctuating emotional responses to others. At times, they are quite distant and at other times they are friendly. This succeeds in confusing other people. There is an inborn reluctance to get involved with people, since people might make demands upon their freedom. These individuals need to feel free, without any ties to anyone. They must learn that since they are living in the world with people, they must compromise their desire for freedom with the necessity of learning to live in peace and love with their fellowman. If these individuals are allowed a quiet time each day for themselves, they would be able to respond to the love and affection of others in their lives. These individuals may experience emotional difficulties with their parents (especially their mothers), from those who live in the home they establish away from the parental home, from friends, and/or from their social groups.

☽ ☌ ♆ The *power* of this conjunction gives great sensitivity to the emotions of the people they are with. This heightened awareness can be utilized in helping others overcome negative emotions, rather than allowing the negative emotions of others to make them negative, also. These individuals are

mystic and not very practical (unless there are other indications of practicality in their chart). There is a strong attraction to art and music. They are compassionate and loyal to those they love. Many times they are disappointed or disillusioned with others because of their tendencies to idealize people they like.

☽ N ♆ These individuals feel *restricted* in discerning spiritual truths. They should look to the houses these planets reside in to determine what past attitudes need revising.

☽ ⚹ ♆ These individuals have the *opportunity* to use their sensitivity to vibrations in the world around them. Because of this attunement, they are vulnerable to the negative thoughts generated around them and should learn to transform this negativity into love energy, through the power of their mind.

☽ □ ♆ This *challenge* is to learn to overcome their emotional sensitivity. These individuals are easily hurt by others. Their deep feelings of insecurity and inferiority cause them to withdraw from others into a world of make-believe. They need to develop a spiritual philosophy which would help them overcome these feelings. These individuals would make fine actors, because of their extreme sensitivity and depth of expression. Neptune's influence may cloud reality, so they should at all times make sure they stick to the truth. These individuals can be easily hurt by their parents (especially their mothers), by those who live in the home they establish away from the parental home, and/or by friends who are in actuality hidden enemies from former lives.

☽ △ ♆ In other lifetimes, these individuals have begun the work of balancing their emotional sensitivity to the vibrations around them, which enables them to utilize their spiritual insights in transforming negative vibrations or assisting those who need help in the astral world. However, if they fail to transform the negative vibrations around them, they will succumb to depression and negativity. Any negative

311

energy can be transformed into love energy through the power of the mind. These individuals give unstintingly of their time to help others and in this respect are completely selfless. They have a great need to be of service to others. There is a love of music which can make them excellent musicians. They could, also, be successful in the literary field. But, above all, they must remember that their health suffers in negative atmospheres, so they must learn to transform this energy.

☽ ⌐ ♆ An *adjustment* is needed in regard to the desire to live in a make-believe world rather than in the world of reality. These are sensitive individuals who feel the vibrations around them. Because of this, they prefer to stay away from people rather than be inundated with negative feelings. They need to learn to transform the negativity they "feel" into love energy through the power of their mind. This practice will enable them to be around people without feeling excessively uncomfortable. They may experience emotional distress with their parents (especially their mothers), with those who live in the home they establish away from the parental home, and/or with friends who are in actuality hidden enemies from former lives.

☽ ☊ ♆ An *awareness* should be developed to sort the truth from the untruth. These individuals are very sensitive and, when upset, may use untruths to untangle themselves from the situation. Unfortunately, their sensitivity does not always enable them to discern when others are telling the truth or untruth, so they can be easily deceived by others. This confusion also causes them to misunderstand what has been said, so that they feel rejected and hurt. If a misunderstanding has occurred, these individuals should openly discuss it with those involved so that the misunderstanding can be cleared up. Otherwise, they will eventually withdraw from these people. They may experience emotional distress with their parents (especially their mothers), with those who live in the home they establish away from the parental home, and/or with friends who are in actuality hidden enemies from former lives.

☽ ♂ ♇ The *power* of this conjunction intensifies their sensitive, emotional energy, causing sudden emotional upheavals. These upheavals are very upsetting to them, because they occur unexpectedly. The eruptions usually occur over trivial matters when the true cause is an inner struggle over other things. This aspect makes these individuals incredibly hard workers with an abundance of energy and the ability to become a great success in the world. They have a warm, loving nature which they may find hard to express, especially to their loved ones.

☽ N ♇ These individuals feel *restricted* in receiving emotional satisfaction from others for their achievements. They should look to the houses these planets reside in to determine what past attitudes need revising.

☽ ✳ ♇ There is the *opportunity* for these individuals to be fulfilled emotionally, if they transform the negative traits of their conscious mind's personality, as represented by the zodiac sign their natal moon is in, with the positive traits of their natal zodiac sun sign. These individuals are intensely interested in mysteries and enjoy reading books of mystery, occult, or science fiction. They are very sensitive psychically and use it to understand others. They enjoy learning and absorb easily.

☽ □ ♇ This *challenge* is to learn to control the simmering emotional turmoils that lie beneath the surface. Most of the time, their conscious mind is ruled by the intellect, but, occasionally, the Pluto eruption causes their intense emotions to burst forth. It is difficult for these people to totally trust those they love, because they fear they will eventually be rejected due to their unworthiness. Because of this, they are constantly tested in their relationships in order to bring about an inner growth. These lessons teach them to trust those they love. These individuals have unusual concepts which they can bring to fruition if they wish. They are apt to be rather set in their ways and should learn to become more flexible. They may suffer inner distress with their par-

313

ents (especially their mothers), with those who live in the home they establish away from the parental home, and/or with the people in their organizational groups.

☽ △ ♀ In other lifetimes, these individuals have begun the work of balancing their psychic sensitivity and their emotions by constructively working on the negative traits of their conscious mind's personality, as represented by the zodiac sign the moon is in. Because of this, they will not play games with anyone's emotions. They enjoy the unusual and mysterious and are attracted by anything concerning psychology and human behavior. They learn and absorb easily.

☽ ⊼ ♀ An *adjustment* is needed in regard to expressing their feelings and viewpoints to everyone and everybody. Because their emotions are so intense, they feel a need to get them off their chests. However, they should speak only to the people they can truly trust. When these individuals find that their confidences have been broken, they are very distressed and may totally withdraw from the individual involved. Discernment is the key to this aspect. It is always good to talk over one's emotional problems, but not to everybody. These individuals may experience discord with their parents (especially their mothers), with those who live in the home they establish away from the parental home, and/or with the people in their organizational groups.

☽ ☍ ♀ An *awareness* should be developed so that they will see others as they really are and not as they wish them to be. Their emotions are especially strong and difficult to control, causing them to be very, very happy or very, very sad. True friends understand these emotional swings and will try to help them overcome this tendency. They must learn not to be possessive or jealous of their loved ones. Since they themselves want freedom, they must grant it to their loved ones as well. They may experience emotional difficulties with their parents (especially their mothers), with those who live in the home they establish away from the parental home, and/or with the people in their organizational groups.

☽ ♂ ⊕ The *power* of this conjunction balances the emotions and the intellect to the moon's vibrations, so that these individuals can achieve personal growth.

☽ N ⊕ There is a *restriction* on achieving personal growth until these individuals revise past life attitudes regarding the houses these planets reside in.

☽ ⚹ ⊕ An *opportunity* this lifetime to work on personal growth.

☽ □ ⊕ *Internal conflict* between the conscious mind's desire for personal growth and an emotional desire for fame and riches.

☽ △ ⊕ In other lifetimes, the conscious mind's personality, as represented by the zodiac sign the moon is in, worked to achieve personal growth and will continue to attract experiences which will assist further personal growth this lifetime.

☽ ⚻ ⊕ An *adjustment* is needed so that they exercise discernment in their personal life, because a previous lifetime's pathway led away from personal growth.

☽ ☊ ⊕ An *awareness* should be developed that personal growth is as necessary as soul growth.

☽ ♂ ♌ The *power* of this conjunction will attract spiritual teachers to assist in emotional purification.

☽ N ♌ There is a *restriction* on attracting spiritual teachers to assist in emotional purification because of a need to revise past attitudes concerning the houses these planets reside in.

$\mathbb{D} \bigast \, \Omega$ There is an *opportunity* for spiritual teachers to enter their lives to help in emotional purification.

$\mathbb{D} \, \square \, \Omega$ There is *internal conflict* regarding the value of spiritual teachers to assist in emotional purification, because of their own problems as a spiritual teacher in a past lifetime.

$\mathbb{D} \, \triangle \, \Omega$ These individuals will attract spiritual teachers who they have been close to in other lifetimes and who have helped them toward emotional purification.

$\mathbb{D} \, \pi \, \Omega$ An *adjustment* is needed in thinking regarding spiritual teachers. The possible emotional difficulties of spiritual teachers do not make them any less capable of assisting others through emotional turmoil.

$\mathbb{D} \, \mathcal{S} \, \Omega$ An *awareness* should be developed concerning their need to find a spiritual teacher to assist in the purification of their emotional turmoil.

$\mathbb{D} \, \sigma \, \mho$ The *power* of this conjunction will attract karmic situations to assist in emotional purification.

$\mathbb{D} \, N \, \mho$ There is a *restriction* on attracting karmic situations to assist in emotional purification because of a need to revise past attitudes concerning the houses these planets reside in.

$\mathbb{D} \bigast \, \mho$ There is an *opportunity* for karmic situations to occur which will help toward emotional purification.

$\mathbb{D} \, \square \, \mho$ There is *internal conflict* because of the inability to accept karmic situations as teaching experiences for emotional purification.

☽ △ ♈ These individuals willingly attract karmic situations which will help them transform their emotional responses to life.

☽ ⊼ ♈ An *adjustment* is needed in thinking, for these individuals have difficulty in accepting the necessity of karmic situations occurring for emotional purification.

☽ ⚻ ♈ An *awareness* should be developed concerning that karmic situations must, and will, occur for emotional purification.

ASPECTS TO MERCURY

(These two planets are never more than 70 degrees apart.)

☿ ☌ ♀ The *power* of this conjunction refines the mind, so that it seeks harmony and beauty in ideas as well as objects. These individuals are optimistic with a lot of charm. Many of them have artistic talents and, if not, have an appreciation of the arts. They are born diplomats with the ability to settle arguments and soothe hurt feelings.

☿ N ♀ These individuals feel *restricted* in being witty and charming to others. They should look to the houses these planets reside in to determine what past attitudes need revising.

☿ ✳ ♀ There is the *opportunity* for these individuals to use the harmony between their mind and feelings as diplomats. They are friendly, sociable, witty individuals who are popular at parties. They know how to express themselves well. There is artistic and musical talent.

317

☿ ☌ ♂ The *power* of this conjunction gives a keen wit, but also a sharp tongue. These individuals should be careful about what they say or they might end up in verbal battles all the time. Many with this aspect enjoy the verbal arguments, since they can make use of their alert mind with quick rebuttals. These individuals are quite independent, determined, courageous, and with the energy to succeed in life. They should learn, however, to think before speaking, since they could easily lose friends through their bluntness and sarcasm. They may experience difficulties with relatives, neighbors, fellow workers, those who serve them, and/or with other people's life-styles.

☿ N ♂ These individuals feel *restricted* in verbalizing their anger. They should look to the houses these planets reside in to determine what past attitudes need revising.

☿ ✶ ♂ There is the *opportunity* for these individuals to use logic and reason when dealing with any of their desires (anything they appreciate and enjoy, whether they are physical, emotional, mental, or spiritual). They have good mathematical ability. And, they also have manual and mechanical dexterity, with the possibility of literary talent.

☿ □ ♂ This *challenge* is to use logic and reason when dealing with any of their desires (anything they appreciate and enjoy, whether it is physical, emotional, mental, or spiritual). Their mental energy should be directed into creative channels. They should watch their tendency to become irritable and fault-finding. They have a tendency to overwork, which is very hard on both their physical body and their nerves. Their approach to life can be too much hustle and bustle, with a lot of running around and nothing being accomplished. They may experience communication difficulties with relatives, neighbors, fellow workers, those who serve them, and/or with other people's life-styles which cause them inner distress.

☿ △ ♂　　In other lifetimes, these individuals have begun the work of balancing their thinking by using logic and reasoning when dealing with any of their desires (anything they appreciate and enjoy, whether they are physical, emotional, mental, or spiritual). They are self-assured and decisive in whatever they do. They have a lot of mental energy and should keep their minds busy. This isn't too difficult to do, since their mind is always full of ideas and opinions. It is important, however, for them to learn to occasionally quiet the mind's chatter through meditation. They are well known for their honesty, but not necessarily for tactfulness unless something else in their chart mitigates the tactlessness. There is literary talent.

☿ ⊼ ♂　　An *adjustment* is needed in learning to discern the truth of their convictions and opinions. Sometimes these individuals will defend their incorrect ideas because of an inborn fear that to be wrong is shameful. They should learn to listen to other viewpoints with an open mind and then decide which viewpoint is correct. They may experience discord with relatives, neighbors, fellow workers, those who serve them and/or with other people's life-styles.

☿ ☍ ♂　　An *awareness* should be developed that their mind and nervous system are being overstrained. Because of this, these individuals will become excessively angry at times and say things that may make very little sense to listeners. The reason for this is because their anger destroys their ability to think clearly and so they are unable to logically present the reasons for their anger. Since their nerves are, also, stretched taut, they must be careful or they will suffer from some type of nervous disorder, such as shingles or an ulcer. A constructive use of this aspect would be for these individuals to become debaters, where they would be forced to think calmly and logically. This would satisfy their desire to challenge other people's viewpoints. Another solution would be for them to write down their arguments when they are calm. These individuals may experience difficulties with relatives, neighbors, fellow workers, those who serve them, and/or over other people's life-styles.

☿ ☌ ♃ The *power* of this conjunction gives an expanded mind which wants to learn and understand all subjects and master as many of them as possible. They enjoy reading and will probably travel a lot, since they are always ready to learn something new. Once they understand or master a subject, they move on to new subjects and new adventures.

☿ N ♃ These individuals feel *restricted* in absorbing and remembering knowledge. They should look to the houses these planets reside in to determine what past attitudes need revising.

☿ ✳ ♃ There is the *opportunity* to develop good judgment. Because of the questing nature of their minds, travel is very beneficial to them. They enjoy socializing and always keep the conversation interesting with their humor. They have the ability to see both sides of an argument and will try to work out a compromise. Because they think clearly and objectively, they are skillful at expressing their ideas. However, they are not particularly fond of detailed work and will avoid it, if possible.

☿ □ ♃ This *challenge* is to expand the conscious mind into philosophic concepts. There is a tendency to be absentminded, even though the mind is very original and fertile. They have artistic and literary talent. These individuals must guard against jumping to conclusions. On the plus side, they are able to put together ideas and concepts that seem totally unrelated to each other. People have a tendency to take advantage of these individuals because of their sympathetic nature and generosity. They may experience communication difficulties with relatives, neighbors, fellow workers, those who serve them, in-laws, and/or in courts of law which cause them inner distress.

☿ △ ♃ In other lifetimes, these individuals have begun the work of balancing their reasoning abilities and judgments. Because of an intuitive inner knowing, they believe in life

after death. They benefit through traveling because they enjoy learning new things. These individuals are generous, tolerant, and optimistic. They are always trying to see the positive side to everything. They are good at organizing and planning, and are very skillful at expressing their thoughts to others.

☿ ⊼ ♃ An *adjustment* is needed in regard to the schemes dreamed up in their fertile mind, since some of them are not carefully or clearly thought out. They have the ability to see and understand all parts of a concept, but careful planning will allow them to bring it to fruition. Then, too, some of these individuals preach high standards to others and then don't live up to them themselves. They need to learn to allow everyone to establish their own moral standards. These individuals may experience discord with relatives, neighbors, fellow workers, those who serve them, in-laws, and/or in courts of law.

☿ ☍ ♃ An *awareness* should be developed so that these individuals discipline themselves to think their problems through logically, clearly, and with full knowledge of the facts. They have a tendency to be sloppy in their thinking and even in their handwriting. On the plus side, they are extremely uncritical of other people and accept them as they find them. These individuals are positive and optimistic, but should always keep an open mind to other viewpoints. These individuals may experience difficulties with relatives, neighbors, fellow workers, those who serve them, in-laws, and/or in courts of law.

☿ ☌ ♄ The *power* of this conjunction focuses an enormous amount of energy into the unconscious mind, giving it depth of thought, organizational ability, good concentration, and directness of speech. However, this aspect also causes depressive moods. These individuals are practical, honest, and moral, but may have difficulty in expressing their affection for others.

☿ ⋈ ♄ These individuals feel *restricted* in communicating with the people in their environment, in their professional career, and with their parents (especially their fathers). They should look to the houses these planets reside in to determine what past attitudes need revising.

☿ ✶ ♄ There is the *opportunity* for these individuals to learn to master a number of subjects. They are practical, responsible individuals. They have sharp minds and are good at organizing, not only themselves but the people around them. This is a good aspect for physical health and self-control.

☿ □ ♄ This *challenge* is to learn to occasionally relax the concentration of their mind upon goals, projects, and concepts. These individuals have a tendency to go to extremes concerning the smallest details. Some of these details are not **essential to the satisfactory completion of the project. This intense concentration places a tremendous strain upon the** nervous system, so that nervous disorders frequently occur, including nervous breakdowns. These individuals are very hard workers who handle everything they do with thoroughness and efficiency. But, if they overtax their minds too much, depression sets in. They may experience inner distress from relatives, neighbors, fellow workers, those who serve them, those in their professional career, over their personal achievements, and/or society in general.

☿ △ ♄ In other lifetimes, these individuals have begun the work of learning to master many subjects. Because of this, they have an above-average intellect with strong reasoning abilities, concentration, and self-control. They have depth of thought and organizational abilities. These individuals make excellent teachers. Their physical health is strong, with excellent recuperative powers.

☿ ⊼ ♄ An *adjustment* is needed in regard to their cynical attitude towards humanity. They should take the time to observe the beauty and harmony in nature. By seeking out

sunny, optimistic people, they can be helped to see life from a more pleasant viewpoint. These individuals may experience discord with relatives, neighbors, fellow workers, those who serve them, those in their professional career, over their personal achievements, and/or society in general.

☿ ☍ ♄ An *awareness* should be developed so that these individuals do not interpret what others say to them in a negative manner. These individuals have difficulties in communicating what they mean verbally to others, so that misunderstandings occur on both sides. It is essential for these individuals to clear up these misunderstandings by reviewing the conversation again. These individuals are conservative in their thinking and prefer to stay with ideas that work for them rather than adopting new ones. However, it would be to their advantage to listen to new concepts and to try them occasionally. They may experience difficulties with relatives, neighbors, fellow workers, those who serve them, those in their professional career, over their personal achievements, and/or society in general.

☿ ☌ ♅ The *power* of this conjunction gives a strong emphasis and drive to awaken the unconscious mind. These individuals have strong intuition. Since so much energy is directed into the unconscious mind, there can be chaotic thinking at times. They are self-reliant, with a need to pursue all subjects they tackle to a satisfactory conclusion. There is originality of thought and a very progressive mind.

☿ N ♅ These individuals feel *restricted* in giving birth to new ideas and concepts. They should look to the houses these planets reside in to determine what past attitudes need revising.

☿ ✶ ♅ There is the *opportunity* for these individuals to probe their unconscious mind, bringing forth new insights and concepts. Their mind readily absorbs knowledge and is strongly intuitive. They have a talent for writing, speaking,

and communicating their ideas to others. These individuals are always ready to listen to new and unusual ideas and concepts.

☿ □ ♅ This *challenge* is to learn to control their mental energy until they have totally thought out the workability of their concept or idea. They have an inspirational mind, but once an idea has formulated, they may not always carry it through to completion. The nervous energy of this aspect makes it difficult to concentrate for very long on any one subject but, by using their willpower, they can do so if they really want to. They are intuitive but not necessarily sensitive individuals, so they may hurt other people's feelings through playful jokes. These individuals may experience inner distress with relatives, neighbors, fellow workers, those who serve them, friends, and/or social groups.

☿ △ ♅ In other lifetimes, these individuals have begun the work of awakening their minds to deep and profound thinking. Because of this, they will attract people who will encourage them to continue this probing into their unconscious mind. They are intuitive and creative. As in the sextile, these individuals have the ability to write, speak, and communicate their ideas to others. They are usually open to new ideas and concepts.

☿ ⚻ ♅ An *adjustment* is needed in regard to disciplining their mind so that they don't jump from one subject to another, without understanding what they have learned. Their minds are always in rapid motion, which makes it difficult for them to concentrate for any length of time on any one subject. However, they must force their minds to obey their will and learn to master each subject before moving on to other interests. If they do not learn to discipline themselves, they will eventually suffer from nervous disorder. Learning to meditate for at least fifteen minutes a day would be very helpful to these individuals. They are quite inventive and see solutions to problems very quickly. They may experience discord with relatives, neighbors, fellow workers, those who serve them, friends, and/or social groups.

324

☿ ⚹ ♅ An *awareness* should be developed to keep an open mind at all times. Their mind is rather antagonistic toward the ideas of other people so that they have a tendency to disbelieve out of hand. However, if their own mind comes to the same conclusion, they find it totally believable. Usually, these individuals like new ideas, but they don't want them "preached" to them. Thus, it is important for them to realize that others are not necessarily "preaching" to them when they present different viewpoints. Like the inconjunct, they need to discipline themselves to stay with a subject long enough to master it. Because of the restlessness and nervousness of these individuals, learning to meditate each day would be extremely beneficial. They may experience difficulties with relatives, neighbors, fellow workers, those who serve them, friends, and/or social groups.

☿ ☌ ♆ The *power* of this conjunction makes the mind extremely sensitive, with a vivid and rich imagination. These individuals are highly intuitive and receive psychic impressions from others which they find confusing until they learn to discern exactly what the vibration represents, such as sorrow, fear, joy, etc. There are several difficulties with this aspect, as it is hard to get the mind to concentrate on logical subjects and to keep the truth and untruth sorted out. They have nervous problems and need peace and quiet each day. This aspect is very beneficial to writers of romantic novels, for musicians, and for actors.

☿ N ♆ These individuals feel *restricted* in revealing to others their artistic and literary abilities. They should look to the houses these planets reside in to determine what past attitudes need revising.

☿ ⚹ ♆ There is the *opportunity* to tap their unconscious mind. This can be done in dreams or by meditating. These individuals are sensitive to the higher realms. They have a poetic and creative mind. Because of this, they prefer the artistic world over the scientific one. They enjoy the beauty and harmony in the world and like to show it to others.

There is a love of the sea, because of its ability to soothe their nerves.

☿ □ ♆　This *challenge* is to learn to recognize reality from non-reality. When problems become too much for them, they recreate the situation in their mind with the ending they prefer, until they become convinced the new ending is reality. They have extremely creative minds which can produce beautiful works of imagination. Since they find it difficult to communicate their abstract thoughts, they should use their ability for artistic expression to communicate these thoughts. These individuals must learn to concentrate when other people are speaking and not wander off into daydreams, for much of their inability to communicate with others stems from this reason. They should, also, learn to keep the truth and untruth sorted out, for it will cause them great difficulties. They may experience inner distress with relatives, neighbors, fellow workers, those who serve them, and/or friends who are in actuality their hidden enemies from former lives.

☿ △ ♆　In other lifetimes, these individuals have begun the work of balancing their mind so that they could use their inspirational powers constructively. They have the ability to express this harmony through writing or painting. There is a sensitivity to the higher realms that can be developed more fully. They tap the higher realms in their dreams, even if they are unable to remember doing so. They benefit by living near the sea, since the sea has the ability to soothe their nervous sensitivity.

☿ ⊼ ♆　An *adjustment* is needed in regard to communicating their thoughts more clearly. This can be helped by writing down their thoughts and then rereading them to see if they are as clear as they want them to be. These individuals are unaware that others have trouble following their conversations, because their conversations do not always have a logical end. Until they learn to express themselves more clearly, they may become very lonely individuals and not

understand why. They may experience communication difficulties with relatives, neighbors, fellow workers, those who serve them, and/or friends who are in actuality their hidden enemies from former lives.

☿ ☊ ♆ An *awareness* should be developed that everyone has faults, and, therefore, no one should be placed upon a pedestal. These individuals have a tendency to place loved ones and very special friends on a pedestal. When the individual inevitably falls off, these individuals are totally disillusioned. This disillusionment may cause them to turn their backs on close relationships with others. They must learn to accept that everyone has human frailties. And, they must learn to sort out truth from untruths. This aspect gives many inspirational dreams that could become a source of creative ideas in literature. They have a sensitive nervous system and should seek an area of peace and quiet each day for at least fifteen minutes. These individuals may experience difficulties with relatives, neighbors, fellow workers, those who serve them, and/or friends who are in actuality their hidden enemies from former lives.

☿ ♂ ♇ The *power* of this conjunction makes the mind capable of keen observation and depth of perception. It is an extremely agile mind with a strong desire to solve any mystery that comes along. These individuals have strong opinions with the power to influence others. They should learn to listen to other viewpoints and to remember to always keep an open mind. They enjoy reading good mystery stories or science fiction. Unfortunately, this aspect gives a highly geared nervous system which can cause impatience and irritability. They must learn when they need to give their mind a rest.

☿ N ♇ These individuals feel *restricted* in convincing others to use their ideas and concepts. They should look to the houses these planets reside in to determine what past attitudes need revising.

☿ ✳ ♇ There is the *opportunity* for these individuals to analyze all situations with logic and intuition. They have writing ability and can easily communicate their ideas to others. They enjoy mysteries and would enjoy a career involving investigation of some type. These individuals are usually self-confident, without being conceited. They have mechanical abilities and enjoy taking things apart in order to see how they work and then putting them back together again.

☿ □ ♇ This *challenge* is to keep an open mind before ridiculing any concept. These individuals want proof of the validity of the knowledge presented to them. This could be called the "doubting Thomas" aspect. The only way these individuals can find the proof they want is to learn to tap their own superconscious mind in order to find the truth from their inner wisdom. Unfortunately, strong doubts always block any link with the unconscious mind. If they truly wish proof, they should begin thinning the veil to the unconscious mind through meditation. These individuals may experience inner distress with relatives, neighbors, fellow workers, those who serve them, and/or with people in their organizational groups.

☿ △ ♇ In other lifetimes, these individuals have begun the work of balancing their logic and their intuition, giving them an unusual ability to study any subject in depth. They have a strong desire to master any skill as completely as possible. Because of Pluto's love of mystery, these individuals are always interested in why people act and say the things they do. They are generally self-confident without being conceited. These individuals will gain recognition from their contemporaries because of their self-discipline and intellectual abilities. They have writing ability and can easily communicate their ideas to others in a logical, easy-to-understand manner. Because of their interest in human nature, they may wish to pursue a career which would allow them to reform society in some manner.

☿ ⊼ ♇ An *adjustment* is needed in learning to speak simply and logically so that they do not confuse other people through the use of complicated, intellectual words. This practice may cause people to think of them as highly intelligent people, but it is not necessary and should be avoided. These individuals have so much going for them that this is a futile practice. They are good at solving mysteries and could do well in research work. These individuals may experience discord with relatives, neighbors, fellow workers, those who serve them, and/or with people in their organizational groups.

☿ ☌ ♇ An *awareness* should be developed in learning not to be so intensely involved with their ideas and beliefs. When others do not believe the same way, these individuals can become angry. If they continually react in this manner, people will avoid discussing any subject with them which might be controversial. They should learn to listen calmly to other viewpoints and consider whether theirs is in error. If they are wrong, they should be "big" enough to admit it. These individuals may experience difficulties with relatives, neighbors, fellow workers, those who serve them, and/or with people in their organizational groups.

☿ ☌ ⊕ The *power* of this conjunction balances the emotions and the intellect to Mercury's vibrations, so that these individuals can think logically and clearly.

☿ N ⊕ There is a *restriction* on using their mental abilities to obtain material success until these individuals revise past life attitudes regarding the houses these planets reside in.

☿ ✱ ⊕ An *opportunity* for using their mental abilities to obtain material success.

☿ ☐ ⊕ *Internal conflict* interfering with the use of mental abilities to obtain material success.

☿ △ ⊕　　In other lifetimes, these individuals have used their mental abilities to achieve material success, and because their motives were correct, they are able to use their minds in this lifetime to again achieve material success.

☿ ⊼ ⊕　　An *adjustment* in thinking is needed so that they can use their mental abilities to obtain material success.

☿ ⚹ ⊕　　An *awareness* should be developed that they should use their mental abilities to obtain material success.

☿ ☌ ☊　　The *power* of this conjunction will attract spiritual teachers to assist in the transformation of their mental thoughts and attitudes.

☿ N ☊　　There is a *restriction* on attracting spiritual teachers to assist in the transformation of their mental thoughts and attitudes, because of a need to revise past attitudes concerning the houses these planets reside in.

☿ ⚹ ☊　　There is an *opportunity* for spiritual teachers to enter their lives to assist in the transformation of their mental thoughts and attitudes.

☿ □ ☊　　There is *internal conflict* regarding the value of spiritual teachers to assist in the transformation of their mental thoughts and attitudes, because of their own problems as a spiritual teacher in a past lifetime.

☿ △ ☊　　These individuals will attract spiritual teachers who they have been close to in other lifetimes and who have helped them toward the transformation of their mental thoughts and attitudes.

☿ ⤙ ♌ An *adjustment* is needed in thinking, regarding spiritual teachers. The fact that spiritual teachers must, also, work on the transformation of their mental thoughts and attitudes does not make them any less capable of assisting others in the transformation of mental thoughts and attitudes.

☿ � ♌ An *awareness* should be developed concerning the need to find a spiritual teacher to assist them in the transformation of their mental thoughts and attitudes.

☿ ♂ ♑ The *power* of this conjunction will attract karmic situations to assist in the transformation of their mental thoughts and attitudes.

☿ N ♑ There is a *restriction* on attracting karmic situations to assist in the transformation of their mental thoughts and attitudes, due to a need to revise past attitudes concerning the houses these planets reside in.

☿ ✱ ♑ There is an *opportunity* for karmic situations to occur which will help in the transformation of their mental thoughts and attitudes.

☿ □ ♑ There is *internal conflict* because of the inability to accept karmic situations as teaching experiences for the transformation of their mental thoughts and attitudes.

☿ △ ♑ These individuals willingly attract karmic situations which will help them transform their mental thoughts and attitudes.

☿ ⤙ ♑ An *adjustment* is needed in thinking, for these individuals have difficulty in accepting the necessity of karmic situations occurring for the purpose of transforming their mental thoughts and attitudes.

☿ ☍ ♑ An *awareness* should be developed that karmic situations must, and will, occur for the purpose of transforming their mental thoughts and attitudes.

ASPECTS TO VENUS

♀ ☌ ♂ The *power* of this conjunction gives courage, strong emotions, and the love of beauty and harmony. There is a great need within these individuals to give and receive affection from others. It is very difficult for them to take any relationship lightly. These individuals have personal magnetism which attracts others. Nevertheless, this is a difficult aspect, since they experience inner conflict of both hostile and affectionate feelings for those they love. They may experience conflicts over their personal resources (money, possessions, talents, sense of self-worth), disagreements with their marriage partner, difficulties with people in cooperative relationships, and/or over other people's approaches to life.

♀ N ♂ These individuals feel *restricted* in giving and receiving sexual fulfillment. They should look to the houses these planets reside in to determine what past attitudes need revising.

♀ ⚹ ♂ There is the *opportunity* for these individuals to learn to give full expression to their warmth and affection for others. They are noncombative individuals who like peace and serenity. Their approach to life is energetic and lively.

♀ □ ♂ This *challenge* is to overcome their feelings of love and hate toward the people they care about. When there are differences of opinion, these individuals release the "hate" through either verbal or physical fights with the person involved. After their hostility is released, they once again feel "love" for that person. Unfortunately, the object of their

love may eventually walk out on them permanently unless these individuals learn to handle this aspect. They would do well to have some type of athletic equipment which they could use when their anger begins to build, such as a punching bag or ball. This will release their anger. It is extremely important for them to do so, or they might develop difficulties in their reproductive organs. They may experience internal distress and anger with their marriage partner, with other people in cooperative relationships, over their personal resources (money, possessions, talents, sense of self-worth), and/or over other people's approaches to life.

♀ △ ♂ In other lifetimes, these individuals have begun the work of learning to give full expression to their warmth and affection for others. They are enthusiastic about life which others find inspiring. Casual affairs are not of interest to them, as they want to feel totally fulfilled through love. These individuals are very creative and enjoy creating something out of "nothing." They are usually kind, to both people and animals.

♀ ⚻ ♂ An *adjustment* is needed in learning to control their anger. As in the square aspect, they experience a love-hate for those they care about. Because of this, their relationships with others can be rather stormy. Finding a good outlet for their hostility would be extremely beneficial—any type of athletic sport would help. These individuals may experience discord and anger with their marriage partner, with other people in cooperative relationships, over their personal resources (money, talents, possessions, sense of self-worth), and/or over other people's approaches to life.

♀ ☍ ♂ An *awareness* should be developed in learning to compromise with others so that their anger does not erupt when they cannot get their way. These individuals, also, experience love-hate for those they care about. But their emotional reactions are more easily controlled than the square aspect. Blowing off steam is not necessarily bad, since it discharges pent-up anger. But it really isn't right to use other people

333

as verbal punching bags. It would be far better to make use of the various athletic equipment available to burn up their hostile feelings. These individuals may experience difficulties and anger with their marriage partner, with other people in cooperative relationships, over their personal resources (money, possessions, talents, sense of self-worth), and/or over other people's approaches to life.

♀ ♂ ♃ The *power* of this conjunction indicates a generous and affectionate individual. They are faithful and loyal friends, who enjoy socializing. There is an appreciation and enjoyment of harmony and beauty. They are restless people who would benefit from traveling. This aspect generally grants them material abundance, which they have earned from other lifetimes.

♀ N ♃ These individuals feel *restricted* in feeling at ease in social situations. They should look to the houses these planets reside in to determine what past attitudes need revising.

♀ ✳ ♃ There is the *opportunity* for these individuals to attune themselves to their higher self. These individuals are optimistic and cheerful. They appreciate harmony and beauty around them. They have creative abilities if they wish to pursue them. One of their finest traits is their loyalties to their friends.

♀ □ ♃ This *challenge* is one of balancing their desires for material things and their desires for philosophic ideals. An overexpansion in material things will cause inner conflict because of the soul's desire for higher goals and ideals. If the motives concerning the material possessions are correct, there will be no conflicts. These individuals may experience inner distress over their personal resources (money, possessions, talents, sense of self-worth), from their marriage partner, from other people in cooperative relationships, from their in-laws, and/or from courts of law.

♀ △ ♃ In other lifetimes, these individuals have begun the work of attuning themselves to their higher self. Their openness to philosophic concepts will attract people to them so that they can continue learning and, possibly, teach higher philosophic thoughts. They are extremely loyal to their friends and treat them with consideration. There may be creative abilities which could be pursued. Honor and integrity are inborn characteristics that have been learned in other lifetimes.

♀ ⊼ ♃ An *adjustment* is needed in learning to overcome laziness. Willpower will have to be exercised, unless this is a genuine case of low energy level. These individuals can be warm and affectionate, but want it in return. They may experience discord over their personal resources (money, possessions, talents, sense of self-worth), with their marriage partner, with other people in cooperative relationships, with their in-laws, and/or in courts of law.

♀ ⚋ ♃ An *awareness* should be developed in learning self-restraint. Because of their love of socializing and fun, they can become carried away beyond the realm of good taste. However, they are positive, optimistic, and cheerful people who are always willing to share whatever they have with others. They need to watch their tendency to spend money they cannot afford. There is an ability to handle people and still be liked. They may experience difficulties over their personal resources (money, possessions, talents, sense of self-worth), with their marriage partner, with other people in cooperative relationships, with their in-laws, and/or in courts of law.

♀ ☌ ♄ The *power* of this conjunction gives restraint and seriousness. They are quite inhibited in showing any outward affection to others and feel that it is really not the thing to do. They do love others, but find it excessively difficult in showing it physically. To handle this problem, they could use special greeting cards to express their feelings. They must learn to guard against becoming too miserly with their

money and possessions, for they will be unable to take it with them when they leave the earth plane. These individuals are reliable friends who can be trusted.

♀ N ♄ These individuals feel *restricted* in showing friendly warmth toward their marriage partner, to other people in cooperative relationships, to those in their professional career environment, and/or to their parents (especially their father). They should look to the houses these planets reside in to determine what past attitudes need revising.

♀ ⚹ ♄ There is the *opportunity* for these individuals to establish long-lasting, reliable friendships. As a rule, they have very few personal friends, but these friends are loyal. They, themselves, are just as faithful and loyal in return. There is an inborn sense of responsibility to their loved ones.

♀ □ ♄ This *challenge* is one of accepting the difficulties they experience in life as spiritual lessons. These lessons are attempting to help them establish better values (anything they appreciate and enjoy, whether it is physical, emotional, mental, or spiritual). Their longing for the emotional fulfillment of an all-consuming love causes these individuals to feel lonely. They need to learn to appreciate the positive traits of their loved ones and overlook the negative traits. When they succeed in doing this, their feelings of aloneness will vanish. They may experience inner distress over their personal resources (money, possessions, talents, sense of self-worth), from their marriage partner, from other people in cooperative relationships, from people in their professional career environment, from their parents (especially their fathers), and/or society in general.

♀ △ ♄ In other lifetimes, these individuals have begun the work of balancing the seriousness of life with the ability to physically demonstrate their affections. Like the sextile, they will form long-lasting, reliable friendships. They will have only a few very close friends, but these friends will be

loyal and trustworthy. They, too, will be loyal and faithful in return. Sometimes these individuals fear that they are not much fun at a party because of their essential seriousness. They are at their best in smaller groups. However, parties and social groups need the stabilizing of serious people. These individuals have a strong sense of responsibility toward their loved ones. They also have an inborn strength and courage to face life's difficulties.

♀ ⊼ ♄　　An *adjustment* is needed in learning to balance the seriousness of life and the enjoyment of life. They feel such a strong sense of duty and ambition that they will place it first at the expense of socializing and enjoying other people. If they follow this path, they will eventually be very lonely people. They may experience discord over their personal resources (money, possessions, talents, sense of self-worth), with their marriage partner, with other people in cooperative relationships, with people in their professional career environment, with their parents (especially their fathers), and/or society in general.

♀ 8 ♄　　An *awareness* should be developed in learning to balance the seriousness of life and the enjoyment of life. These individuals have a tendency to lose their optimism when life presents problems with which they must cope. It is fine to have a sense of responsibility, but they must also learn to trust in divine wisdom which attracts these difficulties to them to help them develop personal and soul growth. Many of these individuals feel lonely, but that is because they are unable to see that other people do love them. Their problem lies in their own opinion of themselves. They have to realize that they must become a loving individual themselves in order to attract love. This is a difficult aspect, because it is asking these individuals to work very hard on their relationships with other people. Love begets love—there is no other way. They may experience difficulties over their personal resources (money, possessions, talents, sense of self-worth), with their marriage partner, with other people in cooperative relationships, with people in their professional career environment, with their parents (especially their fathers), and/or society in general.

♀ ☌ ♅ The *power* of this conjunction gives strong personal magnetism. These individuals are independent and strong-willed. They are troubled with emotional ups and downs which they do not understand, and, thus, have a tendency to blame whoever is handy for their emotional lows. These emotional currents are coming from inside and are creative currents which cannot find any outward expression. When in an emotional low, they should occupy themselves with a creative outlet, such as painting, carpentry, etc. These individuals would also benefit from traveling, as they need unusual changes in their life and because of their strong love for the beauty in nature.

♀ N ♅ These individuals feel *restricted* in showing friendly warmth to their friends and social groups. They should look to the houses these planets reside in to determine what past attitudes need revising.

♀ ⚹ ♅ There is the *opportunity* for these individuals to attract unusual friendships which will fill an unique need within them. These individuals are never possessive of their friends. They are extremely creative, using unusual ideas and designs. They have personal magnetism and are well liked by their friends. This aspect brings unexpected and exciting events into their lives.

♀ □ ♅ This *challenge* is to awaken new values (anything you appreciate and enjoy, whether it is physical, emotional, mental, or spiritual). Unusual friends and cooperative relationships mirror both the positive and negative values these individuals have had in former lifetimes and, possibly, still have in this lifetime. By seeing these traits mirrored, they might formulate new values. Relationships with friends and social groups will end abruptly at times when they have served their purpose, much to the confusion of these individuals. They may experience inner distress over their personal resources (money, possessions, talents, sense of self-worth), from their marriage partner, from other people in cooperative relationships, from their friends, and/or from their social groups.

338

♀ △ ♅ In other lifetimes, these individuals have begun the work of balancing their need for love and their need for freedom. They have unusual magnetism and will attract unique friends to them who will be of considerable aid to them. In turn, these individuals will be of considerable assistance to their friends. As in the sextile aspect, they are not possessive of their friends. Their extreme creativity draws them into using unusual media and techniques. Friends come and go in their lives when the friends no longer fulfill a need. As long as the partings are harmonious, no karma is created. These individuals will constantly receive exciting, unusual, and unexpected events in their lives, which are of considerable assistance in achieving both personal and soul growth.

♀ ⊼ ♅ An *adjustment* is needed with regard to their need for love and their need for freedom. They want to be close to their loved ones, but if it seems too close, they feel smothered. This causes them to back away. At times, these individuals bend over backward to do everything possible for their loved ones and, then, when their loved ones begin to expect it, they feel imposed upon. Needless to say, their actions cause great confusion in the loved ones. This problem is truly distressing for both parties. These individuals must learn that love does not have to be "bought." They may experience discord over their personal resources (money, possessions, talents, sense of self-worth), with their marriage partner, with other people in cooperative relationships, with their friends, and/or with their social groups.

♀ ☍ ♅ An *awareness* should be developed with regard to their need for love and their need for freedom. Like the inconjunct, they want to be close to their loved ones, but do not want to be smothered. In order to avoid confusing their loved ones, they should learn to occasionally say "no" to requests made of them, so that they have the feeling that they are free to make their own decisions. In emergencies, of course, these individuals would be the first ones to help. But, it is extremely important to them that they don't feel as if their loved ones are merely "using" them. If they continue to feel imposed upon, they will build inner resentment which will

339

eventually become a karma of resentment. Learning to be lovingly assertive is the answer to this aspect and will help their loved ones as well. They may experience difficulties over their personal resources (money, possessions, talents, sense of self-worth), with their marriage partner, with other people in cooperative relationships, with their friends, and/or with their social groups.

♀ ♂ ♆ The *power* of this conjunction gives a romantic, dreamy nature. These individuals are gentle, but insecure. There is a great love of beauty and harmony. They may be talented in music and art. They are psychically sensitive with mystical tendencies which can be further developed if they so desire. This aspect causes these individuals to place their loved ones on a pedestal, and, of course, the loved ones are bound to fall off, which causes disillusionment and disappointment. This tendency must be overcome, for everyone has some human frailty. Otherwise, these individuals will be forever seeking a perfect love relationship.

♀ N ♆ These individuals feel *restricted* in being able to find their idea of an all-consuming love relationship. They should look to the houses these planets reside in to determine what past attitudes need revising.

♀ ⚹ ♆ There is an *opportunity* of expressing themselves in some artistic form. But, to do so, they will have to master a specific craft, such as painting, music, etc., as it won't happen by itself. These individuals are very idealistic and readily volunteer to help others in need. They have a strong love of music and would become fine musicians.

♀ □ ♆ This *challenge* is to learn to turn personal desires into universal desires. These individuals have to learn to love without expecting love in return. This is an aspect that calls for these individuals to continuously forgive their fellow-man. When Jesus was asked by Peter how many times he needed to forgive his brother when his brother sinned

340

against him, Jesus replied, "Until seventy times seven." He meant, of course, that we must forgive forever the sins of our fellowman. These individuals did not freely forgive in their previous lifetimes and are holding inner resentments. This stressful aspect is reminding them of the need to turn the other cheek. They may experience inner distress over their personal resources (money, possessions, talents, sense of self-worth), from their marriage partner, from other people in cooperative relationships, and/or from friends who are in actuality hidden enemies from former lives.

♀ △ ♆ In other lifetimes, these individuals have sought spiritual insights within themselves and from others. Because of this, they will attract to themselves this lifetime people who will help them continue their soul growth. They have a great need within themselves to express themselves creatively. Because of this need, they should master some type of artistic craft. They will always want to be surrounded by things that are beautiful and lovely to look at. There is a givingness in these people, which asks for nothing in return. They are very compassionate and warm, but should watch their tendency to idealize love.

♀ ⚹ ♆ An *adjustment* is needed in taking a clear, objective look at the people in their life. These individuals are very idealistic and want a lot of emotional support from their loved ones. In return, they willingly serve, help, and assist those they love. They have deep inner feelings of being unworthy to be loved. In former lifetimes, these individuals came to believe that loving others requires great sacrifices and the denial of their own needs. They can learn to overcome their feelings of unworthiness if they will seek spiritual insights and recognize the divine goodness within all of God's creation. Their intense desire to be of service to others will always be one of their finest traits. However, this can lead to spreading themselves into too many directions and can, then, become detrimental to their physical health. They may experience discord over their personal resources (money, possessions, talents, sense of self-worth), with their marriage partner, with other people in cooperative relation-

341

ships, and/or with friends who are in actuality hidden enemies from former lives.

♀ ☊ ♆ An *awareness* should be developed in recognizing that human frailties exist, even in those they love. These individuals become quite defensive if they feel their loved ones are being criticized. This loyalty to others is praiseworthy, but they should learn to recognize constructive advice from criticism. Many times, other people are not criticizing their loved ones, but merely making an observation. Unfortunately, these individuals may themselves be quite critical of their loved ones, to the extent that some of them become chronic naggers. One of the greatest values of this aspect is its ability to transform material values into spiritual values. They will experience losses of personal property in strange, mysterious ways. These events occur in order to teach these individuals that material possessions are easily replaced and that the only thing they can take with them when they leave the earth plane is their spiritual and personal growth. They may experience difficulties over their personal resources (money, possessions, talents, sense of self-worth), with their marriage partner, with other people in cooperative relationships, and/or with friends who are in actuality hidden enemies from former lives.

♀ ♂ ♇ The *power* of this conjunction gives intensity and creative abilities. It would be very easy for these individuals to fall back into previous lifetime habits of self-indulgence and love of pleasure. This is not an easy aspect, since these individuals have to fight their feelings of jealousy and possessiveness and battle with their tendency to become irritable and angry. On the plus side, this aspect indicates these souls have a strong desire to transform their values and physical desires. They may be easily hurt over their personal resources (money, possessions, talents, sense of self-worth), by their marriage partner, by other people in cooperative relationships, and/or by the people in their organizational groups.

♀ N ♇ These individuals feel *restricted* because other people are denying them that which they value (anything they appreciate and enjoy, whether it is physical, emotional, mental, or spiritual). They should look to the houses these planets reside in to determine what past attitudes need revising.

♀ ✳ ♇ There is the *opportunity* for these individuals to transform their values (anything they appreciate and enjoy, whether it is physical, emotional, mental, or spiritual). They are emotionally self-sufficient, with magnetic personalities. They have artistic ability with a desire to create beautiful things.

♀ □ ♇ This *challenge* is one of transforming their values (anything they appreciate and enjoy, whether it is physical, emotional, mental, or spiritual). This aspect indicates these individuals are working out important psychological problems through their relationships with others. Because of this, they will attract to themselves friends who might act destructively toward them. This occurs because others are mirroring the type of destructive acts they themselves have done in former lifetimes. They cannot resolve their karma if they retaliate by being destructive in return. When the lessons are learned, destructive friends will no longer enter their lives. These individuals do not have a very high opinion of themselves because of their inner knowing of having once been destructive toward others in former lives. But they have learned their lessons, or they wouldn't have chosen such a difficult aspect. This aspect indicates a readiness to atone for their karma. They may experience inner distress over their personal resources (money, possessions, talents, sense of self-worth), from their marriage partner, from other people in cooperative relationships, and/or from the people in their organizational groups.

♀ △ ♇ In other lifetimes, these individuals have begun the work of transforming their values (anything they appreciate and enjoy, whether it is physical, emotional, mental, or spir-

itual). They can help other people transform their lives, as long as they don't try to control or dominate them. Like the sextile, these individuals are self-sufficient with magnetic personalities. They have a deep empathy for the problems of others and are always looking for the good in them. There are artistic abilities.

♀ ⊼ ♇ An *adjustment* is needed in learning not to be jealous or possessive of their loved ones. They, also, need to reevaluate their values (anything they appreciate and enjoy, whether it is physical, emotional, mental, or spiritual). Since one cannot take material possessions with them when they leave the earth plane, they should enjoy them but be willing to release them. This aspect attracts difficult relationships in order to teach personal growth. These individuals may experience discord over their personal resources (money, possessions, talents, sense of self-worth), with their marriage partner, with other people in cooperative relationships, and/or with the people in their organization groups.

♀ ☍ ♇ An *awareness* should be developed that their jealous and possessive traits will drive away those they love. Love is like a fragile flower. "Why did the flower fade? I clutched it to my heart in excess of feeling and crushed it." These words of Tagore so beautifully illustrate what can happen if these individuals do not learn to control their jealous possessiveness. They must, also, watch so that they don't attempt to control others or to allow themselves to be controlled. The transformation of one's values (anything you appreciate and enjoy, whether it is physical, emotional, mental, or spiritual) is a painful and difficult process but well worth the price. If this aspect is yours, take courage in the fact that as you learn your lessons, loving steadfast friends will be guided to you. These individuals may experience difficulties over their personal resources (money, possessions, talents, sense of self-worth), with their marriage partner, with other people in cooperative relationships, and/or with the people in their organizational groups.

344

♀ ☌ ⊕ The *power* of this conjunction balances the emotions and the intellect to Venus's vibrations so that these individuals can transform their values (anything they appreciate and enjoy, whether it is physical, emotional, mental, or spiritual).

♀ N ⊕ There is a *restriction* on beginning the work of transforming their values (anything they appreciate and enjoy, whether it is physical, emotional, mental, or spiritual) until these individuals revise past life attitudes regarding the houses these planets reside in.

♀ ✳ ⊕ An *opportunity* to begin the work of transforming their values (anything they appreciate and enjoy, whether it is physical, emotional, mental, or spiritual).

♀ □ ⊕ *Internal conflict* interfering with the transforming of their values (anything they appreciate and enjoy, whether it is physical, emotional, mental, or spiritual).

♀ △ ⊕ In other lifetimes, these individuals transformed their values (anything they appreciated and enjoyed, whether it was physical, emotional, mental, or spiritual). Because of this, they are able to attract material benefits this lifetime.

♀ ⚻ ⊕ An *adjustment* in thinking is needed so that they can begin the work of transforming their values (anything they appreciate and enjoy, whether it is physical, emotional, mental, or spiritual).

♀ ☍ ⊕ An *awareness* should be developed that they need to begin the work of transforming their values (anything they appreciate and enjoy, whether it is physical, emotional, mental, or spiritual).

♀ ♂ ♌ The *power* of this conjunction will attract spiritual teachers to help them transform their values (anything they appreciate and enjoy, whether it is physical, emotional, mental, or spiritual).

♀ N ♌ There is a *restriction* on attracting spiritual teachers to help them transform their values (anything they appreciate and enjoy, whether it is physical, emotional, mental, or spiritual).

♀ ⚹ ♌ There is an *opportunity* for spiritual teachers to enter their lives to help them transform their values (anything they appreciate and enjoy, whether it is physical, emotional, mental, or spiritual).

♀ □ ♌ There is *internal conflict* regarding the need for spiritual teachers to help them transform their values (anything they appreciate and enjoy, whether it is physical, emotional, mental, or spiritual) because of their own problems as a spiritual teacher in a past lifetime.

♀ △ ♌ These individuals will attract spiritual teachers who they have been close to in other lifetimes and who have helped them toward the transformation of their values (anything they appreciate and enjoy, whether it is physical, emotional, mental, or spiritual).

♀ ⚻ ♌ An *adjustment* is needed in thinking regarding spiritual teachers. The fact that spiritual teachers must, also, work to transform their values (anything they appreciate and enjoy, whether it is physical, emotional, mental, or spiritual) does not make them any less capable of assisting others to transform their values.

♀ ☍ ♌ An *awareness* should be developed concerning the need to find a spiritual teacher to assist them in the transformation of their values (anything they appreciate and enjoy,

whether it is physical, emotional, mental, or spiritual).

♀ ☌ ♅ The *power* of this conjunction will attract karmic situations to assist in the transformation of their values (anything they appreciate and enjoy, whether it is physical, emotional, mental, or spiritual).

♀ N ♅ There is a *restriction* on attracting karmic situations to assist in the transformation of their values (anything they appreciate and enjoy, whether it is physical, emotional, mental, or spiritual) because of a need to revise past attitudes concerning the houses these planets reside in.

♀ ✳ ♅ There is an *opportunity* for karmic situations to occur which will help in the transformation of their values (anything they appreciate and enjoy, whether it is physical, emotional, mental, or spiritual).

♀ ☐ ♅ There is *internal conflict* because of the inability to accept karmic situations as teaching experiences to transform their values (anything they appreciate and enjoy, whether it is physical, emotional, mental, or spiritual).

♀ △ ♅ These individuals willingly attract karmic situations which will help them transform their values (anything they appreciate and enjoy, whether it is physical, emotional, mental, or spiritual).

♀ ⊼ ♅ An *adjustment* is needed in thinking as these individuals have difficulty in accepting the necessity of karmic situations occurring for the purpose of transforming their values (anything they appreciate and enjoy, whether it is physical, emotional, mental, or spiritual).

♀ ☒ ♎ An *awareness* should be developed that karmic situations must, and will, occur for the purpose of transforming their values (anything they appreciate and enjoy, whether it is physical, emotional, mental, or spiritual).

ASPECTS TO MARS

♂ ♂ ♃ The *power* of this conjunction gives frankness and directness of speech which may cause them to be tactless at times. These individuals usually have a lot of energy and athletic ability. They have an inborn sense of timing and plan their lives extremely well. This aspect gives spiritual protection, so that any accidents that occur are usually minor. However, these individuals should not take unnecessary risks. They like to try new and different activities, since they enjoy broadening their knowledge. On the negative side, this aspect may create too much pride, with a dislike of being told when they are in error. They, also, want to see injustices corrected immediately with the guilty party punished. It would be well for them to remember that all injustices are eventually called to account, and they should not pass judgment. Jesus said, "Judge not, lest ye be judged."

♂ N ♃ These individuals feel *restricted* in expressing their wants and desires to others, and this may cause them to harbor inner hostility. They should look to the houses these planets are in to see what past attitudes need revising.

♂ ⚹ ♃ There is the *opportunity* for these individuals to take advantage of the many favorable circumstances that occur in their lives. Their abundant energy could make them excellent athletes. They work easily and effortlessly in any endeavor and in their work. They are usually optimistic people with a positive outlook on life. This aspect has been earned from other lifetimes.

348

♂ □ ♃　　This *challenge* is to develop self-control. They can come across as being too forceful or aggressive in their desire to succeed in life. This trait can be brought under control by practicing their sales pitch on cassette tapes and then listening to how they sound. This method would enable them to bring their enthusiasm and aggressiveness into balance. They usually work too fast, so that their work may be sloppy or half-finished. Part of the reason for working too fast is their restlessness, which creates a need to be on the move a lot. They need professional careers where they are allowed to be on the move, such as a salesman. These individuals may suffer inner distress over other people's approaches to life, from their in-laws, and/or in courts of law.

♂ △ ♃　　In other lifetimes, these individuals have begun the work of balancing their abundant physical energy. They love freedom and the outdoors. Most of them have athletic ability, but may not take the time to concentrate on mastering a sport. They are recognized for their integrity, honesty, and generosity. Even when angry, it fades quickly as they have an inborn knowledge that anger is a waste of energy. They are able to do most anything they desire in life, because they have earned this benefit from other lifetimes. Even during difficult times in their lives, they remain optimistic and never stoop to stepping on anyone else's toes to obtain their desires.

♂ ⊼ ♃　　An *adjustment* is needed in learning to handle the abundant physical energy this aspect gives. Too many times, they take excessive risks with the result that accidents happen. They are not unlucky, merely careless. By learning to control their impulsive energy, they can do most anything they want to do. They have great difficulty in sitting still for very long so that any type of physical activity would be extremely beneficial in toning the physical body and in utilizing their excess energy. These individuals may experience discord over other people's approaches to life, with their in-laws, and/or in courts of law.

♂ ⚻ ♃ An *awareness* should be developed that they are not in competition with everyone in the world. They are not being intentionally abrasive, but have a natural competitive nature. However, they will find that they will get along far better with others if they learn to work in cooperative harmony rather than in competition. They have an abundance of physical energy and are, generally, optimistic. There is athletic ability which would be a constructive use of their energy and competitive nature. Like the inconjunct, they should learn to control their energy or accidents will happen. These individuals are apt to be thoughtless, without meaning to cause pain. Forethought will help them to be more considerate of others. They may experience difficulties over other people's approaches to life, with their in-laws, and/or in courts of law.

♂ ♂ ♄ The *power* of this conjunction gives strong self-discipline and reasoning powers. They have an extraordinary capacity to sustain their concentration until their projects are completely finished. Because of their ability for intense concentration, they would make exceptional athletes where skill is based on the ability to concentrate. These individuals are extremely good at detail work. When they are frustrated, they have difficulty in controlling their anger, which can be quite explosive since they hold in their hostilities. They should learn to verbally express their resentments before they become so uncontrollable. If they find it impossible to talk about their resentments, they should write them out and, then, reread them. If their anger vanishes upon rereading the paper, they can destroy it. If not, they should deliver it to whoever has caused the inner frustrations, with the idea of talking about the frustrations when the paper has been read.

♂ N ♄ These individuals feel *restricted* in expressing their inner frustrations to their parents (especially their fathers), to those in their professional career environment, and/or to society in general. They should look to the houses these planets reside in to determine what past attitudes need revising.

350

♂ ⚹ ♄ There is the *opportunity* for these individuals to succeed in life because they have a sense of discipline and are willing to work hard for what they want. They have common sense and good judgment, but must learn not to give up if it takes them longer to accomplish their projects than it does other people. Whatever they do or make will be created for permanence. Because of this, they want to do their work carefully and thoroughly. These individuals suffer from holding in their anger, and this might lead to bitterness and resentments. They should learn to express their reasons for feeling angry to the individuals involved. Communication can always clear misunderstandings.

♂ □ ♄ This *challenge* is to see the beauty in the world that surrounds them. They see it as one of cruelty and hate, with man against man, and brother against brother. Because of this, life seems incredibly hard to them, and they long for freedom from the restraints of a physical body. This is a strong battle that rages inside of them, until they recognize the good within the world's disharmony. Because of it, they need the love and emotional support of their family. Otherwise, they may retreat within themselves until they become completely unreachable. For this reason, they can appear to be aloof, unloving individuals. Since this is not true, these individuals must recognize that they returned to physical life in order to learn many needed lessons. One of these lessons is to appreciate the beauty in God's handiwork. Like the other Mars to Saturn aspects, they hold in their anger. If they do not learn to release their frustrations, this anger will erupt uncontrollably. They, too, would benefit from expressing their resentments to those involved or by writing them down. These individuals may experience inner distress over other people's approaches to life, from the people in their professional environment, from their parents (especially their fathers), and/or from society in general.

♂ △ ♄ In other lifetimes, these individuals have begun the work of balancing their desires (anything they appreciate and enjoy, whether it is physical, mental, emotional, or spiritual) with a sense of responsibility. Anything they do, they

will do to the upmost of their ability with meticulous attention to details. They are willing to work hard to succeed and are able to utilize this aspect's energy for total concentration. Their work reflects their thoroughness and dedication. They are rather reserved people, which can cause them difficulty in letting go to enjoy themselves in social situations. One of their most positive traits is that they do not seek power, but merely want to do any job well.

♂ ⊼ ♄ An *adjustment* is needed in learning what their responsibilities are and when they can follow their own desires and wishes. This conflict can make them irritable and resentful for no particular reason, since it is a battle going on inside themselves. To resolve this, they should make a list of their responsibilities and, when they have fulfilled them, use the rest of their time for their own enjoyment. On the positive side, these individuals have learned to control their anger by utilizing it constructively. These individuals may experience discord over other people's approaches to life, with the people in their professional environment, with their parents (especially their fathers), and/or with society in general.

♂ ☍ ♄ An *awareness* should be developed that they need to determine what their responsibilities are and when they can follow their own desires and wishes. They often feel frustrated, because they assume they have no choice in doing anything they enjoy. This causes anger to build up, making them sarcastic, bitter, and resentful. Like the inconjunct, they should make a list of their true responsibilities and fulfill them. Then, make a list of what they would like to do for fun and relaxation. By compromising, these individuals can release their overactive sense of responsibility. They are fine workers because of their sense of discipline and their careful attention to detail. Whatever they do, they do it well. They may experience difficulties over other people's approaches to life, with the people in their professional environment, with their parents (especially their father), and/or with society in general.

♂ ♂ ♅ The *power* of this conjunction gives great vitality, honesty, persistence, and courage. They are strongly freedom-oriented, which makes it very difficult for them to take instruction from anyone else since they interpret it as an infringement on their freedom. It is essential for these individuals to learn to take instruction and to listen to other people's viewpoints with an open mind, because this develops self-discipline. Discipline keeps the world from being totally chaotic. They are highly intuitive, with psychic healing powers. Their tempers may always cause them problems, but they can learn to discharge their frustrated energy by punching a bag or through individual sporting events, etc. They seem to have a need to shock people which should be stopped. These individuals may experience conflicts over other people's approaches to life, with their friends, and/or with their social groups.

♂ N ♅ These individuals feel *restricted* in finding friends and social groups. They should look to the houses these planets reside in to determine what past attitudes need revising.

♂ ⚹ ♅ There is the *opportunity* for these individuals to overcome the difficulties they experience in life. They are extremely independent people who prefer to learn through their own experiences rather than secondhand by others. Routine work has a tendency to bore them if it must be repeated in the same way over and over again. They like change.

♂ □ ♅ This *challenge* is to learn to think before acting. These individuals are extremely impulsive, which leads to accidents or rash behavior without considering the consequences of their impulsive action. For this reason, they should learn to plan their actions. They will probably find this hard to do since it is extremely difficult for them to sit still for very long, as they become bored so quickly. They are always looking for something exciting to do. They should have several

projects going at one time so that when they are bored with one, they can move to another. Their greatest problem is their difficulty in being told what to do by others. They dislike it so much that they can become extremely negative or rebellious. This is not an easy aspect, by any means, and these individuals should seek professions which will allow them freedom to move around a lot. These individuals may experience inner distress over other people's approaches to life, from their friends, and/or from their social groups.

♂ △ ♅ In other lifetimes, these individuals have begun the work of balancing their impulsive behavior and anger. They have an intuitive awareness which tells them when to stop in the face of resistance. However, if necessary, they will defend themselves. They have personal magnetism and become leaders, not for power, but because their foresight allows them to see how things will work out. They have a desire to make some type of an unusual mark in the world. Their strength of character helps them overcome many difficulties in their lives. They dislike being bored and will always find something to do which interests them. One of their strongest traits is that they know what they want in life and will obtain it through perseverance and hard work.

♂ ⊼ ♅ An *adjustment* is needed in learning to be patient when projects are proceeding slower than they like. This impatience usually makes matters worse. They have difficulties with an explosive temper, especially if they are restricted or limited in any way. Their inborn love of freedom detests restrictions of any type. They should find a constructive outlet for their energy. Any type of physical activity would be good, but they should never work or play when they are angry, since accidents can happen when their mind is occupied with hostility. They should make decisions only after careful thought and never impulsively. They may experience discord over other people's approaches to life, with their friends, and/or with their social groups.

♂ ⚸ ♅ An *awareness* should be developed that these individuals must learn patience. At times, they become very impatient with people. This impatience may cause them to become irritable or even angry. They attract disruptive people to themselves in order to learn how to handle explosive situations. Outwardly, these individuals are quite orderly and conventional. They have the capability of utilizing their Martian energy for unusual creative talents. When angry or upset, these individuals should seek a quiet place to calm and relax their nerves. Unlike the square aspect, these individuals do not suffer from restlessness. But, they, too, should find some outlet for their energy bursts. Since they have a tendency to move impulsively, they are prone to accidents and mishaps. Learning to think before moving would eliminate many accidents. These individuals may experience difficulties over other people's approaches to life, with their friends, and/or with their social groups.

♂ ♂ ♆ The *power* of this conjunction causes restlessness, discouragement, and at times, confusion. These individuals are being forced to accept responsibilities and discipline in this life. There is an urgent need for them to be totally honest with themselves and with others. They have a strong interest in mysticism and an enjoyment of the arts, such as music, dancing, etc. The sea has a strong pull for them, as they are renewed by its vibrations. If these individuals fail to learn the lessons of this conjunction, they will suffer inner distress, since this is a karmic atonement aspect.

♂ N ♆ These individuals feel *restricted* in bringing their desires (anything they appreciate and enjoy, whether it is physical, mental, emotional, or spiritual) and aspirations into reality. They should look to the houses these planets reside in to determine what past attitudes need revising.

♂ ✳ ♆ There is the *opportunity* for these individuals to bring their dreams into reality, for they are practical idealists. They are patient and will wait until the right time to achieve

their desires (anything they appreciate and enjoy, whether it is physical, mental, emotional, or spiritual). There is a love of the sea and a deep appreciation of all forms of artistic expression, such as music, painting, etc.

♂ □ ♆ This *challenge* is to learn to conquer discouragement. Their feelings of discouragement occur when they fail to achieve something they especially desired. These individuals see failure as an indication of their unworthiness to merit rewards or success. To dissipate their feelings of unworthiness, they may resort to placing the blame of their failure upon others until their gossiping even convinces them it is the truth. Eventually, when the real truth is revealed, these individuals suffer greatly, for they have made themselves unbelievable to others. They could save themselves much inner distress if they would recognize that failures are spiritual stumbling blocks which test everyone's courage in picking themselves up again without emotional turmoil. Some desires might be great hindrances to personal and soul growth and should rightly be denied. If these individuals fail to learn the lessons of this square, they will suffer much inner distress with others, since this is a karmic atonement aspect. They may experience distress over other people's approaches to life, and/or from friends who are in actuality hidden enemies from former lives.

♂ △ ♆ In other lifetimes, these individuals have begun the work of learning to be patient and lovingly assertive. They are the practical idealists who bring their dreams into reality. This is an earned aspect from other lifetimes. Because of this, they have spiritual protection from hidden enemies who might seek to overthrow them. They have learned that patience will bring them whatever it is they desire and to this end they work hard. These individuals are extremely compassionate toward people and animals and are always a soft touch for any hard luck story. The sea has a rejuvenating effect on them, and they benefit from its vibrations. There is, also, a strong appreciation of all forms of art, such as music, painting, etc.

♂ ⊼ ♆ An *adjustment* is needed in learning to be lovingly assertive with others. Too often, these individuals feel that they just don't have enough energy to assert themselves and that they wouldn't win anyway. This attitude creates a general aura of discouragement, causing these individuals to feel physically tired. They do need more sleep than others, but if they would learn to express their opinions more often, they wouldn't have these spells of inertia. If a problem seems unsolvable at the moment, they should set it aside for a few days. When they look at it again, they may see a solution. Some form of physical exercise is particularly good for these individuals, so that their vital forces are made to flow quickly through their bodies. If these individuals fail to learn the lessons of this inconjunct, they will suffer inner distress with others, since this is a karmic atonement aspect. They may suffer discord over other people's approaches to life, and/or with friends who are in actuality hidden enemies from former lives.

♂ ☍ ♆ An *awareness* should be developed by these individuals that they do have talents. Because of their lack of self-esteem, they may distort the truth in order to build themselves up in other people's eyes. Because they are afraid to trust their own intelligence, they may have a strong desire to cheat on examinations and/or to take credit for work they have not done. Like the square aspect, they can convince themselves that the work is their idea, that they helped with it, or that they could have thought of it, etc., until they believe it is their right to take credit for the material. When, and if, they are exposed, their mental suffering is so intense, it could lead to a nervous breakdown. These individuals need to learn to trust that each and everyone of us have talents for our especial use, but that we must work hard to master any skill we can be proud of. If these individuals fail to learn the lessons of this opposition, they will suffer inner distress with others, since this is a karmic atonement aspect. They may experience difficulties over other people's approaches to life, and/or with friends who are in actuality hidden enemies from former lives.

357

♂ ♂ ♀ The *power* of this conjunction gives great courage, ambition, responsibility, and a drive to succeed. They are very hard workers who fight to overcome obstacles. If they become leaders, they do so for the sense of power it gives them. But they will never abuse this power because of their integrity and sense of responsibility toward those they serve. They have difficulty in expressing their warmth and affection for others. These individuals have the remarkable ability to accept life as they find it, without wishing everything to be different. If they want it different, they will work to make it different. Because they have such a strong will, they must be careful not to use it to manipulate others.

♂ N ♀ These individuals feel *restricted* because many of their desires (anything they appreciate and enjoy, whether it is physical, emotional, mental, or spiritual) are denied by others. They should look to the houses these planets reside in to determine what past attitudes need revising.

♂ ✶ ♀ There is the *opportunity* for these individuals to use their energy to achieve their goals. They have endurance, persistence, and determination. Sometimes they can become so engrossed in a project that they are unable to quit, even when they are physically tired and exhausted. They need to listen to their physical body and to stop before they are exhausted. They like to be in total control of their life and prefer to be the leader in any situation. Since this is not always possible, they will need to learn to cooperate and compromise.

♂ □ ♀ This *challenge* is to learn to control their energy. They are so dedicated to achieving certain goals in their life that they work unceasingly to achieve it. However, they need to learn when to relax their self-assertive energies. Otherwise, they will totally deplete both their physical and mental energies. When this occurs, these individuals must have rest and quiet in order to replenish their depleted resources. They may come across as too assertive in their relationships, causing others to draw away from them. To overcome this tend-

358

ency, they should listen to themselves on a cassette tape. These individuals usually succeed in life, because they are willing to work hard to achieve their goals. They may experience inner distress over other people's approaches to life and/or from the people in their organizational groups.

♂ △ ♀ In other lifetimes, these individuals have begun the work of learning to cooperate harmoniously with others. They have courage, the desire to achieve something important in their life, and the ability to work long and hard. Their unusual ideas will improve any project they get involved with. These individuals do not care to fight verbally, but will if necessary. Although they control their anger quite well, when they do lose their temper, it is very explosive. They select friends who are independent and self-reliant, because they themselves are independent and self-reliant. One of their finest traits is their compassion for other people, especially those with problems. This compassion is quite remarkable because of their inability to "feel" what it would be like to be in that person's position.

♂ ⚻ ♀ An *adjustment* is needed in learning to compromise with others. Because of their strong will, these individuals usually want their own way. They must learn to listen with an open mind to other people's ideas and suggestions. These ideas and suggestions might even be more enjoyable than their own. A great many changes will occur in their lives in order to bring about personal growth. Since these individuals have courage, they handle these changes quite well. They may experience discord over other people's approaches to life and/or with the people in their organizational groups.

♂ ☍ ♀ An *awareness* should be developed in learning to harmoniously interact with others. These individuals are very intense and ambitious. Because of this, they unknowingly give the impression that they will allow nothing to stand in the way of their obtaining their goals. This may be true of some of these individuals, but the majority of them are merely concentrating all their energies toward achieving

359

the goals they have set for themselves. They must learn to listen to other people's ideas and suggestions with an open mind. In the final analysis, they may still want to use their own methods, but at least they will have given others an opportunity to express themselves. They might even decide to be adventurous enough to try a few of the ideas suggested by others. It would be wise for them to remember that being excessively stubborn can easily turn friends into enemies. They may experience difficulties over other people's approaches to life and/or with the people in their organizational groups.

♂ ♂ ⊕ The *power* of this conjunction balances the emotions and the intellect to Mars's vibrations, so that these individuals can transform their desires (anything they appreciate and enjoy, whether it is physical, emotional, mental, or spiritual).

♂ N ⊕ There is a *restriction* on beginning the work of transforming their desires (anything they appreciate and enjoy, whether it is physical, emotional, mental, or spiritual) until these individuals revise past-life attitudes regarding the houses these planets reside in.

♂ ✳ ⊕ An *opportunity* to begin the work of transforming their desires (anything they appreciate and enjoy, whether it is physical, emotional, mental, or spiritual).

♂ □ ⊕ *Internal conflict* interfering with the transforming of their desires (anything they appreciate and enjoy, whether it is physical, emotional, mental, or spiritual).

♂ △ ⊕ In other lifetimes, these individuals transformed their desires (anything they appreciate and enjoy, whether it is physical, emotional, mental, or spiritual). Because of this, they are able to attract their desires this lifetime.

♂ ⊼ ⊕ An *adjustment* in thinking is needed so that they can begin the work of transforming their desires (anything they appreciate and enjoy, whether it is physical, emotional, mental, or spiritual).

♂ ⚻ ⊕ An *awareness* should be developed that they need to begin the work of transforming their desires (anything they appreciate and enjoy, whether it is physical, emotional, mental, or spiritual).

♂ ♂ ☊ The *power* of this conjunction will attract spiritual teachers to assist in the transformation of their desires (anything they appreciate and enjoy, whether it is physical, emotional, mental, or spiritual).

♂ N ☊ There is a *restriction* on attracting spiritual teachers to assist in the transformation of their desires (anything they appreciate and enjoy, whether it is physical, emotional, mental, or spiritual) because of a need to revise past attitudes concerning the houses these planets reside in.

♂ ✳ ☊ There is an *opportunity* for spiritual teachers to enter their lives to assist in the transformation of their desires (anything they appreciate and enjoy, whether it is physical, emotional, mental, or spiritual).

♂ □ ☊ There is *internal conflict* regarding the need for spiritual teachers to assist in the transformation of their desires (anything they appreciate and enjoy, whether it is physical, emotional, mental, or spiritual) because of their own problems as a spiritual teacher in a past lifetime.

♂ △ ☊ These individuals will attract spiritual teachers who they have been close to in other lifetimes and who have helped them toward the transformation of their desires (any-

361

thing they appreciate and enjoy, whether it is physical emotional, mental, or spiritual).

♂ ⊼ ♌ An *adjustment* is needed in thinking regarding spiritual teachers. The fact that spiritual teachers must, also, work on the transformation of their desires (anything they appreciate and enjoy, whether it is physical, emotional, mental, or spiritual) does not make them any less capable of assisting others in the transformation of their desires.

♂ ⚻ ♌ An *awareness* should be developed concerning the need to find a spiritual teacher to assist them in the transformation of their desires (anything they appreciate and enjoy, whether it is physical, emotional, mental or spiritual).

♂ ♂ ☋ The *power* of this conjunction will attract karmic situations to assist in the transformation of their desires (anything they appreciate and enjoy, whether it is physical, emotional, mental, or spiritual).

♂ N ☋ There is a *restriction* on attracting karmic situations to assist in the transformation of their desires (anything they appreciate and enjoy, whether it is physical, emotional, mental, or spiritual) because of a need to revise past attitudes concerning the houses these planets reside in.

♂ ✳ ☋ There is an *opportunity* for karmic situations to occur which will help in the transformation of their desires (anything they appreciate and enjoy, whether it is physical, emotional, mental, or spiritual).

♂ □ ☋ There is *internal conflict* because of the inability to accept karmic situations as teaching experiences for the transformation of their desires (anything they appreciate and enjoy, whether it is physical, emotional, mental, or spiritual).

♂ △ ♑ These individuals willingly attract karmic situations which will help them transform their desires (anything they appreciate and enjoy, whether it is physical, emotional, mental, or spiritual).

♂ ⊼ ♑ An *adjustment* is needed in thinking, for these individuals have difficulty in accepting the necessity of karmic situations occurring for the purpose of transforming their desires (anything they appreciate and enjoy, whether it is physical, emotional, mental, or spiritual).

♂ ☍ ♑ An *awareness* should be developed that karmic situations must, and will, occur for the purpose of transforming their desires (anything they appreciate and enjoy, whether it is physical, emotional, mental, or spiritual).

ASPECTS TO JUPITER

♃ ♂ ♄ The *power* of this conjunction urges these individuals to be disciplined, systematic, and thorough. They are able to stick to a job for long periods of time, keeping track of many details at the same time. These individuals like their lives to be structured and regulated. They have certain goals in mind which they always finish and, then, move on to other goals. Since they dislike quarreling, they try to ignore the situation. Any type of conflict makes them restless and irritable. If the confrontations continue, it becomes such a burden to them that they have to leave the scene. Since confrontations can not always be avoided and leaving the scene may not help, they should practice being lovingly assertive. This technique requires no verbal combativeness, but would enable them to release their distress.

♃ N ♄ These individuals feel *restricted* in obtaining enthusiastic approval from their in-laws, from those in their professional career environment, society in general, and/or from their parents (especially their fathers). They should look to the house these planets reside in to determine what past attitudes need revising.

363

♃ ⚹ ♄ There is the *opportunity* for these individuals to achieve any objective they wish through patience, persistence, and a willingness to work hard. They have a good balance between idealism and practicality, giving them the ability to make changes which are usually successful. They are good organizers with a strong sense of duty and responsibility. Usually, they prefer to work alone because of their self-motivation, but they are very capable of working with other individuals as well.

♃ □ ♄ This *challenge* is to learn to stick to one objective at a time until they have completed it. They are mentally restless individuals who like to be continually moving from place to place, changing jobs and careers, but not always accomplishing anything. Since they have so many skills and abilities, they should learn to discipline themselves to finish whatever they start. Their greatest difficulty is that they expect too much of themselves, which makes it impossible for them to accomplish their high goals. They have to learn to accept their limitations and to stop searching for the pot of gold at the end of the rainbow. They may experience inner distress from their in-laws, in courts of law, from those in their professional career environment, from their parents (especially their fathers), and/or from society in general.

♃ △ ♄ In other lifetimes, these individuals have begun the work of balancing idealism and practicality. They have a remarkable ability to see a situation as a whole and in detail. They are excellent executives and in any type of decision-making positions. Their desire to accomplish something significant in the world will undoubtedly come to fruition because of their innovativeness, determination, and perseverance. They will stick to any task, no matter how long it takes to accomplish, since they feel the results are well worth the effort.

♃ ⊼ ♄ An *adjustment* is needed in learning to discipline themselves because of their contradictory feelings. It is difficult for these individuals to feel calm, since they experience great

restlessness inside. They have a tendency to blame their hemmed-in feelings on the people around them, when in reality it is coming from inside themselves. The best way for these individuals to handle this problem would be to write out an evaluation of the situation that is bothering them. This process would pinpoint the source of conflict and allow them to make sound decisions. They may experience discord with their in-laws, in courts of law, with those in their professional career environment, with their parents (especially their fathers), and/or with society in general.

♃ �puͅ ♄ An *awareness* should be developed that they must be more patient with themselves, because they have established too high a standard for themselves. They are simply unable to live up to what they expect of themselves, so that if they feel what they are doing isn't good enough, they want to drop it and move on to something else. This could result in continually moving from place to place, changing jobs and careers, but never really advancing themselves to what they had hoped to achieve in life. This causes their lives to become ones of many reversals, with having to learn the same lessons over and over again. Because of their intense restlessness within, these individuals would be wise to keep several projects going at the same time so that they can move from one to another when they get bored. But, most of all, they absolutely must learn to accept themselves as they are. These individuals may experience difficulties with their in-laws, in courts of law, with those in their professional career environment, with their parents (especially their fathers), and/or with society in general.

♃ ☌ ♅ The *power* of this conjunction gives judgment, intuition, and a quick mind. These individuals could be quite inventive with their strong creative powers. Their minds are like sponges, absorbing new knowledge and experiences. They have a great need to feel free. They are very tolerant of other people's viewpoints. These individuals should travel, if possible, because of their love of freedom and their insatiable desire for new experiences and knowledge.

365

♃ N ♅ These individuals feel *restricted* in receiving enthusiastic approval for their innovative ideas and concepts. They should look to the houses these planets reside in to determine what past attitudes need revising.

♃ ⚹ ♅ There is the *opportunity* for these individuals to have an unusual life if they want to take advantage of it. These individuals are optimists with a pleasing personality. They like to be around interesting people and have lots of change and activity in their life. Routine or repetitive jobs are extremely boring to them, and if they are forced to do them, they become very discouraged. For this reason, they should find jobs that allow them the freedom to move around, without the necessity of detail work. These individuals find that money has a way of materializing in unusual ways just when it is needed the most. This is a spiritual-blessing aspect earned in other lifetimes.

♃ □ ♅ This *challenge* is to learn to be tolerant of other people, not only of other viewpoints, but, also, toward slower-thinking individuals. These individuals have very keen minds with fast reflexes, which not everyone is blessed with this lifetime. Thus, it is important for them to learn to be patient with the slower learners, for the slower learners eventually learn also. Time is never that important. These individuals can, also, get carried away with new ideas and concepts which they want everyone to believe in immediately. If others do not see the value in these new ideas, they should drop the subject. There is no reason to become upset over an idea. Since these individuals reserve the right to think as they please, they must grant others the same right. They may experience inner distress from in-laws, in courts of law, from friends, and/or from social groups.

♃ △ ♅ In other lifetimes, these individuals have begun the work of learning tolerance and of seeking new philosophic concepts. They will have an unusual life, because this is a spiritual-blessing aspect, indicating these individuals have merited this aspect from other lifetimes. They have a mag-

netic personality and deep philosophic beliefs. Even though their own philosophic beliefs are strong, they are exceptionally tolerant of other people's viewpoints. They enjoy new experiences, new places, and new ideas. Their desire for new ideas causes them to continually question the whys of different situations. They are attracted to interesting and optimistic people, because that type of person makes them feel more alive. With their keen judgment, success is assured by middle life.

4 木 甾 An *adjustment* is needed in learning when to work alone and when to work with others. When these individuals only work with others, they soon begin to feel oppressed, until they want to leave the group. On the other hand, when they work alone, they feel lonely. They must learn to evaluate how much time they can devote to working with people without becoming oppressed. Then, they should adjust their lives accordingly. These individuals may experience discord with in-laws, in courts of law, with friends, and/or with social groups.

4 8 甾 An *awareness* should be developed in not becoming too rigid or self righteous about their goals or philosophies and trying to force others to believe them also. These individuals would have started early in life to seek a philosophy which could be meaningful to them. When, and if, they find it, they enthusiastically want everyone to share their philosophy. However, everyone is just as entitled to find their own philosophy. This doesn't mean that they can't talk about what is meaningful to them, but, merely, that they have to respect other people's rights to seek their own path. These individuals are independent, with strong willpower, and great determination. These characteristics are of immeasurable help to them in succeeding in life. They may experience difficulties with in-laws, in courts of law, with friends, and/or with social groups.

♃ ☌ ♆　　The *power* of this conjunction indicates an idealist who is a bit of a dreamer. They are optimistic and, generally, remain cheerful, even in the face of adversity. Unfortunately, this beautiful trait can become negative, because it may blind them to the reality of life. Too many times, they delude themselves that a situation is absolutely marvelous, when in truth it is not. These individuals are generous, sympathetic, and loving. They may have a strong mystical streak and will always be closely connected with spirituality and religion.

♃ N ♆　　These individuals feel *restricted* in receiving enthusiastic approval for their spiritual insights. They should look to the houses these planets reside in to determine what past attitudes need revising.

♃ ⚹ ♆　　There is an *opportunity* for these individuals to use the creative sensitivity of Neptune's vibrations through an art form, such as music, painting, writing, etc. However, they will have to work at mastering the skill, since it is not **automatically given to them. These individuals are intuitive and should follow their inner feelings.**

♃ □ ♆　　This *challenge* is to learn to be realistic about people and their faults. These individuals are apt to view some people through rose-colored glasses and others through jaundiced eyes. If they place people on pedestals, and if they fall off, these individuals are disillusioned, not only with the idolized individual, but with the world. In time, they may overcome their disillusionment. People are a blend of both good and bad characteristics. Accepting this as inevitable, these individuals will no longer be distressed or disappointed. These individuals may suffer inner distress from in-laws, in courts of law, and/or from friends who are in actuality hidden enemies from former lives.

♃ △ ♆　　In other lifetimes, these individuals have worked toward accepting people and the world as they are. They recognize the faults of the world and are willing to help put it

right. They have artistic talents which can be used if they so desire. However, many of them are more interested in helping other people in some manner and will pursue that career instead. These individuals are quite interested in philosophic concepts.

♃ ⚼ ♆ An *adjustment* is needed in learning to accept the world as it is and not how they wish it to be. These individuals waste too much time daydreaming about how they would like the world to be and could easily seek to escape the ills of the world through drugs, alcohol, etc. They would be so much better off preparing themselves through study and knowledge, so that they could physically help correct the problems of the world. These individuals may experience discord with in-laws, in courts of law, and/or with friends who are in actuality hidden enemies from former lives.

♃ ☍ ♆ An *awareness* should be developed in learning to accept people and the world as they are and not how they wish them to be. They have high ideals. By accepting life and people as they are, these individuals could release their disappointments and disillusionments they suffer over human failings. If they would use Jupiter's optimism, tempered with realism, this aspect would cease to distress them. They may suffer difficulties with in-laws, in courts of law, and/or with friends who are in actuality hidden enemies from former lives.

♃ ☌ ⚷ The *power* of this conjunction gives sensitivity, great popularity, and leadership ability. These individuals have a strong drive to achieve something of significance in the world and to learn as much knowledge as possible. Their desire to be in a position of power stems from their need to see positive, creative changes in the world. These individuals should learn to listen to other people's viewpoints with an open mind and to learn to take instructions from others without resentment.

♃ N ♀ These individuals feel *restricted* in receiving enthusiastic approval from others for their ideas and concepts. They should look to the houses these planets reside in to determine what past attitudes need revising.

♃ ✳ ♀ There is an *opportunity* for these individuals to become leaders. They have a strong code of ethics and morality and are excellent at coordinating group activities. These individuals serve as catalysts who improve the conditions of any group they become involved in. However, they must remember to be tolerant of human faults and to maintain their humility.

♃ □ ♀ This *challenge* is to learn humility, patience, and tolerance. If they succeed, they will achieve great success in their life and have an excellent chance of becoming a leader in some way. These individuals have a strong will to succeed in their chosen field. Unfortunately, some of them want to have power over people for ego gratification. They should remember that a true leader serves their people rather than the people serving the leader. If these individuals will remember this, there will be no problem. Some of these individuals adopt rather fanatical religious ideas. The most important lesson of this aspect is to keep an open mind to all viewpoints and philosophies. These individuals may suffer inner distress from in-laws, in courts of law, and/or from people in their organizational groups.

♃ △ ♀ In other lifetimes, these individuals have begun the work of learning humility and respect for other people's viewpoints. There is an inborn sense of right and wrong, giving them the temperament of a reformer. However, they are more than willing to accomplish their reforms through the laws of society. These individuals have very high standards for themselves and are willing to work all their life to help, not only themselves, but others reach high goals. Because of this, their personality is continually changing for the better throughout their life. They have charm and penetrating insight. They are, also, generous and understand-

370

ing with a genuine empathy for the problems of others. This, coupled with their ability to overcome obstacles in their own life, make them a chosen leader in groups and organizations to which they belong. Their interest in metaphysics may eventually lead them to become leaders of spiritual groups.

♃ ⊼ ♀ An *adjustment* is needed in utilizing their creative power in helping themselves and others to achieve goals. Since these individuals have a natural talent for influencing others, they must not misuse this talent. If they utilize their creative power for selfish reasons, they will bring about their own downfall. These individuals may suffer discord with in-laws, in courts of law, and/or with people in their organizational groups.

♃ ⚹ ♀ An *awareness* should be developed in respecting other people's viewpoints and in learning humility. If these individuals can learn these characteristics, they will be able to obtain great success and achievement. They have good intuitive powers which may cause them to think that they are always right. Sometimes what one thinks of as an intuitive flash from one's inner wisdom is merely the conscious mind's analytical insight. Thus, these individuals should be open to other suggestions and to read extensively. Even then, it is far better to tell others that, "This is what I have come to believe, but it may not be so!" These individuals may suffer difficulties with in-laws, in courts of law, and/or with the people in their organizational groups.

♃ ♂ ⊕ The *power* of this conjunction balances the emotions and the intellect to Jupiter's vibrations, so that these individuals can receive spiritual insights.

♃ N ⊕ This is a *restriction* on receiving spiritual insights until these individuals revise past-life attitudes regarding the houses these planets reside in.

371

♃ ⚹ ⊕ An *opportunity* to receive spiritual insights.

♃ □ ⊕ *Internal conflict* interfering with the receiving of spiritual insights.

♃ △ ⊕ In other lifetimes, these individuals received spiritual insights and will continue to attract experiences which will assist in receiving further spiritual insights.

♃ ⊼ ⊕ An *adjustment* in thinking is needed so that they can begin to receive spiritual insights.

♃ ⚷ ⊕ An *awareness* should be developed that they need to begin to search for spiritual insights.

♃ ☌ ♌ The *power* of this conjunction will attract spiritual teachers who can teach them spiritual insights.

♃ N ♌ There is a *restriction* on attracting spiritual teachers who could teach them spiritual insights, because of the need to revise past attitudes concerning the houses these planets reside in.

♃ ⚹ ♌ There is an *opportunity* for spiritual teachers to enter their lives who can teach them spiritual insights.

♃ □ ♌ There is *internal conflict* regarding the need for spiritual teachers to teach them spiritual insights, because of their own problems as a spiritual teacher in a past lifetime.

♃ △ ♌ These individuals will attract spiritual teachers who they have been close to in other lifetimes and who have taught them spiritual insights.

♃ ⚲ ♌ An *adjustment* is needed in thinking regarding spiritual teachers. The fact that spiritual teachers must, also, work to receive spiritual insights does not make them any less capable of teaching spiritual insights.

♃ ⚹ ♌ An *awareness* should be developed concerning the need to find spiritual teachers to teach them spiritual insights.

♃ ☌ ♑ The *power* of this conjunction will attract karmic situations which will teach them spiritual insights.

♃ N ♑ There is a *restriction* on attracting karmic situations to teach them spiritual insights, because of a need to revise past attitudes concerning the houses these planets reside in.

♃ ⚹ ♑ There is an *opportunity* for karmic situations to occur which would teach them spiritual insights.

♃ □ ♑ There is *internal conflict* because of the inability to accept karmic situations as teaching experiences which occur for the purpose of teaching spiritual insights.

♃ △ ♑ These individuals willingly attract karmic situations which will help teach them spiritual insights.

♃ ⚲ ♑ An *adjustment* is needed in thinking, as these individuals have difficulty in accepting the necessity for karmic situations occurring for the purpose of teaching them spiritual insights.

♃ ⚹ ♑ An *awareness* should be developed that karmic situations must, and will, occur for the purpose of teaching spiritual insights.

♄ ☌ ♅ The *power* of this conjunction causes internal tension, creating alertness and restlessness. The alertness helps them to remain calm and systematic, even when faced with major changes or extreme difficulties. This orderliness and attention to details, also, aids them in other endeavors. On the other hand, their restlessness can become so burdensome that they may act impulsively, such as quitting their jobs, breaking away from a relationship, or by unexpected emotional outbursts. However, external things have very little to do with the cause of their tension. Their tension comes from holding in their emotions, until these emotions reach unbearable levels. These individuals should learn to release their pent-up tension through some form of physical activity, such as swimming, running, or tennis. Meditation would be another effective method of releasing this tension.

♄ N ♅ These individuals feel *restricted* in being able to successfully complete any of their innovative ideas and concepts. They should look to the houses these planets reside in to determine what past attitudes need revising.

♄ ✳ ♅ There is an *opportunity* for these individuals to successfully complete difficult tasks because of their persistence and endurance. They are idealistic and practical, giving them exceptional traits to be excellent teachers. They will experience difficulties in their lives, but are able to handle them well. This is due to the fact that difficulties give them a chance to demonstrate their ability to persevere when the situations are challenging.

♄ □ ♅ This *challenge* is to learn how to relax and release their tensions gradually, rather than allowing the tensions to build up to the point that the tensions burst from them in an uncontrollable form. Their bursts of anger are one of the methods used to release their inner tension. This tension comes from wanting to do one thing when they are supposed to be doing something else. The sooner they willingly do the

required tasks, the sooner they will be free to pursue what they really want to do. These individuals may experience inner distress from those in their professional career environment, from society in general, from their parents (especially their fathers), from their friends, and/or from their social groups.

♄ △ ♒ In other lifetimes, these individuals have begun the work of balancing their need for personal freedom and their sense of responsibility. They willingly fulfill their duties and responsibilities. Their organizational ability and their complete attention to detail allows them to do very demanding work. They want to learn everything thoroughly, so will spend considerable amount of time mastering any knowledge or skill they are interested in. For this reason, they make excellent teachers. However, their ability to endure considerable tension may cause them to overtax their physical bodies, resulting in unusual problems or injuries.

♄ ⊼ ♒ An *adjustment* is needed in learning to relax the inner tension in their bodies, caused by their desire to be a responsible person and their desire to be free. This tension can sometimes be seen visually by their nervousness or in the tensing and relaxing of their muscles. In itself, this aspect can be beneficial, for it gives patience and persistence and the drive to accomplish any tasks started. They would benefit by analyzing their life and determining how many responsibilities are rightfully theirs and how many are not. By eliminating the tasks which belong to others, they will have more time to do what they want to do. By being able to have more freedom, they will be able to release much of their inner tension. They would, also, benefit from physical activities and/or meditation. They may experience discord with those in their professional career environment, with society in general, with their parents (especially their fathers), with their friends, and/or with their social groups.

♄ ☍ ♅ An *awareness* should be developed that their desire to be responsible and to be free is creating great inner tension. These individuals have difficulties in working in cooperative relationships, because sooner or later, they become frustrated. Some of their frustration comes from their need to do what other people want them to do, as opposed to their own desires. This in itself should not cause frustration, but eventually these individuals may unexpectedly flare up for no apparent reason. To overcome these flare-ups, these individuals should examine each personal relationship to decide what it is about the other person that is causing them to become so irritated or frustrated. The answer might be something as simple as, "He cracks his knuckles." By seeking the answer, they can, then, overlook the character trait or talk about it with the individual involved. This is a constructive method of releasing their inner tension in cooperative relationships and will help others to understand them better. They may experience difficulties with those in their professional career environment, with society in general, with their parents (especially their fathers), and/or with their social groups.

♄ ☌ ♆ The *power* of this conjunction causes insecurity and a tendency toward depression. These individuals have to learn to trust in people and the world again. In a previous lifetime, they suffered cruelty from others and now have a strong tendency to want to withdraw from society. They have an immense capacity to sacrifice themselves for others.

♄ N ♆ These individuals feel *restricted* in becoming successful in society's eyes. They should look to the houses these planets reside in to determine what past attitudes need revising.

♄ ⚹ ♆ There is an *opportunity* for these individuals to achieve a high spiritual purpose in this life. Their own needs are readily set aside to assist anyone they trust. They work hard to obtain their own hopes and ideals. Their greatest asset is their capacity to detach from emotionally charged situa-

tions and to accept whatever must be. The mind is a blend of practicality and idealism.

♄ □ ♆ This *challenge* is to seek spirituality rather than the achievement of material success in society. Their feelings of loneliness and uncertainty will not be appeased, even if they are at the top of the ladder of material success. This is a karmic-atonement aspect, indicating the misuse of leadership powers in a former lifetime when they had very little compassion or understanding. This does not mean that these individuals lack compassion and understanding this lifetime, but merely indicates why they should seek spiritual riches rather than material riches. They may experience inner distress from those in their professional career environment, from society in general, from their parents (especially their fathers), and/or from friends who are in actuality hidden enemies from former lives.

♄ △ ♆ In other lifetimes, these individuals have sought spiritual insights and will continue to seek a high spiritual destiny this life. They are the practical dreamers who can bring their dreams to reality. These individuals are capable of considerable self-sacrifice when necessary and can make do with very little in their lives in order to eventually obtain their goals and ideals. They work hard to achieve these goals and ideals. These individuals have spiritual protection from the higher realms, which has been earned in other lifetimes. Like the sextile, they have the capacity to detach from emotionally charged situations and accept whatever must be.

♄ ⊼ ♆ An *adjustment* needs to be made in confronting their feelings of unworthiness. These individuals are very creative, hard workers. However, they are never satisfied with their efforts, because they feel they have nothing of value to contribute to society or the world. Unfortunately, it isn't their destiny with this aspect to make an indelible mark upon the world this lifetime. But they must remember that absolutely anything that is done for the well-being and hap-

377

piness of another person is good. They may experience discord with those in their professional career environment, with society in general, with their parents (especially their fathers), and/or with friends who are in actuality hidden enemies from former lives.

♄ ☍ ♆ An *awareness* should be developed that they must learn to trust people again. These individuals have an inborn fear from another lifetime where they were forced to lose their material possessions and standing in the community by someone they trusted. Their lesson this lifetime is to recognize the unimportance of amassing large amounts of material possessions and, instead, concentrate their energies toward spiritual pursuits. It is important for them to remember that material possessions must always be left behind when we cross over. They should learn to enjoy and appreciate their material possessions and their achievements in society, but be willing to release them tomorrow. These individuals may experience difficulties with those in their professional career environment, with society in general, with their parents (especially their fathers), and/or with friends who are in actuality hidden enemies from former lives.

♄ ☌ ♀ The *power* of this conjunction indicates individuals who are capable of self-discipline and self-denial. They have a tendency to view life seriously, causing them to occasionally become depressed. These individuals are tenacious and work hard for what they want in life. However, their tenacity can sometimes be a detriment, because it gives them an intense dislike of any changes in their life. They need to learn to accept change as a teaching experience. If they do meet with failure or defeat, they must avoid becoming bitter. These defeats are spiritual aids in helping them to learn to flow with all experiences and, thus, accept changes in their lives.

♄ N ♀ These individuals feel *restricted* in being chosen to be a leader. They should look to the houses these planets reside in to determine what past attitudes need revising.

378

♄ ⚹ ♆ There is an *opportunity* for these individuals to achieve personal growth because of the many changes that will occur in their lives. They have self-discipline and the ability to endure difficult times. These individuals recognize and appreciate the hard work that others have to do in order to accomplish even the smallest tasks. Because of this, they genuinely admire the efforts of other people.

♄ □ ♆ This *challenge* is to learn to be flexible. These individuals do not like any type of changes in their life and will resist quite strongly. Because of their desire to be in positions of authority, they will be tested many times with seemingly insurmountable obstacles. These challenges are to teach them to flow easily with changes and to learn humility. They are generally quite interested in metaphysics, which could assist them if they would use the knowledge to help transform any negative traits in their personality, as reflected by the zodiac sign the moon is in. This particular aspect causes enough emotional turmoil so that the individual will want to find answers about life. These individuals may experience inner distress from those in their professional career environment, from society in general, from their parents (especially their fathers), and/or from people who belong to their organizational groups.

♄ △ ♆ In other lifetimes, these individuals have begun the work of learning to control their thoughts and emotions, so that they are very seldom carried away by emotional extremes. They have great ability to discipline themselves and make exceptional leaders because of their total honesty, common sense, keen judgment, and reliability. In emergencies, they instantaneously react and assume a quiet leadership. There will be many changes in their lives, but these changes will cause inner strengthening and maturity. Whatever they receive, they feel it must be earned. For this reason, they will slowly climb the ladder of success through hard work and patience. They occasionally like to be alone, because interacting with others confuses them. It is not easy to teach these individuals, for they much prefer to learn from their own experiences rather than secondhand.

♄ ⊼ ♀️ An *adjustment* is needed in learning to adapt to the changes that inevitably take place in their lives. They suffer from inner tension, especially in their muscles, which is a sign of their reluctance to "let go" and flow with the changes that come to them. These individuals have self-discipline and can handle great adversity. They may experience discord with those in their professional career environment, with society in general, with their parents (especially their fathers), and/or with people who belong to their organizational groups.

♄ ⚷ ♀️ An *awareness* should be developed that they need to learn to cooperate with others in peace and understanding. This is a karmic-atonement aspect, but it can be a stepping stone to great personal and soul growth. These individuals have been too domineering in former lifetimes and now must learn to listen to other people's viewpoints with an open mind. Their entire lives will be ones of continually compromising with others, which will require humility, patience, and hard work. These individuals may experience difficulties with those in their professional career environment, with society in general, with their parents (especially their fathers), and/or with people who belong to their organizational groups.

♄ ♂ ⊕ The *power* of this conjunction balances the emotions and intellect to Saturn's vibrations, so that these individuals can learn humility.

♄ N ⊕ There is a *restriction* on learning humility until important lessons are learned regarding the houses these planets reside in.

♄ ✳ ⊕ An *opportunity* to learn humility.

♄ □ ⊕ *Internal conflict* interfering in learning humility.

♄ △ ⊕ In other lifetimes, these individuals attracted experiences which taught them humility and, in this lifetime, they will continue to attract experiences which will teach them humility.

♄ ⊼ ⊕ An *adjustment* in thinking is needed so that they can begin the work of learning true humility.

♄ 8 ⊕ An *awareness* should be developed that they need to begin the work of learning true humility.

♄ ♂ ♌ The *power* of this conjunction will attract spiritual teachers who can help them understand and learn true humility.

♄ N ♌ There is a *restriction* on attracting spiritual teachers who could help them learn true humility, because of the need to revise past attitudes concerning the houses these planets reside in.

♄ ✳ ♌ There is an *opportunity* for spiritual teachers to enter their lives who can help them learn true humility.

♄ □ ♌ There is *internal conflict* regarding the need for spiritual teachers to help them learn true humility, because of their own problems as a spiritual teacher in a past lifetime.

♄ △ ♌ These individuals will attract spiritual teachers who they have been close to in other lifetimes and who have helped them to understand and learn true humility.

♄ ⊼ ♌ An *adjustment* is needed in thinking regarding spiritual teachers. The fact that spiritual teachers must also learn

true humility does not make them any less capable of assisting others to learn true humility.

♄ ☊ ♌ An *awareness* should be developed concerning the need to find spiritual teachers to help them learn true humility.

♄ ☌ ☊ The *power* of this conjunction will attract karmic situations which will teach them true humility.

♄ N ☊ There is a *restriction* on attracting karmic situations which would teach them true humility until important lessons are learned regarding the houses these planets reside in.

♄ ✳ ☊ There is an *opportunity* for karmic situations to occur which would teach them true humility.

♄ □ ☊ There is *internal conflict* because of the inability to accept karmic situations as teaching experiences which occur for the purpose of teaching humility.

♄ △ ☊ These individuals willingly attract karmic situations which will help them learn true humility.

♄ ⚼ ☊ An *adjustment* is needed in thinking, as these individuals have difficulty in accepting the need for karmic situations occurring for the purpose of learning true humility.

♄ ☍ ☊ An *awareness* should be developed that karmic situations will, and must, occur for the purpose of teaching true humility.

ASPECTS TO URANUS

♅ ☌ ♆ (A conjunction between Uranus and Neptune occurs approximately every 171 years. The next conjunction will be around 1993.) The *power* of this conjunction will give these individuals spiritual mysticism and strong intuitive awareness, which existed on the continent of Mu and the innovative scientific abilities which existed on the continent of Atlantis. Since earth will have gone through a purification by the time this conjunction occurs, only spiritually advanced souls will be incarnating on earth. Other souls will incarnate on other three-dimensional planets in distant galaxies.

♅ N ♆ These individuals feel *restricted* in receiving intuitive insights from their inner wisdom. They should look to the houses these planets reside in to determine what past attitudes need revising.

♅ ⚹ ♆ There is the *opportunity* for these individuals to elevate their consciousness through spiritual aspirations. They are idealistic and enjoy learning and hearing about all types of philosophies. These individuals are very intuitive, with psychic potential.

♅ □ ♆ This *challenge* is to have an open mind to all new ideas and concepts concerning different religions and philosophies. They prefer philosophies that have some degree of structure and that are acceptable by society. These individuals are intuitive, with psychic potential. The emotional turmoil they experience with this aspect may lead them to seek relief through bizarre religous concepts, black magic, drugs, and/or alcohol. They would be far wiser to seek emotional release in creative outlets, such as music, art, painting. These individuals may suffer inner distress from friends, from social groups, and/or from friends who are in actuality hidden enemies from former lives.

♅ △ ♆ In other lifetimes, these individuals have worked toward tapping their unconscious minds and elevating their consciousness. Because of this, they are idealistic, with a desire to alter the materialistic concepts they see in the world. They are extremely tolerant of other people's philosophies. These individuals are very intuitive with psychic potential.

♅ ⊼ ♆ An *adjustment* is needed in thinking, for these individuals have a need to study other religions and philosophies before condemning them. Since there is already inner confusion about what they believe to be spiritual truth, they should be more willing to learn about other different philosophies so that they can find a spiritual path that feels right to them. This aspect gives intuitive awareness and psychic potential. They may experience discord with friends, with social groups, and/or with friends who are in actuality hidden enemies from former lives.

♅ ☍ ♆ An *awareness* should be developed that there is a need to study many different philosophies. It is too easy for these individuals to feel that they have all the truth and to stop at that level. Since spiritual growth is never ending, these individuals must continue studying and learning. They could very easily become religious fanatics with a desire to convert the entire world to their beliefs. How sad if their beliefs are only half complete. This aspect gives intuitive awareness and psychic potential. Like the square aspect, these individuals suffer from emotional intensity and need to seek a creative release, such as music, art, dancing. Otherwise, they may try to find emotional release through bizarre religious concepts, black magic, drugs, and/or alcohol. They may experience difficulties with friends, with social groups, and/or with friends who are in actuality hidden enemies from former lives.

♅ ☌ ♀ The *power* of this conjunction gives a strong desire to change outdated social structures. These individuals are eager, but restless. Some of them will undoubtedly misuse

this energy to becoming ruthless in their desire to change society. But, many others will wait patiently and work within society's structures to bring about reform, because they have learned in other lifetimes to value all forms of life. In some manner, these souls will make an imprint upon society.

⛢ ⚹ ♇ These individuals feel *restricted* in rectifying the injustices in the world. They should look to the houses these planets reside in to determine what past attitudes need revising.

⛢ ⚹ ♇ There is an *opportunity* for these individuals to be creatively innovative. They experience many changes in their lives, but accept them as part of human living. These individuals could be effective revolutionaries, but it is not in them to be violent or disruptive.

⛢ □ ♇ This *challenge* is one of learning to be independent. They have an intuitive awareness of their need to stand alone, but this causes them much inner distress because of their emotional need to lean on those they love. These individuals will experience considerable change and upheavals in their lives which makes them feel uneasy and insecure. They may experience inner distress from friends, from social groups and/or from the people in their organizational groups.

⛢ △ ♇ In other lifetimes, these individuals have begun the work of learning to be independent and to be tolerant of other people's viewpoints. They have a great capacity to withstand crises. This strength comes from the deeper levels of their minds, which they have tapped in other lifetimes. They have a profound interest in the mysteries of life and have the ability to solve seemingly unsolvable problems. Their latent clairvoyant abilities can be developed if they wish.

♅ ⊼ ♀ An *adjustment* is needed in learning to see and appreciate other people's viewpoints. They have a very strong need for stability in some form. Because of the many changes that are happening in the world around them, they cling to their ideas and beliefs as a form of stability. They may experience discord with their friends, with their social groups, and/or with the people in their organizational groups.

♅ ☍ ♀ An *awareness* should be developed that there is a need for these individuals to see and appreciate other people's viewpoints. They have an intellectual approach to life and, yet, are curious to know what lies beneath their conscious mind. They would benefit greatly from seeking knowledge concerning the mystery of the inner mind. They may experience difficulties with friends, with social groups, and/or with people in their organizational groups.

♅ ♂ ⊕ The *power* of this conjunction balances the emotions and intellect to Uranus's vibrations, so that these individuals can learn to tap their unconscious minds.

♅ N ⊕ There is a *restriction* on learning to tap their unconscious mind until these individuals revise past-life attitudes regarding the houses these planets reside in.

♅ ✶ ⊕ An *opportunity* to learn to tap their unconscious mind.

♅ □ ⊕ *Internal conflict* interfering with tapping their unconscious minds.

♅ △ ⊕ In other lifetimes, these individuals were able to tap their unconscious minds and have the ability to easily learn to tap it this lifetime.

♅ ⼊ ⊕ An *adjustment* in thinking is needed so that they can begin to learn to tap their unconscious minds.

♅ ⚻ ⊕ An *awareness* should be developed that they need to learn to tap their unconscious minds.

♅ ♂ ☊ The *power* of this conjunction will attract spiritual teachers who can teach them to tap their unconscious minds.

♅ N ☊ There is a *restriction* on attracting spiritual teachers who could teach them to tap their unconscious minds because of the need to revise past attitudes concerning the houses these planets reside in.

♅ ✱ ☊ There is an *opportunity* for spiritual teachers to enter their lives who can teach them to tap their unconscious minds.

♅ □ ☊ There is *internal conflict* regarding the need for spiritual teachers to teach them to tap their unconscious minds because of their own problems as a spiritual teacher in a past lifetime.

♅ △ ☊ These individuals will attract spiritual teachers who they have been close to in other lifetimes and who have taught them to tap their unconscious minds.

♅ ⼊ ☊ An *adjustment* is needed in thinking regarding spiritual teachers. The fact that spiritual teachers must, also, learn to tap their unconscious minds does not make them any less capable of teaching others to tap their unconscious minds.

♅ ⚻ ☊ An *awareness* should be developed concerning the need to find spiritual teachers to teach them to tap their unconscious minds.

387

♅ ♂ ♇ The *power* of this conjunction will attract karmic situations which will trigger the opening of their unconscious minds.

♅ N ♇ There is a *restriction* on attracting karmic situations which would trigger the opening of their unconscious minds because of the need to revise past attitudes concerning the houses these planets reside in.

♅ ✳ ♇ There is the *opportunity* for karmic situations to occur which would trigger the opening of their unconscious minds.

♅ □ ♇ There is *internal conflict* regarding the karmic situations that occur which trigger the opening of their unconscious minds because of their fear to face their past lifetimes.

♅ △ ♇ These individuals willingly attract karmic situations to occur which would trigger the opening of their unconscious minds.

♅ ⚻ ♇ An *adjustment* is needed in thinking, as these individuals have difficulty in accepting the need for karmic situations occurring which would trigger the opening of their unconscious minds because of their fear to face their past lifetimes.

♅ ☍ ♇ An *awareness* should be developed that karmic situations must, and will, occur for the purpose of integrating past lifetimes, by triggering the opening of the unconscious minds.

ASPECTS TO NEPTUNE

(During the twentieth century, Neptune has made only one major aspect to Pluto and that is the sextile.)

♆ ✳ ♇ There is the *opportunity* for these individuals to use their psychic abilities for the benefit of humanity. These individuals can develop clairvoyance and prophetic ability. They have a number of precognitive dreams. There are strong psychic healing powers. One of their finest traits is their desire for justice for all individuals. They abhor violence or anything that might in any way degrade or oppress another human being or animal.

♆ ♂ ⊕ The *power* of this conjunction balances the emotions and the intellect to Neptune's vibrations, so that these individuals can hear and see into the astral world.

♆ N ⊕ There is a *restriction* on hearing and seeing into the astral world until these individuals revise past-life attitudes regarding the houses these planets reside in.

♆ ✳ ⊕ An *opportunity* to learn to hear and see into the astral world.

♆ □ ⊕ *Internal conflict* which interferes with hearing and seeing into the astral world.

♆ △ ⊕ In other lifetimes, these individuals were able to hear and see into the astral world and have the ability to easily learn to do so this lifetime.

♆ ⚻ ⊕ An *adjustment* in thinking is needed, so that they can begin the work of learning to hear and see into the astral world.

♆ ☊ ⊕ An *awareness* should be developed that they need to begin the work of learning to hear and see into the astral world.

♆ ♂ ☊ The *power* of this conjunction will attract spiritual teachers who can teach them how to hear and see into the astral world.

♆ N ☊ There is a *restriction* on attracting spiritual teachers who could teach them to hear and see into the astral world, because of the need to revise past attitudes concerning the houses these planets reside in.

♆ ✳ ☊ There is an *opportunity* for spiritual teachers to enter their lives who can teach them how to hear and see into the astral world.

♆ □ ☊ There is *internal conflict* regarding the need for spiritual teachers to teach them how to hear and see into the astral world, because of their own problems as a spiritual teacher in a past lifetime.

♆ △ ☊ These individuals will attract spiritual teachers who they have been close to in other lifetimes and who have taught them how to hear and see into the astral world.

♆ ⚻ ☊ An *adjustment* is needed in thinking regarding spiritual teachers. The fact that spiritual teachers must, also, learn to hear and see into the astral world does not make them any less capable of teaching others how to hear and see into the astral world.

♆ ☍ ☊ An *awareness* should be developed concerning the need to find spiritual teachers to teach them how to hear and see into the astral world.

♆ ♂ ☋ The *power* of this conjunction will attract karmic situations which will enable them to hear and see into the astral world.

♆ N ♊ There is a *restriction* on attracting karmic situations which would enable them to hear and see into the astral world, because of the need to revise past attitudes concerning the houses these planets reside in.

♆ ✳ ♊ There is an *opportunity* for karmic situations to occur which would enable them to hear and see into the astral world.

♆ □ ♊ There is *internal conflict* regarding the karmic situations occurring which would enable them to hear and see into the astral world, because of their fear of the unknown.

♆ △ ♊ These individuals willingly attract karmic situations to occur which would enable them to hear and see into the astral world.

♆ ⚻ ♊ An *adjustment* is needed in thinking, as these individuals have difficulty in accepting the necessity of karmic situations occurring which would enable them to hear and see into the astral world, because of their fear of the unknown.

♆ ☍ ♊ An *awareness* should be developed that karmic situations must, and will, occur for the purpose of dissolving their fear of the unknown, by enabling them to hear and see into the astral world.

ASPECTS TO PLUTO

♇ ☌ ⊕ The *power* of this conjunction balances the emotions and the intellect to Pluto's vibrations, so that these individuals can elevate their consciousness enabling them to contact the higher realms.

♀ N ⊕ There is a *restriction* on elevating their consciousness until these individuals learn needed lessons regarding the houses these planets reside in.

♀ ✳ ⊕ An *opportunity* to learn to elevate their consciousness.

♀ □ ⊕ *Internal conflict* which interferes with elevating their consciousness.

♀ △ ⊕ In other lifetimes, these individuals were able to elevate their consciousness and have the ability to easily learn to do so this lifetime.

♀ ⊼ ⊕ An *adjustment* in thinking is needed so that they can begin to learn how to elevate their consciousness.

♀ ⚹ ⊕ An *awareness* should be developed that they need to begin the work of elevating their consciousness.

♀ ♂ ☊ The *power* of this conjunction will attract spiritual teachers who can teach them how to elevate their consciousness.

♀ N ☊ There is a *restriction* on attracting spiritual teachers who could teach them to elevate their consciousness, because of the need to revise past attitudes concerning the houses these planets reside in.

♀ ✳ ☊ There is an *opportunity* for spiritual teachers to enter their lives who can teach them to elevate their consciousness.

♀ □ ♌ There is *internal conflict* regarding the need for spiritual teachers to teach them to elevate their consciousness, because of their own problems as a spiritual teacher in a past lifetime.

♀ △ ♌ These individuals will attract spiritual teachers who they have been close to in other lifetimes and who have taught them how to elevate their consciousness.

♀ ⊼ ♌ An *adjustment* is needed in thinking regarding spiritual teachers. The fact that spiritual teachers must, also, learn to elevate their consciousness does not make them any less capable of assisting others to elevate their consciousness.

♀ ⚹ ♌ An *awareness* should be developed concerning the need for spiritual teachers to teach them how to elevate their consciousness.

♀ ♂ ☊ The *power* of this conjunction will attract karmic situations which will enable them to elevate their consciousness.

♀ N ☊ There is a *restriction* on attracting karmic situations which would enable them to elevate their consciousness, because of the need to revise past attitudes concerning the houses these planets reside in.

♀ ⚹ ☊ There is an *opportunity* for karmic situations to occur which would enable them to elevate their consciousness.

♀ □ ☊ There is *internal conflict* regarding the karmic situations occurring, which would enable them to elevate their consciousness because of their fear of the unknown.

♀ △ ♑ These individuals willingly attract karmic situations which would enable them to elevate their consciousness.

♀ ⊼ ♑ An *adjustment* is needed in thinking, as these individuals have difficulty in accepting the need for karmic situations occurring which would enable them to elevate their consciousness.

♀ ☍ ♑ An *awareness* should be developed that karmic situations must, and will, occur for the purpose of enabling them to elevate their consciousness.

ASPECTS TO THE ASCENDANT
(Concerning temperament and character.)

♂ ☉ Sunny, charming disposition. Radiate vitality.

N ☉ Restricted in revealing their true personality.

⁎ ☉ Sociable, energetic. Enjoy traveling.

□ ☉ Internal conflict as to what to pursue in life.

△ ☉ Self-confident and candid. Enjoy performing for others.

⊼ ☉ Depth of character, stoic. Frequently misunderstood because of complex nature.

☍ ☉ Unusually sociable who need people around them.

♂ ☽ Difficulties in hiding their emotions. A strong empathy for others.

N ☽ Restricted in revealing their emotions.

⚹ ☽ Need people around them. Understand the needs of others.

□ ☽ Changeable cmotions. Nervous tension. Need quiet times.

△ ☽ Emotions openly revealed. Enjoy life and people.

☌ ☽ Emotionally disciplined. Hide their feelings.

☊ ☽ Need to control their emotional responses to others. Can become too emotionally involved in other people's lives.

♂ ☿ Active mind which needs the stimulus of communicating with others. Restless.

N ☿ Inability to verbally express their thoughts.

⚹ ☿ Enjoy talking and working with people, especially those of an intellectual nature. Many interests.

□ ☿ Nervous energy. Can have lack of clarity in expressing their thoughts. Talkative.

△ ☿ Curious, active mind which needs to express itself in a visible form. Communicate clearly and concisely. Sociable.

☌ ☿ Problems in communicating because they are too wordy. Nervous.

�195 ☿ Need mental stimulation, such as debating. Prefer analytical people. Like to challenge other people's ideas.

♂ ♀ Charming and appealing nature, but may lack sincerity. Want their home to be comfortable and beautiful.

N ♀ Pleasing personality, but inner feelings of being unloved and unappreciated.

✳ ♀ Cheerful, easygoing, pleasant personality. Love of beauty in any form.

□ ♀ Charming, pleasant personality, but may lack sincerity. Can be lazy.

△ ♀ Cheerful, easygoing personality. Attractive in appearance, with a lot of charm. Have artistic talents.

⚻ ♀ Feel that love is an act of service to others. Seem to be only able to project their warmth to personal friends and loved ones.

☍ ♀ Approval important to them. Like to be with warm and friendly people.

♂ ♂ Independent people who like to have total control over their own lives. Strong integrity, but explosive temper. Athletically inclined.

N ♂ Inability to release inner conflicts due to inner frustrations.

✳ ♂ Independent and self-assertive individuals. Like active, energetic friends. Integrity and loyalty.

□ ♂ Inner struggles between personal desires and the need to get along harmoniously with others. Impulsive, emotional, with angry outbursts.

△ ♂ Courageous, strong-willed, independent, and impervious to other people's opinions of them. High standards. Devote all their energies into whatever they are interested in. Will defend their beliefs and ideals.

⋀ ♂ A need to learn to compromise in all cooperative relationships. Will work hard for a personal goal.

⚹ ♂ A need to compromise with others. Are aggressive and competitive. Independent.

♂ ♃ Generous, helpful, and honest. Are generally optimistic, even when suffering from inner conflicts.

N ♃ Inability to feel at ease in social gatherings.

✳ ♃ Sociable, optimistic. Are broadminded and tolerant.

□ ♃ Make a favorable impression on others, but can become wrapped up in their own desires. Like luxurious things and enjoy traveling.

△ ♃ Open, gregarious, and fun-loving. Very optimistic. Are interested in knowledge and have creative ideas.

π ♃ Must learn to compromise with others. Benefit the most by helping others.

⚹ ♃ Enjoy learning from others, as they recognize the need for knowledge. Good relationships with others. Good sense of humor.

♂ ♄ Serious, responsible individuals. Find it difficult to relax.

N ♄ Inability to make close friendships.

✳ ♄ Loyal and reliable people who willingly assume responsibilities. Not particularly comfortable in large groups.

□ ♄ Very competent. Can be overly critical of themselves. Find it difficult to relate to friends because of inner feelings of unworthiness.

△ ♄ Realistic, practical, with organizational ability. Enjoy working hard. Hard for them to relax.

π ♄ Serious individuals who prefer to work on important projects and, so, find it difficult to relax and enjoy themselves.

⚹ ♄ Serious-minded, withdrawn individuals. Prefer relationships with mature people. Find it difficult to relate to others due to their lack of confidence.

♂ ♅ Unconventional individuals who are free spirits. High-strung and nervous. Have original ideas. Are both creative and artistic.

N ⛢ Inability to feel free because of restricting forces in their life.

⚹ ⛢ Have definite ideas. Are independent with a quick mind. Enjoy working on a variety of projects, all at the same time.

☐ ⛢ Original, independent, rebellious. Like to have a lot of projects going on at the same time. Nervous energies.

△ ⛢ Creative, innovative minds. Adaptable to changes. Enjoy new ideas and concepts. Prefer to experience everything first-hand.

⚻ ⛢ Restless energies which need to be released in creative channels. Strong desire for freedom to do as they wish.

☍ ⛢ Like unusual, interesting people. Are easily bored. Strong desire for freedom to do as they wish.

☌ ♆ Very sensitive to the vibrations around them. Psychic and intuitive. Feel a need to serve others.

N ♆ Inability to perceive that human frailties are the reason people are in the physical world.

⚹ ♆ Empathy and compassion for others. Have intuitive and psychic abilities.

☐ ♆ Perceptive about the vibrations around them. The truth and untruth should be sorted out in their mind. They lack self-confidence.

△ ♆　　Great imagination, creative. Sensitive to the needs of others. Intuition and psychic ability.

⊼ ♆　　Generous, sensitive. Until the soul learns, these individuals will give either gifts or service in order to receive friendship and affection from others.

⚻ ♆　　Can be selfless in relationships. Very creative individuals. Are attracted to spiritual teachers they can idealize, because they are too easily disillusioned by the rest of humanity.

♂ ♀　　Extreme sensitivity with great intensity towards people and activities. Emotional individuals who have good concentration.

N ♀　　Inability to form any intense relationship with others.

⚹ ♀　　Serious individuals with personal magnetism. Inquisitive mind. Diplomatic in their relationships with others. Leadership qualities.

□ ♀　　Intense, brooding individuals. Inclined to be secretive about their emotional feelings. Need to learn to compromise with others.

△ ♀　　Intensely emotional individuals who are inclined to be serious. Interest in a variety of philosophies and a desire to reform the ills of society. Personal magnetism.

⊼ ♀　　Can be impulsive in their behavior and should learn to think before they act. Need to learn to compromise with others.

⚻ ♀　　Tendency toward intolerance and will need to learn to

compromise with others. Extremely intense in their relationships with other people.

♂ ⊕ Have programmed success.

N ⊕ Have restricted their success in order to learn needed lessons.

✳ ⊕ Opportunity for success.

☐ ⊕ Obstacles they have to overcome in order to deserve success.

△ ⊕ Will be successful.

⊼ ⊕ Motives must be adjusted before they can obtain success.

⚸ ⊕ Motives must be purified before they can obtain success.

♂ ☊ These individuals have programmed a spiritual life.

N ☊ There is a restriction on leading a spiritual life while important lessons are being learned.

✳ ☊ Opportunity for their approach to life to be a spiritual one.

☐ ☊ Internal conflict between the desire for a spiritual life and a material life.

△ ☊ Their approach to life will be a spiritual one.

401

π ♌ An adjustment must be made in the conscious mind's thinking before they can lead a spiritual life.

⚹ ♌ An awareness should be developed for the need to seek a spiritual life.

♂ ♑ These individuals will on occasions become former lifetime personalities.

N ♑ These individuals will continually repeat the same former lifetime personality until they have purified it.

⚹ ♑ An occasional pull back to former harmonious lifetime personalities.

□ ♑ These individuals will on occasions become former negative lifetime personalities.

△ ♑ A strong pull back to former harmonious lifetime personalities.

π ♑ These individuals will on occasions fluctuate between a variety of former lifetime personalities within a brief span of time.

⚹ ♑ These individuals will on occasions experience being former negative lifetime personalities and positive lifetime personalities.

ASPECTS TO MID-HEAVEN
(Concerning one's success in the outer world.)

♂ ☉ These individuals need society to approve of their personal achievements.

N ☉ These individuals will not receive society's approval until needed lessons are learned.

✳ ☉ There is an opportunity for these individuals to succeed in society's eyes.

□ ☉ Internal conflict because of the conscious mind's desire to be a success in society's eyes and the programming of their souls in order to avoid the misuse of power.

△ ☉ These individuals will achieve success in society's eyes.

⊼ ☉ These individuals need to adjust their motives for being a success in society's eyes. Otherwise, they will not achieve it.

⅄ ☉ These individuals need to develop an awareness that their motives for becoming a success in society's eyes need purifying. Otherwise, they will not achieve it.

♂ ☽ These individuals can utilize their emotional sensitivity in a career and/or personal achievements.

N ☽ These individuals must learn objectivity before they can utilize their emotional sensitivity in a career and/or personal achievements.

✳ ☽ These individuals have the opportunity to utilize their emotional sensitivity in a career and/or personal achievements.

□ ☽ The internal conflict between reason and emotion has to be mastered before these individuals can become a success in society's eyes.

△ ☽ These individuals will utilize their emotional sensitivity in a career and/or personal achievements.

☓ ☽ These individuals have to bring their excessive emotions into balance with their logic in order to gain objectivity, so that they can become successful in society's eyes.

⚻ ☽ Due to the need to learn objectivity, these individuals will have more difficulty than any other aspect in achieving success in society's eyes.

♂ ☿ These individuals are objective, logical, and able to communicate, making it possible for them to succeed in society's eyes.

N ☿ These individuals have difficulty in communicating their thoughts verbally, which is a hindrance to becoming successful in society's eyes if there is a need to express themselves verbally.

✳ ☿ Intuitive feelings, along with their logical thinking, gives these individuals the opportunity to become successful in society's eyes.

□ ☿ Internal conflict caused by the gossiping about them by fellow workers may discourage them from wanting to become successful in society's eyes.

△ ☿ Intuitive feelings, along with their logical thinking, assures these individuals of becoming a success in society's eyes.

☓ ☿ These individuals must become aware that even though they may be the object of gossiping by their fellow workers, they should not indulge in this practice also. This type of indiscretion will hinder becoming a success in society's eyes.

♀ ☿ This indicates fellow workers can cause distress through gossiping about the individual, which may discourage them from wanting to become successful in society's eyes.

♂ ♀ Ability to attract success because of their ability to get along with people.

N ♀ Inability to attract success because they are unable to project their warm personality.

⚹ ♀ Opportunity to utilize their pleasant personality in a career and/or personal achievements.

□ ♀ Can attract success if they do not resort to insincere flattery, which is always detected.

△ ♀ Ability to attract success because of the kindness and charm they have shown others in other lifetimes.

⚻ ♀ Ability to attract success by overcoming feelings of unworthiness.

� ♀ Can attract success if they want it.

♂ ♂ Energy is directed toward being successful in society's eyes.

N ♂ These individuals are prevented by their own programming from being successful in society's eyes, until needed lessons have been learned.

⚹ ♂ An opportunity to utilize their energy in being successful in society's eyes.

□ ♂ They can be a success in society's eyes, but they divert too much of their energy into personal conflicts.

△ ♂ Their strong energy drive assures them of being successful in society's eyes.

⊼ ♂ These individuals desire to start at the top of the profession they chose. If this is not possible, they lose their desire to become successful in society's eyes and will work at most anything rather than have to slowly climb to the top.

⅄ ♂ These individuals prefer to enjoy their chosen career, rather than seeking one which would appear to be successful in society's eyes.

♂ ♃ Will be successful because their ambition is directed toward the good of humanity.

N ♃ These individuals have to be programmed to learn humility before they can become a success in society's eyes.

✳ ♃ Their ability to harmonize large groups of people will assure them success in society's eyes.

□ ♃ There is an internal conflict for power with this aspect, along with a desire to help humanity. They should be sure to examine their motives carefully, because they can become a success in society's eyes.

△ ♃ These individuals are true humanitarians who will make the world a far better place if they do seek success in society's eyes.

⊼ ♃ Because of their innate love of freedom, these individuals will probably not desire to become successful in society's eyes, for their career might restrict their love of spontaneous traveling.

⚼ ♃ These individuals would not mind being successful in society's eyes, as long as their career would give them enough freedom to enjoy their family life and travels.

♂ ♄ Even though these individuals have leadership capabilities to become a success in society's eyes, they came into this incarnation with the need to sit at the feet of other leaders, because of their desire to test themselves to be sure they had learned true humility.

N ♄ These individuals programmed this restriction in order to learn more needed lessons with regard to humility and the type of qualities needed to be a more benevolent leader.

⁎ ♄ These individuals are practical and disciplined. Even though they prefer to work alone, they could easily achieve success in society's eyes.

□ ♄ There is internal conflict within these individuals to retreat from society because of their experiences of being unloved and rejected by society in former lifetimes. In order to become a success in this lifetime in society's eyes, they will have to emerge from their protective shell.

△ ♄ These individuals are systematic and work to develop a proficiency in whatever interests them, so that they are assured success in society's eyes.

🝆 ♄ Even though these individuals are disciplined and work hard, they prefer not to be in the limelight. They are more comfortable when their work is clearly defined by someone in authority.

⚻ ♄ Since these individuals find it difficult to relate to society as a whole and prefer the company of a few intimate friends, they have no desire to be a success in society's eyes.

♂ ♅ Can be successful if they use their innovative, original ideas and concepts in creative channels.

N ♅ These individuals programmed this restriction in order to contain their rebellious instincts against society, until they have learned understanding.

✳ ♅ Will want to be successful in society's eyes, if their career is one that is unique and unusual.

□ ♅ These individuals will need to overcome their inner resentment at taking instructions from others. This conflict blocks their innovative, original ideas and concepts from making them a success in society's eyes.

△ ♅ Will be successful in society's eyes, if their career is one that is unique and unusual.

🝆 ♅ These individuals have no desire to be successful in society's eyes, for they prefer to pursue simpler goals.

⚻ ♅ These individuals have no desire to be successful in society's eyes, for they prefer freedom to the restrictions imposed by society.

♂ ♆ These individuals can become a success in society by utilizing their psychic abilities.

N ♆ These individuals programmed seclusion from society to search for spiritual insights.

⚹ ♆ These individuals may not wish to be successful in society, unless it will benefit humanity in some manner.

□ ♆ These individuals will not pursue success in society, unless they are working for a high ideal.

△ ♆ These individuals are quietly successful through their humanitarian works.

⚻ ♆ These individuals prefer to work for other people.

☊ ♆ These individuals have strong ideals and could become a success if they so desired.

♂ ♇ An intense desire to be successful in society's eyes.

N ♇ These individuals have programmed to remain out of society's eyes until they know themselves better.

⚹ ♇ Are ambitious and will undoubtedly seek success in society's eyes.

□ ♇ A desire to be a reformer in order to bring about changes in the world, but they must first learn to cooperate with others before they can be successful.

△ ♀ They will use their resources and talents to become a success in society's eyes.

⊼ ♀ These individuals have no desire to be successful in society's eyes, for they prefer to pursue other goals.

⚹ ♀ These individuals have no desire to be successful in society's eyes, for they prefer to pursue other goals.

♂ ⊕ These individuals flow with all experiences, so that success is easily achieved in the outer world.

N ⊕ A restriction on the ability to flow with their experiences, so that these individuals cannot achieve success in the outer world until they learn to do so.

✳ ⊕ An opportunity to flow with their experiences, so that success can be achieved in the outer world.

☐ ⊕ Internal conflict over their experiences in life, so that success in the outer world is denied until they learn to flow with them.

△ ⊕ The ability to flow with their experiences, so that success is achieved in the outer world.

⊼ ⊕ An adjustment in their thinking is needed, so that they can flow with their experiences before any real success can be achieved in the outer world.

⚹ ⊕ A need to cooperate, to flow with, their experiences before any real success can be achieved in the outer world.

♂ ♌ The career and/or personal achievements of these individuals will bring spiritual growth.

N ♌ The career and/or personal achievements of these individuals will restrict spiritual growth until important lessons are learned regarding the house affairs the North Node resides in.

✳ ♌ The career and/or personal achievements of these individuals may bring spiritual growth.

☐ ♌ Inner conflict over achieving spiritual growth, because the conscious mind wants personal acclaim from society.

△ ♌ The career and/or personal achievements of these individuals will bring spiritual growth.

⊼ ♌ A change in thinking regarding their career and/or personal achievements will bring spiritual growth.

☍ ♌ An awareness that their career and/or personal achievements will not hinder them from achieving spiritual growth.

♂ ♑ A desire to fulfill past lifetime karmic obligations, rather than receiving recognition in society's eyes.

N ♑ A restriction on fulfilling past lifetime karmic obligations, due to a need for personal growth concerning the house affairs the South Node resides in.

✳ ♑ An opportunity to fulfill past lifetime karmic obligations, rather than receiving recognition in society's eyes.

411

□ ♈ Inner conflict over the necessity to fulfill past lifetime karmic obligations, rather than receiving society's recognition.

△ ♈ A willingness to fulfill past lifetime karmic obligations, rather than receiving recognition in society's eyes.

⚹ ♈ A need to adjust their thinking with regard to the need for fulfilling past lifetime karmic obligations, rather than having the recognition of society.

⚻ ♈ A need to compromise with past lifetime karmic obligations and their desire to succeed through a career and/or personal achievements in society's eyes.

Index of Charts and Illustrations

CHARTS

ILLUSTRATIONS

Subject Index

417

N

426

CRCS PUBLICATIONS

CRCS PUBLICATIONS publishes high quality books that focus upon the modernization and reformulation of astrology. We specialize in pioneering works dealing with astrological psychology and the synthesis of astrology with counseling and the healing arts. CRCS books utilize the insights of astrology in a practical, constructive way as a tool for self-knowledge and increased awareness.

ASTROLOGY, PSYCHOLOGY & THE FOUR ELEMENTS: An Energy Approach to Astrology & Its Use in the Counseling Arts by Stephen Arroyo
... $7.95 Paperback; $14.95 Hardcover
An international best-seller, this book deals with the relation of astrology to modern psychology and with the use of astrology as a practical method of understanding one's attunement to universal forces. Clearly shows how to approach astrology with a real understanding of the energies involved. Awarded the British Astrological Assn's Astrology Prize. A classic translated into 8 languages!

ASTROLOGY AND THE MODERN PSYCHE: An Astrologer Looks at Depth Psychology by Dane Rudhyar 182 pages, Paperback $5.95
Deals with Depth-Psychology's pioneers with special emphasis on Jung's concepts related to astrology. Chapters on: Psychodrama, Psychosynthesis, Sex Factors in Personality, the Astrologer's Role as Consultant.

ASTROLOGY, KARMA, & TRANSFORMATION: The Inner Dimensions of the Birth-Chart by Stephen Arroyo 264 pages, $9.95 Paperback; $17.95 Deluxe Sewn Hardcover
An insightful book on the use of astrology as a tool for spiritual and psychological growth, seen in the light of the theory of karma and the urge toward self-transformation. International best-seller.

CYCLES OF BECOMING: The Planetary Pattern of Growth by Alexander Ruperti
.. 6 x 9 Paperback, 274 pages, $9.95
The first complete treatment of transits from a humanistic and holistic perspective. All important planetary cycles are correlated with the essential phases of psychological development. A pioneering work!

AN ASTROLOGICAL GUIDE TO SELF-AWARENESS by Donna Cunningham, M.S.W.
.. 210 pages, Paperback $6.95
Written in a lively style by a social worker who uses astrology in counseling, this book includes chapters on transits, houses, interpreting aspects, etc. A popular book translated into 3 languages.

RELATIONSHIPS & LIFE CYCLES: Modern Dimensions of Astrology by Stephen Arroyo
.. 228 pages, Paperback $7.95
A collection of articles and workshops on: natal chart indicators of one's capacity and need for relationship; techniques of chart comparison; using transits practically; counseling; and the use of the houses in chart comparison.

REINCARNATION THROUGH THE ZODIAC by Joan Hodgson Paperback $5.50
A study of the signs of the zodiac from a spiritual perspective, based upon the development of different phases of consciousness through reincarnation. First published in England as *Wisdom in the Stars.*

LOOKING AT ASTROLOGY by Liz Greene 8½ x 11, $5.95
A beautiful, full-color children's book for ages 6-13. Illustrated by the author, this is the best explanation of astrology for children and was highly recommended by *School Library Journal.* It emphasizes a healthy self-acceptance and a realistic understanding of others. A beautiful gift for children or for your local library.

A SPIRITUAL APPROACH TO ASTROLOGY by Myrna Lofthus ... Paperback $12.50
A complete astrology textbook from a karmic viewpoint, with an especially valuable 130-page section on karmic interpretations of all aspects, including the Ascendant & M.C. A huge 444-page, highly original work.

THE ASTROLOGER'S GUIDE TO COUNSELING: Astrology's Role in the Helping Professions by Bernard Rosenblum, M.D. Paperback $7.95
Establishes astrological counseling as a valid, valuable, and legitimate helping profession, which can also be beneficially used in conjunction with other therapeutic and healing arts.

THE JUPITER/SATURN CONFERENCE LECTURES (*Lectures on Modern Astrology Series*) by Stephen Arroyo & Liz Greene Paperback $8.95
Transcribed from lectures given under the 1981 Jupiter/Saturn Conjunction, talks included deal with myth, chart synthesis, relationships, & Jungian psychology related to astrology.

THE OUTER PLANETS & THEIR CYCLES: The Astrology of the Collective (*Lectures on Modern Astrology Series*) by Liz Greene Paperback $7.95
Deals with the individual's attunement to the outer planets as well as with significant historical and generational trends that correlate to these planetary cycles.

CHILD SIGNS: Understanding Your Child Through Astrology by Dodie & Allan Edmands 150 pages, 12 photos of children Paperback $6.95
An in-depth treatment of a child's developmental psychology from an astrological viewpoint. Recommended by *Library Journal,* this book helps parents understand and appreciate their children more fully. Nice gift!

DYNAMICS OF ASPECT ANALYSIS: New Perceptions in Astrology by Bil Tierney. Groundbreaking new work! 288 pages, Paperback $8.95
The most in-depth treatment of aspects and aspect patterns available, including both major and minor configurations. Also includes retrogrades, unaspected planets & more!

ASTROLOGY FOR THE NEW AGE: An Intuitive Approach by Marcus Allen
.. Paperback $5.95
A highly original work with an uplifting quality. Emphasizes self-acceptance and tuning in to your own birth chart with a positive attitude. Helps one create his or her own interpretation. Ready now.

THE PRACTICE & PROFESSION OF ASTROLOGY: Rebuilding Our Lost Connections with the Cosmos by Stephen Arroyo late 1984, Paperback $7.95
A challenging, often controversial treatment of astrology's place in modern society and of astrological counseling as both a legitimate profession and a healing process.

HEALTH-BUILDING: The Conscious Art of Living Well by Dr. Randolph Stone, D.C., D.O. Approx. 150 pages, Paperback
A complete health regimen for people of all ages by an internationally renowned doctor who specialized in problem cases. Includes instructions for vegetarian/purifying diets and energizing exercises for vitality and beauty. Illustrated with drawings & photographs.

POLARITY THERAPY: The Complete Collected Works by the Founder of the System, Dr. Randolph Stone, D.O., D.C. (In 2 volumes, 8½ x 11),
The original books on this revolutionary healing art available for the first time in trade editions. Fully illustrated with charts & diagrams. Sewn paperbacks, over 500 total pages.

A JOURNEY THROUGH THE BIRTH CHART: Using Astrology on Your Life Path by Joanne Wickenburg...168 pages, Paperback$7.95
Gives the reader the tools to put the pieces of the birth chart together for self-understanding and encourages creative interpretation of charts by helping the reader to think through the endless combinations of astrological symbols. Clearly guides the reader like no other book.

THE ASTROLOGY OF SELF-DISCOVERY: An In-Depth Exploration of the Potentials Revealed in Your Birth Chart by Tracy Marks....... 288 pages, Paperback.....................................$8.95
A guide for utilizing astrology to aid self-development, resolve inner conflicts, discover and fulfill one's life purpose, and realize one's potential. Emphasizes the Moon and its nodes, Neptune, Pluto, & the outer planet transits. An important & brilliantly original new work!

THE PLANETS & HUMAN BEHAVIOR by Jeff Mayo...180 pp, Paperback $7.95
A pioneering exploration of the symbolism of the planets, blending their modern psychological significance with their ancient mythological meanings. Includes many tips on interpretation!

ASTROLOGY IN MODERN LANGUAGE by Richard B. Vaughan...340 pp, $9.95
An in-depth interpretation of the birth chart focusing on the houses and their ruling planets-- including the Ascendant and its ruler. A unique, strikingly original work! (paperback)

THE ART OF CHART INTERPRETATION: A Step-by-Step Method of Analyzing, Synthesizing & Understanding the Birth Chart...by Tracy Marks Paperback ..$7.95
A guide to determining the most important features of a birth chart. A must for students!

THE SPIRAL OF LIFE: Unlocking Your Potential With Astrology..... by Joanne Wickenburg & Virginia Meyer...paperback..........$7.95
Covering all astrological factors, this book shows how understanding the birth pattern is an exciting path towards increased self-awareness and purposeful living.

HOW TO HANDLE YOUR T-SQUARE by Tracy Marks...(new edition)..$10.95
The meaning of the T-Square, its focal planets, aspects to the rest of the chart, and its effect in chart comparisons, transits and progressions. A perennial best seller! (paperback)

NUMBERS AS SYMBOLS OF SELF-DISCOVERY by Richard B. Vaughan...... 336 pages, Paperback.....................................$7.95
A how-to book on personal analysis & forcasting your future through Numerology. His examples include the number patterns of a thousand famous personalities.

For more complete information on our books, a complete booklist, or to order any of the above publications, WRITE TO:

CRCS Publications
Post Office Box 1460
Sebastopol, California 95473
U.S.A.